An Anthropology of Contemporary Art

ALSO AVAILABLE FROM BLOOMSBURY

Anthropology and Art Practice, edited by Arnd Schneider and Christopher Wright

Anthropology of the Arts, edited by Gretchen Bakke and Marina Peterson

Art, Anthropology and the Gift, Roger Sansi

Arts and Aesthetics in a Globalizing World, edited by Raminder Kaur and Parul Dave-Mukherji

An Anthropology of Contemporary Art

Practices, Markets, and Collectors

EDITED BY

THOMAS FILLITZ AND

PAUL VAN DER GRIJP

Bloomsbury Academic
An imprint of Bloomsbury Publishing Plc

B L O O M S B U R Y

LONDON · OXFORD · NEW YORK · NEW DELHI · SYDNEY

Bloomsbury Academic

An imprint of Bloomsbury Publishing Plc

50 Bedford Square	1385 Broadway
London	New York
WC1B 3DP	NY 10018
UK	USA

www.bloomsbury.com

BLOOMSBURY and the Diana logo are trademarks of Bloomsbury Publishing Plc

First published 2018

British Library Cataloguing-in-Publication Data
A catalogue record for this book is available from the British Library.

ISBN: HB: 978-1-3500-1632-3
PB: 978-1-3500-1623-1
ePDF: 978-1-3500-1641-5
eBook: 978-1-3500-1642-2

Library of Congress Cataloging-in-Publication Data
Names: Fillitz, Thomas, 1953- editor. | Grijp, Paul van der, 1952- editor.
Title: An anthropology of contemporary art : practices, markets, and
collectors / edited by Thomas Fillitz and Paul van der Grijp.
Description: New York : Bloomsbury Academic, An imprint of Bloomsbury
Publishing Plc, 2017. | Includes bibliographical references and index.
Identifiers: LCCN 2017046768| ISBN 9781350016231 (pbk.) |
ISBN 9781350016323 (hpod)
Subjects: LCSH: Art and anthropology. | Art, Modern–21st century–Economic aspects.
Classification: LCC N72.A56 A65 2017 | DDC 306.4/7–dc23 LC record available at
https://lccn.loc.gov/2017046768

Cover design by Liron Gilenberg | www.ironicitalics.com

Typeset by Deanta Global Publishing Services, Chennai, India
Printed and bound in Great Britain

To find out more about our authors and books visit www.bloomsbury.com. Here you will find
extracts, author interviews, details of forthcoming events and the option
to sign up for our newsletters.

Contents

List of Illustrations

Contributors

Dayana Zdebsky de Cordova is a doctoral student of social anthropology at the Federal University of São Carlos, Brazil. Among her research interests are contemporary visual arts and tangible and intangible heritage, and their intersections with urban contexts. Among her publications are *Conversas sobre Arte*, Máquina de Escrever (2015) and *As muitas vistas de uma rua—histórias e políticas de uma paisagem*, Máquina de Escrever (2014).

Philippe Descola is professor at the Collège de France, where he holds the chair of the anthropology of nature and directs the Laboratoire d'Anthropologie Sociale. Descola has served as visiting professor in universities all around the world, and has given several distinguished lectures, such as the Radcliffe-Brown Lecture at the British Academy, and the Clifford Geertz Memorial Lecture at Princeton. He was awarded the gold medal of the CNRS in 2012, and is a foreign member of the British Academy and the American Academy of Arts and Sciences. Among his influential publications are *Par-delà nature et culture*, Gallimard (2005); *La Fabrique des images. Visions du monde et formes de la représentation*, Somogy et Musée du Quai Branly (2010).

Paolo Favero is an associate professor in the Department of Film Studies and Visual Culture, University of Antwerp. A visual anthropologist with a PhD from Stockholm University, Paolo has devoted the core of his career to the study of visual culture in India. Presently he conducts research on image-making, politics and technology in contemporary India as well as on questions of ontology and methodology in the context of emerging digital visual practices and technologies at global level. He was a member of the executive committee of the European Association of Social Anthropologists, and is vice-chair of the ECREA Visual Culture network. His work includes the film *Flyoverdelhi* (2004); together with G. Dahl, O. Bartholdsson, and S. Khosravi the book *Modernities on the Move*, Stockholm Studies in Social Anthropology; and the article "Learning to Look Beyond the Frame: Reflections on the Changing Meaning of Images in the Age of Digital Media Practices," *Visual Studies*, 29(2) (2014): 166–79.

Thomas Fillitz is a professor in the Department of Social and Cultural Anthropology, University of Vienna. He has served as visiting professor in

various universities in Europe and as secretary of the European Association of Social Anthropologists. Among his publications are: with A. Jamie Saris, eds., *Debating Authenticity. Concepts of Modernity in Anthropological Perspective.* Berghahn (2013); and "Anthropology and Discourses on Global Art," *Social Anthropology/Anthropologie Sociale*, 23(3) (2015): 299–313.

Alex Flynn is British Academy Postdoctoral Fellow in the Department of Anthropology, Durham University, UK. His current research focuses on contemporary art in São Paulo, specifically on the production of knowledge, artistic interventions with activist connotations, and ethico-aesthetic practices. He is co-founder of the network Anthropologies of Art [A/A] of the European Association of Social Anthropologists. Alex was recipient of the São Paulo Association of Art Critics Awards' 2016 APCA Trophy for his curatorial practice. His publications include: with Jonas Tinius, eds., *Anthropology, Theatre, and Development: The Transformative Potential of Performance*, Palgrave MacMillan (2015); with Leonardo Araujo and Claire Fontaine, "Claire Fontaine: em vista de uma prática ready-made," GLAC (2016).

Paul van der Grijp is Professor of Anthropology at the Université Lumière Lyon and researcher of the Lyon's Institute of East Asia. He conducted lengthy periods of fieldwork in the South Pacific (Western Polynesia and Fiji) and Asia (Hong Kong, Singapore, Taiwan). Among his recent publications are: *Art and Exoticism. An Anthropology of the Yearning for Authenticity*, LIT Verlag (2009); *Manifestations of Mana. Political Power and Divine Inspiration in Polynesia*, LIT Verlag (2014).

Alicja Khatchikian is a cultural anthropologist and photographer. She has an MA in social and cultural anthropology from the University of Vienna. She has worked on living culture and intangible heritage in Namibia, and performance, body, and contemporary art in Italy and China. Her current research interests revolve around the intersections between ethnography and creative processes. Her thesis was titled "Moving Bodies: An Anthropological Approach to Performance Art" (2016).

Danila Mayer has a PhD in social and cultural anthropology from the University of Vienna. She is lecturer at Karl Franzens University Graz, Austria, and directs a research laboratory at the Fachhochschule St. Poelten, Austria. Her research interests are cultural institutions and organizations, specifically biennials, youth cultures, and scenes of classical music. Currently, she works on global aspects of opera. Her publications include *Park Youth in Vienna. A Contribution to Urban Anthropology,* LIT Verlag (2011); "Anthropological Approaches to the Istanbul Biennial of Contemporary Art," *Anthropology of the Middle East,* 8(1) (2013): 1–23.

Leyla Belkaïd-Neri is Assistant Professor of Anthropology and Design Practice, and director of the Departments Fashion Design and Strategic Design Management, Parsons Paris/the European Campus of Parsons School of Design—The New School, New York. Her research work includes the project that led in 2012 to the registration of the *Rites and craftsmanship associated with the wedding costume tradition of Tlemcen* on the UNESCO Representative List of Intangible Cultural Heritage of Humanity. Among her publications are: *Veils*, Vestipolis (2009); "Habits et habitus en héritage: les designers de la diaspora chinoise à New York," in A. Monjaret (ed.), "Mode, codes vestimentaires et pratiques corporelles," *Revue Hommes et Migrations du Musée de l'Histoire de l'Immigration*, 1310 (2015): 85–90.

Stuart Plattner was Emeritus Professor of Anthropology at the University of Missouri, St. Louis. He was program director for cultural anthropology of the National Science Foundation (USA) and founding member, as well as president of both the Society for Anthropological Sciences and the Society for Economic Anthropology until his retirement in 2005. Among his many publications are: *High Art Down Home: An Economic Ethnography of a Local Art Market*, The University of Chicago Press (1996); as editor, *Economic Anthropology*, Stanford University Press (1989).

Roger Sansi is Professor of Social Anthropology at the Universitat de Barcelona, Spain. He has worked on Afro-Brazilian culture and religion, on the concept of the fetish, and on contemporary art in Barcelona. He initiated the network Anthropology of Art [A/A] of the European Association of Social Anthropologists. His publications include: *Art Anthropology and the Gift*, Bloomsbury (2015); *Economies of Relation: Money And Personalism in the Lusophone World*, University of New England Press (2013).

Jonas Tinius is a postdoctoral research fellow at the Centre for Anthropological Research on Museums and Heritage (CARMAH), Humboldt University Berlin. His research explores how Berlin-based curators, contemporary artists, and art institutions engage with notions of alterity and otherness through critical curatorial strategies to reflect on German and European identities. Together with Roger Sansi and Alex Flynn, Jonas Tinius is co-convener of the network Anthropology of Art [A/A] of the European Association of Social Anthropologists. Among his publications are: with Alex Flynn, eds., *Anthropology, Theatre, and Development: The Transformative Potential of Performance*, Palgrave MacMillan (2015).

Acknowledgments

This book is the outcome of presentations and discussions with many colleagues on a contemporary anthropology of art. Our first approach took place during the 12th EASA Biennial Conference in 2012 at Paris-Nanterre, where Thomas Fillitz and Paul van der Grijp organized the panel "Confronting Uncertainty: Imagination in Art and Material Culture." During the 13th EASA Biennial Conference in 2014 at Tallin, discussions continued in the panel "Anthropology of Art: Today and Tomorrow," which Thomas Fillitz had coordinated together with Ursula Helg (Freie Universität Berlin). Since then the idea of the book has continuously grown and taken concrete shape.

Contributors to this book who actively participated as presenters and discussants in the EASA panels are: Danila Mayer (2012), and in 2014 Dayana Zdebsky de Cordova, Paolo Favero, Alex Flynn, Roger Sansi, and Jonas Tinius. Philippe Descola supported the project from the beginning, and Stuart Plattner readily provided a so-far unpublished manuscript. Leyla Belkaïd-Neri and Alicja Khatchikian followed with great enthusiasm our invitation for producing a chapter. We would like to thank all of them for their commitment to, and trust in, this project. We regret that some colleagues, like Ursula Helg, eventually could not contribute to this book. We moreover thank the anonymous reviewers for their invaluable comments.

Finally, we would like to express our gratitude to Miriam Cantwell, our editor at Bloomsbury, and her assistant Lucy Carroll for their commitment to this project, and the publisher's copy editing team for its expert editorial work.

Thomas Fillitz and Paul van der Grijp
Vienna and Lyon, April 2017

Notes on Texts

● The editors and the publisher gratefully acknowledge the permission granted to reproduce, in English, Philippe Descola's article, originally published in French, as Chapter 1.1: Descola, P. (2006), "La fabrique des images," *Anthropologie et Sociétés*, 30(3): 167–82. DOI: 10.7202/014932ar. Available online: http://id.erudit.org/iderudit/014932ar. The editors wish to express their gratitude to Ulrike Davis-Sulikowski, University of Vienna, who provided the translation of the text.

● The editors would also like to thank Stuart Plattner for kindly providing a shortened version of an unpublished manuscript as Chapter 3.1.

● All other chapters are original contributions of the authors to this book.

Introduction

Paul van der Grijp and Thomas Fillitz

What is generically termed as the "global art world" of contemporary art is still a European/North American–determined "umbrella" notion, which designates, or even hides, important changes within the field of art—its creation, dissemination, exhibition, and consumption—in the present time. First, one can observe a massive proliferation of art biennials all over the world, and particularly in the Global South, with their number far exceeding 250. Art biennials moreover have replaced museums of modern art as the sites for informing us about the newest trends, as well as about art creations in many parts of the world. Second, starting from the early 1990s, there has been an ever-growing awareness that contemporary art is being created in all regions of the world. Third, various types of art institutions—like art foundations or museums of contemporary art—may be found in many places around the world, and have agendas that relate to regional art discourses and their histories. Fourth, curators and other art world professionals come from many regions of the world. Fifth, art market structures too are affected by changes. Art fairs for contemporary art first appeared on the European market in the 1960s, expanded in the 1980s, and, from the early 2000s on, have been spreading all over the globe (see Moulin 2009). Major auction houses and branded galleries are establishing branches in economically emerging places. Most potential collectors are no longer restricted to Europe and North America; they now come from China, India, Russia, or the Arab Emirates, and the category of "collector" itself refers to new types of art buyers.

These massive changes raise challenges. Some fine art museum flagships such as the British Museum, the Louvre, and the Metropolitan Museum position themselves as "world art museums." Regarding contemporary art, major art biennials now appoint truly international curatorial teams for dealing with the huge diversity of contemporary art. Leading museums of contemporary art have started extending their collections to contemporary art of various regions of the world, for example the Tate Modern in 2011 and

eim in 2012.[1] In these domains, it is, furthermore, not only a
sitioning oneself within a new framework or adapting collecting
nainly requires one to reflect on the organization of the display of
th different historical and regional provenances. The Tate Modern
has, for instance, adapted a new ordering system in its display spaces since
its extension in 2016, and abandoned the canon of occidental art history.
In academia, departments of global art history (for instance in Heidelberg,
Germany) or world art (leading centers being East Anglia, UK and Leyden,
the Netherlands) have been established; others are specializing in the arts of
specific regions of the world, and art curricula are being amended accordingly.

New research challenges are on the agenda. In the context of this book
we would like to mention the following ones. (a) The multitude of images
we are encountering, as well as new digital technologies, encourage us to
reflect on how images of the world are artistically expressed and the way
in which they challenge the perceptive capacities of the viewer (see Part 1,
"Image and Medium"). (b) Art, in its historical and geographical scope, and
specifically contemporary art, can no more be debated from the sole vantage
of occidental art history. New and larger frameworks are being developed, and
new art institutions, such as biennials, require specific investigation (see Part
2, "World Art Studies and Global Art"). (c) Within contemporary art markets,
the field of gallery investigation is of particular relevance to anthropologists,
since it enables them to examine the dynamics of the interactions between
artists, gallerists, and collectors; art fairs are of major interest regarding the
various activities that are enacted within a few days at specific sites (see Part
3, "Art Markets, Maecenas, and Collectors"). (d) Particular contemporary art
practices, such as relational/participatory or community arts, have influenced
new reflections regarding collaboration between artists and anthropologists.
Indeed, the attraction is the emphasis on the site specificity and social
relations as constitutive of the artistic process, away from the artwork as a
distinct object. There are, however, several issues at stake, such as the kind
of social relations that are enacted in a particular environment, or the role of
the ethnographer. Further, one may wonder about the importance accorded to
relational arts in the dominant international art language, in relation to the claim
of considering the category of contemporary art not as another universal one,
but to conceive it from the vantage of local art worlds' conceptions (see Part 4,
"Participatory Art and Collaboration").

These are the themes at large that will be dealt with in this book in
search of a contemporary anthropology of art that connects to the overall
interdisciplinary field of research studies on visual arts. Since the early 1990s,
the anthropology of art has received a new impetus within the discipline,
and its approaches are multiple. The new movement started with the call
for an aesthetic anthropology by Coote and Shelton (1992), who revitalized

the approach proposed by Jopling (1971). With their "critical anthropology of art," Marcus and Myers (1995) redirected the study of art to the art world—especially to the art world of the United States; that is, how it includes, excludes, and circulates works of art from other regions of the world, thereby producing cultural difference. Plattner (1996) examined the contemporary art market in St. Louis, United States, and proposed a methodology for the field of gallery investigations. Considered as one of the most influential anthropological approaches to the study of art, Gell (1998) developed a general anthropological theory of art which is based on the centrality of the agency of artworks and social relations. Finally, Schneider and Wright (2006, 2010, 2013) focus on the fructuous topic of the relationship between contemporary art and anthropology, first by considering interactions with artists who practiced fieldwork, and later in connection to relational/participatory art, insofar as it emphasizes social relations and collaboration.

Although all contributors to this book are anthropologists, the structure of the book is informed by engaging with discourses of art history/theory. Our focus is less to deal with disciplinary differences and boundaries, as Westermann's *Anthropologies of Art* (2007) does. In the context of the present-day new global art order (Vogel 2013), and acknowledging that the study of art is more than ever an "interdisciplinary field" (Morphy and Perkins 2006: 22–3), we rather would like to present the various chapters in connection to approaches and concepts from art history/theory.

Image and Medium

Part 1—"Image and Medium"—invites us to reflect on images in an apparently unconventional way. On the one hand, Philippe Descola presents his first insights for an anthropology of figuration—while clearly asserting that it is not an anthropology of art. Paolo Favero, on the other, explores what he calls "new images," which are made possible with contemporary digital technologies. From a broader perspective, however, both these authors deal with the central questions about pictures: (a) What kind of images are we dealing with in the context of the anthropology of art, and (b) what is the nature of these pictures? We would like to relate these two lines of reflection to the wider context of Hans Belting's central theses in his *Bild-Anthropologie* (2001).[2] First, the body is the locus of the image (ibid.: 12), and second, he emphasizes the medium of the image, asking how images are materialized in pictures (ibid.).[3]

When using the notion of "anthropology," Belting conceives it as not referring to a specific discipline, but speaks of an anthropological approach to

pictures insofar as the body is the locus of images. Thus, we are experiencing the world in images and are producing pictures of the world (ibid.: 11). This consideration may be related to Augé's conception of the contemporary world, insofar as the latter consists of a multitude of interconnected worlds, whereby each of these worlds has at least some representations of the others, images that may be distorted, falsified, invented, or stereotyped (1994: 127). Belting's interest is the creation of the picture in a social space, a production that is different to the production of (interior) images, although they stand in close relationship to each other. Hence, leaving the differentiation between collective and individual images apart, Belting (2001: 12) understands the image production as a threefold enterprise: the production of the picture in a social space, the activity of sensuous perception, and the so-connected production of the (interior) image.

In anthropology, the connection between experiencing the world and creating images of the world is usually dealt with in relation to considerations of ways of seeing. Conceiving them as practices, and not as discourses about seeing, is central to Grasseni's concept of "skilled visions," in which she emphasizes that "vision pervades our cultural forms of life in skilled ways that depend both on the way sight is physically trained and on our social positioning" (2011: 29). "Skilled visions" correspond to the "schooling of the eye," yet involving all senses (ibid.: 20). It thus not only orients our perception, but also structures our understanding of what we see (Grasseni 2007: 5). Grasseni extends her concept to all kinds of images we produce upon perception, and thereafter to different experiences of vision—"professional, aesthetic, ecstatic, . . . exercises of vision, each a skilled and social activity in itself" (Grasseni 2011: 20).

Although Belting focuses on works of art, his anthropological approach— the body as locus of the images—also applies to other domains. Yet, he encourages us to clearly differentiate between the pictures we encounter, as—following Grasseni—they require special training. The feature of artworks is their embeddedness within particular discourses that are moreover specific according to the discipline in which they are dealt with. In the anthropology of art, such reflections encourage us to differentiate among the various art categories the discipline is dealing with, such as ethnic art, tribal art, tourist art, popular art, world or global art, and contemporary art.

In the context of differentiating between the perception of different kinds of pictures, Rancière (2001) developed the concept of the *partage du sensible* (the distribution of the sensible), which became most influential for artists and art world professionals. By this he denominates a system of sensible evidences that produces a common area for insiders, as much as the concomitant divisions (*découpages*) by means of which insiders are distinguished from outsiders (ibid.: 12). Yet, Rancière positions the reflection on "skilled visions," to use Grasseni's notion, within a political context, and

further asserts that forms of art contribute differently to this distribution of the sensible (ibid.: 39, 48). Moreover, his notion of the *régime esthétique de l'art* (aesthetic regime of art) delimits accordingly a specific regime of identification for art, a distinct mode of being sensible to the products of art (Rancière 2004: 17, 34).

It is worth noting that Rancière points out a double dimension of aesthetics: first, a regime of visibility and intelligibility of art and, second, a modus of an interpretative discourse that belongs to this particular regime (ibid.: 21). This is interesting, insofar as Rancière acknowledges that aesthetics primarily refers to art practices as "manners of doing" (ibid.: 14). At this point one may trace a connection to Gell's concept of art and agency (1998), since technical virtuosity is a central category for the agency of the artwork, an aspect Gell also highlights with the pun of *The Technology of Enchantment and the Enchantment of Technology* (1992). Yet, Rancière deals with multiple contemporary art practices, such as installation or participatory art, and with new technologies for the production of the artwork. He thereafter postulates a fundamental displacement regarding the aesthetic regime of art, a shift away from the "manner of doing" to the increasing importance of the manner of being sensible to art (Rancière 2004: 20–1).

This multitude of artistic practices, as well as Rancière's emphasis on the manner of being sensible to art, leads us to Belting's second thesis of his *Bild-Anthropologie*: the medium in which the image becomes a picture, and through which we interact with the picture. Belting (2001: 20) assigns a privileged role to the medium. An image requires a medium in which it may materialize itself, and it requires a specific form of sensibility of the viewer. Connecting the thesis of the preeminence of the medium to the one of the body as "locus of the images," Belting argues that we use our bodies as medium both for producing interior images and for receiving exterior images (ibid.: 29). Belting intends to trespass the dualisms of materiality: form, as much as the one of idea, and execution (ibid.: 13). Medium and image belong together, and Belting's further elaborations are accordingly based on the relationships of image-medium-living body.

In the context of this conception of the medium of art, the picture which guides our perception of images (ibid.: 12), one needs to consider from an anthropological perspective Gell's conception of the index in his art nexus (1998). In his examination of the index, Gell confines himself to "art-like-situations" that "can be discriminated as those in which the material 'index' (the visible, physical 'thing') permits a particular cognitive operation which I identify as the *abduction of agency*" (ibid.: 13, italics by the author). Intending to focus on visible art—and not including other arts—Gell restricts his reflections of indexes, which are "real, physical things, unique and identifiable," and therfore excludes, among others, performances and reproductions (ibid.).

Yet, in his outline of the index Gell extensively relies on examples of things other than art—smoke, dolls, idols, or his Toyota car. Although we agree that the conception of the index may be applied to all things, we argue with Grasseni's concept of skilled visions to emphasize the discrimination between capacities of seeing. This too is apparent in Rancière's concept of the *partage du sensible* (distribution of the sensible), in as far as it creates a common field that requires specializations and produces a social distribution of agents. Similarly, Belting strongly argues for the need to differentiate between pictures we encounter, and that a special narrative about images and pictures determines the field of art. Positioning the index within a concept of things at large, as Gell does, does not, then, explain its specificity in the realm of arts.

Moreover, insofar as Gell claims to develop an anthropological theory for all arts, his definition of the index leaves an open question about art practices that produce no material, physical things, such as performance art, digital art, or relational/participatory art. In relation to performance art, he asserts that the distinction of an artwork as material object has no "theoretical significance," insofar as an artwork too "is a 'performance' in that it motivates the abduction of its coming-into-being in the world" (ibid.: 67).[4] It follows that it is not the picture but the abduction of agency on the side of the viewer which is central to social relations. In this sense we understand his generic statements about contemporary art that "indexes the contemporary art public, who constitute the intended recipients of such work," and if a contemporary artwork is exhibited at Saatchi's, "it indexes this famous collector and his patronage of contemporary art" (ibid.: 24).

Belting, however, directly connects the medium to the creation of the picture of an image, and the (interior) image the beholder thus produces via his sensuous perception (see his three interrelated levels mentioned above: picture creation, perception, and production of interior images). Finally, on behalf of a general anthropological theory of art, Gell considers the abduction of agency for any artwork, for the Trobriand canoe prow-board (1992)[5] or the Congolese power figurine (*Nkisi Nkondi*, 1998: 59–62), as much as for works of European modernism.[6] In his considerations of the medium, Belting indeed demarcates between different art media, as they require different "skilled visions" (Grasseni) from the viewer. On this basis he formulates a fundamental distinction regarding the meaning of representation. In the case of Trobriand prow-boards or Congolese power figurines, beliefs and rituals determine the selection of a material for becoming the medium. Contemporary artists, however, select a medium in the context of their artistic practice and their intention. This distinction is fundamental in as far as it concerns the relationship to the image which appears in the hosting medium.

Both Descola and Favero deal differently with the ways in which we encounter images. Descola's program of an anthropology of figuration treats

works of art as agents, but in contrast to Gell he focuses on the iconic characteristics of the objects. Favero reflects upon "new images" that use the medium of new digital technologies, and why they entail the training of new capacities of vision from the viewer.

Philippe Descola addresses figuration on the basis of his *Par-delà nature et culture* (2005). It asserts that the diverse ways of organizing experience of the world may be brought back to a reduced number of modes of identification. The latter correspond to the different ways of distributing qualities to existing entities; that is, endowing them with certain aptitudes which render them capable of a specific type of action. Descola configures this identification to four ontological formulas: animism, naturalism, totemism, and analogism. If figuration is a universal disposition, the products of this activity call for a particular mode of figuration: the type of entity it creates, the type of agency that invests these products, and the means by which they are made visible in as far as each of these modes of identification stipulates different properties for the figurative objects. Fundamentally, Descola's objective is to highlight that to each ontology corresponds an iconology that is its own.

Central in Paolo Favero's chapter is the notion of "swallowing images," that is, images showing an ambition to immerse the viewers in their own space. Questioning the idea that the digital era has entailed a rupture with previous (analogical) ways of producing and using images, and addressing also the key influence of geometrical perspective in our present ways of engaging with images, the chapter suggests that "new images" ask us to re-center ways of intending images that have become marginalized in the dominant European/North American discourse on visual culture. Similar to images belonging to "other" places and times, "swallowing images" are in fact objects of contemplation and reciprocity rather than of representation and narration.

World Art and Global Art

With both the multitude of art practices in Europe and North America, as well as with the rising presence of art from all regions of the world, art history/ theory needed to search for new narratives about art. In the early 1990s, two different paradigmatic frameworks were introduced: world art and global art. Regarding the present-day conception of world art, John Onians relates it to the need of the School of Art History at the University of East Anglia (UK) to engage, in 1992, with the Robert and Lisa Sainsbury Art Collection—hosted in the same institution. This collection consists of a huge diversity of artworks: from European modernism to post–Second World War art—including design,

architecture, and other art media—to arts from various epochs, and from various regions, including Oceania, Africa, the Americas, and Asia.[7]

The school thus changed its name to the School of World Art Studies, and this new field of art research required redefinition (Onians 2006: viii). It is not our intention to recall art historical attempts since the late nineteenth century of a more inclusive world art history. The German notion *Weltkunst* (world art), however, introduced before the 1930s, was well inscribed in colonial thinking of the time. It was used for all arts that were not included within occidental art history, and these artifacts were considered on the grounds of the latter's concept of art as an autonomous aesthetic field (Volkenandt 2004).

The notion of art was thus re-conceptualized in terms of "all the artefacts that any human beings anywhere had ever thought to be of overriding visual interest" (Onians 2006: viii). World art thereafter meant "treating all art equally," and to view art created in Europe "not as the centre of the art history, but as just another 'dark continent'" (Onians 2003: 259). The new framework considers as its field of research all art from all times and all geographical areas, and it proposes to consider these arts in relation to many variables, such as the environment, available technologies and materials, and sociocultural systems (ibid.: 261). World art thus combines disciplines such as art history, anthropology, archaeology, psychology, neurosciences, museology, and all those which are working on any art. In 2010 the School of World Art Studies launched its journal *World Art*.

In anthropology, Eric Venbrux and Pamela Rosi organized an invited session at the 2002 Meeting of the American Anthropological Association's Conference entitled "Conceptualizing World Art Studies" (Venbrux and Rosi 2003: 191). As Venbrux and Rosi outlined, the aim of this panel was, first, to examine the rapprochement between art history and anthropology of art, and second, to reflect upon a true equality of all arts of the world (ibid.: 191–2).

Of major importance for our present purpose is Van Damme's (2006, 2008) conception of anthropology's contribution to world art studies, which he conceives in three domains: Anthropology A, B, and C. Conceptualizing Anthropology-A "as the study of humanity" (2006: 70), the anthropology of art "would refer broadly to the examination of artistic phenomena in human" life (ibid.). Put in other terms, a central topic would concern the "origin of artistic and aesthetic behavior, as well as their continued existence in human life" (ibid.: 72). Van Damme, however, remarks that anthropological contributions to this topical area are rare. Anthropology-B refers to the study of "other societies," and the anthropology of art on their visual arts (ibid.). This is the area of most of anthropological studies of art, and many art historians, with their disciplinary methods, have joined in this interest. Finally, Anthropology-C concerns the specific contributions of the anthropological approach to the study of art, or what art historians "might learn from anthropology" (ibid.: 74).

Van Damme assumes it to be the sociocultural contextualization, that is, the "myriad ways in which a variety of visual artistic phenomena may be related to the rest of culture," an approach that has already taken grounds within a more recent "social history of art" (ibid.: 75–6).

In this book, we suggest that Descola's anthropology of figuration may be connected to Anthropology-A world art studies, while Belkaïd-Neri's chapter, an ethnography of the art of fashion designer Stella Jean, is clearly inscribed within Anthropology-B world art framework.

Leyla Belkaïd-Neri examines the iconographies that contribute to the creation of a garment and to the social performances of the subject that designs it, by specifically presenting fashion designer Stella Jean. Describing her various collections since 2011, Belkaïd-Neri elaborates on how Stella Jean draws on dialogues with vernacular sartorial practices and visual representations that have become symbols of identity and pride for colonized populations after centuries. Stella Jean thereby aligns with transnational designers who aim at re-injecting collectivity into globalized fashion artifacts, and produce cultural and visual entanglements that address identity conflicts, as well as issues of social engagement and sustainability. Belkaïd-Neri's ethnographic presentation also contributes to the emergent research field of South-South exchanges in her anthropological study within the field of design.

Two major art theoretical objections—in particular of proponents of the notion of "global art"—against the notion of "world art" are, first, that it is loaded with meanings of the colonial past, and second, that it still conceives the notion of "contemporary art" from a European/North American–centric perspective. Within this framework, there seems to be a general consensus that the category "contemporary art" started in the 1980s, and was specified as postmodern art between the 1980s and 2000. From then on, as a consequence of globalization processes, this conception of "contemporary art" has expanded to another universal dimension (Heinich 2014).

Embedded within such a framework, the notion of "contemporary art" is subject to debate as a category of both periodization and analysis. Considering, for instance, art practices in the People's Republic of China, historical corner pillars are fundamentally different. We would like to mention some of them. The officially unapproved exhibition of *Xing Xing* (Stars Art Group) in September 1979, in the neighborhood of the National Museum of Beijing, is often put to the fore as the first public independent manifestation of Chinese artists. Others argue that another group of independent artists, *Wuming Huahui* (No Name Group),[8] was already active during the Cultural Revolution, and had its first public exhibition in the Beihai Park in Beijing earlier in July 1979 (Wang 2014). Also, the government's violent campaign of 1986 against independent artists and art groups was another hugely influential moment in recent Chinese art history. The regional importance of such events

on artistic practices therefore does not support a universalistic periodization and conceptualization of "contemporary art."

A scandal in the Beijing art world of 1985 further illustrates the opposition of artists and regional art world professionals to such a universalist conception. Two exhibitions were scheduled at the same time: a collective one of Chinese abstract painting, and a solo exhibit of American Robert Rauschenberg in a prestigious exhibition space. A meeting between the artists from both exhibitions was arranged. In the eyes of Zhang Wei, a former member of the *Wuming Huahui*, it should have been a meeting on equal terms between members of the avant-gardes from two different continents. As Rauschenberg behaved as if meeting "his young admirers," Zhang Wei started to shout at him, causing the latter to quit the exhibit (Noth 2012: 59).

In the early twenty-first century, the spectacular success of Chinese artists in contemporary art markets is evidenced with auction sales statistics. In its world art market trends of 2014–15, Artprice lists thirty-two artists from China among the top one hundred highest turnovers (Artprice 2016). More importantly, the art historical specificity and vitality of present-day Chinese art practices is well acknowledged (see for instance Nakamura, Perkins, and Krischer 2013; Hopferer et al. 2012). Yet, instead of using "contemporary art," Chinese artists as well as art critics prefer to speak of "experimental art" (*shiyan meishu*), and this raises a double question: (a) about the notion of "contemporary art" itself, and whether it should be altogether rejected considering its European-North American centrism; (b) or whether it is a matter of contesting its universalistic criteria as a means for producing power relations, that is, hierarchies and hegemonic discourses. After all, the notion of "contemporary art" is used in African and Latin American art worlds, whereby its universalizing fixation is rejected and replaced by local and regional art discourses.

The other framework, global art, intends to counter both the universalizing meaning of "contemporary art" and the notion's overall misuse for power relations in art discourses, as well as in exhibition and market practices since the 1980s, and proposes another conceptualization and approach. While it too was introduced during the early 1990s, its references are two mega-art events with a global outreach. First, the *Bienal de La Habana*, which positioned itself with its second and third editions (1986, 1989) as the Third World biennial (see Weiss et al. 2011). Its overall objective was to produce a counter-exhibition space and South-South circulation practices. Hence, it focused on contemporary arts from the Global South, while excluding the ones from the dominant European/North American art world. Second, global art is a reaction to the *Magiciens de la Terre* exhibition in 1989 in Paris, in which the curatorial team mixed the contemporary art of Europe and North

America with art creations from other regions of the world. Both these mega-art events contributed significantly to a rising awareness among art specialists in Europe and the United States of worldwide practices of contemporary art and, moreover, that these artistic practices could not easily be considered from the perspectives of European or North American art discourses.

Yet, in its early days, the notion of global art was quite vague. For an in-depth investigation, artist and art theorist Peter Weibel and art historian Hans Belting launched, in 2006, the "Global Art and the Museum" (GAM) [9] project at the Zentrum für Kunst und Medien (Center for Art and Media) in Karlsruhe, Germany. They formulated the mission of the project (which would last until 2016) as the study of this multitude of contemporary art productions at a global scale, the constantly rising importance of art biennials, as well as the foundations of contemporary art institutions (such as museums of contemporary art) in the Global South.

Having been critical about the occidental art historical narrative since the 1990s, Belting (2009: 48) views contemporary art practices within global art in a counterposition to occidental art history. His thesis is that global art is postcolonial and inclusive regarding the worldwide production of contemporary art (Belting 2013: 178). This implies, first, that any universal definition of contemporary art is inappropriate, and, second, that global art requires discourses that do not exclude, nor marginalize, art practices that are considered as contemporary from local art world perspectives. Scholars, curators, and artists from all regions of the world "speak in many tongues and differ in how they conceive of art in a local perspective" (ibid.: 184). Conceiving the equality of worldwide contemporary art creation, and conceptualizing its analyses from local perspectives,[10] the GAM project highlights the needs both for including art specialists from the different regions of the world, and the collaboration of scholars from various disciplines—including anthropologists.

Both Weibel and Belting emphasize that the notion of global art is meaningful only insofar as one postulates the horizontality of the present-day organization of the diversity of contemporary art. It is a search for new art discourses that reject the universalizing canon of the European/North American art world, and aim at going beyond the repeated documentations of inequalities, stratifications, and exclusions (Weibel 2013: 21). This opposition concerns as much data regarding global trends of art markets as exhibition practices that are informed by the hegemonic gaze from the European/North American art world.

For the latter case, such misconceptions are, for instance, well exemplified in Clare Harris's (2013) comparative discussion of exhibiting contemporary Tibetan artists at the *Biennale di Venezia* 2009, at the Rubin Museum of Himalayan Art in New York 2010, and at the Songzhuan Art Centre in Beijing

2010. Harris brilliantly exemplifies the impacts of (a) applying the universalizing European/North American canon to negative art critical assessments of their works in New York and (b) praising Tibetan artist Gonkar Gyato in Venice because of the political dimension of his works on display which lead to extra-art considerations. In contrast to such critical distortions, all the artists "felt most at home" in Beijing, since their works had been evaluated "in the light of Chinese art criticism" (ibid.: 44).

Two chapters of this book are embedded in this conception of global art:[11] Mayer's ethnography on the Istanbul Biennale, and Fillitz's discussion of theories of art worlds in the context of the Biennale of Dakar, *Dak'Art*. Looking back at the various editions of the Istanbul Biennale, Danila Mayer explores this cultural institution in the context of a world metropolis in change. The first international art exhibition in Istanbul, later to become the *Istanbul Bienal* (1987), triggered a booming art world. Capital-driven like its host city, the Biennale represented the unruly expansion of the metropolis during the last three decades. The city of Istanbul, nevertheless, was continually exposed to a controversial impact of contemporary art practices. International curators and artists cherished the site while exposing the city's social and political contradictions. In doing so, the *Istanbul Bienal* found its place within the global art worlds network, and contributed to establishing Turkey's main city on the cultural world map. Presently, following the failed *coup d'état* of 2016, one can observe that the local contemporary art world as a whole is under pressure, and the Biennale's future is uncertain.

Thomas Fillitz's chapter starts with Marcus's and Myers's (1995) assertion of the art world as a topic of a critical anthropology of art. Fillitz questions how the latter notion is conceived. He focuses on art theoretical concepts and discusses them in view of his ethnographic study of the Biennale of Dakar, *Dak'Art*. By adopting the framework of global art, Fillitz shows that with the focus on art discourses, "art world" must be considered as locally, and not universally, determined. Second, to acknowledge the specificity of the Biennale of Dakar within the global biennials network, these art worlds need to be conceived as equal, whereas sociological studies of local art worlds, which include art markets, rather shift toward emphasizing their respective inequalities.

Art Markets, Maecenas, and Collectors

Art market institutions do not deal with art historians' or (other) art theorists' conceptions of contemporary art, but rather take time frames to such ends. The leading French database Artprice, for example, defines contemporary art

as "art that was created by artists born after 1945" (2016), and auction houses may include in this category the newest art of living artists. In an overall perspective, auction sales[12] of contemporary art cover 12 percent of the global art market share, with post–Second World War art reaching 22 percent (ibid.).

Art markets are constituted by the interplay of three major fields: galleries, auction houses, and since the mid-1960s, art fairs for contemporary art. The latter are corporations which assemble several hundred galleries and often also independent artists (that is, those not belonging to a gallery) within a single place for a few days at a distinct time of the year. At a global level, all these fields have been influenced by important changes since the 1980s. Major galleries are either founding branches in different, economically emerging centers, or they collaborate in transnational and/or global networks of partner galleries. Leading auction houses such as Christie's and Sotheby's have spread their branches to such centers. Art fairs are proliferating nowadays all around the globe. Yet, some leading ones have also extended their scope by creating new branches. *Art Basel* (founded in 1970), the number one art fair for contemporary art, expanded to *Art Basel Miami* in 2002 and, in 2013, positioned itself in Hong Kong by acquiring the former Hong Kong art fair.

In contrast to the two frameworks of world and global art studies, which are searching for art discourses without hierarchizing either between art practices or between regional art worlds, art market data reveal expressive hierarchies and hegemonies of a few centers and institutions for contemporary art, and art media. According to Artprice's statistics for the first half of 2016, China holds the leading position with 35.5 percent of the market share, followed by the United States (26.8%), the United Kingdom (21.4%), France (4.6%), and Germany (1.6%). New York, however, holds by far the first place in the cities' ranking—it too is responsible for 95 percent of the US market for contemporary art—then come London, Hong Kong, Beijing, and Paris. Regarding auction houses, Christie's is the leader (36 percent of the global market share), followed by Sotheby's (25%), Phillips (11%), and the Chinese company Poly International (4%) (ibid.). Finally, regarding art media, the most wanted ones are painting (67.4%), sculpture (14.9%), drawings (10.8%), and photography (4.8%) (ibid.).

So far, anthropological research studies have largely neglected to consider the contemporary art markets. Anthropology has primarily focused on markets of ethnic art, such as Sally Price's *Primitive Art in Civilized Places* (1989), or Christopher Steiner's investigation on the market in Ivory Coast, *African Art in Transit* (1994). In *Painting Culture* (2002) Fred Myer describes the transfer from an ethnic art to the category of contemporary Aboriginal art.

Regarding the market of contemporary art, the fields of auctions and art fairs are under-researched in anthropology. Art fairs could be of particular interest, as Moeran and Pederson (2011) argue in their more general reflections

on fairs and festivals, insofar as such institutions too are constituted by "the intersection of institutions and individuals, on the one hand, and of economic, social, and symbolic activities, on the other" (ibid.: 8). As other types of fairs, the most important art fairs constitute a "cyclical cluster" (Power and Jansson 2008): each of these events is well located in a particular city, at a specific time, and over a period of a few days. These clear parameters are essential for ensuring that major galleries book their stalls for different fairs, and most potential collectors may travel from one to the other (see Thompson 2008; Thornton 2008). Art fairs, however, focus on a diverse public from many regions of the world: artists, art world professionals of all kinds, media, and art-interested individuals. In a small article on *Frieze Art* London of 2011, Henrietta Moore asserts that such institutions "are places of pure enjoyment" (2012: 87). Moore argues that the large participation of a wider public that cannot afford to buy (60,000 visitors in 2011) is due to the fantasy of "participating to an exclusive, if not celebrity, lifestyle" (ibid.). These art events nowadays are most successfully combining art transactions with exclusive events (such as previews, parties, and dinners) which are reserved for superstar artists, branded galleries, branded collectors, famous experts, celebrities, and CEOs of major sponsors. Besides generating economic income for the organizing institution, and gallery sales, art fairs further promote competition among collectors; regarding the wider audience, they operate both in including while marginalizing it within the same event (Fillitz 2014: 91).

At present, less prestigious art fairs are organized in larger cities in order to open up a less expensive—and accordingly less elitist—niche in the market of contemporary art. These art fairs are open for both artists and galleries as exhibitors. *ART3f* is such an organization. It constitutes a regional "cyclical cluster" (Power and Jansson 2008) comprising Bordeaux, Lyon, Nantes, Nice, Metz, Mulhouse, and Paris, and today extends to Antwerp, Brussels, Lausanne, and Luxembourg. The most important organization in this market segment is *Affordable Art Fair*. Its first edition took place at Battersea Park in London in October 1999, and now includes Amsterdam, Brussels, Hamburg, Hong Kong, Milan, Singapore, and Stockholm. Globally, it attracts 220,000 visitors and produces a yearly total turnover of US$408 million.[13]

Regarding the gallery field, Stuart Plattner's ethnography of the local market of contemporary art in St. Louis, United States, *High Art Down Home* (1996), is unique for several reasons. First, Plattner considers this market within the local setting, and stretches out to that of New York. He thereby shows the stratification of art markets at a national level and the local hierarchy between galleries, as well as the role of museums for the validation and the economic value production of artworks that are on sale in this primary market.[14] Second, he presents methodologically his field of ethnographic research, the triangular

relationships between artists, gallerists, and collectors. Third, in this market field moral aspects are of high relevance to economic transactions and the social relationships between these three categories of agents (ibid.). Plattner's ethnography may be complemented by sociological investigations of art markets such as Olaf Velthuis's (2007) study of the gallery fields in New York and Amsterdam. On the basis of interviews with gallerists, Velthuis indeed provides valuable insights into the production of prices, and the different meanings both gallerists and collectors attach to them. In this comparative research, Velthuis further demonstrates that, apart from the high-end strata, local art markets are also characterized by price ceilings for artworks.

We moreover would like to mention the influential studies by Raymonde Moulin (1992, 1997) of the French art market and of aspects of the global art market. Moulin too stresses the importance of the triangular relationships between artists, gallerists, and collectors for a better understanding of art market practices. It is worth noting that Moulin (1997: 194) emphasizes anthropology's possible contribution to further in-depth investigation of the dynamics of informal practices between them. Indeed, these categories—artist, gallerist, collector, and we may add the one of art dealers[15]—actually hide the fact that each of these groups is quite heterogeneous nowadays (see Peterson 1997; Abbing 2006; Thompson 2008).

In this book, Stuart Plattner discusses the market for contemporary art in Florence (Italy), and compares these ethnographic data with his insights of the St. Louis study. In Florence, artists, gallerists, and collectors struggle with the city's cultural politics, which are focused more on successfully exploiting the unique Renaissance heritage for mass tourism than on investing in a burgeoning contemporary art world.

Another important aspect of Plattner's studies of St. Louis and Florence concerns the eminent role of collectors. In St. Louis, he showed how gallerists were expecting "good" ones to act as Maecenas for galleries and artists, to engage themselves in museum boards, to periodically donate works of art to museum collections, and to consider the lending of works for special exhibitions as another duty in the name of the love of art (see also Buck and Greer 2006: 241–68; Wagner and Westreich Wagner 2013: 182–5). In the case of Florence, the role of collectors, however, also contributed to the city's regional marginalization, insofar as initiatives of two collectors for founding art institutions had focused on other nearby sites: one of them founded in Pistoia a most impressive avant-garde art sculpture park, and Pisa is fortunate in having been selected to host a major foundation of contemporary art.

Dayana Zdebsky de Cordova's chapter relates to global perspectives of the Brazilian art market. In her ethnography, she examines the postulated growth of the Brazilian market during the times of global financial crisis (2008 and subsequent years). Specific measures were applied and indicators elaborated

to create a public awareness of an expanding national art market. Yet, De Cordova argues that this is a distorted image that was consciously produced by means of these strategies and promoted by media, speculating collectors, and state institutions.

Two other chapters explore the field of collecting by examining two different kinds of collectors and their collections. Jonas Tinius provides a critical reading of a couple of morally dubious German art dealers/collectors, the Gulitts, a case that found fame a few years ago, together with an analysis of the SAVVY Colonial Neighbours Archive project. The goal of this comparative chapter is to present the notion of "awkward art." With this notion, Tinius refers to objects, practices, institutions, and discourses that are contested, marginalized, or even forbidden on the grounds of the social relations they embody. A second line of argument examines the agency of such artworks as diverted from their problematized status of an awkward art. Tinius's overall objective thereafter is to reflect upon directions of a contemporary anthropology of art which considers art as a subject of ethical enigmas that are well embedded in processes of problematization.

Paul van der Grijp presents two extended case studies of art collectors. Chan-wan Kao from Taiwan, who owns the world's largest collection of artistic representations of the lion (in various media), founded his own museum in the late 1990s. The other personality is Paul Yeou Chichong of Tahiti, who collects paintings—masterpieces of European modernism. The author argues that a collection is a social identity marker that provides (in Bourdieu's terms) cultural capital and augments the social status of the collector. The author presents these two collectors within his configurational perspective on private collecting in general, taking up Plattner's three axes for the examination of art markets (psychological, sociological, and economic) and complementing them with a fourth, the educational axis. The latter is particularly emphasized in the chapter's last section, in which van der Grijp discusses, among others, the importance of this private museum for allowing public access to the collection of lion representations, as well as stakes of collectors' donations to museums.

Participatory Art and Collaboration

The last section examines issues of relational/participatory art and collaboration between artists and anthropologists. Such art practices are dealt with under many different names: among others, collaborative art, socially engaged art, community art, or dialogical art. These specific forms of contemporary art arose in the 1990s mostly in France, and have since then spread widely

(Roberts and Wright 2004: 531: 1; Bishop 2012). Nicolas Bourriaud, art critic and former director of the avant-garde center Palais de Tokyo in Paris, first defined these art practices in his influential *Relational Aesthetics* (2002)[16] as "an art taking as its theoretical horizon the realm of human interactions and its social context" (ibid.: 14).[17] With this publication, Bourriaud brought these art practices more into the central concerns of art worlds' professionals and institutions.

Participatory art implies several major shifts in conceiving artists, artworks, and audiences. For Bishop, artists become producers of situations, artworks shift from valued objects to long-term projects, and audiences are integrated as participants or co-producers (2012: 2). Kester emphasizes participative interactions as forms of creative praxis that are on-site specific and rely on shared labor (2011: 9). Such projects often "have been developed outside of traditional art venues . . . and were produced instead in conjunction with local communities, neighbourhoods, or sites of political resistance" (ibid.). But not only the names for these art practices are heterogeneous but also the artists may be individual ones or collectives of varying sizes that are permanent, fixed groupings, or project-based flexible ones (Enwezor 2006: 225). Projects and collaborations cover a wide spectrum: from Rirkrit Tiravanija's cooking of a Thaï soup for a gallery audience, the creation of a work of art out of a dialogue with inhabitants of a city (e.g., Jochen Gerz), art installations produced with a neighborhood (e.g., Thomas Hirschhorn), the empowerment in creative skills of villagers (e.g., the Senegalese project-based collective *Huit Facettes*), social interventions for marginalized social groups (e.g., the Austrian collective *Wochenklausur*), to explicitly political projects collaborations of artists collectives with social movements (e.g., the Argentinian collective *Taller Popular de Serigrafía*).

Participatory art operates with things and images that are embedded in everyday life, to construct relationships and social spaces (Rancière 2004: 35). At stake is the transfer from art's autonomy to its heteronomy, for Rancière the original and persistent tension of art's aesthetic politics: either separation and resistance to any transformation into everyday life, autonomy, or the aim of producing new everyday life forms, heteronomy (ibid.: 62). For many specialists, participatory art expresses this shift as a movement against market regulations, first away from single authorship, and secondly against the commodity constraints (Martin 2007: 12; Bishop 2012–2013), while Rancière, in line with Bourriaud, highlights as central the reconfiguration of social bonds (Rancière 2004: 79).

The study of participatory art projects reveals several challenges to art specialists. For Bishop, solely relying on any written or visual documents produces only fragmentary evidences. Proceeding in such a way, firsthand data would be missing: about the site, the duration of the performances,

of the dialogues and interactions (Bishop 2012: 6). Site visits thereafter are mandatory. Other challenges relate to matters of authorship, of the work's quality, or the postulated equality of interactions. Last but not least, analyses of these art practices require us to engage with concepts from social sciences, such as community, society, empowerment, or agency (ibid.: 7).

Participatory art moreover enables the development of a further step in the fructuous relationship between contemporary art and anthropology. For Schneider, collaboration is the third dimension in this process, the first having been the "artist as ethnographer" (Foster 1996), and the second a post-writing culture perspective on experimentations in fieldwork and forms of presentation and representation (Schneider 2015: 24–5).[18] Schneider and Wright view the eminent anthropological interest in participatory art first in as far as artists deal with anthropological themes, and second, that social relations as much as their site specificity are crucial in these art forms (Schneider and Wright 2013: 3, 9). They therefore consider as most attractive the perspective of an "anthropological practice *with* artists (rather than one that remains *of* artists) and, conversely, an art practice *with* anthropologists" (Schneider and Wright 2010: 5, italics by the authors).

An overall assessment of participatory art projects is difficult, in as far as the notion is applied to a huge diversity of artistic practices. A major topic of art specialists is participatory art's role as a critique and disengagement of capitalist exchange and its relationship to the commodity form (Downey 2007; Martin 2007; Bishop 2012). In this context, the services, or gifts, provided by such projects are questioned: "artists make forays into the outside world, 'propose' . . . usually very contrived services to people who never asked for them" (Wright 2004: 535). This claim of gift giving is also one of the central topics of Sansi's *Art, Anthropology and the Gift* (2015). He argues that in these contemporary art forms, the gift is conceived as a free exchange between peers and leads to egalitarian social relationships, whereas anthropological theories of the gift stress its obligatory dimension and the production of social hierarchies (ibid.: 88).

In the context of anthropology and contemporary art, we would like to discuss the following four topics: (a) the present-day preeminent position of participatory art, (b) matters of collaboration, (c) the question of the site and the community involved, and (d) the resurgence of claims for nonrelational arts.

Art theorists assign participatory art its position among present-day art creations, in as far as it is fully incorporated within the contemporary (Papastergiadis 2008: 363), and so complies with Terry Smith's definition of contemporary art, art that is "truly an art *of* the world," and "comes *from* the whole world" (Smith 2011: 8; italics by the author). Indeed, the global spread of participatory art is a widely acknowledged phenomenon (Papastergiadis

2011: 276; Kester 2011: 1; Bishop 2012: 2). It is considered as the leading art form in our present times, insofar as it operates with objects and images of everyday life and aims at positioning itself in art's heteronomous space, specifically in taking an active role in reconfiguring social relationships (Groys 2008; Papastergiadis 2008, 2011). Papastergiadis articulates ten characteristics of contemporary art which underline the role allocated to participatory art, among which we want to cite the following ones: "artistic practice is defined through, not in advance of, collaboration" (#1), "artistic practice is inserted in the same time-space continuum as everyday life" (#5), and "horizontal models of cultural and social engagement are created" (#9) (Papastergiadis 2008: 378).

Nevertheless, Bishop emphasizes that it is "flourishing most intensively in European countries with a strong tradition in public funding for the arts" (Bishop 2012: 2), and others assert or question the "increasingly ascendant patterns of contemporary curatorial practices" (Downey 2007: 271). Truly, internationally leading curators—such as Nicolas Bourriaud, Catherine David, Okwui Enwezor, Charles Esche, Hou Hanrou, or Adam Szymczyk—are by and large integrating such practices within mega-events (biennials, *documenta*), and thus not only promoting "the art world interest in such work" (Kester 2011: 9), but transferring them right into its center of interest.

From our anthropological vantage, as well as from the one of global art as a postcolonial concept, this again appears as an international dominant art language that insufficiently considers the heterogeneity of local or regional contemporary art creations. There is, in our view, a contradiction in claiming on the one hand that, today, investigations of specific art worlds are needed for demonstrating that contemporary art is "in distinctive ways and to specific degrees, local, regional, *and* international" (Smith 2013: 188, italics by the authors), while asserting the global preeminence of participatory art practices, on the other.

For sure, the reflections of Marcus, and Schneider and Wright, on collaboration with contemporary artists have raised fructuous debates in anthropology. Recently, Grimshaw and Ravetz (2015) have highlighted several fundamental differences between the work of artists and anthropologists. These concern, among others, the ways artists and anthropologists approach their work, and how they produce their results. The work of both groups relies on fundamentally different training, and while anthropologists articulate their achieved knowledge as description or explanation, artists aim at "presenting" or "enacting" their insights in a work of art (2015: 429–30).

Alicja Khatchikian's chapter may be positioned in the same line of reflection. She describes her experiences in researching, participating, and collaborating within two performance projects. Following the invitation of an artist to participate in a performance during her ethnographic research, Khatchikian

first reflects upon her synchronic roles as ethnographer and performing artist, and her problems engendering from this double position, in particular about the challenges she faced, as she never had any training as a performing artist. These experiences prompted an invitation from another performance artist for a collaborative project. Its objective was the combination of anthropological and artistic skills to explore alternative points of encounter between ethnography and art practice. Unfortunately, the collaboration was dragged into a state of creative paralysis from both sides, and the project was abrogated within a year.

Site specificity and social relationships are another major topic of scrutiny within participatory art. As much as this art form is claimed to transfer from an art world into concrete social contexts, Bishop nevertheless stresses that such art practices are widely integrated within art worlds' institutions. Biennials are major sites and galleries, and often local or regional governments commission them (Bishop 2012: 2). Within the scope of the site, Downey (2009) too questions how communities are selected and integrated within a project, and thereafter what kind of communities are involved—gallery goers, provisional ones for a short-term project (ibid.: 594; see as well Barusha 2007)? In the context of art world institutions, specifically regarding her experiences with participatory art projects during an edition of *Frieze Art* London, Henrietta Moore (2012) critically states that "this is art as a form of politics fantasied as 'real life'" (ibid.: 89).

Alex Flynn discusses this spatial topic in relation to the Global South platform conceived as acts of epistemic disobedience. Building on his ethnography of an alternative art space in São Paolo, the Occupational Hotel Cambridge, he argues that art theorists and artists working within the framework of the Global South platform are assuming a rising importance in the reconfiguration of this space. Artists working within this paradigm, moreover, activate an entirely different form of collaboration from the ones dealt with by Bishop or Bourriaud. Flynn highlights that such artistic practices are positioned at border zones of art world and nonart world spaces, and operate in activating relations and hierarchies from concrete everyday life.

As mentioned above, the most fundamental critique of participatory art from within art theory relates to the claims of disengaging from capitalist exchange, of opposing the commodity or value form of art markets (Martin 2007). Indeed, the transfer of the artists' skills (such as flexibility, inventiveness, imagination, mobility) as new configuration of the worker of the future within contemporary capitalism, the questionable category of public/collaborative authorship, the re-integration or appropriation of relational projects within local art world and market institutions, the eminent role of curators for their present-day success, and the idealistic considerations of reconfiguring social bonds as objectives of such artistic practices, all have by now also produced

an image of participatory art as another utopia, and possibly as a new dead-end in the arts.

These considerations are the starting point of Roger Sansi's chapter that examines the new call for nonrelational art—that is, a movement of fully repositioning art within its autonomy. Sansi, however, aligns this call with reflecting upon both relational anthropology and relational art, and questions whether a nonrelational art and a nonrelational anthropology are thinkable. In relationship to art discourses, Sansi introduces the ideas of philosopher Graham Harman (2014), who advocates a nonrelational aesthetics. The latter argues for artworks as independent from their social context, their commodity character, and from any other object; it has a depth that is beyond any encounter, though the beholder, in her/his interaction with it, is co-constituent of the work. In his examination of relationality in anthropology and art, Sansi concludes with the vision of a post-relational anthropology and post-relational art, both of which are critical and tend to overcome an all too ubiquitous relationality.

Perspectives

This book immerses the reader within several fields of anthropological inquiries of art, and may be considered as encouraging further research studies in the anthropology of art. The overall framework for the ethnographic presentations in the various chapters is the consideration of art practices, art institutions, and discourses on art in the postcolonial present. By this we mean that there can no more be universals, neither for defining contemporary art, nor regarding categories such as "the" art world or "the" art market. From an anthropological vantage, as well as from the present-day realities, the field of art is constituted of the diversity of interconnected local and/or regional art worlds and art markets at the global level.

Two main objectives structure this book: (a) to place research studies in the anthropology of art within the wider context of other disciplinary art discourses, and (b) to position particular ethnographic studies within several major fields of research in the anthropology of art. Considering the plethora of art practices—in time and space perspectives—and the multiple approaches to the subject, we are convinced that multidisciplinary dialogues are more than ever mandatory. Regarding the anthropology of art, it appears, for instance, of utmost importance to clearly articulate which images are being dealt with. This is apparent with Descola`s anthropology of figuration, as much as with Belkaïd-Neri's chapter within the framework of world art studies. Favero's examination of new digital technologies in the production of images leads us into

a field that is yet quite under-researched (in many disciplines), but is likely to become most prominent in the near future.

The various ethnographies related to art biennials (Mayer and Fillitz), to art markets of contemporary art and collectors (Plattner, de Cordova, Tinius, and van der Grijp) are valuable insofar as they inform about the specific nature of such institutions and actors, and largely refrain from general considerations. Drawing these lines of reflections further, themes like art fairs, the interactions between gallerists-artists-collectors, the present-day heterogeneity of collectors, or the concept of "awkward art" would require more anthropological attention. In the context of dialogues between contemporary art and anthropology, experiences like those made by Khatchikian are valuable, as they also show concrete examples of difficulties in the realm of collaboration. Flynn's and Sansi's chapters further problematize the category of collaboration in different ways—the former on the basis of concrete artistic practices; the latter in discussing another shift which is occurring in art discourses, the calls for a new nonrelational art. Finally, we would like to stress a concept that has not specifically been highlighted in this book, but is emphasized in Flynn's chapter, contemporary South-South networks and circulations—of ideas, techniques, artworks, artists, or curators.

If the anthropology of art was for some time marginal within mainstream anthropology, the impetus it received in the 1990s diversified its topics of research, and together with following works, they all contributed in transferring it into another central subdiscipline of anthropology. Within the anthropology of the contemporary, the anthropology of art provides from its perspectives valuable ethnographic insights into local, regional, transcultural, and global interconnections of the present worlds.

PART ONE

Image and Medium

1.1

The Making of Images

Philippe Descola

It is about a year ago that I started being seriously interested in the theme I have chosen for this lecture.[1] I therefore take the opportunity to test in front of you what is still just an assembly of loose reflections on cultural forms of image-making. At this early stage of my research I need, first, to specify the methods and the domain of what could be an anthropology of figuration, essentially in the scope of fields covered by the anthropology of art, art history, and the philosophy of aesthetics. Here, figuration is understood as the universal operation by means of which any material object is ostensibly invested with "agency," which is socially defined following an activity of shaping, of ordering, of ornamentation, or of placing in a situation. This activity aims at conveying the object the potential for the iconic evocation of a real or imaginary prototype which is indexically denoted (via the delegation of intentionality) in as far as it plays on a direct resemblance of a mimetic type or on any other type of indirect or immediate motivation. Adopting the intentional perspective developed by several authors[2] in this respect—the idea that the best way to approach works of art is to treat them rather as agents having an effect on the world instead of considering them according to the meaning attached to them, or the criteria of beauty to which they should respond—the present approach needs to be distinguished from the former in as much as it does not consider art to be related solely to the object. The domain it characterizes may not be specified in a transhistorical and transcultural way, let alone on the sole basis of perceptive or symbolic properties that supposedly should be intrinsic to it. By privileging the process of figuration I wish to accentuate the fact that among the multitude of nonhuman objects which may be ascribed

an autonomous social efficiency—such as a sacrificial victim, a coin, a fetish, or a copy of the constitution—I am interested uniquely in those which hold as well an iconic character. This allows one at least to avoid the embarrassment into which one may fall when aiming at defining with precision the attributes, even purely relationally, of the art object. I would like to clarify in this context that iconicity in Peirce's sense is not simple resemblance, even less so realistic representation, but the fact that a sign exhibits the same quality, or configuration of qualities, as the denoted object. This relationship allows the beholder of the icon to recognize the prototype to which it refers.

To be anthropologically interested in figuration does not mean to do anthropology of art. Indeed, this subdiscipline essentially strives at reproducing the social and cultural contexts of the production and use of non-occidental artifacts. Occidentals have invested the latter with an aesthetic virtue in order to make, for instance, their meaning accessible to the public who frequent ethnographic museums, according to similar criteria as the ones accepted for the aesthetic appreciation of those objects that are traditionally on display in art museums—categorization, periodization, function, style, quality of elaboration, rarity, symbolism, and so on. As useful as the multiplication of studies dealing with concepts of beauty in non-European civilizations or of the conditions of their making may be, or with the function and the reception of this category of artifacts to which occidentals acknowledge an aesthetic value, this endeavor may not be defined in the strict sense as anthropological. Apart from a few rare exceptions—in particular the one of the regretted Alfred Gell—it is not founded on any general anthropological theory, and its objective is not to produce one. One is confronted with a different stage of the anthropological work, which is analogous to the one occupied by art history, and which should better be called an ethnology of art: the former is studying occidental art objects, the latter is dealing with artifacts from non-occidental contemporary cultures which seem to share an air of familiarity with these other objects.

Addressing the field of figuration is above all the occasion of testing an anthropological theory I have developed in a recent book (Descola 2005). It asserts that the diverse ways of organizing the experience of the world, individual and collective, may be brought back to a reduced number of modes of identification. These latter correspond to the different ways of distributing qualities to existing entities, or "existents," that is endowing them, or not, with certain aptitudes which render them capable of a particular type of action. Founded on the diverse possibilities of imputing to an indeterminate *aliud* analogous physicality and interiority, or dissimilarities to the ones any human makes experience of, this identification may be expressed in four ontological formulas: Either the majority of beings are renowned for having a similar interiority while distinguishing themselves through their body—this

is the case of animism (Amazonia, the North of Northern America, Siberia, and some regions of Southeast Asia and Melanesia); or humans are unique in possessing the privilege of interiority while relating to the *continuum* of nonhumans through their material characteristics—this is naturalism (Europe from the Classic Age on); or some humans and nonhumans share, within a denominated class, the same physical and moral properties issued from a prototype, and outright distinguish themselves from other classes of the same type—this is totemism (primarily the Aborigines of Australia); or all elements of the world are differentiated among each other on the ontological level, the reason for finding stable correspondences between them—this is the analogism (China, Renaissance Europe, West Africa, Andes, Mesoamerica). I think I succeeded in showing on the one hand that each of these modes of identification envisages a type of collective more particularly adequate to rally in a common destination of the types of being it distinguishes; that is to say, each ontology generates a sociology that is proper to it. On the other hand, the ontological intentions, which are operated by each of these modes, have an impact on the definition and the attributes of the subject. Therefore, each ontology secretes both an epistemology and a theory of action which are adapted to the problems it has to solve. So it seems logical to now examine the effects that are induced by these four formulas on the genesis of images. If figuration is a universal disposition, the products of this activity—that is to say the type of entity it creates, the type of agency that invests these products, and the means by which they are made visible—in principle should vary, in as far as each of these modes of identification stipulates different properties for the figurative objects, and so calls for a particular mode of figuration. Fundamentally, the task is to highlight that a specific iconology corresponds to each ontology.

The modes of figuration, however, have not to be conceived as styles in the sense of art history but rather as "morphologized" ontologies. They do not so much allow us to foresee the general form of an image which is invested by a socially defined agency, but instead to anticipate the type of agency associated with a type of form. An anthropology of figuration, as I understand it, differs in these regards from the theory of the art nexus developed by Alfred Gell (1998). He proposes a simple mechanism for classifying on the basis of a generative combination of the different possible relations between the four terms of the artistic activity—index, prototype, artist, and recipient. These relations are deployed around intentional objects, which are not defined by formal characteristics, but by the type of agency delegation that these objects mediate. Indeed, his theory provides a means to escape the Eurocentric iconological criteria of occidental aesthetics, and this is already an immense merit. It nevertheless does not contribute to the elaboration of a comparative grammar of figurative schemes. Yet, as the intentional dimension of the objects is for

Gell totally a function of the relations within which they are inserted, the theory of the art nexus does not inform us about the formal characteristics which are propitious for the expression in an object of this or that type of delegation of intentionality. Nor does the theory inform us about the reasons, other than the functional ones, which would explain some stylistic convergences where the influence of diffusion seems excluded. Moreover, as soon as Gell focuses on a local iconological coherence, as in his analysis of the Marquesian corpus, he no longer involves the mechanisms of incorporation and of delegation of agency, except marginally, for justifying the correspondence between stylistic codes and social structure on the basis of the very generic principle that objects of art are social agents insofar as they are products of social initiatives.

Before addressing the characteristics of the modes of figuration proper to each of the four modes of identification, one needs, however, to consider several difficulties which are connected to such an enterprise. The first problem to confront is the one of the pertinent level at which a difference or a resemblance in the figurative schemes becomes significant. A simple formal similitude between this or that technique of figuration that is employed by far-distant civilizations in time or space is not sufficient in itself for inferring their ontological identity. One may demonstrate this with two examples. The first one is the *split representation* (Franz Boas), or *représentation dédoublée* (Claude Lévi-Strauss), which may better be denominated as *figuration éclatée* (broken-up figuration). It consists in representing, on the lateral and sometimes superior prolongation of a human or animal figure, the flank or the dorsal face of the prototype. The second one is the *figuration radiologue* (radiologic figuration)—the occasional or permanent unveiling via diverse procedures of the internal structure of an organic body. The "broken-up figuration" is attested in North America as well as in ancient China and Melanesia. Given these localizations, it might not be the product of a diffusion, nor is it an index of the membership of these three areas to the same ontological archipelago. As Boas had already witnessed for the art of the northwestern coast of Canada, it merely testifies an identical means of solving the problem of extension on a two-dimensional surface of the representation of three-dimensional objects, the figure being unrolled and flattened. The same is the case for the "radiologic figuration:" The winged masks of the Northwestern coast, the medieval opening virgins, the Florentine anatomic mannequins, or some Aboriginal paintings of northern Australia which are containing the skeleton of an animal, all are analogous solutions to the challenge of representing the content of a corporeal envelope, and may not be considered as indices that these diverse objects would refer to common ontological properties. Quite the opposite is the case, as the properties these techniques have as mission of figuring are much more characteristic of the figurative schemes. In the case of the "radiologic figuration," for instance, the winged masks of animals of

the northwestern coast or of the Yup'ik Eskimos mostly reveal a human face, that is an interiority of human type lodged in an animal body, a dispositive typical of an animist ontology;[3] whereas the paintings of Arnhem Land are figuring totemic animals, their organs and body having been pre-cut up with dotted lines, representing the portions of meat to be allocated according to kin. They therefore unveil the internal structure of a social morphology that coincides with the anatomic structure of a totemic prototype (see Taylor 1996). In other words, one and the same figurative technique is applied in two distinct ontological regimes, in order to produce the presence of completely different properties.

The second problem encountered is partially attributed to borrowing in the recurrence of forms and motives from far-distant locations of the planet. It is considered a good method for being solely interested in cases of formal resemblance of civilizations which are sufficiently distant from each other in space—for diffusion being not particularly probable, and after having verified the historical indices which seem to exclude it. This supposes that one disposes of reliable information about the images which are to be analyzed. A figurative scheme is indeed an ensemble of means in the service of an end which consists of making visible in a recognizable form this or that trait which characterizes a particular ontology by individualizing it in an image. Hence, an image will behave vis-à-vis the other existents in a mode sui generis through the agency it seems to prove—to return to the two precedent examples, the human type of interiority lent to animals in an animist regime or the coincidence between social morphology and corporeal morphology in a totemic regime. For elucidating this aspect one needs to possess ethnographic or historical evidences about the iconic and indexical dimensions of the images, that is to say about the nature of the referent to which they refer as well as about the kind of agency imputed to them. Such a precaution is required if one intends to avoid the two characteristic weaknesses of the anthropological analysis of images, the anachronistic retrospective and the invocation of psychic archetypes. The first weakness is well illustrated by the speculative interpretations of paleolithic cave art on the basis of hazardous analogies with contemporary shamanism, an operation which tends to dissipate ignorance (of what the cave painters searched for) through confusion (regarding the actual nature of shamanism, a practice which nobody agrees on in defining). Regarding the second weakness, it is the recourse to explaining images by invoking a renowned universal disposition of human nature in their origin, as Belting does (2004) for example, when he sees the desire to keep the memory of the dead in the production of images. This suffices to deny the consideration of many societies (in New Guinea or Amazonia), where the departed are feared and devoted to the quickest oblivion.

If an anthropology of figuration needs to forbid itself the consideration of images of which one does not dispose of information, it has by definition as well to exclude the domain of the nonfigurative. Truly, the border between the figurative and the nonfigurative is often not easy to trace. It rather consists of a continuum with three terms that are organized along a gradient reaching from a maximal resemblance (mimetic iconicity, corresponding to "realism" in aesthetics) to a total absence of resemblance (an-iconicity, corresponding to abstract art and to a certain category of decorative art), passing via several forms of nonmimetic iconic figuration. Indeed, the so-called decorative arts may be iconic if the compositional motives refer to a prototype they are figuring in a stylized manner, and if this denotation is present to the spectator. In order to have iconicity, in fact, the motivation has to be activated by figuration that is recognizable in at least one quality of the prototype. This genre of stylized decoration often has a function which one may qualify as *iconogène*; that is to say it stimulates the visual imagination and this way unleashes the production of mental images which may be perfectly figurative without ever being actualized by material support. This is, for instance, the case of the facial paintings of the Jivaro (Taylor 2003). In other cases, on the contrary, the decorative motives are perfectly an-iconic, in as far as their eventual original motivation became inactive. The agency so becomes purely internal to the composition and is a result that the motives and combination of motives seem to interact spontaneously with each other, thus producing the impression of being animated by the simple fact of their structural and positional characteristics. This is why nonfigurative decorations function as very efficacious mind-traps. They are mechanisms Which capture and fix the attention, and are capable of evoking an attachment to the objects which they are embellishing, while rendering these objects, as well as the activities to which they are connected, more salient on the psychic and emotional level. One may as well think that this effect of focusing attention allows one to detach oneself from the mundane preoccupations and to fix one's thoughts on the nonrepresentable—the other positive side of the iconoclastic of certain Book religions. Or, on the contrary, it may be employed to apotropaic ends, as it is the case with the complex labyrinth motives which are adorning the houses in Tamil Nadu, India, and are destined to fascinate the demons in order to withhold them on the threshold (Gell 1998: 84–86). In decorative nonfigurative art the layout therefore creates agency: freed of any immediate symbolism, the motives lose their individual salience to let subsist just the movement evoked by their combination and their repetition. The same is true for abstract art, except that in this case the effect of agency is no more internal to the representation, but directly imputed to the intentionality of the artist, recognizable and individualized by a style on its own, that is to say identified with a person and objectivity in a

patronyme, different to the most often anonymity which is characteristic of decorative productions.

To define the characteristics of the modes of figuration in relation to the modes of identification requires raising three central questions. The first is the one of the objectives: What does one search for in figuring? Which traits of this or that ontology will be rendered present in a salient way in the most common figurative objects, and which type of delegated agency is going to be invested? Here particularly one needs to interrogate oneself about the kind of relationship to the denoted object which figuration will privilege in this or that ontology in function to the selected iconicity, that is to say about the number and the pertinence of the qualities of the prototype which have been retained in the icon. Is the intention to render present some entity in the form of a copy which would be hard to differentiate from the prototype, or in the way of an evocation which is based on a metonymic allusion, or under the forms of a veritable actualization, namely an autonomous object which is no more conceived as representation of an exterior referent, but rather as its metamorphosis under an original form? The second question is the one of the codes: Which types of formal schemes are to be privileged in order to realize at best the chosen ends by each ontology? Which options are selected to perceiving this or that property imputed to interiority and physicality, or this or that disposition these properties are inducing in this or that class of existents? Finally one has to raise the question of means: Which techniques make the codes work, and which types of artifacts or which modification of material are they focusing on producing? To this, one has to add two subsidiary questions. First the question of genre: May one produce a link between a mode of figuration and a "figurative genre" (*genre figuratif*), hereby understood in a larger and more abstract sense than the one it holds in art history, that is to say, not as a subject of composition, but as a particular configuration of relations between the index, the prototype, the producer, and the recipient by accentuating the agency of one or the other of the terms? Regarding the question of style, it may be envisaged as a taxonomic refinement of the former question, a descent toward the level of species and the variety: How do styles vary among themselves within one and the same ontological archipelago? Does this differentiation follow the power lines of the contrasts between the dominant schemes of relationships which have been elaborated in *Par-delà nature et culture*[4] (exchange, predation and production, protection, transmission)?

In this chapter I shall only deal with the question of the objectives. To question oneself about the objectives assigned to each mode of figuration consists in questioning oneself about the characteristics of each ontological configuration which is going to be objectified in images. As the distribution of qualities, which each ontology operates, is organized around a contrast

between the plane of interiority and the one of physicality, one may expect that the figurations are going to differentiate each other in exploiting primarily this contrast and in rendering these different combinations perceptible. This is what one may aim at verifying in examining each of the four modes of identification, one after the other.

Animism

Animism is defined as the generalization of an interiority of human type to nonhumans, combined with the discontinuity of the corporeal physicalities, that is to say of perspectives on the world and ways of inhabiting it. Figuring an ontology of this type should consist of making the interiority of different kinds of existents visible, and of showing that this common interiority is lodged in bodies with very diverse appearances. These latter need to be identified without any ambiguity through indices of species. This is the reason why one so often encounters composed images in the animist regime, where anthropomorphic elements, which are evoking human intentionality, are conjunct with attributes specific to animals, spirits, even plants; the most common images, the most coherent on the cognitive level, being those which contain indices tenuous of humanity—traits of the face, for instance—grafted on forms of globally savage animals (*thériomorphes*). Yet, such images are composite only in appearance: they do not figure *chimera* composed of anatomic pieces that are borrowed from several species, but of nonhumans of whom one signals by means of some human predicates that they do possess an interiority like humans—which renders them capable of a social and cultural life. The Yup'ik masks figuring in a very realistic way this or that animal in the middle of which is embedded a human face constitute an exemplary illustration of it, as is the case of an Inuit drawing collected by Bernard Saladin d'Anglure (1990: 179), representing a man and a bear about to greet each other. The interiority of the bear is just figured by its sole anthropomorphic behavior—standing, dressed in a parka, the arm outstretched for a handshake. Considering that metamorphosis plays a crucial role in animist ontology, one further has to expect that the latter receives a figurative expression. The metamorphosis rather being an anamorphosis, a change of the viewpoint, all devices functioning as commuters may serve to these ends. This certainly is the case for transformation masks, so it is with certain types of sets or animal motives whose human bodies are decorated in movement: if they are skillfully decorated and oscillate between human and animal postures, the illusion of a to and fro movement between the two species is easy to create. A good example is the motives which decorate the body of the participant in the bear dance and the frog dance of the Kwakiutl,

on the one hand, or in the dance of the man "in bird form" of the Kaluli of the Grand Plateau in New Guinea, on the other.[5]

Naturalism

The formula of naturalism is inverse to the one of animism: humans differentiate themselves from nonhumans not via the body, but via their spirit, as they also differentiate among each other through the spirit, in packages, thanks to the diversity of the realizations which their collective interiority authorizes in expressing in distinct languages and cultures. Regarding bodies, they all are subsumed to the same decrees of nature, and do not allow us to singularize through kinds of life, as it was the case with animism. If the beginning of European naturalism is fixed by convention at the beginning of the seventeenth century, with the beginnings of the scientific revolution, one needs to be careful that each of the domains of the practice, within which the modes of identification operate their work of ontological discrimination, possess their own logic of transmission, and indeed their specific rate of mutation. In other words, the symptoms of ontological change do not necessarily appear simultaneously in each of these domains. This happened at the time when naturalism progressively came up with naturalism in Europe. The new world has first started to get body in the images, nearly two centuries before becoming a reflexive discourse.[6] If the two traits, which a figuration of the naturalist ontology has primarily to objectify, are the distinctive interiority of each human and the physical continuity of beings and things in a homogeneous space, then without any doubt these two objectives received a debut of realization in Flemish painting from the fifteenth century on. This happened long before the scientific turmoil and philosophical theories of the Classic Age would convey to them the argumentative form which usually signals the birth of the modern period for historians of thought. The new way of painting, which arises in Burgundy and Flanders at the time, is characterized by the irruption of the figuration of the individual, first in the illuminations (those of the *Très riches Heures* of the Duc du Berry, for instance). There, persons with realist traits appear, painted in a realist frame, carrying out realist activities. Later paintings (of a Robert Campin or a Jan van Eyck) are characterized by the continuity of the represented spaces, by the precision with which the last details of the material world are rendered, and by the individualization of the human subjects, each endowed with a facial expression of its own. The revolution in the art of painting, which occurred then, sustainably installs in Europe a manner of figuring which chooses to accentuate individual identity as much as the icon, the prototype, of the artist and the recipient. It is a manner of figuring that is translated

in a continually rising virtuosity in two novel genres: the painting of the soul, that is the representation of the interiority as index of the singularity of the human persons, and the imitation of nature, that is the representation of the material contiguities within a physical world which merits being observed and described for itself.

Comparing animist and naturalist figuration allows us to better stress their contrasts. The goal is to show an interiority in both ontologies, but with very different means, in as much as the field of the entities to which one lends an active intentionality has not the same extension. Animism is not preoccupied with figuring the interiority of humans (it is a given as archetype of any interiority), and rather focuses on visualizing the one of nonhumans in the form of recognizable human attributes (generally a face). Yet, naturalism reserves interiority exclusively to humans and will proceed in figuring this one, as much as a general property of a species and as index of the singularity of each person, by way of particularization of facial traits (specifically of the gaze). The treatment of physicality is even more dissimilar. Animism visualizes physical attributes according to which each species of existents distinguishes itself from the others but without any uniformity of the formal codes, nor concern of mimetic resemblance, nor juxtaposition of the figurations (meaning an imitation of nature). It does so because each class of intentional existents has a legitimate point in the world; there is no privileged position from which total uniformity of representation could be activated—therefore the absence of any landscape figuration in animism. The opposite occurs with naturalism: the emphasis on the physical continuities requires indeed that existents have to be painted in a high number and according to similar techniques within a homogeneous space, where each of them holds a position which may be rationally connected to the one of the others. Therefore landscape, still life, and central perspective are the emblematic expressions of modern painting, what constitutes its radical novelty. In other words, whereas animism objectifies subjectivities in visualizing how they are incorporated, naturalism succeeds at rendering invisible the mechanism (perspective as arbitrary viewpoint) by means of which the objectivities it depicts are subjectified. Naturalism and animism are as well distinguished in the relationship they establish between the degree of iconicity and the type of agency of what they are figuring. Naturalism's concern, which characterizes modern painting since its origins, may be translated by the desire to include the largest number of possible qualities inherent to the prototype within the image, with the paradoxical result that the more the image is resembling—in the *trompe l'œil*, for instance—the more it claims itself as an imitation, and more so, it attracts the dexterity of the painter, that is to say the dominant role of his agency. In contrast, animism appears relatively indifferent to resemblance, a reflection of an attitude which sees in images not copies of the real, but kinds of replica incorporated in the

prototype (generally a spirit, or an animal spirit), which are doted to these ends with an agency that is as powerful as the latter's. This is quite different to the naturalist case: because the image is not really mimetic, its agency predominates over the one of the often anonymous human who has created it, thereafter efficaciously intensifying the one of the prototype.

Totemism

The totemic identification is founded in sharing within a class of existents, grouping humans and diverse kinds of nonhumans, of a limited ensemble of physical and moral qualities that the eponymous entity is reputed to incarnate at the highest level. In the Aboriginal societies of Australia, where this ontology is best attested, the nucleus of the qualities characterizing the totemic class is reputed of being issued of a primordial prototype, traditionally called "being of Dreaming" in the ethnographic literature. In the present case, figuration will have to visualize the profound identity of the humans and nonhumans of the totemic class; internal identity, given that they incorporate a same "essence" of which the source is localized in a site and of which the name synthetizes the field of predicates they possess in common. Physical identities, because they are constituted of the same substances, are organized according to the same structure and therefore possess the same kind of temperaments and dispositions. It is not useful to first consider the general status of images in Australia, in order to understand how these figurative finalities are applied. Everywhere, they are all linked to the beings of Dreaming and to the actions within which these prototypes are engaged, to give order to the world and to render it conform to the subdivisions which they themselves incarnate. Indeed, among the Yolngu (Northeastern Arnhem Land), the motives that are employed in figuration, as those observable on plants and animals (they have the same name), are attributes of the beings of Dreaming of which they incorporate properties in a visible way. First, they appeared on the body of the being of Dreaming which they represent, and they are designated through it as iconic heritage of the totemic class it has engendered. They are, moreover, the iconic expression of the events which have caused the motives of which they are traces. Finally, they contain the powers of the beings of Dreaming and may, in that capacity, serve ritual ends (Morphy 1991). Among the Walbiri of the Central Desert, the *guruwari* motives are the visible signs left by the beings of Dreaming—their traces, the traits of the relief as result of their metamorphosis, the ceremonial objects of which they have prescribed the usage, and the motives associated to each of them, which may be painted on the soil, on the body of the dancers, and on diverse types of ritual objects and fineries—at the same time as they incorporate the always active generic power

these beings have left in the totemic sites for being actualized generation after generation, in humans and nonhumans composing the totemic classes each of them has established (Munn 1973).

If one considers the modalities of implementing the figurative objectives of Australian totemism, two of them seem present all over the continent. One may call them the *présentification structurale* (structural appearance) and the *présentification structurante* (structuring appearance). The first one—well illustrated by the painters of the style called "X-ray"—inert animal or human silhouettes within which skeletons and organs are represented with high precision—of the occidental part of Arnhem Land, specifically those of the Kuwinjku. It consists of highlighting the permanence of the identities of structure between humans and nonhumans, while applying the figurative language of physicality (Taylor 1996). Three recurrent traits characterize the latter: the neatness of the morphological organization and of the internal divisions (which visualize the permanence of the metonymic relationship of identity between humans and nonhumans); the embedding within the figure of the totem of its attributes and creations, presented as organs (which visualizes not a particular being situated in the world, but the qualities of the world enveloped in a particular being); the rigid immobility of the represented being of the Dreaming (which visualizes the inalterable character of the divisions it has installed, so that movement is in the figurative gesture, not in the figure). Any dynamism, any narration, any background is excluded to the advantage of the unique figuration of the order incorporated in the prototypes. By contrast, the *présentification structurante* (structuring appearance) figures the activities of the beings of Dreaming under the form of traces they have left, and characterizes the paintings (in former times on sand, today on canvases for the world market) of the Aborigines of the Central Desert.[7] These are a series of graphemes which tend toward pictography—they may be combined, sequential, and with constant denotation—and their sequences illustrate most often the narration of accounts of the generative operations of the beings of the Dreaming, at the same time as movement on a surface, and as incorporated effect of these operations in the traits of the relief. Yet, as Ingold (1998) has well observed, either one figures the agents of the generation without their traces (Arnhem Land) in order to show that the world is but one with the body of those who ordered it, or one figures the traces without agents (Central Desert) for showing that, as these have disappeared from the scene, their institutionalizing action has ended (ibid.). This way of dealing with time very clearly contrasts with what animism aims to visualize—in the articulated masks, for instance—the tilting of the point of view of human and nonhuman reaching until the metamorphosis of the one and the other. That is to say, a rapid movement which is realizing itself in the present time, in opposition to a static structure—totemic prototypes, or results of their action, incorporated

in the environment—which is referring to the origins of the word. This too contrasts with what naturalism objectifies in images, the diversity of human individualities and its realist seizure of diverse ages of life, which are combined to the homogeneity of the depiction of space and of the objects it contains. The diversity of phenomenal expressions and of human interiority indeed are opposed to the unity and the immutability of the totemic prototypes, while the material continuity of the worldly objects is opposed to the singularity of the sites which are generated by the beings of Dreaming.

Analogism

I would like to remind the reader that the analogical identification rests on the acknowledgment of a general discontinuity of interiorities and physicalities, resulting in a world populated by individualities. This world is difficult to inhabit and reflect, because of the proliferation of the differences which are composing it, if one would not strive for finding between the existents as well as between the parties of which they are constituted, networks of correspondence enabling an interpretative line. One will understand that there exist possible ways to represent the association of these singularities in an ontology where the ensemble of existents is fragmented into a plurality of instances and determinations. In that way the objectivation of analogism in the images may appear less specific than the modes of figuration of the three other ontologies. Still, it is not impossible to highlight several salient traits which an analogical figuration should bring to the foreground. In as far as the analogism accentuates the fragmentation of interiorities, as well as their repartition in a multiplicity of physical media, one will first have to desubjectivize the interiority of humans and nonhumans. In such a way, the latter will be disseminated and coupled to a physicality which too is distributed. In other words, one will have to show an ensemble of feeble and coherent discontinuities, either directly within a unique object of which the composite nature will have to be evident—the statue of an Aztec divinity such as Quetztalcóatl, for instance—or indirectly, while indicating that the image is a metonymic part of the prototype—therefore the importance of *mimesis* in the objects which serve the "sympathetic magic" (J. Frazer) so characteristic of analogism. Or, one will highlight that each index has only meaning and agency because it is inserted within an aggregate of indices of different natures, which may be structured spatially, via alignments (an Andean line of *huacas*), or a concentric wrapping (a reliquary in Melanesia or Europe), or in temporal form, by simple and regular adding of an element to the whole (an ancestor altar in Africa). In brief, the figurative objective of analogism is

primarily to make present networks of correspondence between discontinued elements. This notably presupposes multiplying the components of the image in order to better disindividualize its subject. In this sense, and whichever the precision of the representation of details the analogical figuration may reach, it does not so much aim at imitating with verisimilitude a "natural" prototype objectively given. It rather aims at restoring the texture of affinities within which the prototype becomes meaningful and acquires an agency of a certain type. Here the difficulty is related to the fact that what the analogism is ambitious to make present in the images reveals itself as being even more abstract than what the other modes of identification intend to figure: not a relationship of subject to subject as in animism, or a shared relationship of inherence to a class as in totemism, or a relationship of subject to object as in naturalism, but a meta-relationship, that is an encompassing relationship structuring disparate relationships.

Examining how analogical collectives have conceptualized this kind of figurative operation is a way of bypassing this difficulty. One may take as example the Huichol aesthetics (northwestern Mexico), and the Chinese aesthetics. The Huichol aesthetics is organized around a very polysemous concept, the *nierika*.[8] It is derived from the verb "to see," and denotes ritual objects which are drilled with a hole in their center, or decorated with a circle, as well as facial paintings, sites of cult considered as passages between levels of the cosmos, the visionary capacity of shamans, iconographic motives, and votive paintings. The latter ones are nowadays the best-known form of *nierika*, due to their success on the international market of ethnic arts. All these referents are called *nierika*. They all have in common of being tools, allowing communication and mutual observation between the cosmic strata, and between the humans and the ancestral divinities (therefore the role of the central canal which is analogous to an eyelet). They are connectors, which fulfill in the figurative domain a function similar to the one of sacrifice, that is, to forging a link of contiguity between initially dissociated entities. The *nierika* refers as well to another characteristic of the analogical ontologies, the interlocking of cosmological schemes: which ever their real form, all *nierika* objects indeed are structured by an ideal model in staggered rows—a center surrounded by four cardinal points thus reproducing the structure of the cosmos. It is a model that is replicated at each point of the periphery at a reduced scale; the result is assimilating itself to a fractal figure of the type of snow crystals. Its structure appears in innumerable motives and images of the Huichol. Regarding the contemporary *nierika* which are destined for the art market, they tend to abandon the simple forms which are expressing economically schemes of connection, of replica or networks, to the advantage of dynamic figurations of the cosmos, thus being absolute cosmograms,

literally depicting the interlacing of symbolic correspondences which are deploying from a central point.

They too offer a stark contrast to the conventions of the totemic morphogenesis. The latter are figuring inside a prototype with a generally animal form, the accomplished and immutable structures, which are defining the qualities of the totemic class issued from the prototype. They instead are figuring the network of the links as well as temporal and spatial schemes by means of which the world is animated and continually transformed. Furthermore, this transformation is a sequence that is selected from the general flux, which constitutes the texture of the analogical connections, and not the two-stage movement which is characteristic of the tilting of viewpoints that the animist figuration strives for visualizing. The *nierika* is a connector, not a commuter.

Although the criteria of Chinese aesthetics seem at the antipodes of those of Huichol aesthetics (mimetic exactitude vs. stylization, perspectival construction vs. absence of perspective, specialized techniques acquired from a master vs. generalized know-how, etc.), their finalities are finally quite narrow, and, above all, largely differ from those of naturalism, animism, and totemism. The ideal of Chinese painting is not reaching beauty, but tenting to recreate a total microcosm, thus visualizing the unifying action which one credits the vital inspiration in the macrocosm. In other words, the objective is figuring a replica of the cosmos at another scale.[9] The Vacuum is central in this endeavor. In a literal sense, first, through the important surface the Vacuum devolved to the non-painted space. It acts as interstitial environment for the spiritual breaths ranging the visible and the invisible worlds, thus connecting them. Second, in the painted space, through the function of Vacuum devolved to the cloud as the mediator between the Mountain (to which it lends the form) and Water (from which it is formed), the two attached terms (*Shan-Shui*) are defining and denoting landscape painting. The latter too highlights this other characteristic of analogism that is the ambition of visualizing the network of correspondences between man and the universe: to paint the Mountain and the Water indeed is to portray sentiments and dispositions which animate humans, the principal traits of the physical environment which enter into resonance with the interior environment.

Huichol and Chinese aesthetics thereafter both set the figurative activity as objective, the exposition of the way singularities, initially particularized by their nature, their situation, their status, their appearance, succeed in establishing correspondence. This may either be term by term as in the connection between Mountain and Water, or within a network of affinities with further textures as in the case of the Huichol, succeeding in reducing, within the space of the image, the magnitude of discontinuities which singularize them.

Both aesthetics further share the intention of figuring the entangled links between macrocosm and microcosm. The image is perceived not only as a reduced, more or less iconic model of the universe, of which it reflects certain qualities at another scale, but also as an expression of the analogies which may be detected between human qualities and properties of the cosmos. In brief, in the analogical regime, one does not search for visualizing things, intentionalities or structures, but instead dynamic processes, whichever prototype the image is figuring.

1.2

To Swallow or to get Swallowed, this is the Question: On Viewing, Viewers, and Frames in the Context of "New" Images

Paolo S. H. Favero

Prologue

"*A juxtaposition in fate*" sings Björk as I open up her latest 360-degree videoclip, *Stonemilker*, on YouTube.

"*Find our mutual coordinates*" chants Björk as she plays with her fingers, forming a cross in front of her face.

She then walks out of the frame, leaving me alone on a volcanic beach, facing a dark sea.

"*Moments of clarity are so rare*"—her voice anchors me back to the scene, I feel the need to turn around chasing where the voice comes from. With the cursor I move to the right of the image and I find her staring at the sea—"*I better document this*"—I am tempted to follow here gazing out again. Yet, I decide to stay, looking at her looking at me.

"*Across the view is fears, All that matters is*"—Björk fades out of sight again. This time I decide not to chase her. I remain still, looking at the waves of the sea, softly breaking against the dark rocks of the volcanic beach. Björk's voice keeps me company in my contemplation.

Introduction

In a world increasingly flooded by visual stimuli, images enter our lives today, in their manifold dialogues with digital technology, in new unexpected modalities, morphing their nature and appearances, gathering new functions, roles, and meanings. They are, as those of us living in digitized environments discover every day, networks, relations, and communities made visible (think of the textual dialogues, the @ and the hashtags on the timelines of Facebook and Instagram); they are geographies (think of the incorporation of GPS metadata in the images we produce with our cameras); and they are also things (think about the popularity of 3D printing which, through the mediation of images, converts abstract ideas into material items or about interactive documentaries and their constant invitations to engage with the world surrounding the viewers).

Images are undoubtedly something new today. Mitchell (1994) said long ago that digital images are a new "token" made to "disturb and disorientate by blurring comfortable boundaries and encouraging transgression of rules on which we have come to rely" (ibid.: 223). Pushing this even further Crary (1990) suggested that the birth of digital imagery constitutes a revolution, "a transformation in the nature of visuality probably more profound than the break that separates medieval imagery from Renaissance perspective" (Crary 1990: 1). But is this really true? What kind of token or thing are new images really? And also, are they really something new?

We seem today to have, undoubtedly, overcome the fear of the death of photography postulated by, among others, Richtin (1990) and nicely summed up by Mirzoeff (1999) with his famous sentence "after a century and a half of recording and memorializing death, photography met its own death sometime in the 1980s at the hands of computer imaging" (ibid.: 86). We have also left behind naïve ideas about the image as a "transparent window on the world" (Mitchell 1984: 504) becoming more aware of the possible deceptions and mystifications that these objects can generate. Yet, we are still caught up in an interesting and unsolved set of doubts regarding digital images' ontology, their meaning, and capacity to fit in our conventional understandings of the visible world. Surely, we have not lost our fascination with them; quite the opposite. A quick look into the market of cameras (digital as well as analogue) and smartphone apps reveals that we are more than ever caught up in images' magical web, attracted not only by what they represent, by the stories they can tell and instigate, but also, importantly, by what they do to us.

This chapter aims at offering an exploration of this domain from a particular vantage point. Bringing anthropology, visual culture, and the history of arts in dialogue with each other I want to enquire into the politics of viewing in the

context of emerging digital imaging technologies and practices, basically in the context of what I will from here onward address as "new images." I will, in particular, ground my analysis upon the observation of a small selected sample of what I opt to call "swallowing images," that is images showing an ambition to suck the viewer into them, to immerse them in their own space, hence blurring the distance between the viewer and viewed, the observer and the observed. The swallowing images I will focus on here represent, I suggest, good beacons for identifying one of the leading trends in contemporary digital/ visual culture, that is, the ultimate overcoming of the frame (and ambition that new images share indeed with analogue images from prehistory onward, see Elsaesser 2013). With this chapter (as I have done with other publications, see Favero 2013, 2016, 2017), I may perhaps be able to raise critical questions regarding the extent to which the digital has really entailed a rupture with previous (analogical) ways of producing, using, and experiencing images. Re-evoking perhaps earlier debates on the dialectic between human agency and technological determinism (Hay and Couldry 2011; Jenkins 2006; Kittler 2010), I suggest that such practices and technologies stitch the future (and the present) back onto the past. They make us draw a full circle with the history of mechanically produced image and hence force us to rethink the assumptions that have guided our understanding of this field. Let me warn the reader that, in a manner perhaps unconventional to anthropology, I aim here at addressing these technologies and practices per se. I am hence not aiming at addressing their content, what they actually represent and portray. Instead, in a manner perhaps unconventional for anthropology, that as Wright (1998) suggested generally prioritizes anthropological relevance on "aesthetic composition," I am interested in matters of form and in how form relates to the experience of the viewer.

"New" images

Let me start this chapter empirically and look into a few concrete examples gathered through my ongoing interactions with the world of contemporary image-making practices.[1] As I mentioned above one of the leading (and still expanding) trends within the contemporary image-making industry is the search for what we could call immersive images, that is of images that transcend the boundary between the space of the frame and that of the lived space of the viewers, hence making the latter experience themselves as part of the world of the image.[2] I have here selected three different examples, each tapping onto a particular interpretation of this tendency. All these three products/practices belong, albeit in different ways, to the contemporary arena

of popular image technologies. They have in common the fact of being dynamic and interactive, that is responsive to the interactions with the viewers. They are also immersive. They are swallowing (albeit in different degrees and with different modalities) the viewers, asking them to enter the image and position their gaze from within the image itself. I will suggest below that these three images (and the practices that they represent) put a question mark on the conventions that have sustained Western bourgeois understandings of the meaning of images from the birth of Renaissance perspective onward. They open up our visual culture again, asking us to bring back to the center of our visual culture narratives regarding the meaning and ontology of images that have progressively been marginalized.

Before I go deeper into this issue, however, let me unpack a little further the examples I just offered. *Photosynth*, which consists of a smartphone application and a homepage, allows its users to both view and generate their own images (or models) or to simply view ready-made (and professional) ones, or those made by other users. Launched in 2006 this is the ideal precursor of the various (swallowing) 360 degrees or panoramic smartphone and camera applications that are available in the market today.[3] *Photosynth* creates three-dimensional models on the basis of an algorithm capable of stitching together detected "interest points" (a form of 'point cloud'). *Photosynth* will soon be removed from the market (the app has already been removed). Yet, it has managed to inspire the production of a variety of applications capable of producing swallowing images. Explorable on a computer with the help of the cursors or, by using the sensors of the phone, with the help of movement when using a smartphone, swallowing images have so made an entry in the world of popular culture proper. It may be worth pointing out that since 2016, Facebook too has incorporated on its stream the possibility of viewing panoramic images.

The second example of swallowing images that I mentioned above is made up by a somewhat more niche-oriented product. It describes one specific moment in viewing a photograph produced with Lytro, a light-filter camera containing 40,000 micro lenses. Light-filter cameras allow viewers to change their points of observation with the help of the mouse during the act of viewing, hence generating what could be called a dynamic image. Exemplifying Mitchell's 1994 intuition regarding digital images' performative, incomplete, and ever-changeable character these images invite us also, differently from monolenticular photographs (that is those produced with conventional cameras equipped with one single lens), to intervene upon the quality and depth of the gazing. Focus and depth of field are here in fact no longer fixed. They cease to be a property of the image becoming rather the result of the dialectic of encounter between the images and its viewers. It is

within this dialectic that the image gathers the sense of movement that we perceive when exploring it on the computer screen.

My final example is made up by the world of 360-degree videos. Exemplified here by Björk's *Stonemilker*, these videos offer a dynamic view. With the help of the cursor the viewers can travel inside the image, selecting what to see. They can follow Björk or, as I was tempted in the vignette with which I opened this chapter, direct their gaze to the places she looks at, exploring the landscape in which she immerses herself, etc. Indeed, while other 360-degree videos may allow users to also penetrate the space (changing hence the point of observation as in Google Street View) this particular video anchors them in one fixed position. Nevertheless from here they can enjoy a degree of freedom of observation, looking around, above, below, and beyond. This video can also be viewed from a mobile platform such as a smartphone, or with virtual reality (VR) goggles. In this case, the experience changes quality. With the help of the sensors reading the movement of the device, the viewers are not only invited to enter the image but they also learn to move within it, using their body (their hands or head depending on the absence or presence of goggles) as the engenderer of the selection, hence sanctioning the fusion of the virtual world with the user's movement (Ryan 2015).

The three image-practices that I presented above do indeed raise some important questions regarding the ontology of new images and regarding our possible ways for analyzing them. We encounter them in fact with a set of shifting boundaries. In the first (and partly also in the second) example, *Photosynth* objects appear, for instance, to us in motion as a result of our own "entering" the image, of our moving inside of it. Basically we experience movement even though the image we are exploring is composed of stills. So, are we now in the realm of photography, of film, or of what else? Should we analyze this image from within the conceptual space of still or moving images? And if we were to accept that this is a photograph (or rather the result of the stitching together of several photographs), can this photograph contain a story now that I cannot see the whole big picture and now that it can be viewed in different ways? And if it is so, when does this story begin and when does it end (an awkward question to ask in relation to photographs)?

Let us move on to the second image. As we have seen light-filter cameras allow viewers to change their points of observation during the act of viewing. Threatening, as I mentioned above, the conventions of photography (liberating focus and depth of field) Lytro situates now within the choices of the viewer what earlier on was fixated in the image itself. So, what is the indexical value of these images? And again, given that these images can be viewed in different ways, can they really contain a truth?

And finally Björk's magnificent video pushes all such uncertainties even further. If we were, for instance, to address this video in filmic terms (using,

that is, conventional techniques based on the identification of cuts, changes of lenses and lightning etc.) where would we begin? Do we really have scenes and sequences here? If so where do they begin and end? What is the narrative of this clip? What story does it tell?

It is therefore evident that we need a new set of tools for analyzing these images. Conventional techniques of visual analysis (albeit far from irrelevant) are however not enough for doing this. These images raise also another order of questions. Far from treating the viewers as "distant," "distinct," and "disembodied" (Marks 2002: 13) they foreground them as embodied subjects (the last does this with particular vigor), swallowed up, that is, in the world that the image itself portrays. A good example of haptic visuality, that is of a visuality that does not build on the separation of the viewing subject and the object (optic visuality) such images force us to enter a space of visual reciprocity. This is what happens in particular with Björk's video when seen from a smartphone. This clip does not only bring the viewer in the image, it also stitches together, through an "enchanting" (see Gell 1992) performance the two worlds that end up meeting each other through the screen. A poetic form of augmented reality I would say. Moving up and down my feet merge with Björk's and the sea behind her back fills up the wall facing me in my office. We can say that these kinds of images bring to the fore a sense of mutuality, reciprocality, and hapticness. The inclusion of the viewer in the image is indeed connected to the critical role of the frame. Watching Björk's video, the feeling is of being at the center of the image, literally incorporated in it, swallowed by the frame, the world out there merging with that contained by the image. Entering the image, and losing the frame out of sight, we renounce to that privileged position allowing us to control the image and hence I would like to add, also to carve out a coherent story from it. In order to understand this critical transformation any further we need, however, to insert these practices in a broader historical perspective. The next section will be devoted to this.

Putting things "into perspective"

Cinema and photography, the two dominating visual languages of modernity, build on rules and assumptions that they inherited from previous visual practices and in particular from Renaissance perspective. Inspired by Alhazen's[4] eleventh-century *Book of Optics*, where the act of looking is for the first time visualized as a pyramid with the eye on the one end and the visible field on the other, European painters, architects, and mathematicians started toward the fifteenth and sixteenth centuries developing a mathematical/geometrical formula capable of converting three-dimensional depth into a flat surface.

Notably it was Leon Battista Alberti who, inspired by Brunelleschi, theorized the set of converging lines on which much post-Renaissance art was built. As Leonardo da Vinci described it,

> Perspective is a rational demonstration whereby experience confirms that all objects transmit their similitude to the eye by a pyramid of lines. By a pyramid of lines, I understand those lines which start from the edges of the surface of bodies and, converging from a distance meet in a single point; and this point, in this case, I will show to be situated in the eye, which is the universal judge of all objects. (Leonardo in Mirzoeff 1999: 39)

While not being entirely un-contested (under the rule of perspective the West witnessed to the use of *vraisemblance*, of anamosphism, and of a number of other playful popular visual practices) perspective grew to become recognized, from the sixteenth century onward, as a natural model of vision. Marking the shift away from resemblance to representation (in order for the viewer to perceive a wheel the painter would have to paint an ellipse) this visual regime nicely mirrored also Descartes's hierarchization of the relation between the sense and intellect with the former being part of the fallible human body and the latter connected to the soul, the ultimate "interpreting judge of sensory perception" (see ibid.: 43).

Perspective was, to use Jay's (1988) terms, a scopic regime, that is a dominant theory of vision. As a natural reflection of the West's growing obsession with rationality, lines and mathematics (as against colors, senses, etc.), perspective consituted, however, also a particular politics to it. Conventionally metaphorized and divulgated with the help of a window allowing to measure a particular view, perspective created a strict separation between the observer and the observed (the world).

Centering everything around the eye of the performer, perspective marked the entry into the modern age, an epoch characterized, as McQuire suggested by referring back to Heidegger, by the "conquest of the world as perspective" (1998: 22) and hence by a new relation between representation and subjectivity. Pushing the viewers out of the image, perspective marked a separation between the external world and the internal psyche. According to perspective there is in fact no reciprocity. Lifted up to the level of "God" the viewers do in fact exercise control upon the image and no longer need to situate themselves in relation to it. As Metz suggested, it "inscribes an empty emplacement for the spectator-subject, an all-powerful position which is that of God himself, or more broadly, of some ultimate signified" (1982: 49). Perspective had, in other words, a very particular politics to it, and made the act of looking synonymous to an act of control. Alongside these transformations images ceased being objects of contemplation, becoming instead tools for

narration lending themselves also for the use as tools for propaganda (Hauser 1999; Argan 2008).

Geometrical perspective created therefore a space that was simultaneously aesthetic, analytical, and political. As Mirzoeff suggested, it was a "powerful formula for visual standardization: a mathematical vision which could be continually projected onto the real in a social context in which mathematics was increasingly offered as the universal measure of knowledge" (1999: 19). Therefore we could say that it paved the way for the development of the panopticon, which as Foucault (1977) showed, functioned as a metaphor for the society of control. A perfect accomplishment of the Cartesian separation of body from mind, perspective managed, we could say, to tame, domesticize, and control the image, inserting itself in the long struggle between text and image that characterized medieval Europe, when religion (the Church) armed with a text (the Bible) engaged a fight against the icon-loving heathens (see Flusser 2005). Perspective contributed in rationalizing the image, removing from it its magical powers and inserting it more truly in a terrain of representation.[5]

Indeed, the dominant status of the meaning of images that accompanied perspective can be easily questioned when looking at those visual cultures that belong to other times and spaces. Different civilizations have created visual depth with the use of other strategies and conventions. Japanese and Chinese scrolls wrapped the viewers in images, both horizontally and vertically. In relation to these images a viewer could be in one and many places at the same time (rather than having one privileged position) and would conventionally also be surrounded by them. Mughal paintings used color and symbols as a tool for conveying layers of depth (see Skeikh 1997). Depth could be symbolized, for instance, by a star-clad blue ceiling and each layer of profundity in a room could simply be marked by a new color.

In Europe too, Byzantine art made an intensive use of materiality in order to generate a sense of depth. Icons were notably produced in relief or constructed with the help of materials whose texture would provide the viewer with a sense of direct engagement and hapticness. The use of metal notably helped detaching the icon from any representational duty. These images were in fact objects of contemplation rather than narration (Argan 2008).[6] They substituted the ideal landscape surrounding the object portrayed with a reflection of the lifeworld of the viewer. Giving birth to what looks like a decontextualized image, these techniques managed to collapse the distance between the observer and the observed in a movement that is by all means going in opposite direction to Renaissance perspective. Doing this they anchored the image itself in the lived world of the worshipper or rather the worshipper in the image. On the surface of the thin golden layer that surrounds the icon, the viewers could see their own reflection and the actual world surrounding them (the index literally becoming the viewers themselves).

The swallowing effect could be even grander in the churches. Roman Catholic and Greek Orthodox churches designed under the influence of Byzantium literally embraced, sucked up, and devoured the viewer (see Figure 1.2.1). Often ugly and square from the outside (think for instance of the Mausoleum of Galla Placidia in Ravenna, fifth century AD) these churches were filled with visual details in the inside. The use of mosaic in particular, with its variety of different materials capable of absorbing and defracting the light in different ways, would have a deceiving and displacing effect on the viewers. It eluded their perception of the dimensions of the space in which they found themselves, hence leading to a transcendence of physical space altogether (see Argan 2008). As Greek Orthodox churches still make evident today, the worshippers are surrounded by the glittering lights generated by the mirroring of the candles on the metal and the glass tiles composing the image, by the smell of incense and the sound of the bells. This exposure to a full sensorial experience brings them, through the senses, in touch with the divine.

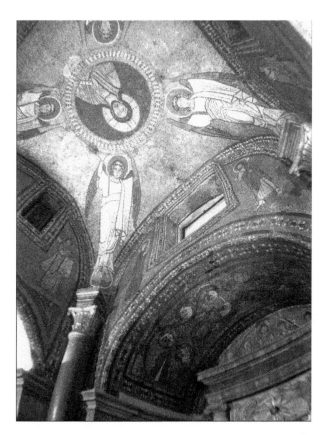

FIGURE 1.2.1 *Chapel of San Zenone in the Church of Santa Prassede (817–24), Rome. Photograph by Paolo Favero.*

Foregrounding presence (see Pinney 2001) and contemplation (Argan 2008) rather than realist representation and narration such visual practices are indeed still very much in use today, in the context of, for instance, Orthodox religion but also in pockets of popular culture connected to Catholicism (see the use of for instance lenticular prints with religious motifs popularly known as 3D images).

Such principles are also very visible in other contemporary cultural contexts. Pinney has shown, for instance, how in an Indian context images are a matter of "corpothetics" rather than aesthetics (2001: 157). Prioritizing questions of efficacy and effect images are in this context better understood as "things that matter" (Edwards 2006: 28). The divine is literally present in the image and the act of seeing, as Babb (1981) and Eck (1998) have shown, is a matter of reciprocity. In such contexts, images are also to be touched and, in likelihood with Byzantine icons, materials such as metal, gold, etc., are often used which generate a variety of mirroring effects. As implied in the notion of *Darshan*, the act of looking is, in this context, also an act of being looked at, an ongoing interpenetration leading to a full immersion in the image. As Eck expresses it, "because the image is a form of the supreme lord, it is precisely the image that facilitates and enhances the close relationship of the worshipper and God and makes possible the deepest outpouring of emotions in worship" (1998: 46). One becomes, as Babb suggested, "what one sees" (1981: 297). Image and the divinity merge allowing the devotee to take in or, as Babb says "to drink with the eyes" (ibid.) in an act that could probably be inserted within the logic of contagion of qualities and hence of magic. What Dundes (1980) called a "liquid logic" seems to characterize this particular way of gazing. Such view also mirrors the insights that Elisabeth Edwards gained by looking at the role of photographs among Australian Aboriginal people. In her path-breaking essay *Photographs And The Sound Of History* (2006) Edwards suggests that, in this context, photos are "relational objects" or, as we saw before, "things that matter." Central in articulating histories that have been suppressed, photographs do not only articulate something visual but constitute part of a much broader performance. They are held, caressed, stroked, and sung. They become hence sound, the sounds of voices, of songs of memories becoming verbalized as stories—an oral history materializing the relationships between specific individuals who engage each other through such images. "Photographs operate not only simply as visual history but are performed, I shall argue, as a form of oral history, linked to sound, gesture and thus to the relationships in which and through which these practices are embedded" (ibid.: 28).

A quick look into the meaning of images across time and space reveals hence the relativity of dominant modern (bourgeois) Western views. Paradoxically we are lead to re-evaluating the insights of the ancient Greeks and Romans who

believed that the eye had the capacity to throw out rays that would touch the things we see.[7] Despite having inherited its core principles from Renaissance perspective (the frame as a window, the separation observer-observed, etc.) photography has always been capable of hosting practices that go well beyond conventional notions of representation and narration. Photographers have always been obsessed with using the new medium in order to generate new kinds of dialogues between the image and the world it portrayed. Hence we can witness the immediate emergence of landscape formats, stereoscopic and telescopic images, etc. Photographs were embraced for the most varied purposes, from proving the existence of spirits and ghosts (a practice that remains still largely unstudied; see Clanton 2016) to creating physical arousal in the viewers (see the manifold experimentations with erotic and pornographic photography; Gilardi 2002), and so on. As Kittler (2010) has pointed out, there is little to be surprised about this. This is in fact really the duty of visual technologies, that is to enlarge our field of experiences and perceptions, enriching it by taking us beyond what could be sensed before.[8] Yet, despite this, the more playful practices have largely been marginalized under ruling notions of documentation, narration, and realism. Rooted, to paraphrase Edwards, in "realism, subjectivity and individualism and in Western modes of historical truth, narrative and identity" (see Edwards 2003: 86), photographs have been largely engaged as a tool for representing and narrating, hence renewing the realist ambitions that were made possible by Renaissance perspective. After all, as Bazin said it: "Photography and then cinema on the other hand are discoveries that satisfy, once and for all and in its very essence, our obsession with realism" (Bazin 1967: 7). I believe that anthropology is a good example of this tendency. With its obsession for content or, to paraphrase Chris Wright (1998), for "anthropological relevance," it has marginalized the role of "aesthetic composition" (the form) and engaged with image-making practices and technologies almost exclusively as tools for documentation.

What new images do

New images seem to move against the dominant trends in Western visual culture that I described above. Disrupting the conventions that characterize our understanding of camera-produced images they threaten the assumptions that we have inherited from Renaissance perspective and that have been strengthened by photography, offering the image a new (old) duty and a new (old) politics. In other words they seem to have more in common with Byzantine icons than with documentary photography.

New images are the result of a different process of production of visible evidence. They seem to maintain (or produce anew) a strong connection with, paraphrasing Thomas and Pinney, "photography's other histories" (2003), that is, for those ways of interpreting and using images that belong to other places and times. Blurring the boundary between the categories on which we build our conventional approaches to the visual world such images seem to reclaim their historical right (and duty) to intervene upon us, our bodies and world. In the new images that I have described above the visual stands for more than representation, it is presence—a presence that foregrounds a connection between the world of the observer and that of the observed. Reminiscent of Edwards's observations regarding the way in which photographs among Aboriginal Australians occupied "the spaces between people and people, and people and things" (Edwards 2006: 27) such images seem to function as "passages" (see Favero 2017), as portals or connectors allowing the represented object to "reach out beyond its formal boundaries to a larger world" (Greenblatt 1990: 42). We could suggest that the dominating modality of relation to such images is a sense of being in them, a stance which is then more remindful of contemplation than of narration. This is really what I see myself doing as I enter Björk's video. I just hang in there, contemplating the space I am in. The disembodied embodiment that I am allowed to experience (one where my eyes and swinging are indeed incorporated but not my hands nor my arms) transforms me into a meditating entity. I observe myself observing, progressively realizing my own dismemberment.[9]Reminiscent of the modalities of viewing that characterizes the visual engagement with icons (which, as Argan [2008] pointed out, are characterized by contemplation and not narration) or for that matter with Hindu depictions of divinity, such viewing practices do still require a degree of further unpacking. Elsaesser and Hagener (2015) suggest that such technologies allow the entrance into multiple possible lifeworlds and that they signal a change, to paraphrase Elsaesser, in "our perceptual and sensory default values ... changing our sense of spatial and temporal orientation and our embodied relation to data-rich simulated environments" (Elsaesser 2013: 235, 221). While agreeing with these statements I believe that we probably still lack a terminology capable of grasping the internal logic of this visual regime, which builds upon a tension between a full mimetic immersion (see Taussig 1993) and a very particular form of dismemberment.

In order to fully understand the act of swallowing, and hence this new dialectic between the viewer and the viewed, we need to come to terms with the boundary that separates the image from the lived world. Summed up by the notion of the frame this boundary may take many different shapes. In the case of *Lytro*, for instance, we do indeed sense the presence of a regular frame, yet within that we are offered multiple points of observation

and conditions of viewing. Destabilizing our relationship with notions of focus and depth of field (that here become dynamic and ever-changing) Lytro disrupts the idea of the monocular privileged point of view. With the help of the cursor we can change the position of our eye along also with the quality and depth of the gazing. The same could be said about *Photosynt* and 360-degree cameras, which in a way, speak even more clearly about the desire to overcome the frame. Lippit has suggested, with regard to 3D cinema, that "the impulse towards stereoscopic cinema is sustained by a fundamental cinematic desire to eliminate the last vestige of the apparatus from the field of representation, the film screen" (Lippit 1999: 213–4). Constituting possibly nothing but another leg in "the long battle of stereoscopic vision versus monocular vision" (Elsaesser 2013: 231), new images constitute another leap in this struggle to overcome the visibility of the means that make representation possible. And once the frame, that protective tool giving us a privileged position in relation to and protecting us from the visible world, has disappeared from our sight we have the feeling, as in Björk's video, of being at

FIGURE 1.2.2 *Collage of different aspects of the production of a 360-degree image produced with the smartphone application FOV. Copyright Paolo Favero.*

the center of the image, literally incorporated in it. The image speaks to me, it interpellates me, it develops in a dialogue with my modalities of exploration, with my moving and touching. It becomes, in other words reciprocal.

Indeed by celebrating this moment of immersion, of being swallowed, we forget that a frame (physical and metaphorical) actually exists. Exemplified perhaps by the metaphor of the bubble (Sloterdijk 2011), the sphere or the circle, 360-degree images are composed by surfaces stitched together with the help of points of reference. Figure 1.2.2 shows this process with relation to the smartphone application FOV.

Conclusions

Typifying Friedrich Kittler's insight that every medium owes its existence to another previous medium, the hegemony of perspective constitutes, hence, a narrowing down of the possibilities for conceptualizing, using, and producing images that are at human disposal. In his six-point critique of geometrical perspective, nineteenth-century Russian philosopher and theologian Pavel Florenskji suggested that perspective neglects, among other things, also a very basic fact of human physiology. Reducing vision to a form that is, in his words, "as monocular as the Cyclops" (2002: 262) it neglects the fact that human beings see things binocularly. The second eye, Florenskji suggested, is the critical judge that helps us giving depth and value to what we see and I would add to close the gap between me and the world that surrounds me.

Probably, as Didi-Huberman suggested, "we ask too little of images . . . by immediately relegating them to the sphere of the document . . . we sever them from their phenomenology, from their specificity and from their very substance" (2003: 33). New images seem to open up this space again. Widening up the visual field to a broader set of possibilities that dialogue as I have shown with the past as much as with the future they materialize the Tongan proverb I saw in an exhibition, quoted by an artist: "We walk forward into the past and backward into the future." Blurring the conventional assumptions on which we build our understanding of images they force us to rethink the assumptions that characterize our dominant ways of engaging with them, recentering also those visual practices that have become marginalized in Western visual culture. New images are, in fact, similar to images belonging to "other" places and time, objects of contemplation and reciprocality rather than of representation and narration. And they aim at transcending the frame, that screen that divides us from the world and that allows us to keep a distance from and to exercise control upon the image.

However, a set of important questions remain unanswered. How should we address the role of the viewers in this context? Wherein resides their agency in this new (and old) dialectic between the observer and the observed? Behind the temptation of celebrating such new practices as signs of our entry into a new era dominated by active forms of spectatorship, by collaboration, co-curation, and participation (Jenkins 2006) hides in fact the specter of new forms of control and "soft" capitalist exploitation (see Thrift 1997). As Boltanski and Chiapello (2006) have suggested, participation is the favorite form of expression of the contemporary "spirit of capitalism." Today's spontaneous forms of sharing information with the help of smartphone applications, smart watches, social media, etc., correspond in fact also to just as many acts of voluntary subjugation to the market. Rather than active participants and co-creators we could hence consider ourselves to be "unpaid labourers" (Gehl 2009),[12] enthusiastic collaborators eager to be monitored, controlled, and swallowed by the contemporary capitalist system.

So perhaps we may want, to conclude, to turn things upside down and turn our gaze toward another of Björk's videos. In her 2015 *Mouth Mantra* Björk lets a micro-camera positioned inside her mouth film her (or better film her body from the inside) as she sings. From that vantage point what we see are rounded images of the membranes of her mouth, of her tongue, gums, and teeth in shades of red purple and blue. At times we peep out, we see her lips, her mouth. Suddenly, in an act of dissociation we can see Björk standing in a dark room; as she sings we fall prey to an inversion celebrating, to use Merleau-Ponty's words, "the inside of the outside and the outside of the inside" (1964: 126). Then we get swallowed again, trapped in her saliva, squeezed between the membranes of her mouth. With no control over what happens we are perhaps less enchanted by what goes on, fearing that there is no way out from her body.

PART TWO

World Art Studies and Global Art

2.1

The Design of Pictorial Ontologies: From Unstitched Imaginaries to Stitched Images

Leyla Belkaïd-Neri

The duality between what has been so far categorized as art or as design cannot be easily exceeded or undone. Despite the admission of clothing and textile into anthropological analysis, fashion design has long been the forgotten victim of such a dichotomous theory of culture. In this chapter, I envisage contemporary art as in part extended to translations and struggles occurring at the level of the visual representations that disrupt the surface of certain typologies of clothing artifacts. The attempt is not to subsume fashion design to the conventional territory and historiography of art but rather to gain knowledge about the material and immaterial processes that produce contemporary culture by examining the iconographies that contribute to the creation of a garment and to the social performances of the subject who designs it. I consider the symbols and patterns integrated in to the surface of clothing objects designed to be adapted and used in everyday life as images in their own right. Thus, investigating the iconicity of textile artifacts in relation to the technologies and narratives that lead to their seasonal renewal means integrating the material culture of fashion within a larger conceptualization of culture.

In this chapter, I explore the material translations and the meanings of the images produced by a fashion designer whose research exemplifies some of the current evolutions in the work of a new generation of transnational artists. I address the polysemous incorporation of figurative iconographies on textile

envelopes imagined and made to dress the body, drawing on the observation of existing pieces disseminated by the company of the designer and on the analysis of the collections presented to the public and media through recent fashion shows. I also examine how the encounter between digital printing technologies and traditional craftsmanship leads to renewed forms of artistic representation on contemporary clothing artifacts. The issue this chapter raises is the recognition of fashion objects that become art-like surfaces as an aesthetic production able to partake in contemporary culture. In turn, this leads to a critical comprehension of fashion design practices of representation as a process of materialization of image-based thoughts and artistic experimentations.

Fashioning postcolonial hybrids

The production of high-end clothing can instantiate complex identity and political issues, even if fashion designers rarely share the "art for art's sake" idealism with visual artists and generally assume the "utilitarian" finality of their innovations. The technical skills required to make fashion artifacts of exceptional quality tie certain clothing pieces to the category of artworks from a technological perspective, "excellence being a function, not of their characteristics simply as objects, but of their characteristics as *made* objects, as products of techniques" (Gell 1992: 43, italics in the original). The notion of technical excellence prompts Alfred Gell to identify the different arts as the components of a vast technical system, crucial to the existence of all societies, which he defines as the "Technology of Enchantment" (ibid.), emphasizing the relation between art and technology. Gell's epistemological perspective sheds new light on the work of contemporary fashion designers who create disruptive visual representations to express a political voice. Among them, Stella Jean, an Italy-based designer born in Rome in 1979, defines her aesthetics as a "Wax and Stripes Style." The iconic image that contributed to her growing success brings together a colorful bell-shaped skirt and a fitted striped shirt.

The first collection produced in 2012 evokes the original junction of various aesthetics related to the Afro-Caribbean culture of the designer's Haitian mother, Violette Jean, and to the memory of the classic elegance of her Italian father, Marcello Novarino. Stella Jean's design work reflects the intricacy of this hybrid ethnic background: "I had struggled to find my identity. I found it through my work. I put my two worlds together and found fashion was looking for that" (quoted by Hume 2013). Nested in a fictional Caribbean-Mediterranean archipelago of prints, colors, and patterns, her work explores issues of race and class through the media of textile and fashion. Because the history of Haiti has intersected with European colonialism,

the designer's trademark material is the batik, a typology of cotton printed following a wax-resist dyeing technique, originally inspired by Indonesian design, mass-produced by Dutch manufacturers, and sold to the West African colonies since the mid-nineteenth century, after a stint in the Netherlands Antilles. The traditional waxed fabric which became one of the symbols of black African identity and of independence from colonial power in the 1960s is metaphorically questioned by the designer in relation to her own roots: "We think wax comes from West Africa. The slaves sent to the Caribbean islands came from West Africa. Yet wax is European, like me. No one ever believes I am Italian, but I am" (ibid.).

Stella Jean launched her eponymous label in Rome in 2011. Season after season, before a new collection is displayed under the spotlight, the voice of Haitian actress and singer Toto Bissainthe bellows words in Creole followed by "*Rassembler!*"[1] The rallying scream, registered in the 1960s, is a call used to gather Haitian people to fight for freedom from colonialism. It resonates as an initiation to a contemporary ritual that revives the history of the world's oldest "Black Republic." This ritual that occurs twice a year is called a fashion show. It addresses the issue of fashioning and displaying pictorial forms and symbolic systems to articulate new modernities on people's bodies. In 2012, the shape of the voluminous skirts exhibited during Stella's first show recalls the elegance of Italian women walking in the chic streets of the island of Capri, Italy, in the 1950s and 1960s. It simultaneously reminisces about the traditional Caribbean female gowns inspired by nineteenth-century European dress.[2] This dual remembrance is fostered by the unusual bi-dimensional patterns added by the designer on the surface of almost every piece of the collection.

In Stella Jean's collections, strong graphic representations are scattered across the outer layer of skirts, dresses, shirts, and coats. The array of images created by the designer are usually obtained with two techniques: hand painting or screen-printing.[3] For the Spring-Summer 2013 collection, focus is put on the contrasted volumes of the garments that compose each silhouette. Batik sleeveless dresses with a bell or slimline shape, both inspired by 1950s Western European fashion, are combined with sweaters chromatically strengthened by contrasting horizontal stripes or with unisex light blue cotton shirts. The timeless masculine shirt engages in an ambiguous dialogue with the African wax motifs of skirts and dresses that claim a historical European ascendance because of their shape. The outfits indeed belong to an imagined history in which African visual aesthetics can merge with the elite fashion tradition of the West. This anachronism is emphasized by the addition of printed figurative elements, mostly parrots and tropical vegetation, on some pieces of the collection. On a white bell skirt, worn with a batik shirt on top of a striped sweater, two enormous multicolored roosters are printed face to face. It is unclear whether the configuration of the image aims at representing

a cockfighting scene as a reference to Caribbean popular culture or as a visual metaphor for the opposition between conflicting male powers—the colonizer and the colonized—both dominating over the native female subject incarnated by the voluminous skirt.

In Stella Jean's work, proportions and colors are subjective, but often recall unexpected folkloric aesthetics. Most of the models of the 2013 show have their hair covered with batik turbans, draped in a Western couture manner or following West Indies style. In Haiti, as in all Caribbean islands, the colonial laws did not allow slaves and freed black women to wear hats. This distinctive element was reserved for white women only, while Afro-Caribbean people had to invent vernacular forms of cotton headscarves knotted over the forehead. The designer brings back the headdress of the Afro-Caribbean slave and colonized women to the fore, emphasizing its visual identity by the use of wax prints and colorful fabrics with enhanced checks and stripes. While paying tribute to the inventiveness of her Haitian mother's ancestors, she uses textile surfaces to mirror the claims of today's minority women. Stella Jean simultaneously plays with other accessories to escape a self-exoticization process that she has accurately avoided since the very first public presentation of her work. The high-heeled pointy feminine pumps that complete every outfit evoke the memory of a Western elegance that is representative of the 1950s, a historical period that the 37-year-old designer has never known. She establishes new periodizations by borrowing from the past of two distinct cultures as if she kept on navigating across the childhood of her two parents, the Haitian mother and the Italian father, to reconstruct her own identity. Creating images to print them on surfaces worn on the body allows for the articulation of an imaginary hybrid past and for the representation of a different present time. On the Spring 2013 catwalk, the political dimension expressed through the invented temporality of the pictorial features of the collection is somehow weakened by the omnipresence of white models. The enigmatic absence of the black woman highlights the focus placed on iconographies to represent the identity narrative and the new temporalities that are key to the designer's social and artistic project. To avoid transforming the fashion show into a theatrical set with actors playing determined roles, the ethnicity of the model does not seem to interfere in the postcolonial storytelling. Evidently, the artistic media explored by Stella Jean deals exclusively with the materiality and the visuality of the dress.

Holistic printed surfaces

Contemporary fashion design forces us to re-examine the dichotomy between the inner and the outer (Warnier 2006). In Western cultures, truth and authenticity

are considered as being placed inside and in-depth. Because fashion designers fix a *pastiche* of images, temporalities, and geographies on the outer layer of the subject, their work is often viewed as superficial in the pejorative sense of the word—that is, meaningless and frivolous. In *Stuff* (2010), Daniel Miller explains that seeing "clothing as the surface that represents, or fails to represent, the inner core of true being" (ibid.: 13) is a cultural fact, taking as an example the case of the Trinidadians who have a real devotion to clothing and style. Because Trinidadians believe that the intimate is situated on the external surface, the visual aspect of the clothes they wear is not viewed as trivial. The adorned surface of the body reflects the cultural construction of the self and is never at odds with interiority. Similarly, contemporary fashion designers express their own search for identity on the outer layer of the artifacts they produce for others, using colors, prints, embroideries, and all kinds of visual techniques as a path to explore vernacular cultures, return forgotten kinship, and shape the future of humanity. Stella Jean opens the show of the Fall 2013 season with a man wearing a waxed cotton outfit, followed by women displaying wide batik skirts and striped androgynous pullovers. Her creative nomadism spurs her to borrow visual elements from a culture that has apparently no ties with her own origins. Capes inspired by the alpaca shawls made by peasant women in the Andes to cover their shoulders and bust, but also accessories like the Bolivian melon hats disrupt the Italo-Caribbean narrative of the designer. This time, the bell-shaped skirts recall the *cholita* traditional dress worn by Bolivian women who live in mountainous areas rather than 1950s Western couture.[4] However, waxed fabrics are recurrent enough in the collection to confirm that the identity quest of the designer is still relevant. Melon hats are added on batik turbans and African waxed cotton linings are visible inside woolen single-colored coats. Batik also covers up other garments such as capes of different lengths. In this winter collection, the strong combinations of patterns used to translate the political statement of the designer are conveyed by a triad of graphic prints: first batiks, essentially on the skirts and linings, secondly thin vertical stripes or checks on shirts, and thirdly large horizontal stripes with contrasting vibrant colors on sweaters.

Series of voluminous artifacts like skirts, capes, and coats made of thick wool blankets with geometric patterns recall the textile crafts of native Indians from Central America. The Fall 2013 collection, also inspired by the multilayered *cholita* dress, investigates the heritage of colonized populations that conveys the memory of racial segregation. It is worth pointing out that the Bolivian *cholita* traditional dress can reach important weights not only because of the need to resist low temperatures and hard climatic conditions, but as a consequence of historical contingencies. Indeed, the Spanish colonizers forced indigenous women to wear voluminous skirts that oversize and deform the natural shapes of their bodies as a symbol of discrimination. Following

the questioning of her own roots, Stella Jean draws dialogue with vernacular sartorial practices and visual representations that have become symbols of identity and pride for colonized populations after centuries. The parallel with the Indonesian-Dutch-African history of the batik textiles is blatant. As the tribute to native cultures melts with the memory of her own mixed roots, the designer extends her territory of experimentation to a larger panel of non-Western cultures. This expansion inserts additional overlapping layers of images on the body as a form of artistic move toward the unbounded union of the peripheral subjects' aesthetics.

The same interest for marginalized cultures that do not belong to the designer's parental Haitian and Italian references becomes visible again two years later. In Stella Jean's Fall 2015 collection, very few batik fabrics are used, while visual patterns from India are privileged for prints and embroideries. From the Americas to Southern Asia, the search for different colonized people's artistic legacies brings a new aesthetic into contemporary fashion objects. Figurative elements and lively scenes inspired by Indian miniatures are applied on checked plaid fabrics. It is not a coincidence if the woolen materials selected by the designer recall the classic British textiles to enhance the visual contrast between two visible layers of cultures that coexisted in India, but rarely merged together. On the surface of her creations, the confrontation between the two worlds is not only visual but also tactile. Indeed, the printed characters inspired by the Indian miniatures seem artificially painted on garments since the limit between their contour and the woolen textile underneath remains clearly impassable. Their smooth surface conflicts with the slightly hairy wools of the thick voluminous skirts and coats. In addition to this disparity, the shapes of the woolen artifacts remain geometric while the lines of the Indian imagery are lively curved. The front of a brown woolen dress with a check pattern, worn by an African model, welcomes the colorful image of an Indian *fakir* with a white beard and a big turban. In this collection, the visual and tactile confrontation could also involve a gendered dimension since dull brownish and grayish checked wools are primarily used to make male coats, jackets, and pants in the British sartorial tradition. This gendered opposition is as a matter of facts emphasized by the predominance of female protagonists wrapped in their fluid traditional saris among the iconographies borrowed from the Indian repertoire. Once again, the traditional dress of the native woman meets the pragmatic materiality of the European male colonizer.

In Fall 2015, the surface of the bell-shaped skirt does not belong anymore to the batik family. It is made of heavy wool or totally covered with shiny Indian patterns embroidered on a dark pink base, worn with a striped masculine shirt and a big checked coat. In other compositions, printed images representing elements of traditional Indian architecture illustrated by local miniaturists disrupt leopard patterns. In the angle of a trench-coat with a classic color,

Indian white-bearded elders are depicted. The identity of the powerful British archetype is being questioned by the application of the figurative image of indigenous characters which come to the surface to dig out the millenary story of the silent dominated people. The following fall, Stella Jean decides to move from India to sub-Saharan Africa. The live songs of a gospel group accompany the ritual of the show. On the outfits, images of European characters in uniforms that date back to colonial times are associated with African masks and motifs. For the first time, patterned knits provide basis for the bi-dimensional artistic experimentations of the designer. In the collection, the Masaai dress worn as a rectangular cape is transformed into a contemporary artifact. The designer explains that the idea of producing a Masaai *loden* in her Fall 2016 production is a tribute to the European-made *loden* used by her father. Outfits covered with thick black lines that bound geometric patterns made of white, red, yellow, brown, green, or blue triangles evoke the vernacular art of native Africans in the remotest areas of the continent. After sub-Saharan Africa, the migratory trajectory of Stella Jean reaches Salvador da Bahia for the Spring 2016 collection. Following the same playful search for otherness, vivid raffia fringes, batik flounced elements, colorful ruffles, and small motifs of traditional native characters are resurrected to symbolize the resilience of South American peoples.

A corpus of deterritorialized iconographies

Fashion as a Western social practice and as an industry is historically tied to modernity, capitalism and its corollary, colonialism (Appadurai 1988; Kondo 1997). Today, transnational designers try to reverse the phenomenon, reinject collectivity into globalized fashion artifacts, and produce cultural and visual entanglements that address identity conflicts, as well as issues of social engagement and sustainability. The disruption of more performing technologies, in particular sophisticated digital printing techniques, enhances the reinterpretation of totemic images to express new mobile identities on the fashioned body. The porosity between these technologies and traditional craftsmanship such as weaving, painting on silk or cotton, and embroidering can lead to an original use of iconographies on contemporary clothing artifacts. It is clear that this recent development blurs further the boundaries between art, design and craft practices, techniques and productions.

The work of Stella Jean avoids the disjunctions between past and present, rich and poor, dominant and dominated people. The use of traditional imagery freely applied on the urban clothes and accessories she disseminates within today's globalized fashion system mobilizes history and recontextualizes

mythologies through all sorts of painting, printing, embroidering, and knitting techniques. The designer reinvents her own genealogy by the application of pictorial layers on the material envelopes that delimitate the space of the human body. The colorful motifs she creates season after season narrate the historical contingencies of the enslaved and the colonized subject (Rutherford 1990). Stella Jean's appropriation of symbols, icons, and everyday images that belong to vernacular non-Western cultures certainly shortens geographical, historical, and ethnical distances visually. In 2013, the Italian-Haitian designer began a long-term partnership with Ethical Fashion Initiative, a United Nations project that builds bridges between craftsmen from different developing countries and international high-end fashion companies.[5] She started collaborating with traditional weavers from Burkina Faso who produce locally hand-loomed fabrics following the centuries-old *bogolan* technique of dyeing and printing cotton with fermented mud.[6] This artistic cooperation encourages the exchanges and visual encounters between the designer's vivid palette and the vernacular knowledge of the West African artisans.

Stella Jean also involves Haitian jewelry makers from Port-au-Prince, Jacmel, and Croix-des-Bouquets who transform papier-mâché and wrought iron into contemporary accessories for her. The Ethical Fashion Initiative cooperative project opens up a new perspective not only on sustainable productive methods, but also on the design of fashion artifacts as an innovative practice that interconnects creative people, aesthetic repertoires, and artistic representations.

The contribution to the safeguarding of ancestral weaving crafts in the remotest regions of the Southern hemisphere leads Stella Jean to consolidate her humanistic values and political vision (Featherstone

FIGURE 2.1.1 *Stella Jean craft production in Burkina Faso. Copyright Anne Mimault and ITC Ethical Fashion Initiative.*

2005). Since fall 2015, the waxed fabrics she manipulates are designed internally in her studio and developed locally by small African producers. By encouraging self-sustaining craftsmen communities, the designer fights cultural homogenization using fashion design as "an instrument of counter-colonisation."[7] She simultaneously broadens the repertoire of motifs that enrich the surface of clothing and jewelry artifacts. Hence, the seasonal ritual of the fashion show is turned into a display of images that describe her search for cultural diversity. On the other hand, Stella Jean organizes streaming video projections of her fashion shows in the African workshops where local artisans have given birth to unique hand-loomed fabrics for her, and in the Veneto and Umbria factories, Italy, where dressmakers with traditional Italian sartorial skills have cut and assembled the prototypes and final pieces. The live ritual therefore becomes a collective festive moment for small communities of craftsmen settled in different continents.

The pictorial cosmologies of reinvented kinship

In the Western world, the denigration of the materiality of surfaces and the supremacy of function over superficial ornamentation affects the analysis of all the artistic productions categorized as "decorative," in particular fashion objects because of their close relation to femininity, appearance, ephemerality, and permanent change. We have seen how Stella Jean's work brings the inner outside and how memories, symbols, and ancestral cosmologies emerge at the surface using different artistic media and techniques. Daniel Miller considers "the idea of keeping things on the surface as a defensive strategy against the condition of extreme degradation" (Miller 2010: 16) in some postcolonial cultures, especially in societies where slavery has been practiced. Can the "adaptive tendency to keep things on the surface, to refuse any internalization and thus to minimize one's sense of loss" (ibid.) explain why minority designers of African or Caribbean descent look differently inside themselves and focus on the metamorphosis of the surface as if conflicting memories had to stay on the visible layers that warp up the subject? In Stella Jean's work, identity and memory are rarely internalized or interiorized (Connerton 2006). The display of borrowed totemic signs and singular cosmologies on the surface becomes an artistic decision for self-definition. It expresses freedom and creoleness. In fact, the images placed on the clothed body convey ancestral kinship and new kinship at the same time. In several collections, characters printed or painted on cottons, silks, and wools narrate random episodes of the life of hybrid imaginary families reconstituted on textiles as new communitarian manifestos worn by bodies in motion. The Spring 2016 collection shown at the Museo

delle Culture in Milan includes some references to Brazilian indigenous arts. Outdoor market scenes introduce small naive characters of men and women dancing on the canvas of white printed pieces. The Brazilian indigenous dancers, the black men and women from the West Indies sometimes depicted with a basket on the head, the peasants from the Andean mountains with their round hats represented in seated positions, the old fakirs, the groups of Indian ladies wearing colorful saris, and the colonial policemen with their iconic outfits constitute the figurative metaphors of ambivalent genealogies driven by the artistic choices of the designer.

Besides, the unusual interrelation between various streams of nomadic experiences goes in parallel with the representation of vegetal beings associated with the natural environments of the geographical areas corresponding to Stella Jean's virtual constellation of non-Western cultures. In her recent work, the notion of sacred nature seems to reflect that of sacred humanity. For the Spring 2016 season, red birds, green cactus of the Mexican desert, and pink vegetables with long leaves are printed or painted on striped fabrics with geometric patterns. Society and nature become constitutive of a unified kinship ritual injected in today's world by the contemporary production of the designer. Before the direct references to nature of Spring 2016, the exploration of vegetal and animal beings to animate the artifacts created by Stella Jean is already tangible in her earlier work. In the Spring 2014 show that exceptionally takes place in the Armani Teatro[8] in Milan, the bell-shaped dresses and skirts of the 1950s are back, once again cut in African-style waxed cottons. Headscarves made of check-printed cottons are tied in the West Indies manner on top of the models' heads. While different batik graphics are mixed in the same outfit or juxtaposed with stripes and checked patterns, hand-painted motifs of tropical fruit are present in abundance on the wide surfaces of silky artifacts. The orange silk of a skirt is adorned with painted coconuts and enormous papayas. The same imposing fruit motifs are placed among big green leaves on another skirt with black-and-white horizontal stripes. Other pieces seem saturated with hand-painted and embroidered pineapples, avocados, and giant passion fruit. The production of Spring 2014 also includes an enigmatic zebra pattern on a green silky skirt. In addition to this luxuriant flora and fauna, colorful roosters reappear again. This time, the striped surface of a long dress welcomes the vibrant green, orange, and blue feathers of the two birds as they face one another like adversaries ready to fight. While Stella Jean's work ties links with her real and imaginary ancestries, the figurative prints she superficially adds on color-injected batik fabrics and on striped, checked or one-block artifacts reconnect the surface with the essence of the materials she uses. The materiality of the vegetal fibers, mammals' leathers and birds' feathers turns back to the outside and becomes in a certain way visible through the iconographies of various sorts of local plants and animals.

Stella Jean's botanical and zoological experiments on plane surfaces wrapped around the body attempt at recreating a renewed and enlarged network of relations not only between humans of different cultural backgrounds, but also between humans and nature (Descola 2005). These visual attempts are not only recurrent during warm seasons, but also in fall and winter collections. In 2014, European menswear textiles and batik prints coexist with the reproduction of traditional East Asian fish and rooster motifs. Added patterns are not limited to waxed cottons, but are extended to knitwear pieces. An exotic yellow bird printed on a batik skirt dialogues with a red fish knitted in a woolen gray sweater. Tiny green fish swimming in a big oval basin are placed over the dark red satin of a long dress to turn it into an original totemic object. An enormous peacock feather painted on a batik artifact reveals a slightly Africanized palette in which green is deliberately replaced by a warm orange. Once again, the designer pictures big roosters on the surface of a striped skirt. The stripes look darker than those of the former seasons, but the animals still

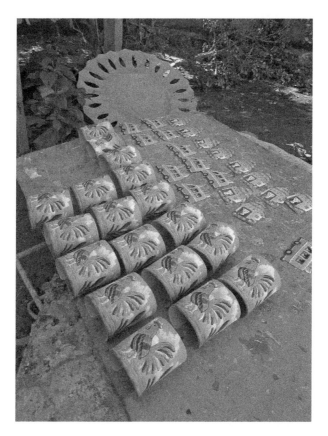

FIGURE 2.1.2 *Hand-painted metal bracelets made by Haitian artisans for Stella Jean, December 2014. Copyright Francesca Cartier.*

have green, yellow, and blue feathers with bigger and more graceful shapes. Vivid roosters are also printed in the middle of striped sweaters. The visual contrast created by the red comb of the animals and the spherical pearls of different diameters embroidered on their abdomens emphasizes the Creole dimension of an inspiration that remains strongly connected to the ethnical background of the designer's mother. Indeed, the cockfights were and still are deeply anchored in the Haitian culture.[9] Like the African batik that has European roots, Spanish colonizers introduced the Haitian rooster to the West Indies in the seventeenth century. The artistic representation of the animal therefore brings to the surface the powerful presence of images connected to identity symbols that incorporate cultural creolization within themselves (Gilroy 1993).

The designer depicts other kinds of unvalued objects belonging to the Caribbean material culture following the same political concept of symbolizing the irreducible identity of the colonized subject through things and animals who often hide a European background. Vintage carts, cars, and buses, as well as donkeys, parrots, smaller birds, and roosters animate her production as if their visual resurrection could transform them into vivid characters of a modern universal tale. Stella Jean becomes a storyteller who transmits the heritage of both her Caribbean and Italian ancestries by spreading bright images over a creolized dressed body. In her work, struggles occur at the level of the visual materiality of the external layout adopted by the new cosmopolitan subject to evolve into today's society (Beck 2006). She clearly cancels distinctions between living species and everyday commodities, between humans and animals, between plants and objects. Hence, designing clothes and fashion artifacts means connecting categories, temporalities, and places to set up new social and cultural cosmologies. The images of humans, animals, vegetal species, and things therefore induce new sets of ontological relations not only to enable the return of distant forebears and their encounter, but first and foremost to let otherness shape society.

An exegetical use of images

The artistic motifs added on the surface of clothing artifacts are forms by which contemporary designers question and discover who they really are. These forms later help others, that is, users, to design their own identities through new images that determine their appearances and social lives. Such a decorative action on the clothed body's surface is meant to unveil the real identity of the designer instead of covering it up. Consequently, the overlapping of figurative motifs on textiles never becomes a disguise. The

decorative signs created by Stella Jean are significant mediators that take the form of animate and inanimate beings. It is worth observing that this mediating function is often based on the creative appropriation of vernacular forms of art. The designer's search for expressivity and authenticity is most of the times generated by the artistic representation of houses, palaces, landscapes, animals, objects, and human figures in the popular cultures she explores. This visual translation is made possible by the efficient experimentation of cutting-edge printing technologies and handicraft know-how. The Fall 2016 impressive prints inspired by the art of the Masaai and by Southern African masks show how an important amount of images entangled with local artistic expressions are treated by the designer within a new context and on different sorts of material surfaces. Non-Western techniques of painting are transferred from wood, canvas, textile, paper, or metal to soft fabrics adapted to dress the mobile body. This appropriation of other peoples' artistic codes encourages her to examine further her identity as a transnational subject, as a modern woman, but also as a contemporary designer and artist.

Stella Jean's artistic experiences and practices could be defined as an exegetical exploration of vernacular images from the Caribbean area, Africa, Central and Southern America, India or Eastern Asia applied on the surface of contemporary clothing artifacts. In the collection of Spring 2017, football polo shirts, dresses inspired by Western 1940s fashion, and sarongs are mixed together. Among various colorful patterns, the big icon of the rooster coexists with fish and landscapes originating from ancient Japanese art. Once again, the bi-dimensional representation of a non-Western traditional visual motif is adopted and quoted by the designer. Following the same scheme, two years earlier, popular art of the Caribbean was at the very heart of Stella Jean's work, crossed with the more graphic aesthetics of extra-size baseball T-shirts. Indeed, the Spring 2015 show begins with an Asian woman wearing an orange baseball tee that holds the name of Bamako. A hand-painted Caribbean art's landscape entirely covers her skirt. Blue sky, dense forest, and small houses depicted on the surface make the piece look like a work of naive art wrapped around the hips. From the capital of Mali to the capital of Haiti, the tee worn by the second model mentions Port-au-Prince. The name of Ouagadougou, capital of Burkina Faso, printed on the front of a third baseball tee emphasizes Stella Jean's intention to shake down the hegemonic boundaries of the West and bring the culturally isolated and forgotten places of the weakest subjects in the forefront. The globalized aesthetics of the characteristic typography of American sport apparel meets the art of the marginalized Caribbeans. West Indian popular painting is therefore investigated to introduce a disjunctive narrative that breaks up the ethnocentric polarity between North and South. However, the designer does not select the names of the Southern hemisphere's cities randomly to transcend frontiers and frame a different

world. Bamako, Port-au-Prince, and Ouagadougou are the places where she regularly goes to work with local artisans who weave textiles or make jewels for her seasonal production. Thus, establishing new cartographies to draw renewed relations between cultures does not occur at a theoretical level or in a utopian perspective, but following a concrete journey where dialogue and integration take shape with the real manufacturing of contemporary artifacts.

The figurative prints of the Spring 2015 production contrast with the large stripes and checks of the fabrics hand-woven by West African artisans, frequently used for pants and jackets. Still, half of Stella Jean's collection displays painted images which relate directly to the art tradition of Haiti and the West Indies. The bi-dimensional silhouettes of black women wearing colorful garments and headscarves depicted against the backdrop of a lush green landscape, the vivid market scenes where women, animals, and tropical fruit merge together, and the typical old multicolored minibus of Haiti are clearly recognizable on the large printed surfaces of jackets, dresses, and skirts made in shiny silks, white canvas geometric panels,

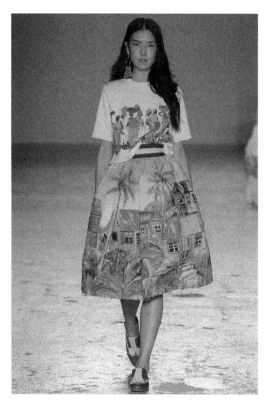

FIGURE 2.1.3 *Scenes and characters printed on a catwalk look, Stella Jean, Spring 2015. Copyright Yannis Vlamos for Indigitalimages.com.*

or fluid crepes. A trapezoidal coat welcomes a huge landscape and lively scene with Caribbean characters and small shacks. The asymmetry of the image printed on each piece enhances its artistic value by breaking the symmetry of the more classic structure of the garment. The conventional regularity of Western fashion patternmaking is altered by the spontaneous asymmetry of the adorned surface. By avoiding symmetry, the designer does not only communicate meaning through added decorative patterns used as signs, but creates new visuality and materiality to express the reinvention of culture as difference. Through the reinterpretation of vernacular expressions of art, her creative process questions the materiality of symbolism and signification, that is, "the historicity inherent to signs in their very materiality" (Keane 2005: 183).

Conclusion

After analyzing the stylistic, morphological, and aesthetic features of various collections of fashion artifacts, I have suggested that the new agency of images, forms, objects, and bodily practices brought into society by today's fashion designers call back ancestral beings and generate new mythologies. The disruption of sophisticated screen-printing techniques enhances the rise of vernacular elements associated with the multiple cultures that have surrounded the designers' childhood experiences and coexisted in their imaginaries. As many other transnational designers, Stella Jean produces, but is also the product of, intricate mnemonic, historical, and social processes. I have attempted to show how she tries to override categories and discontinuities between North and South, Western and non-Western, inner and outer, form and ornament, humans and nonhumans, handmade and machine-made.

In this chapter, I have argued that what is constituted within representation is a debate on power confrontations and a reflection on culture, gender, colonialism, slavery, but also tourism and globalization. I have emphasized how the encounter between new digital printing technologies, traditional craftsmanship, and vernacular visual arts disrupt fashion as a tautology of Western culture and revolutionize its relation to the social production of difference. As multiple temporalities, geographies, climates, tropisms, crafts, and imageries lead to renewed practices of representation, the diachronic examination of the production of images that characterize the syncretic artifacts disseminated by contemporary fashion designers in connection with new forms of political claims reframes and widens our understanding of current cultural cosmopolitanisms.

2.2

How Global Art Came to Istanbul: The Context of the *Istanbul Bienal*

Danila Mayer

Prologue

November 2016. The *Sinopale*, a biennial art festival on the Black Sea and scheduled for July/August, was postponed by the curatorial team due to current political issues. The fifth Canakkale Biennial, planned to open in September and to be headed again by art doyenne Beral Madra, was canceled three weeks before. The 2017 edition of the renowned art fair Art International in Istanbul was canceled in spring 2016, because the organizers feared a decrease in international visitors (Boucher 2016). Recently, the Contemporary Istanbul fair has been attacked by members of the Erbakan Vakfi group: they protested against a statue by Turkish artist Ali Elmaci, which showed Sultan Abdul Hamid II's portrait on a woman's body. Art institution SALT Beyoğlu, directed by eminent figure Vasif Kortun, had to be closed. Art in the Republic of Turkey faces troubled times, to say the least, and it is worth to see how the country's largest art event in its biggest city, the Istanbul Bienal, is doing these days.

Preparations go along fine, say Zeynep Seyhun and Duygu Su Pur. They are in charge of the Istanbul Bienal's international press relations for Istanbul Kültür Sanat Vakfı (IKSV, Istanbul Foundation for Culture and Arts). This institution is privately owned by the Eczacıbası family, and produces the Biennale and several other large culture festivals in Istanbul. In early 2017, the curatorial team is preparing the fifteenth edition, which will take place

from September to November 2017 under the curatorship of the Danish-Norwegian artist duo Elmgreen and Dragset. Their theme will be *iyi bir komsur—a good neighbor*—and they want to address "multiple notions of home and neighbourhoods" (IKSV 2016).

So, what is happening in Istanbul? The Galataport building project is in full swing. This completely revamped area along the Bosphorus close to the Golden Horn will be a huge shopping and recreation area mainly for cruise ship passengers. Protested against for years, the project is now under the motto "The Urban Transformation Claims the Shoreline." One of the former storage buildings, then used for art exhibitions, Antrepo No. 3 was torn down, and No. 5 is being transformed into luxury apartments. Istanbul Modern—Antrepo No. 4, used as museum since 2004, is barely visible behind the building machinery, and it will undergo a total reconstruction soon.

The *Istanbul Bienal* has accompanied and influenced the city's rise for almost three decades. One may wonder, however, how political developments of 2016 in Turkey may influence and endanger Istanbul's recently gained position as an important hub and metropolis of contemporary art. How will the global and local art scenes interact with new political frameworks; how will the meanings of Turkey's contemporary arts and their relevance change? The art markets are fickle networks of personal friendships, interconnections of artists, traders, and collectors, of global capital transfer and investment, spurred by the creativity of innumerable artists, and with art fairs and biennials as their main global events. *Contemporary Istanbul's* press conference chairman Ali Güreli's words "solidarity" and "support" (Aima 2016) sound strange and defensive, coming from people who hail the artists and their works as unique and auratic, and from a world where private ownership is of utmost importance. In short, everyone in the art scene is running for cover. Maybe, as Istanbul gallerist Aslı Sümer told Artnet News, stress and particularly difficult circumstances are the main incentives for making art, and will have a "positive effect on the quality of art" (Kinsella 2016).

Introduction

The *Istanbul Bienal* was first held in 1987 as *Uluslararası Istanbul Cagdaş Sanat sergileri* (International Istanbul Contemporary Arts Exhibition) and in 1989 as the second international *Istanbul Bienal*. These first mega-events were organized according to multiple national contributions which were curated by the participating countries. In its three decades, the *Istanbul Bienal* developed into a big event in the global art world's calendar. Looking at the *Istanbul Bienal's* history since 1987, and its context in the unruly metropolis on the

Bosphorus, is a study of urban transformation, interaction at the local and the global levels, and fervent political processes.

In the Republic of Turkey the arts were long under the guardianship of the state. The latter regarded its role as the propagation of national and secular ideals: "during the foundation years of the Republic [the mission of art] was to facilitate modernization and make the public embrace the revolutions" (Dervişoglu 2009: 40). Over the years, as public support for the arts decreased, Turkey's large family-owned industries (Sabancı, Eczacıbası, Koç) stepped in and began to sponsor and invest in art in the 1970s. Nejat Eczacıbası founded IKSV in 1973; it is Turkey's largest private cultural institution. "The priorities of IKSV include understanding Western art, sharing its knowledge with the people, and supporting the project of Westernization" (Dervişoglu 2009: 45), while at the same time revitalizing the long tradition of Anatolian art. In 2004, the Eczacıbası family started to use Antrepo No. 4 as the Istanbul Modern Museum to display their huge art collection. There are other important private art sponsors. The Koç holding runs the gallery ARTER, supports the *Istanbul Bienal*, and entertains plans for a new museum of contemporary art. The Sabancı family owns the Sakip Sabancı Museum, and the Elgiz family runs the Proje4L Museum for displaying its collection of Turkish and international art.

The *Istanbul Bienal* has slowly put the Republic of Turkey on the map of the global contemporary art world, propelled many artists into global contexts, and paved the way for the establishment of a genuine, globally oriented art scene in the city. It had a political context from the beginning, originally to present the Republic (after the trauma of the 1980s military coup d'état) as a country where contemporary art was produced in "consonance with global art trends, and that Istanbul was a candidate to become a center of the international art scene" (Madra 2011: 31). In the meantime it has become a mega-event trying to counter the rising political project of new, religion-oriented parties in Istanbul and Turkey. The ruling party, Adalet ve Kalkınma Partısı (Party for Justice and Development, AKP), represents the religious-conservative groups, many of whom are upwardly mobile, economically potent, and middle-class. The upper echelons of liberal secular powerful groups, however, are representatives of Turkey in international art circuits. IKSV also handles for the Turkish Republic's participation in the prestigious *Biennale di Venezia*.

The *Istanbul Bienal* has a budget of around €2 million (WHW 2009: 37). Most of it is in kind, such as free use of billboards and murals for advertisements, the use of public buildings, and permissions and promotions from the municipalities (IKSV 2013a: 162–63; Elif Obdan Gürkan, personal communication, September 16, 2011).

The *Istanbul Bienal* is an active member of the Biennial Foundation. Founded in the Netherlands, this umbrella organization of biennials has been active since 2009. In their (incomplete and evolving) *Directory of Biennials*, it

lists around 200 biennials (Biennial Foundation n.d.: 4). In the following, I shall first consider a general overview of contemporary art biennials. The second section will deal with a historical perspective of the *Istanbul Bienal* for its first two decades. This will be followed by an extended discussion of its last four editions. I shall end my considerations of the *Bienal* in examining it in the context of the city of Istanbul.

Biennials of contemporary art

Art theorist Irit Rogoff celebrates biennials as "linked peripheries" that "bypass the traditional centers of art and culture" (Rogoff 2009: 114). Furthermore, in the biennial context "world" is a dearly used reference as art biennials are often hyped as new worlds, even as possible utopias. Bige Örer, current director of the *Istanbul Bienal*, is no exception in that respect with her belief in art's power to change the world, to "transform the world we live in into a better place" (Örer 2011: 21). While this might or might not be true, in many biennials, artists have an opportunity to expose and to critically comment on the state of the world today, including their own disputed and difficult position in it. Biennials' most prominent curators aim at introducing new artists and their artworks in combination with more established positions.[1]

A more critical position, however, argues that the global culture of art biennials does not enhance an egalitarian space of reciprocal flows (Fillitz 2009: 116). Biennials thereby are conceived as global contact zones that highlight changing global relations (ibid.: 125). George Baker, in his *The Globalization of the False: A Response to Okwui Enwezor* (2010), sees biennials as the problem, not the solution. As many post–Second World War biennials "seem to emerge in locations of historical trauma," they obscure traumata rather than working through them. Because biennials are part of the official culture, they might be "tools to cover over ruptures" (ibid.: 450). In general, biennials could be seen as "expedient rituals of purification," which should purge a city or even a country of "the social realities of impurity, disorder and dirt" (Mörtenböck and Mooshammer 2008: 60). Some scholars also consider them as complying with neoliberal agendas, and emphasize their postinstitutional dimension, fulfilling post-Fordist demands of flexibility and immaterial working conditions. Characteristically, temporary contracts are a main organizational principle, which often entails structural amnesia, negation of the local context, superficiality, and lack of concentration (Gielen 2009: 16).

In contrast to such arguments, Vittoria Martini, who worked on the history of the *Biennale di Venezia*, argues that the "*founding narrative*" (2010: 13, italics of the author) needs to be centrally considered for the analysis. Each

biennial of contemporary art has a separate history, context, and goal. This coincides with observations that curators try to counter the increasing use of biennials by cities and regions for their own marketing, in putting political issues onto their artistic agendas (Seijdel 2009: 4). That too was the case of the *Istanbul Bienal*, but it created tensions with the state and the wider public (see below).

Fully congruent with the wave of the global spread of art biennials, Turkey had a vivid proliferation of such formats in the recent past. Besides those in Istanbul, Sinop, and Canakkale, biennials of contemporary art had been held in Adana, Ankara, Antakya, Izmir, and Mardin. Some of them occurred just for one or a few editions—yet, none of them seems to be active anymore. Considering the present-day overall threats contemporary art faces in the country, it is totally unclear whether further ones may be founded (Cultural Exchange).

The *Istanbul Bienal* 1987–2007: The "founding narrative" and a retrospective view

The first two *Istanbul Bienals* in 1987 and 1989 were directed and coordinated by Beral Madra, then already an experienced curator in Istanbul with international standing. These mega-events, titled *Contemporary Art in Traditional Places*, employed the structure of national presentations, and displayed in 1987 works of artists from eight and in 1989 twelve countries, with a large majority of contributions from Turkey. She emphasizes that these large exhibitions for the first time brought the Istanbul art scene into contact with the international art circuit, and thereby helped artists to gain access to other art scenes (Madra 2011: 31). Current phenomena of visual culture were introduced to society for the first time with these Biennales (ibid.: 35). More importantly, the artistic production in Turkey in the early 1980s had gained new momentum in terms of artistic identity and autonomy, and was showcased in these international exhibitions (ibid.). New art practices, like installations, were staged, and Madra recalls: "Turkish artists of the 1980s were still dealing with the remnants of the ideological polarization of the 1970s, but they felt compelled to close the gap between the West and local art forms" (ibid.). Therefore, the first *Istanbul Bienals* "placed not only Turkey, but also the post-Soviet region and the Middle East, on that seemingly inaccessible great map and changed their fate of remaining on the 'periphery'" (ibid.: 33).

Vasif Kortun curated the third *Istanbul Bienal* in 1992 (postponed for one year because of the Iraq-Kuwait war). Familiar with multicultural and postcolonial New York blockbuster shows of the 1980s, he started as curatorial assistant of the 1989 edition. Today, he is a major player in global art circuits, and a

"god-figure" of Turkish contemporary art. He recalls that after having seen the groundbreaking *Magiciens de la Terre* exhibition in Paris (1989), he wanted to create a response from Istanbul (Kortun 2011: 63). This *Bienal* edition was still organized in the form of national exhibitions. Under the theme *Production of Cultural Difference*, Kortun nevertheless reduced the proportion of Turkish artists, and assembled a large-scale international exhibition. He strengthened artistic relationships with Bulgaria, Romania, Russia, and Poland, and tried to disregard countries that participated just because they could afford it, like Switzerland and Germany (Kortun 2011: 65). Kortun also brought in curators from abroad. Addressing cultural difference through art from fifteen countries, he used the large old industrial building Feshane, the former national hat factory built in 1840, as single exhibition space. In the wake of the 1989 fall of the Berlin Wall, he found that "we had to establish new, normalized relationships among equals, not only for the 3rd Biennale but also for the future of the project" (ibid.).

René Block was artistic director of the fourth *Istanbul Bienal* in 1995. He was a major player in *documenta*, and had established galleries in Berlin and New York in the 1960s. Block has a long-standing professional involvement with art from Turkey. For this edition of *Istanbul Bienal*, he gave up the model of national presentations, and curated the show under the title *ORIENT/ ATION—The Vision of Art in a Paradoxical World*. As exhibition space, Block turned to one of the Antrepos on the Salıpazarı shore in Tophane. This area of the city has since gained much importance as a venue for contemporary art: the Istanbul Modern Museum and the Mimar Sinan Academy of Fine Arts are in the neighborhood, and new galleries have moved to the vicinity, establishing themselves in small alleys previously dominated by stores selling pumps, generators, and other mechanical devices.

Rosa Martinez was the general curator of the fifth *Istanbul Bienal* in 1997; as an independent curator, she had already directed a biennial in Barcelona. This edition, *On Life, Beauty, Translations and Other Difficulties,* had first a strong emphasis on women artists and the evolution of sexual identity (Martinez 2011: 95), and second on transcultural connections. As main venues, she used public spaces—the Haydarpaşa and Sirkeci train stations and the Atatürk Airport: these sites were conceived "as doorways to new identities" (Martinez 2011: 101). She programed other exhibitions in eminent buildings, such as the Hagia Eirene Museum and the Imperial Mint within the Topkapı Palace on the historical peninsula. Furthermore, artists and inhabitants in the Karanfilköy neighborhood collaborated to produce an event about the right to shelter. In the book published after the preliminary conference of the twelfth Biennale, *Istanbul'u hatırlamak—Remembering Istanbul* (2011), Martinez states that in Istanbul, "transnational models of capitalist consumption exist alongside the fundamentalist ideology of a mythical and essentialist past, while levels

of poverty only continue to increase" (Martinez 2011: 97). Martinez thus summarized how the urban conglomerate had developed toward increasingly difficult circumstances since her critical approach two decades ago.

Paolo Colombo was the general curator of the sixth *Istanbul Bienal* (1999), *The Passion and the Wave*. At that time he was director of a museum for contemporary art in Geneva (Switzerland). The title was inspired by a Greek/Turkish singer, whose name Dalgas is "wave" in Turkish, and "passion" in Greek. Colombo used space in the Dolmabahce Palace and various outdoor locations for the exhibitions. As the mega-event took place shortly after the devastating earthquake of 1999 in Izmit, the Biennale had a very late "go ahead" from the IKSV, and a cloud of grief left by the catastrophe deeply marked its overall experience. In this mood, selected artists donated works for auctions to raise money for the victims.

The title of the seventh Biennale edition (2001) was *Egofugal—Fugue from Ego for the Next Emergence*. Yuko Hasegawa, then director of a Japanese contemporary arts museum, had been appointed as general curator, and she later became artistic director of the Sharjah Biennale in 2013. Hasegawa contrasted what she considers the "three Ms" of the twentieth century—materialism, male domination, monetarism—with the "three Cs" of the twenty-first century—collective intelligence, coexistence, consciousness (Hasegawa 2011: 131–32). Her conclusion in 2011 was that Istanbul has a crucial position in global trends, "including, unfortunately, the cultural and political instability of many countries in Asia and the Middle East and the increasing turmoil over immigration policies throughout Europe" (ibid.: 143). These conditions make the *Istanbul Bienal* a very demanding venue for the artistic expression of criticism, resistance, and innovative approaches, but she addressed these in manifold ways within the exhibition spaces. There were several media installations where people could "see what others see" (ibid.: 133), and participatory art—such as a 4-screen projection in public space by Rirkrit Tiravanija, a "magic carpet" by Chris Burden, or the Cambalache Collective's exchange of goods with people in the streets.

General curator Dan Cameron selected for the eighth edition in 2003 the Ayasofya Müzesi (Hagia Sofia Museum), the Yerebatan Cistern, some public spaces, and again one of the Antrepo. As an American, the invasion of Iraq by US-led forces earlier in the same year had a huge impact upon him, and fundamentally influenced his curatorial work. He felt the obligation to "make my own opposition to American foreign policy on Iraq one of the key references in my investigation" (Cameron 2011: 155). This edition's theme thereafter was *Poetic Justice*, and raised issues of "unilateral justice" (ibid.), and Istanbul was projected to the center of such discussions. At the time of his commission for the *Istanbul Bienal*, Cameron was chief curator at the New Museum in New York.

In 2005 Vasif Kortun was again appointed for the Biennale's curatorship, this time in collaboration with Charles Esche, another internationally renowned curator. *Istanbul* was the vision for this edition. Encouraging deeper interactions between young, emerging artists and the metropolis, almost half of the exhibiting artists were invited beforehand to Istanbul on residency programs which were lasting up to six months. The curators endeavored to make sense of Istanbul's transformation processes as the city was "moving faster than the exhibition," since "all of the big spaces . . . were headed for privatization" (Kortun 2011: 173). Also, Esche and Kortun expressed harsh criticisms about art under current capitalism, which is allowing itself to become nothing more than a "harmless outlet for dissenting voices" (2007: 321–22). Taking the metropolis itself as theme and bringing in artists led to fruitful interaction; and as artists got a deeper impression of the city, their work became an important stepping-stone in their careers in combination with the growing prestige of the *Istanbul Bienal*.

Another internationally most renowned curator, Hou Hanru, was appointed as general curator for the tenth edition of 2007. Under the title *Not Only Possible, But Also Necessary: Optimism in the Age of Global War*, he "intended to reflect the complications of the city of Istanbul" (Hanru 2011: 187). With a strong focus on the general public, he used new venues: the Atatürk Kültür Merkezi on Taksim Square,[2] the Istanbul Manifaturacilar Carsısı (Istanbul Textile Traders' Market), and the Kadiköy Halk Egitim Merkezi (Public Education Center Kadiköy, on the Asian side of the city). These two latter sites thereby were used both for their original function and as exhibition space. The interactions between artists, exhibitions visitors, traders, employees, and the general public of the sites developed in sometimes unintended ways. Hanru in retrospect stresses the necessity for artists to "reconnect our artistic visions and practices with social realities" of a "locality in transformation" (ibid.: 197). This edition brought the Biennale to a new level of interaction: artists not only worked in and about the city, he instigated them to intensify their interactions with inhabitants, who might not have been interested in the arts before.

Recent *Istanbul Bienal* editions

The curators' collective *What, How and for Whom (WHW)* from Zagreb curated the eleventh *Istanbul Bienal* in 2009. Their theme was based on Berthold Brecht's *Denn wovon lebt der Mensch?* (From what does mankind live), and they implanted it onto Istanbul as *insan neyle yasar?* (What keeps mankind alive). The exhibitions were shown in Antrepo No. 3, in the Tütün *Deposu* (Tobacco Warehouse) in Tophane, and in the Feriköy Rum Okulu (Feriköy Greek School) in Sişli. In the guide and the text book, in an "effort to

peel away the Biennale's usual glossy surface" (WHW 2011: 213), *WHW* made the conditions of production transparent, as the *Istanbul Bienal*'s budget was broken down into its specific costs for curators, artists, and other ones.

The artworks on display had a strong focus on the Middle East, Central Asia, the Caucasus, and Eastern Europe (*WHW* 2011: 211), and problematized the "internationalization of the art world" as a "new set of unequal relationships" (ibid.). Gender issues, critiques of capitalism, war, and oppression were predominant themes. In the exhibition guide and the catalog this political art and the critical articles clashed with the spaces allotted to advertisements of large businesses, private enterprises, and mass media.

At the official opening, loud protesters criticized the curators for their "mock-communist" stance and their complicity with the sponsors. The area in front of the large ground floor hall at Antrepo No. 5 was packed with both protesters and visitors, while the cars of politicians and other honored guests were waved through the crowds every few minutes. The groups of dancing and singing students who protested the event by creative means (Koç mustaches, Turkcell hats) received much attention from visiting art globetrotters. Discussions about the Biennale were heated, and many young artists and students living and working in Istanbul refrained from visiting the Biennale as a form of protest against its elitist character. At a conference that was introducing the following Biennale in 2010, *Istanbul'u hatırlamak/Remembering Istanbul*, curators too criticized *WHW*'s openly communist stance. In their reaction, *WHW* insisted that exhibitions remain spaces allowing for interaction, and that they can be "valuable as a keeper of memory. Especially memories of possibilities that once existed and are still worth fighting for" (*WHW* 2011: 209)—a museum of transient utopias.

The following twelfth *Istanbul Bienal* in 2011 withdrew into art's so-called white cube. The curatorial team, Jens Hoffmann and Adriano Pedrosa, deliberately did not disclose their list of participating artists before the opening of their *Isımsız—Untitled*. They did not want "to attract viewers with celebrity names," but let the exhibition speak for itself (Hoffmann and Pedrosa's press conference, September 16, 2011). Hoffmann and Pedrosa structured the Biennale in five chapters after "Untitled" works of Felix Gonzales-Torres. The two sites, Antrepo No. 3 and 5 provided an intriguing exhibition architecture of walls—being at the same time open and closed. The sheer number of artworks in the confined spaces was blinding and virtually blocked out the urbanity outside—a definite goal of Hoffmann and Pedrosa. In their press conference and the Biennale guide, they distanced themselves from "exceedingly political" biennials of the past two decades, "in which aesthetic concerns have been given less consideration than the pressing political concerns of our time" (Hoffmann and Pedrosa 2011: 23). The two curators refused to engage in any discourse with Istanbul: consistent with the

ideology of the white cube, they attempted to avoid "competition with other visual stimulations, or unintended contextualizations" (ibid.: 25). Therefore, this Biennale lacked the sense of confrontation with the city and its problems. In a historical perspective, the mega-event was a clear counterpoint to *WHW*'s disputed show, and distanced itself from most earlier as well as the two following events.

Generally, the exhibition had a focus on artists from the Middle East and from Latin America. The show attracted 110,000 visitors between September and November 2011. More than 3,000 people were accredited for the preview and opening days, including about 700 national and international journalists: a nice increase compared to 2009, said Elif Obdan, *Istanbul Bienal* spokesperson to the international press (September 16, 2011).

"The public" was the focus of the 2013 edition under the title *Anne, ben barbar mıyım?/Mom, Am I Barbarian?* with the curatorship of Fulya Erdemci. She had been director of the Biennale from 1994 to 2000, and had repeatedly curated the Turkish Pavilion at the *Biennale di Venezia*. Erdemci planned to use many locations in public spaces for art, in order to investigate "the notion of the public domain as a political forum" (IKSV 2013b). Urban transformation was once again to be addressed by using vacant public buildings for the exhibitions, and "hall marks of current urbanism such as shopping malls, hotels and office-residential towers" for artistic interventions (ibid.). Erdemci aimed at creating a "space for the weakest ones and the most excluded" (ibid.), and also to put forms of democracy into discussion. For the first time in the history of the *Bienal*, admission became free of charge—a practice that later was kept for the next edition.

But as protest movements around Taksim Square and Gezi Park gained momentum several months before the thirteenth *Istanbul Bienal* was to open its doors in September 2013, Erdemci decided to pull back from public spaces. The *Istanbul Bienal* tried to come home to its host metropolis and to the controversial topics and burning problems of the present, but was overtaken by acute processes of actual protest, state repression, and new political constructions of "the public."

After having been artistic director of *documenta* 13 in 2012, Carolyn Christov-Bakargiev acted as general curator of the fourteenth edition of *Istanbul Bienal* in 2015. Her theme was *Tuzlu Su—Saltwater: A Theory of Thought Forms*, and projected the Biennale once again into various districts of the metropolis. Christov-Bakargiev conceived this mega-event for "the large We," the whole population of Greater Istanbul (press conference, Italyan Lisesi, September 2, 2015). The shows were widely distributed, and visitors had to spend much time on "saltwater," as Istanbul's oldest *hamam*, or spectacular sites on Büyükada (an island in the Marmara Sea) were included. The Biennale therefore required much walking from patrons, media, workers, and the general public. During its twelve weeks, there were 545,000 visitors at the thirty-six venues.

The *Istanbul Bienal* in its contexts

In its thirty years, *Istanbul Bienal* has interacted with transformations and transitions of the global contemporary art worlds, with the growing number of biennials worldwide, and with other such events in its own country. From small beginnings to the present-day mega-event and the so-accumulated prestige in international art world networks, the *Istanbul Bienal* has been from the start a project of secular-liberal powerful groups, wealthy family enterprises who could ensure the support by engaged artists and art professionals, much enthusiasm from those working with the cultural institution, and a growing compliance by Istanbul's emerging art public. Almost all directors and curators of the Biennale have addressed the socio-economic processes to which Istanbul had been subjected, whether selecting works of art in historical sites or in old industrial derelict buildings, by bringing artists in residence, or by making local protest a part of the show.

Ab initio the *Istanbul Bienal* was intended to educate the Turkish public in contemporary Turkish and international art. Üstüngel Inanc, a former public relations manager of the Biennale, recalls that the organizers of the first editions tried to make connections with a public that could not define what contemporary art is: "they thought of it only as 'galleries and paintings,' and we had to reach out to the public, we distributed flyers to tell people 'What is a biennial?'" The first editions were "modest attempts" attracting around 25,000 visitors. But in 2011, "The Biennale was mentioned in all tour guides," Inanc said, "therefore the Biennale's premises are crowded every weekend, and include many visitors from the cruise ships" (personal communication, Rampa Galeri, November 2011).

The *Istanbul Bienal* has paved the way for the favorable reception of contemporary art in Istanbul, for the establishment of numerous new galleries, and for the private collection of contemporary art, which has become fashionable among the Istanbul upper echelons: "The atmosphere for artists is open, everything develops, and the close side-by-side of the positive and the negative in the city makes for great creativity and ample opportunities for the artists to produce. Artists are on their way in international arts realms, come back and work here; the same is true for the collectors. There were several sales of Turkish Contemporary in London, and the Turkish collectors went to stock up on art. And, everyone can be a collector: you can buy a work from a student, and maybe, in five or ten years, s/he might be a big one!" (personal communication, Elif Obdan, November 24, 2011).

Criticisms of the *Istanbul Bienal* include, as Charlotte Bydler (2004) points out, that local artists complained to be neglected, in contrast to artists and curators from abroad who were treated with "exaggerated respect" (ibid.:

130). Another one concerns the Biennale's budget that is considered to suck up the sparse public support for art. Or, as Ezgi Serdar, an Istanbul artist, expresses: "There is a huge amount of expensive advertising for the biennials, but common Istanbulians are not very attracted, and nobody from the *gecekondu* [lit. built over night; informal building areas] can come because of the high cost of public transportation, and also because people have to work" (personal communication, Beyoğlu, September 2009).

These other positions, however, nowadays express the contrasts more clearly and openly. In 2010 in Tophane,[3] a district with an increasing number of art galleries, locals protested and attacked art lovers, who hung out on the streets, with frozen oranges. This clash of "lifestyles" is also an expression of fear from the very real threat brought about by gentrification. But events as the 2016 violent censorship at the *Contemporary Istanbul* art fair are seismographically registered in the art press and the art markets, and might devalue Istanbul's position as a hub for art. The *Istanbul Bienal* brought galleries, art fairs, and a growing art collectors' scene to Istanbul, and has important direct and indirect connections with city developers. Artists and curators have repeatedly addressed issues of its host city as well as global problems; they have not been able to slow down the rapid transformations of urban society. Exhibiting in spaces that are still in use, moreover, points to the curators' aims for much-needed interaction and re-connection with local realities: with the public, the common people. In a metropolis charged with economic and social competition, social change, and with a violent recent history of bombings and assassinations, where the common and the public are under scrutiny, can art contribute to bridge the gap between social groups, or does it solely guard the threshold of division? From the first editions, the clefts in Istanbul's urban society emerged more clearly and widened, and the public, or "large We" (Christov-Bakargiev) of Istanbul is increasingly fragmented.

Conclusion

Discussing aspects of the *Istanbul Bienal's* history, and connecting it to the political and socio-economic contexts of the metropolis, leads to an ambiguous picture. There is the eminent contrast between differing political positions: not the ruling party (religious-conservative), but the powerful, economically strong family-owned holdings support contemporary art, also in global scenes. These latter, for instance, take care of Turkey's national presentation as at the *Biennale di Venezia*. As public funding for contemporary art is almost nonexistent, the IKSV and other private sponsors are by and large controlling contemporary art creation.

Another ambiguity is about the criticisms the Biennale raises, especially from leftist and anti-elite groups. Their objections to the Biennale's "mock-critical" positions bring many students and people from Istanbul art world to refrain from attending the mega-event. A string of countermovements to the Biennale have emerged, and view those connected to the Biennale as complicit with the capitalist art markets and with globally dominant economic circles. This actually becomes apparent with the Biennale's complicity with large investors and city developers. The Biennale's exhibitions have often cast light on the urban transformations due to their projects—the decline of former industrial production, and the development from prevalent industrial production to a consumer-, trade-, and service-based economy.

The free admission to the various venues too may be seen as an example of such a double bind. It contrasts with the ubiquitous omnipresence of security guards. The intention behind the "large We"—to demonstrate the Biennale's openness, the free and warm welcoming atmosphere to local and global visitors—clashes with an impression of a city under siege, where international tourists, cosmopolitan art world members, and the global press must be shielded and protected from possible attacks. Such attacks tend to develop at large against galleries, art patrons, or art fairs. Artworks too are not exempt from them, as they often have to be withdrawn or covered due to presumable heresy or antinational feelings. Under pressure from various sides, curators and art world members therefore decide to withdraw. Such was the case for the Biennale in 2013: confronted with state repression and a newly emerging public hostility, it decided to avoid public spaces and to express its position by withdrawing into art's white cubes. It seems that at present, the oppositions between the "urban other" and the idealistically evoked "large We" have disabled the Biennale's ability to create "new worlds."

Acknowledgments

People who helped with this chapter are Ezgi Serdar, artist and graphic designer in Istanbul; Üstüngel Inanc, public relations manager, Rampa gallery Istanbul; Elif Obdan Gürkan, who is in charge of international media for IKSV; Zeynep Seyhun and Duygu Su Pur from the Biennale team at IKSV; and Muzaffer Hasaltay, Vienna.

2.3

Concepts of "Art World" and the Particularity of the Biennale of Dakar

Thomas Fillitz

Introduction: Coping with art theoretical concepts

Dakar's art world professionals unanimously agree that the foundation of the Biennale of Dakar, *Dak'Art*, was the consequence of a long-lasting lobbying of Senegalese visual artists from the mid-1980s on. President Abdou Diouf finally announced its foundation in 1989, and its first edition took place in 1992, as an international biennial. Similar to the *Biennale di Venezia*, embassies and cultural institutes were approached for nominating their artists for this event. Indeed, artists from Africa, the Americas, Asia, and Europe participated in this edition. Yet, the goal was not achieved, as the event's evaluation concluded. Many of the countries invited had not responded, there was no real selection, and in retrospect, the production of a mere copy of the *Biennale di Venezia* did not seem rewarding.

The Senegalese state decided in 1993 to uphold the Biennale project while changing its scope. The Biennale became the *Biennale de l'art africain contemporain* (Biennale of contemporary African art), with its first edition being held in 1996. From then on, a secretary general would direct the Biennale's affairs, supported by a committee of orientation responsible for organizational matters, and a committee of selection for choosing the works of art for the main venue, the "international exhibition." The focus on contemporary African

art implied that only artists with the citizenship of an African state, or artists from the African diaspora, were eligible for the Biennale's core venue.

The Biennale was, and still is, a suborganization of the Ministry of Culture. The secretary general is a civil servant of the ministry, and the minister appoints the members of the committee of orientation. In agreement with the committee of orientation, the secretary general then nominates the members of the selection committee. Until 2006, the half of the latter's membership consisted of African art specialists, with the remaining half from Europe and/ or North America. Above the Ministry of Culture, however, is the president of the Republic, the Biennale's existence being by and large dependent upon his benevolence.

This brief overview of the Biennale of Dakar shows different actors and institutions as central to its foundation, its organization, and the selection of artists and their works. It highlights what Marcus and Myers claim as the object of study of a critical anthropology of art: the art world (Marcus and Myers 1995: 1). They formulate a main thesis for anthropology's concern with such a research project: "In this regard, the very specific anthropological critique would concern the art world's *manner* of assimilating, incorporating, or making its own cross-cultural difference" (ibid.: 33, italics by the authors).

Yet, the central question imposes itself: Which concept of art world is at stake? In principle, there are two approaches to start with: the art theoretical of Danto (1964)[1] and the sociological of Becker (1982). Reflecting on Andy Warhol's *Brillo Boxes*, Danto concluded that for considering them as art and not as products of consumer culture, one needs first to be acquainted with the narrative of occidental art history, and second, as a work of art they belong to the autonomous field of art, and not to everyday life. The art world is therefore universal—a unique universe of artworks defined by art historians and art theorists according to occidental art history.

Howard Becker (1982) reformulated this notion from a sociological perspective. An art world involves the cooperation of all people who contribute to the production, dissemination, and consumption of the work of art, thus displacing the study from the work and from the artist. Becker conceives the notion in terms of interactions between all actors and institutions that are involved in the production, distribution, and consumption of an artwork. Art worlds further are locally bounded and plural, in as far as each art has its own art world.

This chapter is an engagement to exchanging between art history, art theory, and anthropology regarding the very notion of "art world." My discussion will rely on three examples related to my ethnographic research on the Biennale of Dakar. These latter will be examined in conjunction with concepts of art world. The question therefore is which concept enables us to conceive the particularity of the Biennale of Dakar within the global art biennials network.

The first section will deal with the foundation and the general structure of the Biennale on the basis of Becker's theory. The second section deals with selection committees and their decisions, with critiques expressed by local artists and art world professionals. These ethnographic data will be related to Bydler's conceptualization (2004) and Danto's reconsiderations of the art world (1997). The third section will introduce two types of hierarchies: First, statistics of selected artists according to citizenship illustrate preferential connections of the cultural institution *Dak'Art*; second, the awarding of the main prize of the Biennale turns the attention to leading art media. These facts will be discussed in the light of Stallabrass's (2004) concept of the embeddedness of the art market within the art world. Within this context, I will further apply Groys's concept. Groys insists on art's autonomy, and relegates hierarchies, as can be seen in market sales, to relations of power (2008a). In the fourth and final section I shall consider *Dak'Art* within the global art world's network. This will be related to two radical positions which altogether reject the notion of "the" art world in the singular: the art world of internationally most renowned curator and art theorist Enwezor (2002, 2009) and that of art historian Belting (2013a, b).

Their concepts support the main argument of this chapter. The plurality of interconnected art worlds implies conceiving the present-day global art worlds network as characterized by the equality of locally and regionally normative contemporary art discourses. I shall argue that such a conceptualization precisely allows an understanding of the particularity of the Biennale's discourses. Hence, this is another facet of an art-related cultural criticism that confronts hegemonic discourses as productions of difference.

The foundation and structure of Dak'Art

Regarding the foundation and overall structure of the Biennale of Dakar, Becker's concept of the art world appears appropriate for examining the different interests at stake; that is, the interests of the lobbying local artists, of the state, and of the Biennale.

The artists principally articulated their concern around the topic of art itself, and further argued that art is a central field of culture for promoting Senegal's international recognition. They accordingly recalled that the president was the protector of the arts, as first president Léopold Sédar Senghor understood it, and that the state's duty as patron of arts and culture was inscribed in Senegal's constitution (Nzewi 2013: 123). Behind this official discourse, however, was another one. The many artists of this generation I talked to insisted that their stance was the institutionalization of a truly international

biennial, as the edition of 1992. One can consider this as a discourse of art for art's sake, insofar as these artists searched for a truly international platform, within which they could compare their artistic achievements with those of their peers from other regions of the world. They were interested in exchanging and being challenged, in order to reflect the possible new trajectories of their artistic practices. For them, the reframing of the Biennale on contemporary African art was an illicit appropriation of the cultural institution by the state.

The second concern of these artists for the foundation of a biennial was the visibility of their artistic achievements. In 1988, the Musée Dynamique, founded in 1966 for housing the collection of Senegalese modern art and international art exhibitions,[2] had once and for all been allocated to Senegal's Supreme Court; galleries were at the time nearly inexistent; and the main opportunity for presenting their artworks was the yearly national salons, organized by the National Association of Senegalese Visual Artists (ANAPS, founded in 1985 [Harney 2004: 147]). According to these artists, a biennial was the timely framework for an international exhibition stage.

From the outset, the state was disinterested in the artists' discourses of art for art's sake. The Biennale is important to the state as a showcase on the international stage for Senegal's cultural politics, and for its commitment to freedom and democracy (Nzewi 2013: 19). In this context, state officials are highlighting today the continuity between the Biennale and the *Premier Festival Mondial des Arts Nègres* (1966), the major cultural project of President Léopold Sédar Senghor. Ivorian art theorist and curator Yacouba Konaté, general curator of the 2006 edition, rejects this continuity, insofar as the Biennale searches the international art challenge, while Senghor's festival was inscribed within discourses related to independence and the pan-Africanism of the time (Konaté 2009: 38).

By restructuring the Biennale as exclusively focusing on contemporary African art, the institution would visualize Senegal's leading cultural position within the continent, and would promote the image of Dakar as the African cultural node—an argument I often heard. From such a vantage, it becomes understandable why the state insisted on maintaining the Biennale as a sub-institution of the Ministry of Culture.[3] Artists and matters of artistic creation were of lesser importance. These achievements were most visible in 1992 and were heavily criticized by my artist-interlocutors: state officials were at the front stage at all events of the Biennale, whereas they were relegated to a secondary level. I could observe similar situations at the various grand openings I attended: on stage the president of the Republic and his entourage, the secretary general of the Biennale, and the president of the committee of orientation; in the ceremony hall, state officials, ambassadors, and Senegalese personalities were seated in the front rows, artists in the back.

The Biennale has several tasks to fulfill: It has to, among others, keep the dialogue with the local artists; it has to structure its unique position within the

global art biennials network; it has to promote art world actors and support art education; and it has to comply with the state's cultural-political interests. The Biennale thereafter is stuck between artistic and social, economic, and political objectives. Regarding the artistic field, the Biennale has to provide an image of recent artistic trends. But it has to do so in considering art creations of artists from multiple regions of Africa and its diaspora, and not only within local discourses. From the Biennale's side, the decision to concentrate on contemporary African art is a fundamental idea for clearly positioning itself within the global biennials network. *Dak'Art* indeed is the principal stage for contemporary African art.

The Biennale thus requires us to contemplate what is going on within the global art biennials network, and to cope with such international art languages. Here, the Biennale joins the artists' intention of "art for art's sake" discourses and challenges, but at different scales. It deals with these intentions in its entanglement with those in other regions of Africa, and with internationally acknowledged art practices (see next section).

This wider context is important to the state for using the Biennale for its international cultural image. When President *Maître* Abdoulaye Wade stated during his opening speech of the 2010 edition "I want more Diaspora in the Biennale," he had his eye on improving Senegal's position as African cultural leader, as well as his own. Yet, the cultural institution further requires improving local art-related fields, like the art market, art education, or to raise the interest in contemporary art among the Senegalese population (see below)—that is, it has to comply with political, economic, and social duties. These are the major fields on the basis of which the state would evaluate the Biennale's performance.

This presentation of complementing and conflicting intentions around *Dak'Art* explicitly shows the major shortcomings of Becker's sociological theory. Both the Biennale and the artists are most interested in art discourses, in the art media (for instance painting, sculpture, installation, video), and in the quality of the artworks. Their topic is the production of art as a challenging, creative process of representation.

Discourses of art: Selections and critical voices

Dak'Art has a special procedure for exhibiting artworks within its "international exhibition." Artists have to apply with a personal dossier, documenting among other things their artworks, their exhibitions, and providing some art critiques on their work. These files are the basis for selection procedures. Three formats had been applied regarding the decisive role of selection committees. Between

1996 and 2004, they were large in number (up to sixteen), half of them being African experts, and the other half European and/or North American ones. For the edition of 2006, the system was changed insofar as an African expert, Yacouba Konaté, was for the first time nominated as general curator, and was free to invite his curatorial team. For the editions of 2010, 2012, and 2014, selection committees were small (three to four members), and only experts with the citizenship of an African country, wherever they were living, were eligible.

From the Biennale's side, the choice for inviting non-African experts to selection committees was clear. First secretary general Rémi Sagna told me that the Biennale required these experts in order to guarantee an international quality. These experts would contribute to a better visibility of the cultural institution within the global art biennials network. By appointing an internationally renowned curator as the committee's president, this objective was further strengthened, a strategy that was applied between 1998 and 2004.[4]

Yet, this strategy regarding the selection practices was contested. According to local artists and art world members, many of the non-African experts were not acquainted with the history of modern/contemporary art in Africa. No wonder that an African essence still featured among the criteria in 2004. Non-African experts largely relied in their decisions on their knowledge of European/North American contemporary art discourses. One of the most prominent local specialists reported to me that the president of the 1998 selection committee even went as far as requesting to reopen the selection procedure shortly before the opening of the Biennale. He suddenly argued that it would not match international European/North American standards, and would ruin his *renommée*. The selection of the 2000 edition elicited huge protests as the committee's president, James Elliott, proclaimed that painting was over, and installation art was the new leading art medium. Installation art was practiced in the Dakar art world from the late 1960s on, by the art group *Agit-Art* for instance. The scandal, as some interlocutors referred to it, was on the one hand this marginalization of painting, which is the main art medium in the *sous-région* nowadays. On the other, these installations at *Dak'Art* 2000 introduced new media of information technologies. Senegalese art historian Abdou Sylla therefore speaks of a "radical rupture" vis-à-vis former local forms of installation art (Sylla 2011).

Further, local artists criticized the intensified inclusion of artists from the diaspora. They had been lobbying for the Biennale, and now they were largely unconsidered in selections. They also argued that artists from the diaspora had little to do with the contemporary art that was practiced in African sites. These latter were much more influenced in their practices by international art discourses, and their peers in Europe or North America, and they had access to art media resources which artists in Africa did not. Characteristically, artists living in the diaspora had created these new forms of installation art.

The Biennale reacted to such criticism by turning toward African expertise, first in 2006, and later from 2010 onward. Local art world professionals agree that the most successful edition was that of 2006. It too was the largest Biennale, showing more than 160 artists, their average number being between forty and seventy. Yacouba Konaté and his team actually decided for a larger concept—of not only focusing on the so-called newest art trends, but including also perspectives from the history of modern African art. It thereafter was a well-balanced mix of older achievements and newer ones, between various art media, and artists from many regions including the African diaspora.

A major break occurred with the edition of 2010 which suffered significantly from huge budget cuts dictated by the state. The selection committee abrogated any African essence as criterion, while rejecting altogether the occidental art historical perspective. It favored painting as art medium, and declared as eligible only artists of the younger generation who had not yet been chosen for the "international exhibition." The older generation of local artists appreciated the re-appraisal of painting, but not their exclusion, while the younger artists rather critiqued the preferential art medium to the detriment of newer ones. In 2012 and 2014 the trajectory of a more international dimension of selected artworks was enhanced. The differentiation between artists of the diaspora or artists living in an African country lost importance, and various forms of installation art became more prominent. In an overall perspective of the Biennale's editions two lines of argument may be distinguished in respect to the production of images of contemporary African art: (a) Dakar's local art world discourses versus the impact of occidental art history's ones, concomitant with influences of internationally dominant art discourses, and (b) the art media that were privileged.

Regarding the first argument, Charlotte Bydler's conceptualization seems rewarding. For the contemporary art world, Bydler notes that Danto's universalizing discourse is in practice generally broken down into national art world narratives. These national art worlds are structured according to specific, hierarchically organized networks: following World System theory Bydler speaks of core, periphery, and semi-periphery art world networks (Bydler 2004: 181–95). On the basis of her insights, the descriptions of the Biennale's strive for showing newest trends of contemporary African art, and the so-connected debates may be viewed as following. Selections would appear as considerations from the core art world network (the Western European/North American), complemented with those of a periphery network (various local African art worlds), whereas critical voices are expressed from a specific national one, Dakar's art world.

The second critical line refers to the art media, and the inclusion of multiple ones in the Biennale's "international exhibition." In this respect, I would like to draw on Danto's reformulation of the art world in his *After the End of Art*

(1997). Still reflecting changes in art practices in New York, Danto hypothesizes the rise of a "post-historical art" from the 1970s on. Applying the notion of "post-historical art" as a means of periodization, a missing stylistic unity characterizes this present-day contemporary art production. Hence, the former grand narrative has come to an end. Each artwork thereafter requires to be understood within its multiple contexts—its causes, meanings, connections, and art media (Danto 1997). This absence of stylistic unity may be seen in *Dak'Art* (after 2000, and more so after 2010) as passing over any national or regional narrative for the image of the "international exhibition," its privilege of a multiplicity of art media, the related considerations of the younger generation of artists, as well as the impact of artists of the diaspora. If the lobbying artists requested the Biennale as a format for challenging their art achievements, and for exchanging at an international level, by means of the various selection committees the cultural institution transfers these claims toward displaying the most advanced, as well as contradictory, trends of contemporary African art.

Bydler's conceptualization of hierarchical art world networks as well as Danto's freedom of formal art practices, nevertheless raise further questions. On which grounds are these hierarchies constituted, and what about the privileging of installation arts?

Artists, art media, and the production of hierarchies

Although citizenship of artists is no criterion for selection, the Biennale provides statistics about the artists' citizenship, or about their African origin. Considering the officially published statistics as well as the catalog of the "international exhibition," artists from forty-one countries have been selected between 1996 and 2014.

Yet, these statistics need to be carefully understood, in as far as they do not provide information about where the artists are living and working. In only a few cases, artists either refused to provide such information (in 2000) or ticked "Diaspora" (in 2006, 2008, and 2014). Some selection committees have reacted to the problematic specification of the artists' citizenships or their claims of diaspora: the selection committee of 2010 clearly expressed as criterion "artists with citizenship from an African country wherever they are living," as one of the curators told me. In 2014, the committee refrained from any mention of citizenship in the "international exhibition," given that many artists were not living in their countries of birth, or had dual-citizenship.

Tang (2011) problematizes these kinds of statistics, and views them as strategies of biennials for marketing and exploiting these affiliations: "As artists are largely identified in press material by their place of birth rather than that of residence, this arguably allows biennale marketing to exploit their identities" (ibid.: 81). In the case of the Biennale of Dakar, statistics obviously document the African reach of the "international exhibition." These statistics also unravel another aspect. There is an overall consideration on artists from Francophone countries, artists from Anglophone countries being mostly chosen from South Africa and Nigeria, whereas artists from East and Central Africa are marginal. The Francophone dominance is even more acute if one looks at the most important prize, the *Grand Prix du Chef de l'État/Grand Prix Léopold Sédar Senghor*. Only once, in 2014, was a non-Francophone artist selected, the Nigerian Olu Amoda sharing the prize with the Algerian Driss Ouadahi.

This prize, furthermore, shows another aspect, namely that from 2000 on—with the exception of 2014—only installation artworks had been selected. Again, this coincides with the "international exhibition," where new media such as installation art, video, and photography dominate from 2000 on. How to explain the favoring of Francophone art worlds and of a particular art medium to the detriment of other African art worlds and other art media? Does this imply in both fields the conscious production of hierarchies of art creation? May these two phenomena be understood as a contemporary trend toward constraining the diversity of art creation?

Considering the notion of "art world" in the singular, art historian Julian Stallabrass conceives two forces within the art world for explaining such phenomena: the diversity of artistic practices, and the uniformity produced by the art market, again in the singular. This multitude of artistic practices is assured without economic pressures, and comprises the artists' freedom to experiment with art media and matters of representation, enabling a "hybrid diversity of art forms" (Stallabrass 2004: 34). Yet, Stallabrass conceives the art market as integral to the art world, and brings in the logic of global capitalism. Hence, it operates as neutralizing this diversity, transforming this multiplicity of artistic creativity into uniformity. The art world accordingly stages these artworks to "international prominence" (ibid.: 71). In doing so, the art market consolidates the present North American hegemony of the art world (ibid.: 72).

In considering the art market as fundamentally structuring the art world, it indeed seems difficult to apply Stallabrass's concept to the ethnographic example of the Biennale. First, the global art world is shaped less by North American hegemonies, but more so by present global capital. That approach rather addresses mechanisms of this universalized art world for including or excluding artworks, and this is the topic of research of the transnational

transfer of artworks.[5] Second, this raises the question of how far this global art market, or the local one, interferes into the Biennale's agenda.

It became obvious that beginning with the edition of 2000, selections have favored forms of installation art. Is this due to decisions of the market, or of leading curatorship? Three actors are of interest: the roles of gallerists; of collectors, for raising the value of their artists if selected; and of curators, for their international standing. Gallerists and collectors are included in the structuring of the various editions of the Biennale. One finds them for each edition among the members of the committees of orientation, but this latter one has nothing to do with the selection process. Gallerists and collectors, however, also act in the committees of selection. Those I talked to actually insisted that they would not combine both roles. Two gallerists emphasized that, as members of the curatorial team, their task is different from the business of their galleries. Working for the Biennale involves complying with the objectives of *Dak'Art*, as well as with the criteria for selection. The business of the gallery work is different: it requires a clear, characteristic program, and it demands a long-term perspective. Regarding the influence of collectors, a prominent Senegalese collector even invited me in 2012 to visit his collection. He wanted me to see that his curatorial activity was different from his collecting one. His collection of modern Senegalese artists truly was very different to the artworks he had helped to select. According to him, the work for the Biennale required judgments on the basis of the knowledge of contemporary African art, and by applying the criteria the committee had agreed upon. His collection in contrast depends on his taste, his personal interests, and his relationships with artists.

Insofar as market interests may not explain the preponderance of installation art for *Dak'Art*, Stallabrass's conceptualization is unsatisfactory, or at least too generic. This choice needs to be understood as belonging to dominant international art languages of art specialists, who consider it as the present-day leading art form: it unfolds social, cultural, and political criticism by means of the images of everyday life the artist selects and combines (Groys 2008a).[6] In other words, it corresponds to this language's overall definition of contemporary art, art that is "truly an art *of* the world," and "comes *from* the whole world" (Smith 2011: 8; italics by the author).

Regarding the production of hierarchies, such as the preferential connections to Francophone art worlds, Groys's theory of the art world (2008b) seems more revealing. Against art discourses influenced by art market interests, Groys reminds us of fields where art is not subsumed under market rules, such as biennials (ibid.: 9). He therefore differentiates between art world and art market, and clearly takes an unequivocal stand for the autonomy of art. Consequently, the art world "should be seen as the socially codified manifestation of the fundamental equality between all visual forms, objects and media" (ibid.: 14). Any hierarchy between pictures, that

is any aesthetic judgment, is connected to external forces that need to be examined (ibid.: 15). The "equal aesthetic rights for all artworks" (ibid.: 13–14) are constitutive of the autonomy of art, and of the rejection of any *a priori* production of hierarchy. This too implies acknowledging today's pluralism of contemporary art.

Although Groys argues within the framework of the neglect of former socialist avant-garde art in the West European art world, his thesis of the equality of all artworks is as valid for contemporary African art. Regarding the preferential consideration of Francophone artists within the Biennale of Dakar, Groys's approach enables us to explain it in the context of Senegalese cultural politics, and less as a rejection of art practices from other African art worlds. Former secretary general Rémi Sagna confirms this, as he views this issue as a matter of being socioculturally (and historically) closer to each other, of being better informed about each other.

In an overall perspective, Groys's theory opens up possibilities to examine artistic practices beyond *a priori* hierarchies, thereby focusing on the artworks' potentials for cultural criticism. It also allows us to study inequalities between works of art as products of other strategies, such as those of the West European/North American hegemonic art market, or of dominant international art languages. The plurality of contemporary art, however, is not an exclusive characteristic of the art world, identified with the European/North American one. Indeed, it also characterizes the multiple, specific discourses and art practices in different centers, as in Dakar with its Biennale. The art theoretical concept of the art world in the singular thereafter requires a critical re-assessment.

Dak'Art within the global art worlds network

In the context of the proliferation of art biennials and the constitution of the global biennials network, *Dak'Art* may be related to the second wave that was spreading around the world. This was the period during which the Biennial of Cairo was founded in 1984, and in 1985 the Biennale of Bantu art (CICIBA). Shortly after Dakar came the Johannesburg Biennial in 1995—the City Council turned it down during the second edition of 1997. The third wave of the foundation of biennials started around the 2000s, manifesting itself in Africa with biennials in multiple centers, such as the East Africa Art Biennale (EASTAFAB) in Dar-es-Salaam (founded in 2003), the Marrakesh Biennale (2005), and the Triennial of Luanda (2005–7).

Yet, the Biennale of Dakar continues to consider itself the Biennale par excellence dedicated to contemporary African art. In the previous sections, I

aimed at showing that this latter category is subject to negotiations with each edition between artists, the selection committees, art world(s) professionals, and the art-interested public. At stake are the "equal aesthetic rights for all artworks" (Groys 2008a: 13–14); that is, out of which art discourses the notion is considered. In an encompassing perspective, one sees an African expertise that is entangled within wider international (global) art discourses. The African expertise hereby refers to the knowledge of the history of modern African art and contemporary art practices in the various centers. It too consists of altogether rejecting occidental art historical narratives as validating the quality of artworks of African artists, or of artists of the African diaspora.

The Biennale being moored in Dakar, the African expertise too was time and again challenged by local art discourses, that is, by the history of modern art in Dakar. From that gaze, it raised the question about which forms of art are possible, or desired. While there is largely agreement in rejecting the valuation of their artworks from an un-reflected occidental art historical perspective, other more nuanced critiques are about selecting works of art which had little to do with local art practices, either in the art medium, but more so the themes of representation. The point worth emphasizing is not that they declined these works of art as their characteristic of art, but rather as not fitting and reflecting the local cultural contexts. The critique of installation art is not against this medium per se, but against the production of hierarchies—marginalizing painting, hence applying another universalizing notion of contemporary art.

The particular position of DakʾArt within this new constellation of a global art biennials network, the Biennale's role as art flagship in Dakar, and the locally characteristic art discourses this cultural institution entails, are all aspects that highlight a changing structure of what is commonly referred to as "the" global art world. But even this latter notion insufficiently takes into account the fundamental differences between such locally situated discourses. Two art theoretical positions challenge this universal dimension, and propose a radical re-conceptualization of the concept of art world: that of internationally renowned curator and art theorist Okwui Enwezor, and that of prominent art historian Hans Belting and his colleagues of the "Global Art and the Museum" project.[7] Both see a new condition of present-day contemporary art in times of globalization, which cannot be integrated within any unitary, universal grand field, such as the global art world.

Enwezor considers that practices of contemporary art from diverse regions of the world are being acknowledged nowadays; not that these practices have recently emerged, but they have now been recognized within dominant art discourses, and grand exhibitions in Europe and North America have been organized accordingly. Enwezor thus conceptualizes an "off-center principle, namely the multifocal, multilocal, heterotemporal, and dispersed structures around which contemporary art is often organized and convened" (Enwezor

2009: 38). Off-centers are in opposition to any hierarchies produced from a specific site; they rather are conceived as "the simultaneous existence of multiple centers" (ibid.: 38). Indeed, Enwezor emphasizes pluralism and equality between them, each producing "counter-hegemonic/counter-normative" gazes, and searching for "new relations of power and cultural translations" (Enwezor 2002: 56, 59).

Belting's reformulation of the concept of art world is based upon his theory of global art (see van der Grijp and Fillitz in this book). Global art is a postcolonial approach to contemporary art practices, insofar as it considers the category from the vantage of the specific centers where it is produced, and as it is including these different, worldwide creations as equal within its scope (Belting 2013a: 178).[8] Belting also posits that the "last remaining stronghold of the Western art concept was the notion of an art world in the singular which survives even today as the belief in a 'global art world,' again in the singular" (Belting 2013b: 247). Belting argues for a contemporary use of the notion in the plural on three points: (a) the plurality of contemporary art practices in various regions of the world (as theorized with the concept of global art), for long altogether separated by dominant discourses of the European/North American art world, or organized according to a center-periphery mapping; (b) the rise of museums of contemporary art in many places all around the world: they are organized according to different local and regional histories, have audiences of their own, and may by no means conform to European/North American images of such a type of institution; (c) one further sees curators and art specialists from these regions taking a leading stance in the structuration of these collections. Hence, Belting concludes that these new art worlds' evidence (among other biennials) calls for differentiation, "for breaking down the global panorama . . . into smaller units with a geographical or cultural profile of their own" (ibid.: 254).

Both Enwezor's "off-center-principle," and Belting's plurality of art worlds differ from sociological and anthropological considerations of the plurality of art worlds. Their concepts are a radical critique and reformulation of universalizing discourses of art. For sure, one needs to acknowledge that there are anthropological contributions in this field, such as the volume of Thomas and Losche (1999) on art in Australia, or the one of Nakamura, Perkins, and Krischer (2013) on art in Asia. Yet, these latter do not engage with the concepts of art world in the "new world order" of art (Vogel 2013).

The plurality of art worlds enables us to convey the full meaning of Biennale of Dakar from the situated gaze of the Dakar art world. This focus reveals the specificity of the local art world, both of the understanding of the artworks, and the production of the image of the "international exhibition." Yet, this local art world is not a separated, bounded entity. *Dak'Art* clearly reveals interconnections with international debates. This relates as much to

the selections of artworks for the Biennale, as to the exchanges artists are seeking, particularly for reflecting on new art media and techniques for artistic representation. This implies examining the nature of interconnections with the global art worlds network from Dakar's perspective, and not out of European/ North American art discourses.

Conclusion

The central question of this chapter was about the notion of art world as object of study of a critical anthropology of art (Marcus and Myers 1995: 1). This chapter engages with art theoretical debates, insofar as it studies ethnographic aspects of the Biennale of Dakar foremost in relationship to concepts of art world.

Theoretical considerations of the notion of "art world" started with one universal art world, determined by the occidental art historical narrative. From an anthropological perspective, the concept of one globally encompassing art world, as embedded within universalizing art discourses, does not make sense (see Fillitz 2013). Anthropology's insights rely on its methodology of ethnographic fieldwork, and aim at explaining artworks and cultural institutions (like biennials) out of its locally situated social interactions (see Phillips 2005).

Two major variations to the art world approach have been highlighted: Bydler's re-conceptualization of largely national art worlds, thereby producing hierarchies between art world networks, and Stallabrass's concept, according to which the art market is determining the art world. Following the logic of global capital, the market neutralizes the assumption of the freedom and diversity of artistic practices. Hence, both these considerations operate with the *a priori* hierarchy of hegemonic art world discourses. Within such a conceptual framework, the Biennale of Dakar could only be studied as a cultural institution of a peripheral art world. One possible consequence thereafter would be to view it as a copy of the European biennial model, and not as a particular art institution, as its history suggests.

More revealing is Groys's discussion of the art world. He argues for an art world understanding that is founded on the autonomy of art, implying the equality of all artworks. This is a precondition for the artwork's potential for cultural criticism, an aspect well central to Marcus's and Myers's critical anthropology of art (Marcus and Myers 1995: 1–2). He thus detaches the art market from the art world, the production of hierarchies being not a matter of art creation, but being due to social, cultural, economic, and political inequalities. This concept allows for better understanding *Dak'Art* as a specific cultural institution, equal to other institutions of similar format, and explaining

the hierarchies produced within the cultural institution as relating to Senegal's preferential cultural politics.

Nevertheless, the equality of all artworks requires a further adjustment. Normative art discourses around the Biennale of Dakar cannot be included within an overall global one. Both Enwezor's concept of off-centers (2009), and Belting's pluralism of art worlds (2013a, b) emphasize that within a present postcolonial framework, contemporary art has to be examined out of its locally moored conceptualizations. Instead of speaking of the global art world for today's new art order, we are instead confronted with a global art worlds network, that is, a plurality of interconnected art worlds. As a consequence, the specificity of an art world is based on its locally normative debates in combination with how it is stretching out to international discourses. This art world "pluralism through connection" is a central aspect for the situated study of cultural institutions like *Dak'Art*, for examining how it is producing its particularity, and thereby resisting hierarchies produced by means of hegemonic art discourses and dominant art market strategies.

Acknowledgments

The author is grateful to the *Biennale de l'art africain contemporain, Dak'Art*, for supporting fieldwork during the editions from 2008 to 2014.

PART THREE

Art Markets, Maecenas, and Collectors

3.1

Contemporary Art in a Renaissance Setting: The Local Art System in Florence, Italy

Stuart Plattner

This chapter investigates the following question: How does a glorious artistic heritage affect the practice of contemporary art? The ethnographic case study focuses on the art world in and around Florence, Tuscany, Italy, a location famous as the birthplace of the Italian Renaissance, which practically created Western visual art.[1] The art studied here is "avant-garde" or "museum-quality" art, meaning art intended to advance the cultural vision through original creativity. Art of this quality—painting, sculpture, and architecture—was commissioned by the Medici family, who ruled the city in its period of fifteenth to seventeenth century glory and set a high standard for artistic patronage. While Florence also has a literary history, the enormous crowds of tourists who visit each year focus on its Renaissance painting, sculpture, and architecture. In this chapter, I focus on painting or visual art (see as well Plattner and Cacòpardo 2003).

The city was the center of the art world five hundred years ago. Does this heritage help or hurt the market for contemporary visual art? On the one hand, I assume that a society's love and respect for historical art should encourage interest in living artists. Michelangelo, Leonardo Da Vinci, etc., were supported as avant-garde artists while they were alive, and did a lot of good for their society, making it internationally famous then and now. It is reasonable to think that contemporary Tuscans, who grow up surrounded by wonderful

artistic masterpieces, and who see tourists come from all over the world to admire these historic works of art, would value living artists as well. On the other hand, the city's current livelihood comes essentially from merchandising its history to mass tourism. There should be resistance to the expense of any resources for contemporary art, in terms of energy and attention as well as money, since present-day art by definition takes away from the city's distinctive Renaissance strong point. The purpose of this chapter is to evaluate these two sensible assumptions in light of ethnographic information.

The chapter analyzes the contemporary art world of Florence in the context of my model of local markets in the United States (Plattner 1996, 1998). While the model is based on ethnographic research in St. Louis, comparative data show that St. Louis is an average US art market (Plattner 1996: appendix 5). The American system is not in any way a gold standard, and while the focus of this chapter is Italy, the comparison is intended to advance our understanding of America as well. The two places, from the local to the national level (St. Louis, Missouri, USA, and Florence, Tuscany, Italy) are extraordinarily different. But both countries are Western, capitalist, and developed while both cities are mid-sized with relatively healthy economies that are not the leaders or central market places of their respective societies. The most significant differences are historical. Florence has an impressively deep history tracing back at least 1,000 years, and became a world art leader in the fifteenth to seventeenth centuries; yet Italian artists are part of a system that has been practically invisible on the world stage in the twentieth century. St. Louis has practically no Western history at all before its founding in the 1700s[2] and no special history of art. Yet American artists are part of the US art scene which has dominated the world art market in the second half of the twentieth century. Thus in the most general terms of their positions in the world art system the two places—Florence and St. Louis—are comparable-in-reverse: one rich in art history and poor in contemporary relevance, the other poor in medieval history and rich in contemporary influence.

The setting: Florence, Tuscany, Italy

The historical art in Florence has been studied by many specialists, no doubt a complete bibliography would be enormous, multilingual, and represent several centuries of research. But the Italian contemporary art market is centered in Milan and Rome. Although Florence is peripheral to this art market, it still is an interesting place for research on this topic. Aside from unique factors—the terms "Florence" and "art" are so linked that even the descriptive material will be interesting to many people—this special case allows us to advance

our understanding of how strongly marked history shapes contemporary life. Contemporary anthropology takes two different positions as given: that historical context is paramount in defining meaning in present-day life and that current issues color and recreate the meaning of historical context. The case analyzed here will help build theory to understand this contraposition. This chapter is based on information primarily obtained in the city and province of Florence, and secondarily in nearby places in the region of Tuscany, specifically the adjacent provinces of Siena and Prato.

A model of local art markets

Local art markets are special cases of regular markets under capitalism, where consumers' understanding of the source of value is problematic and producers' (artists) production goals are inextricably bound up with their identity (see Plattner 1998: 483, Table 1).[3] In local markets too many artists and artworks compete for the limited demand, flooding the market, depressing prices, and restricting, if not practically eliminating, secondary sales.

The lack of cultural or commercial success does not dampen fine art production because of what I call the "van Gogh effect" (Plattner 1998: 485; 1996: 30–3), which legitimizes market failure by disconnecting it from long-term aesthetic value.[4] Contemporary artists who might worry about their failure to sell a lot of work can always take heart from van Gogh and keep their eye on the long term of art history rather than the short term of market sales. They keep producing artworks, acting as if they believed that good art doesn't necessarily sell, and art that sells is not necessarily good (Plattner 1996: 33).

Avant-garde art is in fact an especially difficult commodity to sell. The postmodern nature of contemporary aesthetics, meaning there is no reigning theory of good-and-bad, weakens demand. Since value in local contemporary art is socially determined many potential consumers lacking the right cultural capital hesitate to buy, fearing that their ignorance will lead them to make fools of themselves by overpaying or buying bad art.

This model was developed through ethnographic research in the United States, but is valid for the market I studied in Tuscany. In both places it is extraordinarily rare for an avant-garde artist to be able to subsist on sales of work. Artists seeking representation flood art galleries but most rarely succeed in exhibiting their work in galleries, much less in museums and art spaces. Serious collectors are few and far between (although far more numerous in St. Louis than in Florence). While we will see that both places have a respectable number of artists and dealers, the contemporary art scene in Florence suffers under several unique dark shadows: the lack of attention and resources paid

by the city and provincial authorities; the culturally deadening presence, more like an avalanche of mass tourism; and the provincial sense of distance from major art centers, primarily New York and America in general, secondarily London, Paris, and the German art centers, and finally the major Italian centers of Milan and Rome. On the other hand, the art scene benefits greatly from the presence of inspiring historical art and is sustained, albeit indirectly, by the income generated by mass tourism. Before going on to assess these contradictions I will briefly outline the structure and size of the market so readers will have a context.

The contemporary art market in Florence

Artists

I will present figures for the province of Florence, since the city itself is a rather artificially delimited area in a zone of rapid mass and private transportation. Before I consider any figures it is important to discuss the extreme difficulty of counting artists. The status is self-defined: one is an artist if one says so. But some people might claim the status for its relative prestige without doing any work. For example, I interviewed a Florence artist in his early sixties who worked on his elegant, abstract acrylics in his studio for half of every work day on a regular basis, after he worked in his small business each morning to earn his income. Earlier, this artist had shows in Florence, Milan, Rome, London, Paris, and other cities. But more recently he decided not to bother dealing with the art market, claiming it took too much energy; and he now sells his paintings to people in his community or gives them away as gifts. I had seen his paintings in local restaurants and in homes, and met him through mutual friends, but he would have been invisible to a study based on exhibitions.

A preliminary report of a survey done in 1995 by the regional government (Crispolti 1996) listed 162 artists in Florence province. The survey data show clearly that the researchers focused on fine artists, painters, sculptors, and printmakers, and not on jewelry, craft, or commercial artists.[5] According to the information I have, however, these figures are understated. I intensively interviewed twenty-four artists whom I selected because I knew them to be serious workers. Only six were represented in the regional government study. The omitted artists were of all types and statuses, young and old, successful and unsuccessful, recent immigrants and lifelong residents—but all were dedicated, active art producers. For example, one omitted artist was an American in his late sixties who has lived in Florence for thirty years, had founded one of the most successful art schools for foreign students in the

city, and currently exhibits his paintings all over Europe. Another omission was a Florence native in his mid-fifties who had exhibited all around Italy, including at the *Biennale di Venezia*, and who was well connected socially with the local art scene.

My conservative estimate would be that there are really about three and possibly four times the number of artists as the regional government's survey states, or between 450 and 600 artists in Florence province of about 1.2 million people at the present time. This is roughly similar to my estimate of about 800 artists in the St. Louis metropolitan area of about 2.5 million (1996: ch. 4). Given the likely error in the estimates, I conclude that there are roughly comparable proportions of artists in each population.

I interviewed a couple of young artists on purchase-contract with galleries, a relation rarely seen in the United States.[6] The dealers had contracted to buy work from the artists over a set period of years, with complete or monopoly representation. The Italian dealers paid a very small part of the retail price instead of the normal percent rate, in some cases only 10 to 20 percent, and also covered the costs of catalogs, art fair shows, and sometimes even supplies and studio rent. The dealers preferred to keep their clients' identity secret from the artists who were sometimes not even sure about the final selling price. The young artists had achieved the art student's dream of focusing exclusively on making, not on marketing work. The ugly side of the dream was the intense pressure they felt from dealers to supply products in the style that the dealers preferred, which limited their freedom to freely advance their artistic vision. Artists with contracts are extremely rare however, the majority making a living in the creative ways artists find everywhere, normally with the active help of family.

The fact that many artists do not have shows in prestigious galleries or sell their work does not mean that they or their friends and relatives think less of their artwork. Aside from the van Gogh effect mentioned above,[7] Italian culture seems more comfortable with market irrelevance than the more commercial culture of the United States. As one expatriate US painter who had lived in Italy for many years said:[8]

[Italians] are still a little bit romantic, its still a little bit more of the artist as a person who has something original to say, and they don't expect you to necessarily have a huge success. There are lots and lots of artists who never have a real big show, but who have sold hundreds of works, for very little money, to friends, family, friends of friends, and there is nothing humiliating about it, there is nothing silly about it. [Of course, they don't try to make a living at it] That's right, but they think that you can be a very serious person . . . it's like being a poet. No one expects a poet to be making all kinds of money, and they really do it the same way, they say,

if you are a painter, why should everyone assume that every wonderful painter is going to be discovered? (personal communication in English, November 15, 1999)

Dealers

Through my research I generated a list of sixty-two galleries and centers. Some of the galleries on the regional government list had gone out of business;[9] others on my list had been passed over by the government survey.[10] In comparison, there were eighty-six places in St. Louis where contemporary art could be seen, of which fifty-five were points of sale, the rest being museums or art spaces which normally do not involve sales (Plattner 1996: ch. 5). Given the small numbers and general flux in the gallery business, I conclude that there is roughly the same proportional number of places to show art in each place, or perhaps Florence has a bit more.

Florence seems about as well stocked with artists and places to see contemporary art as is St. Louis. Florentine dealers selling more avant-garde, less decorative work were unanimous in complaining that few of their customers came from the local area, while tourists did not buy their art. They had to work hard to find clients from a wide region in and out of Italy for these arts. A few dealers made the effort to be represented at *Artefiera* (Bologna Art Fair), the most prestigious contemporary art fair in Italy. In terms of population, Florence was represented in 2000 at *Artefiera* by ten galleries (out of the 209 exhibitors). In terms of numbers of galleries from one province, the fair was dominated by the forty-five firms from Milan and the sixteen from Bologna.

Other dealers did not find the expense of the *Artefiera* justified, or were not accepted by the fair administrators. The majority of dealers made their expenses by sales to their traditional customers through the normal labor of merchandizing and networking that any art dealer is familiar with. It is significant that most of the dealers I interviewed owned their gallery space or else had a special rental arrangement with the owner which involved less than market rent. Like artists, the dealers had to rely on special arrangements to deal with the tight real estate market in Florence.

It is difficult to succeed in the art gallery business in any society, and relatively low-level dealers often make ends meet by charging some of their costs to the artists whose work they exhibit. A gallery can receive direct payment from an exhibiting artist for the use of the space (Plattner 1996: 139) which is of course a confidential and normally scandalous act. A dealer's choice to exhibit an artist's work is supposed to be an aesthetic affirmation of the dealer's faith in the quality of the work. When the dealer risks income

on the gallery's ability to sell the work, the aesthetic commitment is affirmed. If the dealer simply acts as a renter (the Italian phrase I heard many times is *affitacamera* [room-renter]) the appearance of aesthetic commitment is a sham. As one artist said: "I would never do a show with a gallery whom I had to pay, because it seems ugly, a squalid thing, also because the galleries who do that are low level" (personal communication, May 5, 2000). Dealers disparaged other dealers with the term *affitacamera*, and several artists complained that dealers they had approached for a show agreed only if the artist would pay a hefty fee, US$500 or even several thousand US dollars. The practice devalues the meaning of shows and was mentioned more commonly in Italy than in the United States. As the director of the best art school in Florence cynically said, explaining why he only looked at the work in hiring art faculty and not on their record of shows as is done in the United States, "all you need is money to have a show and make a catalogue" (personal communication, January 31, 2000).

Collectors

In the United States, local art markets rely on relatively small sets of collectors who show up at openings and art events, and who are reliable supporters of the art world in general. Often the nucleus of high-end collector circles are trained and encouraged by local museum curators, which lends a noncommercial legitimacy to the collectors' activity (see Plattner 1996: ch. 6; Rheims 1980) Florence has no circle of collectors of contemporary art and no museums to help cultivate their taste. All the critic-curators, artists, and dealers lamented this fact. As an artist put it, "There are some people interested in art, there are some collectors, in quotes, because persons with a real, genuine, true interest, well there's not even one! They are like 'white flies' [*mosche bianche*, an Italian expression meaning extraordinarily rare]" (personal communication October 10, 2000). The few dealers who specialized in avant-garde work by emerging artists complained of the traditional and un-adventurous taste of their circle of friends. One such dealer quantified it for me: "My work is focused towards a collector community that is very select, of which only a small part is from Florence, the rest come from Tuscany and a bit from all over Italy. Five percent of my sales are with Florentine clients, forty percent with Tuscan clients." He went on to explain why Florentines were suspicious of contemporary art:

> Unfortunately, Florence is not an easy city for contemporary art, because weighing on the shoulders of the whole population is . . . a history of a certain [high] level, that everyone knows, that makes the Florentine

hostile towards contemporary art. There is a sceptical attitude towards the economic value of contemporary art. {Because its too risky?} On one hand too risky, and also because the Florentine economy is not based on risk but on private wealth. . . . Florence lives on private wealth and on tourism, its not an industrial city, it [does not have] an entrepreneurial approach. (personal communication, November 7, 1999)

The view of Florentines as traditionalist, risk-averse, anticontemporary art lovers was very common. This lack of a well-defined local enthusiast-collector community is the single biggest difference between Florence and other art markets I am familiar with.

Institutions

Beyond artists, dealers, and collectors vibrant art worlds are composed of museums and public exhibition spaces (with professional curators but without permanent collections), art schools, and art publications employing critic-journalists (see Becker 1982). Florence, home to several of the greatest museums of historical art in the world, has no contemporary art museum. This is a bitter fact to lovers of contemporary art, since Florence's ancient rival to the South, Siena, has recently opened a very avant-garde art space in the Palazzo Papesse, while the industrial province of Prato to the Northwest has also recently opened the impressive Pecci contemporary art museum.

The Sienese are already resented for their arrogant assumption of cultural superiority over the rest of Tuscany. Their possession of a truly avant-garde art space, linked to comparable places in France and Germany, gives substance to their airs. The case of Prato is even worse since Florentines love to look down on the Pratese as ignorant, boorish money-grubbing businessmen (Prato has been for many years a world center for high-end textiles as well as for reprocessing woolen goods). This insult is reinforced by the presence of a world-class private sculpture park open to the public, Giuliano Gori's Fattoria di Celle in Pistoia to the near northwest of Prato. The park contains a large selection of site-specific outdoor sculptures made by leading international avant-garde artists. It is comparable to eminent sculpture parks like Storm King in the United States. Even Pisa, near Tuscany's Western coast, has recently opened the Teseco Foundation, a daringly avant-garde contemporary art space located in an industrial park.

The city of Florence *is* the regional center for art education. The city hosts two renowned art schools: the Accademia di Belli Arti and the Istituto d'Arte di Porta Romana. Cosimo I de' Medici founded the Accademia in

1563, on the advice of the great artist-architect-art historian Vasari, with Michelangelo as its first director. The school now is one of about twenty federally supported schools in Italy comparable to colleges. The other school is the Istituto Statale d'Arte di Porta Romana, a state-supported facility comparable to a high school or technical institute. The Accademia, however focuses on teaching basic principles and techniques of the craft of art. In dramatic contrast to comparably elite US art schools, which normally aim to produce graduates who will confront the leading edge of the art market, the Accademia has no intention of graduating avant-garde artists who will have an impact on the market. Other smaller private schools exist to serve foreign students, some specializing in classical academic painting, others in printmaking, restoration or decorative crafts, but again these have little impact on the high art world.

Critic-curators

The scarcity in Italy of contemporary art museums with their staffs of professional curators means that the roles of journalist, critic, consultant, and curator are often combined whereas they are normally separate in the United States. The persons in these roles assume a far more important position in the Italian art world than they usually do in the United States. The most active and successful critics define new art styles based on the work of a chosen set of artists, curate the shows in public art spaces and private galleries, write the newspaper and magazine articles to publicize the new styles, and then write catalog statements affirming their worth.[11] It is common in Italy, but relatively rare in the United States, for galleries to invite critics to curate shows in their spaces.

In Italy the eminent critic Achille Bonito Oliva and the *Transavanguardia* movement in Roman painting of the 1980s is an example most frequently cited. The critic's public relations for this small group of artists helped make them famous and successful. But the lack of institutional support for the local Florentine art world severely hampers critics in their efforts to advance "their" artists in particular and contemporary art in general. As one critic complained, "There is no contemporary art market in Florence."[12] The critic-journalist who, in the Italian style, also worked as a consultant-curator, was in her late fifties and had a distinguished record of writing, curating shows, creating nonprofit art centers and working on public commissions. She went on to criticize the local scene:

A system would mean museums, there are no contemporary art museums in Florence. In Florence they have spent around US$16 million already on

the *Rifredi* [a proposed contemporary art museum], and still need to spend another US$20 million. The *Rifredi* plan began in 1982, together with Prato. . . . Prato opened its *Pecci* museum in 1988, Florence is still dithering around with *Rifredi*. . . . An art system would mean galleries, and there are too few in Florence. . . . The artists leave town, they go away, where are they going to show [here]? There are too few artists, they lack publications, journals, they lack an entire system. {Why? There is plenty of money in this town, and people admire art here.} There is no interest. The city is self sufficient with its history. (personal communication, June 27, 2000)

Another critic-curator, a 34-year-old man who specialized in emerging artists, was equally critical for different reasons:

The problem with this city is that there are too few galleries. On the contrary there are lots of artists, but they look for success in Milan. [In Florence] there is the Academy, there is a great tradition in Florence even of contemporary art, Florence was an important centre of Futurism, in 1912. . . . But now, Florence is isolated, anyone coming to Florence is put down, as a traditionalist, a reactionary. . . . The bourgeois Florentine thinks that [the art of the fifteenth–sixteenth century] was a golden moment, the height of world culture, and they are bound to that idea . . . that Florence was a great art centre because Botticelli was here, but not because the Futurists or Visual Poetry [two twentieth-century Italian art movements] were here. The Florentine, as a person, is a bit reactionary, very provincial, bourgeois, very complacent of his place in the world. (personal communication, December 13, 1999)

The themes these critic-curators brought up were mirrored in practically every other interview. To summarize, their main complaint is that the popular conception of high art is fixed on historical art, which leaves no aesthetic space for contemporary avant-garde art. They go on to complain that the tourist business which supports the local economy focuses on the icons of historic art, so the public officials have no incentive to spend resources on contemporary art; therefore, there are no contemporary art museums, only few galleries[13]. There are no local art journals as the major Italian art journals like *Flash Art* and *Arte Mondadori* are edited and published in Milan. The lack of a lively literary scene focusing on contemporary art allows local people to ignore their own recent and modern art history and impedes the formation of a local collector community. These complaints of art world actors mean that Florence's past overshadows the present.

The past in the present

The preference for historic over contemporary art has several bases. In the first place, the attribution of aesthetic quality is easier when the art is older, as more time has passed during which the opinions of experts solidify. While this is true, the preference I saw in Tuscany included all historical art, not just the art validated by experts. People hung paintings in places of honor that were so blackened with time that the image was barely perceptible.

My most notable experience was when a middle-aged hardware store clerk gave me an impromptu lecture on sixteenth-century Sienese government to support his claim that Siena (today) was a more interesting place to live than Florence. A Prato business executive who was explaining why Florence had not built a contemporary art museum effortlessly shifted from describing a meeting ten years ago to an anecdote about Florentines throwing stones at Michelangelo's David sculpture while it was first installed in the early 1500s (personal communication, July 22, 2000). The effortless blending of past and present revealed by these anecdotes shows the contemporary salience of the past in Tuscany.

The culturally deadening effect of mass tourism

As several interviewees pointed out, there was a vibrant contemporary cultural scene in Florence before the Second World War. The major change seems to have been mass tourism. Most people I interviewed resented mass tourism. For example, a successful local artist in his mid-fifties showed me his downtown studio—a dream of a European artist's studio with high-vaulted ceilings, arched doorways, eighteenth-century murals, and plenty of natural light. He owned this treasure because it had been his grandfather's, then his father's bookbinding workshop; he therefore worked surrounded by meaningful items of family history. But when he stepped outside in the street, he found himself immersed in herds of tourists. He complained bitterly about the nature of high culture in Florence:

> Tourism hurts the soul of a person who works at anything that's not selling souvenirs. A person who lives an active intellectual life in the city is definitely hurt. There's this sense in the air of endless vacation, of shouting, drinking, it's a vulgar reality that the city feels. . . . It's not easy to live here, more than anything in a mental sense, because the city is completely disassociated, because the tourism, the school outings, all these people in the streets, it takes away your desire to create. (personal communication, May 8, 2000)

His complaint was repeated in many other interviews. The problem is the relentless flood of naive tourists—over twenty per year for every inhabitant!— who want to look at the same things, the statue of David, the *Duomo*, and perhaps half a dozen famous places. Several dealers openly court tourist clients, advertising in tourist brochures and hanging their artists' work with sales information in hotels. In one case, an Italian owner named his successful gallery Ken's Art Gallery because the name seemed friendly and approachable to US American tourists—no one named Ken ever having been associated with the gallery (personal communication, November 18, 1999).

The estrangement of intellectuals from the central city, the dissatisfaction with cultural life and the feeling that the civilized qualities of Italian urban life have been sold out for tourist dollars, is not just a feature of the contemporary art market. In spite of the fact that the city and province schedule impressive programs of music, no one, of the hundred people I formally interviewed and the many others I informally discussed my project with, ever said that they were excited with the intellectual life of the city. If that is so, why do so many artists from elsewhere in Italy as well as from the rest of the world live there?

The love of art

The dismal picture of the Florence art world that I have painted is only one face of a complex reality. In fact the society is flooded with contemporary art. It is common to see original paintings and prints in local bars, shops, and homes. In most cases friends or relatives of the owners do the art. In a small sample of private homes I surveyed in a middle-class town in Florence province, about 30 kilometers from the city, the average home had eighteen significant works.[14] It is hard to find comparable data from the United States, but calculating the equivalent number from a study of 200 New York area homes done by sociologist David Halle produces an average of eight paintings and photographs per house (Halle 1993: 216, calculated from Table A-10).

There is a lot of original art in Florentine homes. People obtain art by buying it and by receiving it as gifts from artists, friends, and relatives as well as from organizations. In Italy it is common for public institutions to distribute original artworks to members. For example, a local artist in his late sixties told me how an industrial union distributed his editioned print to their worker-members about ten years ago:

> And the workers have a club, . . . they have an art gallery, and . . . at the time of my show, they said, we'd like you to do a [lithograph] plate, we'll print it, and we'll distribute it to our people. They print 100 of them . . . the

workers paid nothing, like in those days, 15,000 lira [less than US$13 at the time] for a print, it was a numbered, editioned print signed by me, and . . . they do that regularly. So for them, its no big deal, they are used to having contemporary art in their homes. {What you are saying, implies that the market for contemporary art is very broad here} Much broader, here than in most countries, yes. Its very much wider, and broader, and more open. . . . There are a lot of people who paint here, there is a lot of respect . . . for it [art, painting] as an activity. (personal communication in English, November 15, 1999)

One of the thirty surveyed homes belonging to a skilled factory worker had original editioned prints hanging in his garage. When I asked why, the owner explained that he had received the prints as gifts from the blood donation organization for which he volunteered, and had no more room to display them in his home (personal communication, May 10, 2000). It was common, in fact, for people to say they had received paintings as presents on birthdays, weddings, or other occasions. Art is valued, respected, and accepted as part of normal everyday life.

Contemporary art at home in Tuscany

Florentine homes are full of art, yet artists, critic-curators, and dealers complain that there is no appreciation for serious, original contemporary art. A young curator who specialized in helping emerging young avant-garde artists was acidly critical about this: "Tuscany is a kind of oasis, so 'pretty,' [that] so many Americans, so many Germans come here, [because] they love the sweet countryside. . . . Here everything is sweet, picturesque, and the Florentines like pretty paintings" (personal communication, December 13, 1999).[15] A 38–year-old native Florentine artist had another explanation for the lack of avant-garde work: "In Florence, a professional buys a big, beautiful apartment in an antique building. . . . If you're in a fifteenth century house, you want to put fifteenth century furniture in it, . . . [then] you want to put fifteenth or sixteenth century paintings in it" (personal communication, May 11, 2000).

A 59-year-old critic-art historian explained the lack of institutional support for contemporary art by reference to its "un-decorative" nature and the alienation of the bourgeoisie. The critic explained the development of the art world after the Second World War: "Until the end of the 1960s, there was a system of art here in Florence that was favourable, it had a social structure. There were several generations of artists. It was a provincial scene, but [at least] it was a scene." He described how a few local avant-garde artists working with a few exhibition spaces attracted very challenging art from out of Italy in the 1970s,

upsetting the comfortable provincial relation the upper middle classes had with the local artists. The critical issue was not the foreign but the difficult nature of the new work: "Contemporary art provokes [intellectual] questions, but the shopkeeper mentality of Florence prevailed over everything else. The shopkeepers began to determine the image of the city, since the 1970s the mass tourism . . . [prevents] . . . the thoughtful examination of art" (personal communication, May 16, 2000).

Thus, in summary, the mass tourism of the last quarter century depressed the level of intellectual discourse about art. At the same time the un-decorative and often aggressive nature of avant-garde contemporary art alienated the upper-middle-class "shopkeepers"[16] who had once been the natural and enthusiastic supporters of local contemporary art.

Conclusion

The city of Florence was an intellectual center in Italy before the Second World War, the home of notable literary magazines and visual art movements. In the second half of the century the expansion of mass tourism coincided with a decline in the creative intellectual and cultural life of the city, as government authorities focused their efforts on servicing tourism. Several interviewees contrasted the essentially conservative nature of the Florentine elite, whose livelihood comes from merchandizing the past, with the entrepreneurial nature of Prato's elite, whose success comes from creating new industrial products and markets.

The lack of government support for contemporary art in Florence did not affect the fundamental interest in, and respect for, art on the part of the population. People grew up surrounded by masterpieces of visual art, saw the worth of this art validated by the millions of international tourists who flood the city to see it, and developed or maintained an interest in art.

But the government disinterest probably did affect the kind of art supported. The absence of contemporary art museums with their staffs of professional curators and art journals deprived the local population of the high-level discourse that stimulates interest and connoisseurship. Both assumptions discussed at the beginning of this chapter are valid in this case: the local history does stimulate the love and support of art, while the commercial atmosphere severely constrains the nature of the art supported. The contemporary merchandizing of the artistic past seems to stifle the artistic present. While there are sporadic exhibits of contemporary art in historic sites, primarily the Palazzo Vecchio and the Palazzo Strozzi, this art has little impact on the cultural life of the city.

Florence is unique in Western art history, and the extraordinary scale of the tourist industry with few other sources of income is also unique. I suggest this is the theoretical importance of the Florence case, that when commercial interests focusing on the past are dominant, the cultural interests of the present will suffer.

Acknowledgments

My research in Italy from September 1999 through July 2000 was supported by a Long Term Professional Development assignment from the National Science Foundation. I am grateful to Marta Cattarina for help in data collection and interview transcription; to Ruggero, Rosanna, and Silvia Bacci, as well as to Arabella Natalini for valuable introductions to art world people; to Professor Enrico Crispolti of the University of Siena and to Dr. Attilio Tori of the Tuscany Regional Government Cultural Affairs Office for help in obtaining the Tuscany Regional Survey information; to Dr. Massimo Bressan for anthropological advice and help in Florence; and to Dr. Antonia Trasforini of the Istituto Cattaneo, Bologna, for sharing her thoughts on Italian art systems and her survey instrument on Bologna art galleries. I thank the Stanford University Overseas Studies Centre in Florence for graciously providing office support at the beginning of my project. My colleagues and friends Frank Cancian, George Collier, Rudi Colloredo-Mansfeld, Jane Collier, Ricardo Godoy, David Guillet, Leonard Plotnikov, Marie Provine, John Yellen, and my wife Phyllis Plattner gave me the benefit of their comments on drafts of this chapter, for which I am deeply grateful, even when I did not follow their advice.

3.2

Brazil's Booming Art Market: Calculations, Images, and the Promotion of a Market of Contemporary Art

Dayana Zdebsky de Cordova

This chapter presents ethnographic reflections on the growth of the Brazilian market of contemporary art in the years following the 2008 global economic crisis. This growth was promoted by the Brazilian government, market players, and a favorable local economic context in contrast with the catastrophic economic scenario endured by the major global powers. This led to a series of media narratives, presented in the first section of this chapter, which introduces the discursive environment. My initial focus lies on narratives found in the Brazilian press. Subsequently, in the second section I turn my attention to the discursive reproductions of this market growth within the rhetorical context of the (so-called) global art market.

The idea of the Brazilian market growth, reproduced in the media and within the art market itself, underwent efforts of calculation, analyses of constructions, and the promotion of images of an expanding market. These calculations, analyses, and images were largely produced through a project called *Latitude—Platform for Brazilian Art Galleries Abroad,* where the product resulted from a combined activity of the Brazilian government and actors of the market of contemporary art. In the third section, I partially describe the production of *Latitude*. In the fourth, I focus on the first editions of *Latitude*'s

sectorial research on the Brazilian market of contemporary art. I present its strategies for calculating the market, producing the image of an expanding market, and projecting this image onto the market itself. Lastly, I conclude the chapter with some comments on the calculation technologies employed in the reports on the Brazilian art market and their analyses. Besides being narratives and quantifications on an expanding market, once they are disseminated, replicated and promoted, they are used as potential producers of the market itself and its claimed growth.

When art becomes "the safest investment"

"Bolsas europeias têm queda com temor de recessão global"

> *(European Stock Markets Drop in Fear of Global Recession)*

"Sistema financeiro Global está perto de derreter, afirma FMI"

> *(Global Financial System is at a Melting Point, says the IMF)*

"Crise deixa centenas de milhares de desempregados"

> *(Crisis Leaves Hundreds of Thousands Unemployed).*[1]

These are some of the headlines published in Brazil's most widely distributed newspaper, *Folha de São Paulo*, regarding the global economic context following the collapse of the US bank Lehman Brothers. During this critical moment, narratives proliferated across the world on the financial crisis, which began in the US real estate market and later spread throughout Europe, echoing across several non-European and American countries. One of the chief consequences of this crisis, as constantly reported at the time, was the economic growth slowdown.[2]

Amid these capitalistically tragic declarations, media stories occasionally surfaced in newspaper sections dedicated to art and/or the global art market and the crisis's hidden potential, with headlines such as "*Mercado de arte cresce apesar da crise*" (Art market grows despite crisis); "*Crise sem depressão nos mercados de arte*" (Crisis without depression in art markets); and "*O mercado de arte não conhece a palavra 'crise'*" (The art market is unacquainted with the word "crisis").[3] Among the different rhetorics on this growth, some global market players argued that art could become a haven for investments during periods of economic uncertainty, given the plethora of artworks available in the secondary market,[4] thus creating more business opportunities, even if at more modest prices (Miguel 2011). Moreover, as far as the Brazilian market is concerned, optimism was even greater: "*Mercado de arte no Brasil cresce com demanda, colecionadores e dinheiro*" [Art market in Brazil grows with demand, collectors, and plenty of money (Presse 2012)]. The

media also disseminated data on the sector's rapid growth: "*Estudo atesta pico de euforia no mercado brasileiro de arte*" [Study shows peak of euphoria within the Brazilian art market (Martí 2013)]. Some even point out that in 2012 alone, the turnover of Brazilian galleries grew by 22.5 percent (Fialho 2013: 11). Such information was grounded on research on the primary market of contemporary art conducted by a project called *Latitude* (Platform for Brazilian Art Galleries Abroad), managed by the research actors themselves and on which I shall focus in the following.

Brazilian market actors reiterated the idea that "works of art are a good way to protect your money from depreciation" in times of economic instability (Fraga 2012, trans. by the author). Regarding the specific context of the Brazilian art market, the local press frequently reproduced the idea that the crisis did not greatly affect the Brazilian economy, as it was privileged by being an emerging country, in contrast to the economic situation of major global economic powers. Some market players considered investment in art, and especially in established artists, a stable investment and a great way to diversify one's portfolio, protecting the investor from financial loss. According to Heitor Reis, responsible for the first Brazilian art investment fund, Brazil Golden Art (BGA), "works of art are not subjected to daily oscillations or strange movements" (Fraga 2012, trans. by the author). In turn, the purchase of work by young and promising artists at more affordable prices could be an opportunity for individuals willing to start a collection. It could also be a profitable business venture for those investing in art pursuing financial returns, since it was said that these artists could potentially increase their short-term value, especially within an increasingly expanding art market.[5] In January 2013, for example, reports stated that the 600 works of art acquired by BGA during its one and a half years of existence reached a 200 percent appreciation. In this context, Reis commented on Brazilian art: "It most certainly is the safest investment today. I know it may be considered a secondary plan, alternative investment, or diversification. But within a historical perspective, in the last ten years, I guarantee that it was the product with the highest appreciation rate in the country" (Furlaneto 2013, trans. by the author).

A share of Brazilian contemporary art in the global art market

How did the global art market[6] watch and/or relate to such growth? The rhetoric on "Brazil's booming art market" (Phillips 2012) was also replicated at a global scale. The European Fine Art Foundation (TEFAF), considered by the actors in my research as the main foundation/analysis in the field,

underlines in its 2013 report that "sales in the art market in Brazil were estimated at US$481.83 million, or around one per cent of the global art market" (Andrew 2013: 154). The report continues:

> Brazil's principal significance to the global art market has been through the buying power of its high net worth art collectors. Brazil's HNWIs [High Net Worth Individuals] and ultra-HNWIs[7] have undoubtedly had an impact on the global art market, although it is difficult to measure precisely its extent. But it seems clear that, in the short to medium term, Brazil's global significance will be based on its increasing number of HNWIs, rather than on the size of its domestic art market. In this respect it has similarities to both Russia and India. (ibid.: 154)

Actors in the Brazilian local market as well as global analysts agreed that much of this growth happened thanks to the emergence of new collectors. The fact that Brazil had its own chapter was considered an indicator of the country's prestige within the global art market, "for the first time appearing as a player to be observed in the market—and no longer in the generic category of 'Other,' that is, countries whose transactional volume was not significant within the global context" (Fetter 2014: 145, trans. by the author). However, many considered the claim that Brazil only held one percent of the international market to be below the real size of this market, which led to severe critical reactions, especially of local analysts. According to sociologist Ana Letícia Fialho, coordinator of the first editions of the *Latitude* survey, the TEFAF's chapter on Brazil is methodologically fragile "as it omits its sources, and presents an inconsistent empirical basis" (Fialho 2013: 44, trans. by the author). According to her, TEFAF did not work with a primary database that would discriminate between the distributions of contemporary, modern, and antique art sectors within the Brazilian art market, thereby leaving some of its actors underrepresented and others overrepresented. It would be impossible to address the country's expressiveness at the international level without some equilibrium in the representativity of the actors within the research scope.

Market indicators, such as those presented in the TEFAF report, were important for the Brazilian market of contemporary art, "because the industry itself understood the importance of data production for its development and professionalization strategies" (ibid.: 45, trans. by the author). Part of this importance lies in the production of an image of a strong and expanding market. Scientific numbers and the use of internationally acknowledged indicators suggest a coherent market, which led to a series of public narratives. Such data matter, insofar as they act as a factual ballast, for the rhetoric on the Brazilian market at an international context. They are thus structuring this very market and encouraging investments from global players.[8]

The reports' official narratives are of interest, because they are producing the market itself. It is no surprise, therefore, that they are challenged. Efforts to control discourses and information within the market seem widespread. We are faced with conflicting narratives (Fetter 2016). Market actors are disputing the portrayals in the media. It also calls for caution as to what is said and how it is expressed outside the mainstream media. I faced various situations that supported this observation. A gallerist, for instance, told me that he secured incredible sales at an international fair to the point of depleting all his material. In contrast, another one confided to me that "no gallery had sold anything or virtually nothing" at the same fair (personal communication, São Paulo, March 2015).[9] On one occasion an artist was proud of selling very well and, and at another, he gave me an opposite viewpoint. When I asked him about this apparent contradiction, he replied that "one should refrain from stating sales are bad as this would indeed lead to bad sales" (personal communication, Curitiba, June 2012). Regardless of the veracity of each of these declarations and the interests of the market actors, words concerning the market are carefully expressed and replicated as they may create images of this market and have an actual effect upon it. As one gallerist once stated: "the art market does not exist [in itself], it is what people believe it to be" (personal communication, Rio de Janeiro, September 2013).

Latitude: A platform for calculating and promoting the Brazilian market of contemporary art

Studies and reports, measuring and analyzing the Brazilian market of contemporary art, matter because they inform and guide the actions of their actors at a local and global level. Being able to produce and disseminate one's own numbers and images is an important resource for a market to represent itself according to its own interests. That was precisely what the Brazilian government did in partnership with some central market actors.

A major objective of this ethnographic research was to follow the institutional and documental formalization of the Associação Brasileira de Arte Contemporânea (Brazilian Association of Contemporary Art, ABACT) and the creation of project *Latitude*. The latter is the center for those research studies that largely informed the narratives of growth of the Brazilian art market in media reports.

Created in 2007, ABACT is a private nonprofit organization based in the city of São Paulo, which "currently encompasses 46 Brazilian art galleries in the primary market, located in seven Brazilian states, and representing more than

1000 contemporary artists."[10] Its creation involved private legal entities, private entities with public interest, and public entities that happened in the wake of state policies that hoped to place "culture on a different standing, as a priority for Brazilian development" according to Gilberto Gil, the minister of culture at the time (Gil and Ferreira 2007, trans. by the author). One of the government's strategies was to invest in sectors deemed profitable in the arts (such as the market of contemporary art) given its possibilities for generating employment and income. To these ends, a program called Brasil Arte Contemporânea (BAC) existed in the Ministry since 2006. Its goal was to "publicize Brazilian artworks and increase the exports of national visual arts" (Portal Brasil 2012, trans. by the author), targeting "contemporary art galleries organizing periodic exhibitions of their artists within and outside the gallery space" (ibid.). This project involved different partners such as the Agência Brasileira de Promoção de Exportação e Investimentos (Brazilian Trade and Investment Promotion Agency, Apex-Brazil),[11] the Ministério das Relações Exteriores (Ministry of Foreign Affairs), and agents of the Brazilian art market (ibid.). The latter was represented by the Fundação Bienal de São Paulo (São Paulo Biennial Foundation, FBSP).[12]

During the first two BAC administrations (2007–9 and 2009–11), the Fundação Bienal de São Paulo assumed the provisional role as sector representative, while the galleries consolidated the ABACT (Fernandes 2013). In 2011, a change of management took place in the BAC, from FBSP to ABACT. In 2012, the BAC was renamed *Latitude*—Platform for Brazilian Art Galleries Abroad. From this institutional imbroglio, where secretariats and programs are created and eradicated, reallocated, or renamed, we reached the current state of affairs: the *Latitude* program, managed by ABACT and executed in partnership with Apex-Brazil, within which the sectorial research is performed and where the Brazilian contemporary art market measures itself. As a former *Latitude* project manager explained to me, its construction was requested from the project itself. Without an association to represent them, galleries would lack access to state resources (via Apex-Brazil) to invest in their internationalization. Moreover, internationalization did not merely mean to grow outward, since "the quest to grow outwards means the domestic market also grows" (personal communication, April 2014).

Calculating the market, creating and promoting its images

Latitude is responsible for several activities: support for participation in fairs; prospective missions in search of potential markets; art immersion trips to bring opinion makers and potential clients to Brazil (to attend VIP circuits between

fairs, biennials, and art institutions, for example); international promotion, communication, and training of galleries to operate in the international market, and commercial intelligence. *Latitude* defines the latter as

> the area of occupation of the Project's team, which aims at the constant construction of a database and documents to instrumentalize the Management Committee for strategic decision-making. The main products of collective access in Commercial Intelligence are: Sectorial Research, market research, monitoring, and historical analysis of the program. (*Latitude* n.d.)

Performed annually between 2012 and 2015, Ana Letícia Fialho—the most renowned analyst of the Brazilian market of contemporary art—directed the research studies. Galleries provided annual information on, among other things, sold works, the represented artists, client profiles, their investments and expenses, the fairs they attended, adversities encountered, and hiring and discharges in the gallery. Gallerists and researchers involved confirmed to me that the galleries answer confidential questionnaires, and the researchers ensure that the project does not disclose specific galleries, and mentions only the collective of integrated galleries, thereby respecting their interests. The results of this research would allow on a yearly basis "to know the profile, modus operandi, scale, growth, and international insertion indicators of the galleries as well as to understand and monitor the determinant factors for the development of the sector" (*Latitude* n.d.). In turn, this would provide "the Latitude Project and ABACT detailed information . . . in order to support the planning and development of their activities" and "foster the creation of management and commercial promotion tools by member galleries, aiming at the improvement and expansion of businesses in the sector" (Fialho 2014: 10). This wording appears, sometimes with minor variations, across all reports published until 2015.

In addition to using information from the sectorial research to guide individual or collective actions, there is a tangible effort to promote images of a growing market. "This is not a commercial project in that we only support commercial actions. This is a promotional project," said the former project manager, Mônica Novaes Esmanhoto (Fetter 2016: 253, trans. by the author). Moreover, this promotion involves Portuguese and English versions of the reports. After all, one of the research's objectives is "to be a source of objective, organized, and trustworthy data on the sector for agents of the art system, public managers, partners, specialized media, and other interested parties" (Fialho 2014: 10). The dissemination of the results was done via media articles, publications in specialized magazines, summaries, lectures, chat shows, and other formats, which authors gave at market-related events such

as art fairs. The spaces associated to national, and especially international, art fairs are considered "undeniably essential platforms for the dissemination of content" (Esmanhoto in Fetter 2016: 253, trans. by the author). Such events are considered as fundamental to "promote to build this bridge, or knowledge in this case, about our production abroad in order to enable a long-term commercial relationship" (ibid.). These promotional efforts, however, also serve the production of images of the Brazilian market of contemporary art.

Two aspects are to be noted: first, it is necessary to create sufficiently reliable and measurable data of a market to be of interest within the global market. Second, in order to effectively exist and circulate, these images need to be replicated and disseminated.

Informal conversations, gossip, and accusations among contemporary art agents concerning sales without invoices, slush funds, and money laundering are recurrent when researching the market of contemporary art. These discourses sometimes extrapolate informality, and together with a wide media coverage, they gain notoriety, a public and official existence. An example of such a narrative gaining a public dimension was the collection of banker Edemar Cid Ferreira of the Banco Santos (Santos Bank), who presided over the São Paulo Biennial Foundation between 1993 and 1997. He was accused, among other things, of "money laundering, diversion of resources, capital flight, concealment of artworks, and parallel accounting" (Barros 2007, trans. by the author). He could boast a sumptuous (albeit disjointed) collection of art and antiques and act as a visual arts patron. More recently, over 350 artworks used as bribes have gained visibility, seized from 2015 to 2016 by the Federal Police's Operation Lava Jato (Car Wash).[13]

If the art market is indeed mostly informal and unregulated, as it is so often described backstage, one needs to wonder whether the numbers and information provided by research sources accurately depict the financial flows within that market. This was one of the first questions I asked Fialho about *Latitude*'s sectorial research. She answered that the research did not refer to the totality of the market, but to this particular universe of galleries and their formal/regulated movements (personal communication, São Paulo, July 2012). Some people had already told me that these market numbers, commonly referred to as "related to the Brazilian market of contemporary art," were way below the amounts moved by the art market. Then why measure a market in the first place? I asked this question to a person who worked at the Ministry of Culture in 2010. She answered that "while it is impossible to produce precise figures on the art market, we must start calculating in order to regulate and develop public policies for the market" (personal communication, São Paulo, April 2014). I spoke to other art market analysts about the subject and they seemed to agree that, despite the impossibility of constructing precise numbers about this

universe, the numbers produced by the research studies are potential indicators of the totality of what they call the Brazilian market of contemporary art.

Regarding the second aspect, I often heard of the originality of *Latitude*'s research. This referred both to its potential for yearly comparisons of the market and the production of data with the collaboration of galleries, as to a so-called first effort toward calculating the Brazilian market of contemporary art. However, in 2010, two years prior to the publication of *Latitude*'s first report, collector and economist George Kornis and economist Fábio Sá Earp produced, after a request of the Ministry of Culture, and via Funarte (the National Art Foundation), a large report, *Estudo da Cadeia Produtiva das Artes Visuais—Relatório final consolidado* (Study of the Visual Arts Productive Chain—Final consolidated report, 2010). Its authors attempted a much broader analysis, going beyond the primary market, and encompassing the secondary one, including production, promotion, and the institutional exhibition of art. The study lacked access to more specific data on the market regarding the purchase and sale of artworks, and relied on official numbers, such as those of the Instituto Brasileiro de Geografia e Estatística (Brazilian Institute of Geography and Statistics, IBGE). The report of Sá Earp and Kornis estimated that during this period Brazil had "0.25% of the world visual arts market—a meagre 1/400" (Sá Earp and Kornis 2010: 93, trans. by the author). However, this report was barely mentioned in the media, and according to some of my interlocutors it was simply archived. An employee of the Ministry of Culture of the time told me that the study should have been published by the research contractors and "officially released as it refers to a public document, but the contracting institutions did not disclose the work and prohibited their authors to publish the report" (personal communication, April 2014).

Building an expanding art market

Throughout this chapter, I discussed the rhetorics published in the Brazilian media concerning the 2008 global crisis in the context of the global art market and, in particular, concerning the expectations and characteristics of the Brazilian market of contemporary art in the post-crisis years. I explored how people related to the market in question and the Brazilian government built the *Latitude* project, an actor capable of calculating its own market and disseminating self-produced images about it. Finally, I focused on how market calculations were undertaken, projecting images of this very market between the years of 2012 and 2015.

Brazil officially entered the global art market through the production of data on the growth of the Brazilian market at a time of global crisis and economic deceleration. It thereby succeeded in leaving the category of "Others" in the

2013 TEFAF Art Market Report and became a contender holding a portion of the global market—even if at a modest one percent. This dimension deserved further attention, as one gallerist had stated that "the contemporary art market does not exist, it is what people believe it to be" (personal communication, September 2013). This is a situation where reflection and mensuration engender the very object of reflection and actually define mensuration. They are reflections on the world acting upon itself (Latour 1994; Latour and Woolgar 1986; Riles 2001).

A fact that caught my attention was that *Latitude* uses resources and technologies from scientific fields beyond art, especially sociology, and more recently economics, in order to create these images of the market of contemporary art.

The art market is not a given fact. Research studies measuring markets also build, as they themselves assert, indicators as to how these markets exist, thus producing images of totality which are mainly based on their *speculative efforts*. Here, the use of the term "speculative" refers to the imaginative effort for producing such total images of markets. They nevertheless are constructed on the basis of statistical indicators—as I showed in the case of the *Latitude* sectorial research studies. As Fetter (2016) proposes, once these indicators are published, they contribute to establishing minimally shared market images, even though these final or total images are never the same. Thus, specialized rhetorics and narratives shape, rather than follow, the art market.

Acknowledgments

The research on the Brazilian market of contemporary art is part of my PhD project in social anthropology. This multi-sited field research was undertaken in Curitiba, São Paulo, Rio de Janeiro, Brasília, Ribeirão Preto, and Porto Alegre. I thank Aline Iubel, Bruna Fetter, Daniel Rubim, and Cauê Krüger for their attentive reading of the first manuscript of this chapter and their comments. I also thank the Conselho Nacional de Pesquisa (National Research Council, CNPq), which provided me with the scholarship to finance my research. I am grateful to Piero Leiner, my doctoral adviser, for the constant interlocution; to Catarina Morawska Vianna and Alex Flynn for their incentive to explore anthropological interlocutions overseas; to Thomas Fillitz and Paul van der Grijp for their crucial suggestions; and Paulo Scarpa for the translation of the text from Portuguese to English.

3.3

Awkward Art and Difficult Heritage: Nazi Collectors and Postcolonial Archives

Jonas Tinius

Introduction

"What do these objects and the colonial archive have to do with art?" Lynhan Balatbat asks me. "They are just rubbish (*Schrott*)." Together with a colleague of hers, Marleen Schröder, the three of us sit around a makeshift table in the art space SAVVY Contemporary in the northern district of Berlin-Wedding. We have met for an interview about the Colonial Neighbours Archive project coordinated by the two and housed at SAVVY since 2011.[1] Positioned in a side gallery below a former crematorium that had been repurposed as a large creative project space in 2013, the Archive consists of a collection of "objects from Germany's colonial past": family albums, magazines, postcards, beer bottles, coffee jars.[2] Some of these items relate directly to Germany's colonial history (1884–1918), while others point to its legacies and reverberations in the present. Lynhan's qualification that the archive contains not "art objects" but "rubbish" raises an important question about the valuation and curation of problematic objects. Lynhan clarifies:

We are neither anthropologists, nor artists. We see ourselves as working on an archive that is not ours, but an archive of those that contribute to it, or those who try to engage with colonial history or histories of oppression.

She distances herself from a subjective valuation of the objects, seeking instead to offer a relational notion of the archive as constituted by those who relate to it. Lynhan describes the project as "a constant work in progress," which builds on collaborations with its "users"; neighbors, artists, activists—and researchers "like yourself," Marleen interjects. Lynhan's repeated distancing from a positive valuation of these objects stresses her ambivalent position: wary of aestheticizing, she tries not to "other" them as historic artifacts either. "These are commercial commodities and they may not have caused any concern for the people that used or donated them," she underlines. "But," she adds, "others realise that the people shown here are objectified in racist depictions." Her colleague Marleen underlines the difficulty of collecting, handling, and displaying these awkward items:

> These objects are also difficult because they tend to represent one perspective. Our objects are donated to us through an open call, and this may derive them from contexts in which they were not regarded as problematic.

The difficulties the two curators encounter point to the subject of this chapter: the problematization of awkward objects. I discuss this topic by juxtaposing two unlikely yet not unrelated subjects: the aftermath of a Nazi-traded artwork saga and a postcolonial archive in a contemporary art space. As SAVVY founder and *documenta* 14 curator-at-large Bonaventure Soh Bejeng Ndikung comments: "Restitution is a key issue for us. Adam

FIGURE 3.3.1 *A section of the Colonial Neighbours Archive, 2016. Photograph by Jonas Tinius, courtesy of SAVVY Contemporary.*

Szymczyk [director, *documenta* 14] has repeatedly voiced interest to exhibit works from the collection of art trader Hildebrand Gurlitt. By engaging with these paintings, we can open the doors to talk about reparations" (Ndikung in Bloch 2017). This chapter compares these two subjects to develop a better understanding of what I call "awkward art"; that is, first, practices, institutions, objects, and discourses whose status as art is contested, and which, second, are considered uncomfortable. Such awkward art embodies relations considered problematic, and thus afford "careful" curation. What makes the category of awkwardness anthropologically interesting is that it concerns the *problematization* of what makes something difficult. I use this notion in the sense espoused by Michel Foucault:

> A problematization does not mean the representation of a preexistent object nor the creation through discourse of an object that did not exist. It is the ensemble of discursive and nondiscursive practices that make something enter into the play of true and false and constitute it as an object of thought (1966: 670).

Processes of problematization, Paul Rabinow comments, react to uncertainty by making something into a subject of investigation (2003: 47). Awkward art describes practices, objects, and discourses that are *problematized* as disruptive and uncomfortable in contemporary contexts of artistic presentation, because of the way in which they have come into being, were circulated, and exhibited. Borrowing from Sharon Macdonald, on whose notion of "difficult heritage" I build this idea, "awkward art" could also be described as artistic practices, objects, or discourses that are "recognised as meaningful in the present, but that [are] also contested and awkward for public reconciliation with a positive, self-affirming contemporary identity" (Macdonald 2009: 1). Like difficult heritage, awkward art "may also be troublesome because it threatens to break through into the present in disruptive ways, opening up social divisions, perhaps by playing into imagined, even nightmarish, futures" (ibid.).

The ethnographic question that led me to this definition was: how to approach objects in an artistic context, which became the subject of contestation not because of their formal qualities, but because the social relations they retrospectively embody are seen as troublesome and thus demand particular attention for their future reception. By extension, the colonial history and postcolonial curatorial context I describe had become a matter of concern for my fieldwork interlocutors, precisely because they experienced that others had *not* regarded them as problematic.

The way in which my discussion hopes to contribute to a set of new anthropological perspectives on art, then, is twofold. First, I am drawing on Alfred Gell's notion of "methodological philistinism" (2006: 161) to underline

that in our analyses of modern and contemporary art, we might take inspiration from arguments in the anthropology of ethics about how we construe the subject of our studies. Building on James Laidlaw's suggestion that the anthropology of ethics does not rest on the "evaluative claim that people are good; [but] a descriptive one that they are evaluative" (2014: 3), I would like to reformulate the aim of a reflexive anthropology of art not to be an evaluative claim that art is good, but a descriptive one that art is subject to evaluative processes. Taking as its subject the problematization of art, aesthetics, and formal analyses is decentered as only one area of inquiry among others (see Pinney and Thomas 2001; Weiner 1994).

The second discussion I develop concerns the "social potential" (Appadurai 1986) of objects. By this I refer to art objects as mediators, whose agency is refracted through their problematization as art. The aim of these two interlinked discussions is to offer some directions for a contemporary anthropology of art that is skeptical of implicit judgments of art as good (being critical, social, etc.) or bad (being commercial, mainstream etc.), but regards art instead as a subject of innumerable ethical conundrums that are variously embedded or foreclosed by processes of problematization. The consequences of my suggestions for an anthropological approach to art, then, would be to turn the problematization of art and its relations into our very subject, allowing and embracing what I described as the awkwardness of art as a starting point of our analyses.

The two cases I am drawing on for this chapter are very different in scope, and I shall be using them for commentary and analysis, respectively. One is the 2012 Gurlitt Nazi art trove in Munich; a shorthand for the state-led investigation into the provenance of the art collection of Cornelius Gurlitt, son of Hildebrand Gurlitt, a Nazi art dealer who partook in the organized confiscation and trade of "degenerate art," that is, mostly modern art deemed "un-German" and thus sanctioned, sold, and devalued by the Nazi regime. As part of a wider set of inquiries into restitution and provenance, this case sheds light onto the imbrication of legal and economic issues around ownership, aesthetic judgment, and difficult heritage. Drawing on discussions of provenance research and the social life of things, my commentary on this case shows how these artworks become "suspicious" or "difficult" objects that refract, sever, and initiate social relations. By comparing a critical reading of the Gurlitt case to an analysis of SAVVY's Colonial Neighbours Archive project, I hope to illuminate the category of awkward art through its relational and prismatic qualities. I conclude with a view to how this can help us better understand both how curatorial processes are disrupted by instances of awkward art, and how future relations can be initiated precisely on the basis of such awkwardness.

Relationality and awkwardness

The "neglect of art in modern social anthropology," writes Gell, "is necessary and intentional" (2006: 159). It arises "from the fact that social anthropology is essentially, constitutionally, anti-art" (ibid.). This intentional neglect, according to him, is a reaction against the "unredeemably ethnocentric attitude" that "aesthetic awe bordering on the religious" is the only appropriate response to art (ibid.). The "major stumbling-block in the path of the anthropology of art" (ibid.: 159), then, is its blind adherence to its own theology:

> Aesthetics is a branch of moral discourse which depends on the acceptance of the initial articles of faith: that in the aesthetically valued object there resides the principle of the True and the Good, and that the study of aesthetically valued objects constitutes a path toward transcendence. In so far as such modern souls possess a religion, that religion is the religion of art, the religion whose shrines consist of theatres libraries and art galleries, whose priests and bishops are painters and poets, whose theologians are critics, and whose dogma is the dogma of universal aestheticism (ibid.: 161).

In order to establish the ground for a faithless anthropology of art, Gell suggests that we adopt a "methodological philistinism," that is, "an attitude of resolute indifference towards the aesthetic value of art" (2006: 161). There are two aspects of his observations that I consider particularly important for the anthropological approaches to art I outline here, partly in spite of his claims.[3] These are, first, an idea of artworks as relational prisms, and secondly, the notion of art beyond the good, or, as I called it, "awkward art."

To speak of the relational and prismatic qualities of artworks refers to the ways in which they embed, refract, sever, and instigate social relations. The idea of art, artistic practices, and art objects as "relational prisms" may offer a gesture of reconciliation between materialist tendencies, for instance, in the new sociology of art (De la Fuente 2010; Dominguez Rubio 2014), and anthropological approaches to craftsmanship (Ingold 2013) with relational and conceptual approaches to art and museums (Gosden and Marshall 1999; Ssorin-Chaikov 2013; Sansi 2015; Thomas 2016). This distinction is not meant to reify disciplinary divisions, but rather to point to commonalities across a spectrum of approaches to the handling of objects, the experience of social relations, and the creation of concepts.

The notion of a relational prism furthermore underlines the status of art as a contested subject of ethical concern: what "art" is, how "art" comes about, and why we care about "art" are matters of complex social, cultural, and

institutional negotiations that concern questions of value. Like Gell, I here take inspiration from Georg Simmel. In Appadurai's phrasing: "Value, for Simmel, is never an inherent property of objects, but is a judgement made about them by subjects" (1986: 3). As both object and subject of valuation, then, art generates a complex kind of "social potential" (ibid.: 6). This potential is retrospectively social, because it is "premised on the idea that the nature of the art object is a function of the social-relational matrix in which it is embedded" (Gell 1998: 7). Yet it is also social in a future-oriented manner, since "it has no 'intrinsic' nature, independent of the relational context" (ibid.).

The second strand of Gell's argument I want to develop is the notion of a philistine anthropology of art. Such a position affords questioning idealized assumptions that disregard the reactionary or subversive tendencies within art traditions (see Emde and Krolczyk 2012). This skepticism also demands recognition of what Sansi (2015: 68) has described as those anti-art movements cultivated by artists themselves. Since whenever the notion of art is problematized or called into question, it refers to issues beyond itself, such as questions about curation, provenance, or the moral implications of aesthetic judgment. Art understood as a relational and problematic prism is no longer "by universal consent a Good Thing" (Gell 2006: 159); rather, it is good to think with.

The following discussion introduces a set of art objects, whose status as aesthetically appreciated art was radically challenged by a fascist ethico-aesthetic regime. The problematization of the ownership of these artworks and the provenance inquiries they were subjected to highlight the agency of their awkwardness: they are clearly "recognised as meaningful in the present," but also render difficult "a positive, self-affirming contemporary identity" (Macdonald 2009: 1). The difficult necessity to clarify the status, provenance, and ownership of these artworks traded and looted during the Nazi regime and unexpectedly resurfaced in the early twenty-first century, point to their uncertainty, irritation, and awkwardness.

Awkward art I: The Gurlitt art trove

"Gurlitt" has become a byword for one of the most notorious discoveries of Nazi art dealership after the Second World War. It concerns a collection of over 1,500 artworks hoarded in apartments in Munich, Germany, and in Salzburg, Austria, by Cornelius Gurlitt, son of the "certified" Nazi art dealer Hildebrand Gurlitt. Among the artworks found in his apartments were sketches and paintings by Cézanne, Chagall, Gauguin, Monet, Matisse, Renoir, five works by Picasso, a marble sculpture by Rodin, as well as a great number of pieces believed to be lost or destroyed, leading art historians and provenance

experts to declare "art history may have to be rewritten" (Jessewitsch 2013). But the excitement about this discovery was overcast by questions over the provenance of these works.

My anthropological interest in this case concerns questions of valuation and problematization: how art can become subject to moral approval or disproval, and consequently be valued accordingly, classified, and sold to end up several decades later, caught up in a complex government investigation into their ownership. This case also goes beyond itself, as it were, underscoring the interplay between governmentality, aesthetics, and object histories in provenance research (see Chappell and Hufnagel 2012). What makes these works difficult is not their authorship or materiality, what Dominguez Rubio (2014) describes as the key to the legibility of an authentic artwork, but their legal status and legacy.

The Gurlitt Art Trove "saga" (Ronald 2015) began when a shy German man, Cornelius Gurlitt, was held by custom officials during a routine inspection at the Swiss border in late 2010, and, following the discovery of large amounts of money, subsequently investigated for tax offenses. In February 2012, his Munich flat was searched and authorities "secured over 1400 objects as evidence, including 121 framed and 1285 unframed artworks."[4] In November 2013, the German government and the Free State of Bavaria set up the Taskforce Schwabinger Kunstfund (Schwabing Art Trove Taskforce) to "research the origins of the artworks."[5] Just two days after the announcement of the taskforce on November 11, 2013, the first set of details on Gurlitt's collection was published by the German Lost Art Foundation for the registration of cultural objects relocated, moved, or seized as a result of persecution under the Nazi dictatorship. This listing included "25 artworks that were suspected to have been acquired in a forced sale or confiscated as a result of Nazi persecution."[6] Shortly thereafter, the Taskforce, then headed by Ingeborg Berggreen-Merkel, a trained legal expert and former undersecretary of the Federal Government Commissioner for Culture and the Media, announced that all artworks suspected of having been looted would be published on a dedicated website (lostart.de).

Complicating the investigations at this early stage was the unclear status of the artworks, and the difficulties of investigating seized property. While more artworks were published on the database, Gurlitt's refusal to cooperate further frustrated progress. He was subsequently assigned a legal custodian, who mediated contact with the Taskforce. In early 2014, the Bavarian Council of Ministers passed a proposal to be "tabled" at the upper house of the German parliament, the Bundesrat, "for a bill on the restitution of cultural assets," which challenged the statute of limitations for cases "involving confiscated objects where the current owner acted in bad faith at the time of purchase."[7] This bill was controversial because it suggested that this was to be effective

retroactively, allowing cases that had already been closed to be taken up again (Bergmann 2015). By late January 2014, more than 500 artworks from the Schwabing Art Trove had been identified: some were attributed to the Gurlitt family (as they were bought after 1945, for instance), while "others were classified as 'degenerate art'."[8]

In February 2014, further artworks had been found in a house in Austria belonging to Gurlitt; his legal custodian revealed in March 2014 that the Salzburg collection included 238 artworks, of which thirty-nine were oil paintings. Gurlitt's custodian also declared that "Cornelius Gurlitt agreed to return all artworks identified as looted art to the descendants of their last rightful owners."[9] Just two weeks later, Gurlitt signed an agreement with the Federal Republic of Germany and the Free State of Bavaria, recognizing that the Taskforce would continue to investigate "the provenance of artworks suspected of unlawful expropriation, even after the expiration of the seizure order."[10] As a consequence, Gurlitt "waived his right to use statute of limitations as a legal defence."[11] Following his sudden death on May 6, 2014, his last will and testament appointed the Kunstmuseum Bern in Switzerland as the sole beneficiary of Gurlitt's estate, which accepted the bequest of this contentious collection. The prominent albeit ambivalent gift led to public debates about the inheritance, eventually concluding in a court case initiated by Gurlitt's cousin Uta Werner, which confirmed the legality of Gurlitt's testament and thus the valuable bequest. The Kunstmuseum continues provenance research and already restituted artworks, including a pencil drawing by Adolph von Menzel (*Inneres einer gotischen Kirche*). Opening in late 2017, two complementary exhibitions in Bonn and Bern entitled *Bestandsaufnahme Gurlitt* (Gurlitt Survey) review the collection.[12]

After Gurlitt's death, meetings of the Taskforce led to two major developments: one being a publication of a regularly updated and open-for-comment list of the artworks from the Salzburg and the Schwabing Art Trove, and the other the digitized business records of Hildebrand Gurlitt used by him between 1937 and 1941.[13] On January 1, 2015, the German Zentrum Kulturgutverluste (German Lost Art Foundation) was established, assuming the administrative responsibility of the Schwabing Taskforce from the Stiftung Preussischer Kulturbesitz (Prussian Heritage Foundation). It now manages the Gurlitt Provenance Research project, which serves as "the point of contact for queries related to the artworks."[14] At a press conference in mid-January 2016, the Taskforce released its final report into the Schwabing and Salzburg finds, stating that approximately 200 provenance requests regarding the 1,258 artworks in Munich and the 239 objects from Salzburg had been conclusively answered, while further requests were under consideration. Berggreen-Merkel commented on the difficulties of drawing conclusions from scattered sources, noting that "it can only remain a preliminary report" (2016).

This chronology of events only hints at the fragmented, multi-governmental, and multidirectional nature of the Taskforce attempts at rendering intelligible the many traces, relations, and shadows of Gurlitt's collection. The paintings, sculptures, and drawings were awkward in a variety of ways, among others, because they presented difficulties in handling: they resisted straightforward confiscation since they were private property, and yet they demanded scrutiny into the "the provenance of artworks suspected of unlawful expropriation."[15] The investigation into their provenance was complex, since it required investigating past relations, identifying future claimants, and responding to existing restitution claims (articulated in over 300 letters to date of which 200 concern partially overlapping artworks).[16] Furthermore, their legality was inextricably bound up with notions of justice and property, since their restitution demands "fair and just solutions" (Washington Conference Principles eight and nine on Nazi-Confiscated Art), a category that raises questions about the very possibility of fairness and justice in the face of atrocities (Campfens 2014). Additional difficulties arose from compiling object histories. As the taskforce notes: "Unlike tracing the provenance of an object held in a museum, library, or archive, the artworks found on Cornelius Gurlitt's premises were disorganized and not properly cataloged."[17] Stock-books and correspondences on family and business matters were consulted to reconstruct how the artworks had come into the collection, but only after Gurlitt's death could these be made public for further inspection. Further archive materials that remained unavailable to the Taskforce but suspected to be relevant "fill 17 boxes and include books, annotated catalogues, photographs, correspondence."[18] Additionally, "some of his [Hildebrand Gurlitt's] statements made to Allied Forces authorities after World War II on alleged losses of artworks were clearly false."[19]

Where "difficult heritage" erupts into the present as publicly as this case, moral issues become entangled with science and legal disputes, complicating provenance research. To balance politics, the media, justice, and research, conceded one of the leading provenance scholars on the Gurlitt case, art historian Meike Hoffmann, "remains one of the most exacting tasks for the future" (Hoffmann in Boldt 2014). It is to some of the other moral issues, which complicate this endeavor, disrupt German heritage in the present, and raise questions about its future, that I turn now.

In his study *Inhumanities*, David Dennis investigates the Nazis' large-scale manipulation and mobilization of "European literature, philosophy, painting, sculpture, and music in support of its ideological ends" (2012: 2). He shows how culture became a central propaganda tool for national socialist self-fashioning and against any group or cultural current not along official party lines. The conception of the Third Reich as the apex of Western civilization was propagated by manipulating and rewriting art histories, biographies, and

aesthetic canons to echo the state's anti-Semitism and racist doctrines. Much like other cultural institutions (universities, schools, radio stations), artistic production was both censored and reinterpreted by the Third Reich. Drawing on the immense textual archive of the *Völkischer Beobachter*, the National Socialist Party's official organ and most widely circulating German newspaper, Dennis points out how leading staff of the paper used theater and art to turn aesthetic judgments into political instruments. Writing for the *Beobachter*, F. A. Hauptmann, a leader of Nazi cultural initiatives in Leipzig, repeatedly reported and reviewed Jewish performances, such as the ones taking place at the *Stadttheater* of his hometown (ibid.: 352), devaluing its status as art.

This aesthetical subjection to an instrumentalist ethics was the key to official Nazi propaganda, but it was also "part of a massive and wide-ranging purge of German social institutions" more broadly—"Hitler's Cultural Revolution," as the historian Richard J. Evans puts it (2003: 384, 391). The Nazi policies of *Gleichschaltung* or "forcible coordination" (ibid.: 384) encompassed primarily the judicative and executive powers, but extended well into the arts: "Music," for instance, "was a particularly important target for co-ordination" (ibid.: 393). Although the forcible coordination appears as a top-down tool of oppression of which Dennis and Evans provide plenty of striking examples, the ethico-aesthetic regime of Nazi art re- and devaluations also actively "induced talented and respected professionals in the art world to become accomplices of the Nazi leaders" (Petropoulos 2000: 4). Following the negative "purge of artistic and cultural life," Evans writes, "it was time for those German writers, musicians and intellectuals who remained to lend their talents with enthusiasm to the creation of a new German culture" (2003: 461).

From 1933 onward, museum directors who had previously been collecting modern art were laid off and replaced by directors who "banned modern art [*die Moderne*] into the depots . . . and defamed the acquisitions of their predecessors in disgracing exhibitions [*Schandausstellungen*]," as a statement on the official research center for "degenerate art" at the Free University in Berlin declares.[20] Some gave these artworks back, others sold them. The *Schandausstellung* first shown in Dresden in 1933, subsequently toured through Germany to single out "negative examples" of the collection policies of the Weimar Republic.[21] Similar pushes to underline the connection between a certain aesthetic and impropriety included speeches, books, and curated interventions. By 1937, Goebbels was in possession of a decree by Hitler, which he used to confiscate artworks in museums with the aim of creating the 1938 Munich "degenerate art" exhibition in the Haus der (Deutschen) Kunst. On May 31, 1938, the *Gesetz über Einziehung von Erzeugnissen entarteter Kunst* (law regarding the confiscation of products of degenerate art) allowed the wide-scale confiscation and subsequent sale of artworks deemed as "degenerate" and "un-German."[22] In the same year, a select number of works were chosen to be sold or

commercialized (*verwertet*) to foreign buyers, among others by the certified art dealers Gurlitt, Karl Haberstock in Berlin, Fritz Carl Valentien in Stuttgart, and Aage Vilstrup in Hellerup, as well as the Gallery Zak in Paris (see Hoffmann and Kuhn 2016). Goebbels noted in his personal diaries: "We also hope to make some money with this rubbish" (Schulz 2014). From 1938, the Kommission zur Verwertung der Produkte entarteter Kunst (commission for the liquidation of the products of degenerate art) delegated these four art dealers, among them Hildebrand Gurlitt, to sell further artworks at a 5–25 percent commission.

Unsurprisingly, Hildebrand Gurlitt could find his prominent niche in this state-coordinated process of cultural reinterpretation, manipulation, and opportunistic patronage. He was far from being the sole, albeit a self-concerned and proud mediator between auctioning houses and international art collectors. In late 2013, researcher Willi Korte found a correspondence in the Düsseldorf city archives between Gurlitt and Hans Wilhelm Hupp, director of the Düsseldorf Kunstmuseum from 1933 onwards (Rossmann 2013). Their dialogue stressed the Nazis' calculated moral strategizing with the revaluation of art. One example is a 1938 letter exchange between the two concerning the sale of a painting by the Norwegian Edvard Munch, whose work greatly influenced German Expressionism. At the time, Hupp waited for approval from the mayor of Düsseldorf to sell the painting to a potential buyer from Norway, intending to buy "German masterpieces" from the revenue. Gurlitt served as an intermediary in this case. Reviewing his activities, he wrote: "I generally have the impression that the way in which I have been dealing in art for several years now has been excellently profitable—morally and economically" (ibid.). His rhetoric stresses the entrepreneurial self-confidence and his privileged role with respect to the Nazi art market.

Thus, while the Gurlitt find was of an unanticipated scale, it would be misleading to scandalize its "singularity." While 300 galleries, private collections, and art dealers with registered companies were immediately closed in Berlin after 1933 as a consequence of "Hitler's Cultural Revolution," several hundred continued to exist and broker. Asked how surprised he was about the Schwabing find, the expert and director of the in-house trust for provenance research in the Solingen Museum, Rolf Jessewitsch, responded: "Not at all. Since, as all of us who study such topics, I knew that there are more collections with interesting material" (2013). Jessewitsch underlines that exceeding attention paid to the supposedly scandalous exceptionalism of this case risks downplaying the scale of Nazi art trade.

The recent turn to Germany's role in international provenance research offers alternatives. Larissa Förster's call for a "more systematic, comparative, international and long-term approach to restitution, provenance research and the historiography of collections" (2016) in the adjacent field of postcolonial restitution and repatriation advances the relevance of international comparative

studies of awkward art and difficult heritage. As she writes with a view to the Humboldt Forum in Berlin, its confrontation "with calls for a profound historical and ethical re-assessment of the collections before their re-installation," are "partly the result of international debates and international legislation on cultural property and cultural heritage" (ibid.: 49).

Seen as prisms to trace Nazi art-trading mechanism, artworks can seem as mere means to an investigation of ownership claims. But the complex engagement with Gurlitt's hoarded artworks, an instance of awkward art and difficult heritage among many others, sheds light on the way in which they are entangled in wide-ranging political, aesthetic, and ethical regimes. The valuation, redefinition, and commercialization of artworks during the Nazi reign is but one example of their relational and prismatic qualities of art; neither per se good nor bad, but rather subjects of value chains and carriers of difficult heritage relations, they are never "outside ethics" (Geuss 2005). Rather, they become subject to *problematizations* of value.

In skipping subject, time, and sensitivity from German fascism and the Gurlitt case to the Colonial Neighbours Archive at SAVVY, I wish to point to other situations when awkward objects become prisms for looking at how a "difficult past breaks through to interrupt the present" (Macdonald 2009: 1). This juxtaposition is meant to facilitate a comparative view to other situations in which objects within art contexts become awkward and confront curators not just with the handling of difficult objects, but with the curating of the relations embedded in and refracted through them.

Awkward art II: The Colonial Neighbours Archive

I opened this chapter by recounting an interview with Lynhan Balatbat and Marleen Schröder, who coordinate the Colonial Neighbours Archive project at the independent art space SAVVY in Berlin-Wedding. SAVVY, "the laboratory of form-ideas," was founded in 2010 by the independent curator and biotechnologist, Cameroon-born Bonaventure Soh Bejeng Ndikung. Alongside Elena Agudio and Saskia Köbschall, he had established SAVVY to rethink categories such as "Western," "non-Western," and "alterity" through curatorial practices. SAVVY thus positions itself within the existing cultural landscape in the city as a site where distinctions between "West" and "non-West" are discussed from a point of view of form and content, rather than geographical location. As such, the space complements classic practices of "curating" as a practice or arranging objects into an exhibition, with reflections on "the curatorial," or what Rogoff described as "the staging

ground of the development of an idea or an insight" (2013: 45). SAVVY is not strictly speaking a gallery or a collection, and it is not simply a performance venue or academic outpost either; rather, its curators describe it as "a lab of conceptual, intellectual, artistic and cultural development and exchange; an atelier in which ideas are transformed to forms and forms to ideas."[23] The notion of the curatorial, and its critical postcolonial articulation in SAVVY's infrastructure for production allows for art to emerge as a "problem," and less as an object or visual artifact.

For the Colonial Neighbours Archive, the frame of a contemporary art space is both inhibiting and productive; as Lynhan put it, "we resist framing these objects in the archive as art, because we don't want to subject them to this perspective." Her colleague Marleen pointed out that the Archive was not about collecting items, but "interviews, and stories associated with these objects" in an attempt to capture the sociality embedded within them. As the two explain, the objects are framed as *Schrott* (rubbish), in an attempt to "unlearn" the perspective on them as either historicized or aestheticized colonial artifacts. They offer, rather, a view into interstitial everyday archives that echoes SAVVY's broader curatorial approach to difficult heritage:

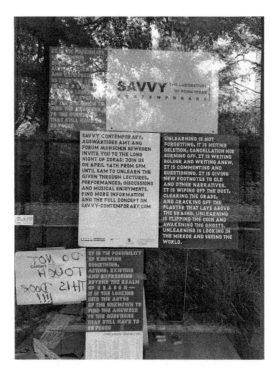

FIGURE 3.3.2 *Placards and flyers displayed outside SAVVY. Photograph by Jonas Tinius, courtesy of SAVVY Contemporary.*

FIGURE 3.3.3 *Reproduced and altered pages of the family album that started the archive. Photograph by Jonas Tinius, courtesy of SAVVY Contemporary.*

Unlearning is not forgetting, it is neither deletion, cancellation nor burning off. It is writing bolder and writing anew. It is commenting and questioning. It is giving new footnotes to old and other narratives. (see Fig. 3.3.2)

The Archive figures not as a foregrounded exhibition, but as a permanent installation in SAVVY. It began as a collaboration with anthropologists at the Humboldt-Universität zu Berlin (Ndikung and Römhild 2013) and initially worked with a colonial family photo album from Cameroon, found in an attic by Ndikung's relatives. To mark out its content, the curators invited artist Marie Kirchner to engage with the object. Together, they detached a series of photocopied pages from the album with red transparent tape. "We made it blurry to conceal parts of it," Lynhan said to me. The album was thus estranged from its prior context. It was problematized in the sense introduced at the outset, that is, not as a stable representation of a stable preexisting object, but as a process of ambivalent investigation.

The archive aims to address what the project founder Ndikung perceived as the gaps in Germany's politics of recognition and memory by challenging how its colonial past is remembered in public museums and archives. As such, it is not just a passive reconstruction of historical objects and their epistemic contexts during German colonialism, but an "information space," as the SAVVY project conveners describe it, that is aimed at examining "the post/colonial here and now."[24] Drawing on the idea of entangled histories, for SAVVY, functions as a way to muddle the distinction between African histories and European or German histories, instead focusing on their enmeshments in contemporary Berlin.[25]

We are not trying to enlighten people about colonialism, or to reproduce yet another discourse on the topic in Berlin, but to see what kinds of relations people have through their everyday objects to traces of German colonialism. (Lynhan, personal communication)

The purpose was to create a relational archive of neighborhood items. Citing Edward Said, the curators underline that "collective memory is not an inert and passive thing, but a field of activity." The project website further describes the online call for donations as a "technique of crowd-archiving" meant to create a "living archive."[26] In doing so, they emphasize the relations produced and evoked by the archive as constitutive of it. Although Marleen and Lynhan retold various episodes of donors recounting how they used the objects at home, it becomes clear that the archive ultimately points to the *future* relations potentially initiated by the archive. "That's why we speak of the archive as a collective process," says Marleen, "which includes meetings like ours now, for instance, or the red tape intervention with artist Marie Kirchner." Lynhan pointed out that the archive "is always present, meaning people who come for a guided tour will necessarily pass through it." She told me about the visit of a Swiss couple, who recounted memories of racist Swiss everyday folklore, such as colonial puppets, upon entering the Archive. "They regarded these objects as unproblematic everyday items," she said, but in the context of the other objects in the Archive, "they realized just how terrible they were." She continued to elaborate how the archive had prompted the couple to rethink their engagement with these problematic everyday objects and to donate several themselves. More than an exhibition of specific items then, the Colonial Neighbours project serves the purpose of *problematizing* colonialism through collective memories associated with everyday objects. Lynhan, Marleen, and colleagues from SAVVY had curatorially framed the archive with a "disposition that is sensitive to the impending, to revelations yet to be produced" (Buckley 2016).

Concluding thoughts: On an anthropology of awkwardness in art

By juxtaposing a commentary on the ethico-aesthetic quagmire of the Gurlitt case with a description of the curatorial framing behind SAVVY's Colonial Neighbours Archive, I have offered two approaches to the category of awkward art. To recapitulate, the notion describes, first, practices, objects, and discourses whose status as art is contested, and which, second, are considered uncomfortable, problematic, or as causing difficulty.

In the Gurlitt case, objects whose "art-ness" were disputed reappeared as difficult heritage, breaking through into the present through a chance discovery, and pointing out lacunae in legal frameworks for dealing with the aesthetic heritage of the Nazi past. The re-emergence of artworks once dubbed as "degenerate" underwent a radical transformation of value, exposing the fragility and malleability of the notion of art, as well as the impact of ethical judgments on aesthetic valuation. The category of awkwardness is anthropologically productive here, because it foregrounds the social relations entangled with these objects through their denunciation and revaluation as art.

The Colonial Neighbours Archive at SAVVY problematized the awkwardness of difficult colonial heritage through detached curatorial reflections. Rather than relying on the detailed histories and minute biographies of objects which are central to the Gurlitt case, its convenors curated these objects as relational prisms, that is, as entities whose agency relied on the networks, experiences, and memories associated with them. They were treated as potential magnifiers of future encounters. By establishing the *possibility* of social relations as the subject of the archive, it offered a way to combine the ambitions of a relational art space with the object-centered ontologies of postcolonial provenance research. Its host institution SAVVY facilitated the distributed agency of awkward objects, encouraging reflection on the curatorial difficulty of exhibiting difficult heritage.

Awkward art is not a definite category that works to encompass a range of definite phenomena with a nexus of qualities or traits that permit clear identification. Rather, awkwardness describes a state of self-conscious discomfort in response to things or practices perceived as improper or unacceptable. As I discussed it here, awkwardness serves not as a means of diminishing the difficulty of certain kinds of phenomena, for instance by suggesting they are merely uncomfortable rather than outright harmful; rather, it addresses the practice of problematizing or disputing the art-ness of objects, practices, or discourses on the basis of a discomforting association with these. As an analytic in the anthropological engagement with art, awkwardness points to where the notion of art is disputed and its status as a "Good Thing" (Gell 2006: 159) no longer self-evident.

Acknowledgments

I would like to acknowledge the Alexander von Humboldt Foundation for funding my research during the time of writing. I also thank participants of the 2014 EASA panel on relational patrons, which I co-convened with Alex Flynn.

3.4

Collecting Art in Asia
and the Pacific

Paul van der Grijp

In his ethnography of the contemporary art market in the metropolitan area of St. Louis, Missouri, Stuart Plattner (1996) distinguished three axes needed to understand collectors of high art: psychological, sociological, and economic or, in other words, the motivations of ego-enlargement, augmentation of social status, and investment. In accordance with this model, I developed a configurational perspective on private collecting in general (van der Grijp 2006). Plattner's three axes are important for the implication that in order to understand collecting as a cultural phenomenon, one cannot reduce the motivations of collectors to any one axis. The various motivational axes form a structural set which is, in my view, to be understood as a process, a *re*configuration. Moreover, for a full cultural understanding of collecting, it is necessary to add a fourth motivational axis, that of acquiring and transmitting knowledge about a certain category of objects, an axis that I call educational. My four motivational axes are all processual and should be analyzed in both synchronic and diachronic perspectives—hence the complementary notions of configuration and reconfiguration. Here follows a brief explanation of the four axes.

According to Plattner (1996, 1998), ego-enlargement is a psychological motivation that is satisfied when one's collection is recognized as "good" and "important"—and it thus becomes an extension of the self. I for my part see another, complementary psychological dimension in nostalgia—a kind of restoration of a lost world that is made manageable, habitable, and emotionally compelling within a sort of microcosm or time capsule. Sociological motivation

may fairly be summarized as a desire to augment one's social status. Collecting can also be, and often is, a form of economic investment. Collectors can sell some of their collectibles, generate a profit, and eventually reinvest this profit in their collection or in other undertakings. In so doing, they can accumulate a reserve of personal capital, and may even go on to become professional dealers (van der Grijp 2012). The notion of profit is an economic metaphor that can be equally applied to the psychological and sociological drives: in which case, ego-enlargement and the augmentation of social status are also forms of profit, in an economy of passion.

The educational motive concerns acquiring and transmitting knowledge about a certain category of objects.[1] Collectors may assume that an increase in knowledge goes hand in hand with the ownership of the objects. According to collectors I have interviewed, daily and physical contact with their collectibles is a precondition for gaining such knowledge. As collectors learn about their objects, many become specialists and are motivated to transmit their knowledge to others. Here too, there is a kind of profit: knowledge about one's collectibles is another dimension of the economy of passion. The configurational approach proposed here implies that in order to describe, understand, and explain collecting as a cultural phenomenon from an anthropological perspective, we should not reduce collectors' motivations to one, two or three motivations, but rather take all four into account.[2] Below, I discuss hypotheses of relevant authors on this matter, beginning with the psychological motivation. Thereafter, I will present two extended case studies of art collectors in Asia and the Pacific.

Mono-causal explanations in terms of obsession

Often, psychological or psychoanalytically inspired propositions such as those by Baudrillard (1968, 1994), Muensterberger (1994), and Stewart (1993) tend to reduce collecting to subjective values. They search for a mono-causal explanation and belittle collectors' motives by deeming collecting to be childish behavior. Baudrillard's collector, in Naomi Schor's lucid evaluation, is "a neurotic, unable to cope with the struggles of intersubjectivity" (1994: 257). Muensterberger dismisses collecting this way: "Collectors share a sense of specialness, of once not having received satisfying love or attention or having been hurt or unfairly treated in infancy, and through their objects they feel reassured, enriched, and notable" (1995: 44). Such negative hypotheses, which see the drive behind collecting as a lack, embody a determinism that is diametrically opposed to my configurational approach to collectors' motivations (van der Grijp 2006: 14–21).

Private collecting has been compared with drug addiction and alcoholism (Glasser 1976), while various other authors see in it an obsession described respectively as "organized," "passionate," "glorious," "blessed," or "magnificent" (Aristides 1988; Calloway 2004; Rheims 1975; Purcell and Gould 1992; Tuchman 1994). Pearce (1995) interprets the phenomenon of collecting as "a passion for possession." The word "passion" implies a certain degree of passivity in which something happens to the collector, and of a certain distress as well as a strong feeling of power, a polyvalence perhaps grounded in the culturally deeply rooted feeling that "sex is a variety of religious experience or, perhaps, indeed, that religion is a variety of sexual experience" (ibid.: 221). Pearce also observes that passionate possession is expressed in anticipation as well as recollection and in disquiet about the continuously passing present. This also explains the recurring hunger and need of collectors to add new acquisitions to an existing collection. I would add the hypothesis that it may also be expressed in a need to create a final place for one's private collection—via a donation—in a museum.

The authors discussed above share a psychological and sometimes reductionist approach of the cultural phenomenon of collecting. Some of them, however, add sociological considerations, which are highlighted in this section. The most frequently cited author in this respect is Bourdieu, who demonstrated the direct link between the taste for aesthetics, art and "culture," and social-economic backgrounds (1979: 326). Bourdieu added the notion of "cultural capital" as a marker of social status. His analysis was in keeping with Veblen's earlier analysis of the nonworking or only symbolically working leisure class. For Veblen, "the occupations of the [leisure] class . . . have the common economic characteristic of being non-industrial . . . 'Leisure' . . . here . . . connotes . . . non-productive consumption of time" (1934: 21, 46). I argue that the creation of a serious collection equals—or at least represents—the production of culture. A collection is a social identity marker that provides (in Bourdieu's terms) cultural capital and augments the social status of the collector. High-level collectors use to refer to the actually rather small circle of major collectors, and may compare their own collection with those of the fabulously rich, or with important museum collections (Plattner 1996: 183). Thus they partake in their elite status. Participating in a museum board provides evidence for such shared status.

The third component of my configurational approach of collecting as a cultural phenomenon is the economic or investment motive. Although Derlon and Jeudi-Ballini claim to have some interest in the economic motive in their analysis of collectors of "primitive" art (2008: 267, 273), they dismiss it lightly.[3] Neither do Baudrillard nor Pearce say much about it. Outsiders often have excessive expectations of the profit collectors could make by selling (part of) their collection, a view that seems to be confirmed by the

high amounts of money paid for art cited in the media. Insiders, however, know that collecting art is, in most cases, a mediocre form of investment. When collectors sell art on the secondary market (that is auction houses), they hardly ever make a profit, according to Plattner (1996: 169) and Velthuis (2005). This stance, however, is not shared by all collectors, as Isabelle Graw observes: "Today, it would be pure illusion to characterize the modern collector as free from speculative interest. And why wouldn't he not be interested in converting part of his collection back into money?" (2009: 77) At present, collectors have direct access to price information of all artists whose works have been sold via the secondary market. Moreover, they have access to reports on the investment potential on the art market. Although this kind of report does not constitute a solid base, as one of *Christie's* top representatives warns: "The problem with ranking artists purely by numbers is that you might only be talking about one or two works that could sell for that price" (Capellazzo in Thomas 2004). According to Wagner and Westreich Wagner (2013: 97), transactions through galleries (the primary market) constitute half of all art sales worldwide. Moreover, transactions through galleries may be higher or lower priced than those through auctions. A prestigious gallery with an intensive program may influence the demand of collectors "dramatically" (ibid.).

The fourth component of my configurational model of collecting, in addition to the three-dimensional approach of Plattner (1996), is the educational motive: acquiring and transmitting knowledge about one's collectibles. Art collectors create their own social networks to exchange information, and "most experienced collectors tend to form a coterie of art world players whose opinions matter to one another" (Wagner and Westreich Wagner 2013: 185). Although looking at mega-collections may be a proper way to enlarge one's scope, Wagner and Westreich Wagner strongly dissuade collectors to copy others: "The greatest reward of building a personal collection is finding one's own voice" (ibid.: 110). Collectors like to be informed by other collectors, dealers, auction house experts, advisers, artists, and curators. Such information may be biased by the self-interest of the various actors. Gallerists used to promote the career of their artists; collectors may do the same with the artists they collect; auction personnel is supposed to promote the work of artists for sale; advisers hope that the artists they recommend prosper; artists recommend their own friends and acolytes; and curators who advise trustees and potential donors on a private basis (as we will see in one of our case studies below) defend the interest of their institution. Publications of art critics would be free from self-interests, although this does not prevent artists from having a negative judgment on critics. Collectors, however, still can take their advantage from critics:

> In dealing with the new or the strange, and even with art that's familiar, collectors can turn to critical discourse to help them understand an artist's meaning, intentions and process, place the work in a historical context, connect precedents and influences, and lift the lid on the abstruse and hermetic. (ibid.: 121)

In the preceding discussion of perspectives on collecting, we have seen that many authors limit their analyses to one or two dimensions only. Apart from Plattner, Wagner and Westreich Wagner, and Pomian, none have developed a multi-dimensional approach to this cultural phenomenon. Wagner and Westreich Wagner rightly underscore that "art collecting stems from a wide variety of motives and offers all sorts of rewards, including personal gratification, social standing and financial profit" (2013: 197). Pomian (1987) distinguished a geographical dimension (the spatial distribution of collections), a social dimension (collecting being only accessible to certain categories of persons), an economic dimension (the circulation and exchange of objects), and a historical dimension. But in Pomian's model, which concerns not only motivations but also circumstances, the psychological and educational dimensions are missing. In my approach, the historical dimension is not conceived at the same level as the social and economic dimensions, since *all* dimensions are processual and should be analyzed in both synchronic and diachronic perspectives—hence the complementary notions of configuration and reconfiguration. In my view, in order to understand collecting as a cultural phenomenon, we should focus on the combination—configuration— of psychological, sociological, economic as well as educational motivations of its principal actors within the setting of increasing globalization. Below, I will illustrate my theses with two case studies of art collectors in Asia and the Pacific. The object of their collections is ancient Chinese and modern European art respectively, and not contemporary art (Heinich 2014). However, these collectors are contemporary themselves and it is my hypothesis that their motives are also to be found among collectors of contemporary art, not only in Asia and the Pacific, but also elsewhere in the world. First, I will give a chronology of events in the two cases. Next, I will analyze the network-related entrepreneurship and art collecting practices. I will finish with the relations of these art collectors to museums.

Hotel and private house full of art

The Lion's Kingdom Museum in Taiwan houses the world's largest collection of artistic representations of the lion. It concerns thousands of art objects

in jade, stone, gold, silver, bronze, wood, earthenware, porcelain, and textile from the Tang dynasty (618–907) until the recent past, mostly from continental China, complemented with pieces from Japan, Korea, Taiwan, and other parts of Asia. The museum was founded in 1998 by Chan-wan Kao (born 1947), an entrepreneur and private collector.[4] Kao invested in various hotels and he built his own hotel, Leo Ocean Resort, close to the town of Toucheng, at Taiwan's northeast coast in Yilan County, where he housed part of his collection in a private museum. In 2010, he was constructing a new wing that was scheduled to be completed shortly and with which his hotel would be extended from 80 to 250 beds.[5] Kao wanted to bring his collectibles closer to his guests so that they may enjoy them, like they can also take advantage of the large hotel garden that he designed over a length of 300 meters of shoreline; his impressive *bonsai* collection displayed in the hall and on the terraces; and the hot water spring that spouts from a lion's head in the bathtubs of every hotel room. Kao says that his private collection is much bigger than the 5,000 lion sculptures in the Lion's Kingdom Museum, so big that even the extension of his hotel would be too small for it (personal communication, Toucheng 2010).

In March 2011, during my second meeting with him, Kao had opened a small museum in a colonial Japanese wooden villa from the 1920s in Taipei.[6] In exchange for the renovation of this historical house, Kao had signed a use agreement of 250 days with the mayor of Taipei. Besides his museum, he also had a restaurant and a gift shop in the villa garden. In this quarter of Taipei are more wooden villas from the Japanese period that all need to be renovated. Kao called his new museum Little Palace, an ironic reference to the National Palace Museum. The long expected extension of Kao's hotel at the coast of Yilan would be opened one week after my third visit to Kao, in 2012, with a new entrance hall, a breakfast hall around a big tree (the extension is literally constructed around it), and a large dinner and dance hall. This new dinner hall has 500 seats, a capacity—after removal of the large round dining tables—that can be doubled for conferences. The hotel was extended from eighty to 205 rooms, and not to the originally scheduled 250 because, now, several double rooms are enlarged. In these big rooms, as Kao showed me, he placed artworks such as antique porcelain (in glass cases), paintings, and *bonsai*. The latter are replaced every other day. About hundred workers were employed in the construction of the new wing and another hundred kept the hotel functioning. The latter number would augment to two hundred after the opening of the new wing, which would imply a strong impulse for the local economy. My fourth meeting with Kao, in May 2013, took place in Taipei. Kao had just returned from mainland China, where he was working on a three-year project for a new hotel complex over there.

In 2008, at the occasion of a doctoral degree committee in Tahiti, I encountered Paul Yeou Chichong, seventy-five years old, who owns an important collection of famous modern painters. Chichong is of Chinese descent, a *Tinito* in Tahitian terms.[7] As a child—Chichong was the first of seven children—he went to the Chinese school, and at the age of six he still did not speak a word of French. Next he went to the Central School of the Roman Catholic brothers, where he not only learned French but also music and drawing. He still remembers his art teacher Boulet, who "always walked around with his charcoal and sketching pad" (personal communication, Pape'ete, 2008). At the time, Chichong knew already how to handle a brush to paint Chinese calligraphy, and soon he became skillful in drawing. Starting from the age of fifteen, he painted often in his free time, sometimes every weekend. However, the brothers of his school sold everything for between 1,000 and 2,000CFP apiece during fairs (the equivalent of between US$9 and US$18).[8] The *Popa'a*, the metropolitan (French) civil servants whose children went to school in Tahiti, bought everything. At age eighteen, Chichong went to Paris to get his high school degree—there was no high school in Tahiti by then. In Paris, he had no more time to paint, but he went to the Louvre every Thursday, when entrance was for free. After high school, Chichong studied at the École des Hautes Études Commerciales in Paris, the equivalent of a business university. He remained in France for seven years,[9] worked two years as an assistant of his brother in Tahiti, and returned to France in order to be trained in the insurance sector. After he came back to Tahiti, in 1963, he started his own insurance company, UAP Chichong.

During my visit to him in his office above the showroom of two French car brands, over which—besides his insurance company—he has the monopoly in French Polynesia, Chichong explains the scope of his collection:

> I'm very eclectic because, for me, painting is culture. But I don't want to exaggerate. I don't know much about Antiquity. I start with Flemish painting, that's my oldest period. I've so many of them, up to the present period. I own at least one painting of every period: a Breughel; of Barbizon artists; Cubists such as Picasso and Braque; Renoir; Gauguin; Le Douanier Rousseau: *Tropical Fruits*—Rousseau has never been in the Tropics, hahaha! It's superb! I also have an Andy Warhol, a Magritte, a Dalí. At present, I have another Dalí in view. That's not for free, indeed. I've to bid at auction. (ibid.)[10]

Four large rooms in Chichong's house are filled up with paintings, some seventy-five in each room stocked tightly on panels sliding over rails.

Entrepreneurship, art, and networking

For Kao, in my first case study, it becomes increasingly difficult to add pieces to his collection of lions due to a new law in the People's Republic of China (on the mainland) that prohibits the sale and export of art and antiques older than one century. Taxes should only be paid for import: "Import," as Kao says, "is easy, export isn't" (personal communication, Toucheng, 2010). With this, Kao also indicates the particular political preconditions under which he has been able to build his collection, whereby he does not limit himself to lions:

> My first aim is to collect lions, but sometimes I see other art objects that are so beautiful that I also purchase them. Most pieces come from mainland China. How they've arrived in Taiwan? That's a secret that I can't yield up, otherwise I'll get problems. (ibid.)

Initially, it was not easy to obtain lion's sculptures, until all kinds of antiquities were sold off in mainland China as a result of Mao's Cultural Revolution (1966–76). At the time, the Republic of China (Taiwan) and the People's Republic of China were still in a state of war, and Kao claims to have had good relationships with the intelligence service, which allowed him to search for and transport interesting pieces.[11]

Just before my departure in 2012, I participated with Kao and his wife in an exclusive dinner party, at which there was also the mayor of Toucheng, three high-ranking police officers, a retired general, the owner of a supermarket, the president of the fishermen's federation, and the president of the farmers' federation. This selection of economic and political relations was a marker of Kao's local sphere of influence. The dinner took place around a round table with rotating middle disc covered with exquisite seafood, while following Taiwanese custom—via ostentatious toasting—large quantities of whiskey were sent down the throats.

The hotel project on which Kao was working in 2013, on more than a million square meters of land in mainland China, will encompass an economy-class hotel with 1,600 rooms, a more expensive hotel with 600 rooms, and a village with one hundred villas. Kao is the leader of the project in terms of design, construction, and management. Besides (mainland) Chinese and American partners the project is developed by three Taiwanese partners, also including the famous architect Lee, who designed the 1-0-1 Tower in Taipei and whom Kao befriended a long time ago. The project is situated in a provincial town that has a rapid growth in the tourist sector, among other things, because of its closeness to the Great Wall, as well as the most southern glacier in the northern hemisphere. In mainland China Kao made friends with an entrepreneur who

has a seat in the city council of the town of the mega-hotel project and with whom he shares his major passions. Kao stated: "His *bonsai* collection is of higher quality than mine, but my jade and lions' collections are much better than his" (personal communication, Taipei, 2013). That Chinese friend owns a large wooden building surrounded by a private park with thousands of *bonsai*. Together they decided to transform that building into a luxury hotel with fifty rooms and to offer part of their collections for sale there. At a later stage, eighty more rooms would be added to that hotel, a project that parallels the other mega-hotel project mentioned above. Kao's consideration in transferring a part of his private collection to mainland China is that "the market is good there" (ibid.).[12]

After having founded his insurance company in French Polynesia, Chichong (in my second case study) became friends with Gilles Arthur, the first director of the Musée Gauguin in Tahiti. Arthur encouraged Chichong to acquire modern art with the following words: "You have the money, why don't you buy a Gauguin?" (personal communication, Pape'ete, 2008). In 1965, they traveled together to France in search for a Gauguin of Tahiti. They could buy a Gauguin of Pont Aven for the equivalent of one hundred million CFP (about US$900,000), but this was still beyond Chichong's financial means. The same art dealer also offered an Utrillo for six million CFP (US$54,000).[13] Chichong was able to get the price down to 4.5 million CFP (US$40,000), and he bought it. Some days later, he would add a small painting of Renoir. Thus they left Paris for Tahiti with two important paintings in their luggage, but no Gauguin.

Some years later, a great-nephew of Ambroise Vollard paid a visit to Tahiti and he was surprised to see that there was no Gauguin on the island.[14] Vollard had been Gauguin's dealer and, at his death, he left 2,000 paintings including several Gauguins.[15] This great-nephew, the son of one of Vollard's heirs, was an architect by profession, but did not work. Arthur brought Chichong in touch with him. Chichong recalls:

One day in 1970, I received a telegram by that great-nephew: "Now, I am ready to sell a Gauguin. You may come over to make your choice." Thus, I went to Paris together with Arthur. The man owned a yacht in Cannes that had to be repaired and he needed money for that. We could choose out of three Gauguins: *Le Bourreau* [The Executioner] for the equivalent of seventy-five million CFP [US$672,000], but that was too expensive for me. The next painting, in between the two others in terms of size, *Le chevalier devant une case* [Horse rider in front of a hut], was also too expensive. The smallest painting represented a *vahine* that Gauguin had named *Le rêve* [The Dream] but which he also could have named *Le sommeil* [The Sleep], a study for a more important work. (ibid.)

Every day, Chichong and Arthur went out for lunch with Vollard's great-nephew at a pub, and every day Chichong tried to get the price down. Twenty-five million CFP (US$224,000) was the lowest price he could negotiate, but he only had twenty-four million (US$215,000). He called his assistant in Tahiti to see what was left in his company's cash desk, but that was only 400,000 CFP (US$3,600). Chichong did not want to take out a bank loan because, he says, "as a real Chinese I didn't want to make debts" (ibid.). He signed a contract with Arthur as representative of the Museum Gauguin in which it was stated that the museum would pay the remaining 600,000 CFP (US$5,400) and that the painting would remain in the museum for at least three years. The museum would also have the right to make reproductions in the form of posters, picture post cards, stamps, and the like.[16] Chichong was pleased to sign the contract: now he could return to Tahiti with his first Gauguin. According to Chichong, the museum could earn those 600,000 CFP (US$5,400) back already within the first year since, because of this painting, there were many more visitors. Local newspapers announced it with the headline: "PREMIER GAUGUIN REVENU AU FENUA" (First Gauguin back in our country). Chichong comments: "everybody here knew that Gauguin hated the Chinese [see, for example, Saura (2003)] and the newspapers wrote that 'Gauguin would turn in his grave on the Marquesas because it is a Chinese that brought back one of his paintings'!" (ibid.).

Chichong kept his Gauguin painting for nine years. He was very busy with his business and, moreover, he had "not yet enough passion" at that time (ibid.). One day, a woman called from Japan with the words: "Monsieur, you have a Gauguin. Are you willing to sell it?" Chichong answered that he was not. Later, the same Japanese woman, a gallery owner, came over unexpectedly and asked if she could see the painting. That was not possible because the painting was in Los Angeles—the insurance in Tahiti became too expensive. "In that case," the woman said, "we go to Los Angeles." She offered US$2 million, while Chichong himself had only paid the equivalent of US$224,000. Arthur advised him to sell the painting. Five months later, Chichong was informed that his Japanese buyer had resold it for US$3.7 million, almost twice the amount that Chichong received. Chichong says that he was "disgusted." Arthur calmed him down by explaining that he would never have been able to find that last buyer. The Japanese gallery holder had her own network.

Next, because he was short of money Chichong also sold his Utrillo and his Renoir. He received for his Renoir five times as much as he had paid for it, but the same thing happened again: his buyer resold the Renoir for much more. Chichong sold his Utrillo for three times his own acquisition price, which made him think: "That isn't a bad idea, investing in art to earn money. So I can make money and still have aesthetic pleasure. That's great!" (ibid.). He went to Lausanne to acquire his second Gauguin from someone who

Chichong describes as the greatest collector and connoisseur of Gauguin. It was a canvas from Gauguin's Pont Aven period, *Le sabotier* (The Clogmaker), for which Chichong may have paid "too much"—at present, this painting is in the Musée Pont Aven. But he still had no second Tahiti work of Gauguin, the aim of his efforts. That turned out to be not a painting, but an *umete*, a wooden bowl that Gauguin had sculpted on the Marquesas in 1902 in *tamanu* wood (*Calophyllum inophyllum*), and painted with two fishes. Chichong had a certain preference for artistic representations of fishes, and did not hesitate to buy it.

Recently, he acquired his fourth "real" Gauguin, a painting of Tahiti at last. Chichong speaks here of a "real" Gauguin because, in the meantime, he had bought some watercolors of Gauguin's Pont Aven period. He also bought an engraving, *Le sourire* (The Smile), dedicated to a family on the Marquesas. Now he owned eight Gauguins—not counting *Le rêve* (The Dream), which he had sold. However, these were small, "modest" works. Chichong says not to have the money to buy a large Gauguin for US$40 million, as there had been sold one at Sotheby's some months previously: "I can't spend so much money on one painting. My income is peanuts compared to that of the owner of [the supermarket chain multinational] Carrefour in France, or the owner of [the supermarket chain] Auchan" (ibid.). Chichong invested much money in his art collection, but his wife does not agree: "She bawls me out all the time. I put everything I earned the last fifty years of business in those paintings" (ibid.).

Motivations of collecting and gifts to museums

What were the motives of Shan-wan Kao for the foundation of a lion's museum? Kao, who studied business management and, next, became an entrepreneur with a hotel-cum-museum, explains his motivations as follows, going back to his student years:

> I didn't choose to study art [at university] because if you choose art for your profession, it's not easy to make money. Most of the great artists who obtain a reputation get a good compensation after they die. I also didn't choose architecture, because then, you've to get involved in arithmetic science. I hate numbers. I prefer art, forms and colours. I don't like calculations—now, I pay an accountant to do that for me. So I chose business management and I majored in business strategy. It's important, to make plans for your career. But I never gave up my interest in art and architecture. (personal communication, Taipei, 2013)

According to Kao, the Chinese believe that the lion can provide good luck. One-twelfth of the world's population is born under the sign of the lion and, as Kao has it, they conceive of themselves as leaders and want to have something special. Lions can be seen everywhere: in children's toys, in logos of companies, and there is a worldwide Lion's Club. Kao named his own hotel, in which he houses his Lion's Kingdom Museum, Leo Ocean Resort, being part of the "Leo Group," of which he is the largest shareholder. Kao goes out hammer and tongs because many Chinese enterprises, from restaurants to banks, put two lions besides their entrance, but Kao has several thousands of lions in and around his hotel: "The high quality of my collection can help me to promote the goodwill for my logo and, with that, for my enterprise. And if I can take advantage from that to further develop this enterprise, I've a stroke of luck" (personal communication, Toucheng, 2010). Kao elaborates ideas related to his collection of lions in his hotel, for example in design. I already mentioned the lion's head in the bathtubs with hot spring water in all his hotel rooms. One of the dishes on the menu of the hotel restaurant is called "lion's head," and consists of a high-quality meatball. For Kao the lion's symbolism combines cultural, artistic, and religious dimensions. The tradition of lions has been introduced in China via Buddhism (van der Grijp 2010). Kao states: "Many Chinese today don't know these things any longer. I see it as my vocation to remember them to the younger generations and, consequently, I play an educational role" (personal communication, Toucheng, 2012).

Kao's collecting motivation is not only educational, but also economic, that is aimed at making a profit through his collection. In 2012, during the addition of a new wing to his hotel including a hall with one thousand seats, he considered inviting Christie's or Sotheby's to organize their auctions there. Recently, Taiwan has been opened up for tourists from the Chinese mainland who appear to have much interest in ancient Chinese art. After the Cultural Revolution, many ancient art objects have disappeared from the Chinese mainland. In the People's Republic of China today, the number of very rich people increases considerably and many of these come to Taiwan and purchase art and antiques for high prices. In 2013, during my fourth visit to him, Kao had not got down yet to the organization of the planned auctions in his own hotel in Toucheng due to his engagement in the new hotel projects in mainland China.

Paul Yeou Chichong (in Tahiti) agrees with my suggestion that we may interpret his collecting as a symbolic revenge on his youth: "That's right. It was a lack, because I couldn't paint any longer. So I went to buy the works of others" (personal communication, Tahiti, 2008). In his youth he painted with passion, but the Roman Catholic brothers of his school sold all his artistic works, and he could not keep any of them. Now that he earns a great deal of money—besides his insurance business he is also the importer of two French

car brands—he buys works of famous artists. As a young adult, he recalls, he had an old car and a house on credit, but he still bought paintings and visited modern art museums all over the world. Musée Gauguin director Arthur, who is no longer alive, advised him to concentrate on one theme, but Chichong replied: "Arthur, you're very kind, but I can't buy Gauguins all the time. I can't constitute a collection of 300 Gauguins, that's impossible! So, I buy all the periods" (ibid.). However, Chichong still has a favorite theme in art: fish: "I've got plenty of fishes all around" (ibid.). He emphasizes the importance of informing Tahitian children and youth about art history and he is ready, as soon as he has his own museum, to invest much time in it.

Chichong negotiated with several political leaders. If they provide a museum he is willing to house his collection of 350 modern paintings in it, anticipating a final donation. However, nobody took the bait. An architect designed the blueprints for a museum, a transformation of an existing public building that fell into disuse in the harbor of Pape'ete. Chichong claims to have received an offer to open a museum under his name in Paris; however, he thinks that his collection belongs to Tahiti. That is where he earned his money, and he wants to do something in return to the *fenua*, his native land. Certain people accuse him of egoism, because he would like to keep all his paintings for himself. He claims to be willing to donate them to the community, but not to be willing to also finance the construction of a museum. His wife and children will inherit a large part of his capital, but Chichong says that he wants to return his collection to the community only under favorable conditions. He is conscious that he should arrange that before his own death, which is why he is working on it now.

Conclusions

Kao's ironic reference to the National Palace Museum by giving the name Little Palace to his temporal exhibit in the Japanese colonial house in Taipei expresses a form of competition and probably implies ego-enlargement. There is also a dimension of nostalgia in the recollection of his child wish to study art or architecture, overruled by his business studies and career. He now collects art on a large scale and supervises large architectural projects. The social status dimension came to the fore in the prestigious dinner party with local authorities as well as in the friendly rivalry in *bonsai* and (other) collectibles with his new mainland Chinese friend and their common hotel cum art marketing project. The analysis shows that Kao's foundation of a museum is also economically and educationally motivated, that is the sale—with profit—of a part of his collection as well as transmission of knowledge

about the symbolism of the lion to Taiwanese youth. The Lion Kingdom's Museum in Taiwan shows an obvious identification with a Chinese identity. It also celebrates Japanese cultural identity (a part of Taiwan's colonial heritage), including its economic ideology and practice through the display of a large *bonsai* collection.

Chichong's collecting activities in Tahiti also imply a dimension of nostalgia. During his lengthy stay in Paris, he was fascinated by art and visited the Louvre frequently. His collection of famous European artists compensates—at least this is my hypothesis, confirmed by Chichong himself—the appropriation and sale of his artistic youth works by his schoolteachers. We can read the psychological motif of ego-enlargement between the lines—the same is true for the sociological motif of the augmentation of social status. Moreover, Chichong speaks clearly about the investment motif in his art collection and he provides us with exact figures. He is an autodidact in his collecting field (the educational motif). Every day, he says, he consults an art book, or a catalog of Sotheby's, Christie's, or Hotel Drouot (a major auction house in Paris). Moreover, he wishes to instruct young Tahitians about modern (European) art. The relationships with museums are evident in the form of cooperation, the intention of a donation to a future museum of modern art in Tahiti. If we want to understand collecting as a cultural phenomenon, we should take this configuration of motives—psychological, sociological, economic, and educational—into account. I will add some more hypotheses on donations.

Collectors donate to museums because the latter represent the imagined community (in the sense of Anderson 1983). Here, we may (with Godelier 1999: 180) refer to Mauss's fourth obligation (after the first three of giving, receiving, and counter-giving): gifting to the gods or, in Melanesia for example, to the spirits of nature or to the spirits of the dead, because they should be the real owners of all possessions in this world. A recurring theme in interviews with wealthy, donating collectors is their acknowledgment that they owe their personal fortune, which was the precondition for their collection, to society: the monopoly that they could obtain in their respective branch of business for some of the most reputed among them, such as the television and computer-screen empire of Shi Wen-long (the Chimei Museum in Tainan, Taiwan), the first insurance empire in combination with the monopoly over the importation of certain French car brands in French Polynesia by Chichong as we have seen above, and the supermarket chain of the late Lord Sainsbury in England (the Sainsbury Centre for Visual Arts in Norwich).

In all these cases, the collectors concerned admit and even emphasize that they owe to society the important capital that they earned with their business—in the latter three examples the imagined as well as real societies are Taiwan, Tahiti, and England—and, thus, they would like to do something in return. This "something" must of course be in proportion with the amount of

wealth that they received previously, their "debt" to society. Shi Wen-long, for example, used to be one of the forty richest people in Taiwan, and is considered by *Forbes Asia* to be worth US$890 million (Flannery 2012: 87). Confronted with the question about his motivations for founding a museum of Western art in Taiwan, which also holds the most important collection of violins in the world, including eight Stradivariuses (Chen 2012: 80), his rhetorical answer was: "What would you do with your money if you were very rich?" (personal communication, Shi Wen-long, Taiwan, May 2013).

In anthropological and other social scientific theories we have seen various hypotheses about contemporary substitutions for religion, which has a long tradition. For Comte (1830–42), for example, religion was replaced by science, positivist sociology in particular; for Pearce—as we have seen above—by sexuality; and for Belk (1995) by consumption. I hypothesize that for collectors, the substitute for religion may be their personal collection. According to Mauss (1923–24) and Godelier (1999, 2009, 2015), the gifts that humans used to make to those imaginary beings to whom they are indebted from the outset, such as gods and spirits, consist of prayers, offerings, and sacrifices by slaughtering an animal or, sometimes, a human being. I propose that the proper offering or sacrifice from collectors to society consists of the gift of their own collection which, in symbolic perspective, may be seen as the equivalent of their own life, their extended self.

The theorists discussed in this chapter converge in their interpretation of the collecting process as sacred, not in a strict religious sense, but as something set apart, with connotations of seduction, love, and sexuality, as a superior form of communication with the material world. In line with this, but going further in the argument, I suggest that participating with one's collectibles in a museum exhibition, or the donation of one's collection to a museum, or even founding one's own (Higonnet 2009), is, from the collector's point of view, a sacred gift that transcends the collector's life span and implies a superior form of communication with the rest of the world. The difference with common wills and bequests to one person or a few family members is that such donations are given to the imagined community as a whole. Moreover, gifts are not restricted to the period after the collector's death, since many donations are given by collectors while they are still alive and well. Private collectors are not only motivated psychologically, sociologically, economically, and educationally; they also have a wish for the immortality of their collections and, with that, of themselves. The point is that they find a supreme solution for coping with the idea of their own mortality.

Participatory Art and Collaboration

4.1

Trespassing Borders: Encounters and Resistances in Performance Art

Alicja Khatchikian

Introduction

In 1974, Marina Abramović was at the beginning of her long-standing career when she presented her *Rhythm 0* piece at the Galleria La Morra in Naples, Italy. Instructions to the audience were simple: I am an object, choose one instrument and use it on me as you wish.[1] Neatly organized on a long table were seventy-two different objects including apples, cosmetics, a Polaroid camera, razor blades, a gun, and one bullet. Over six hours, the artist remained passive while audience members commenced applying lipstick to her skin, removed her clothes, cut her, and eventually placed the loaded gun into her hand. *Rhythm 0* was the last in a series of five works performed by Abramović between 1973 and 1974, whereby the artist investigated her physical and mental limits: yet while challenging herself, her performances tackled institutional structures of power and disturbingly questioned the ethical territory between the spectators' and the artist's agencies.

This body/self that Abramović straightforwardly presented and art historian Amelia Jones has defined in all its "powerful historicity and political potential" (Jones 1998: 197) was largely conveyed in avant-garde theater and performance through the presence of the artist. Besides the artist, the idea of the spectator also having a role stemmed from a notion of the body as a

"site of intersubjectivity" (ibid.: 14) and foregrounded an understanding of aesthetics as a political domain.

Contemporary artists in performance still propose conditions of socialization that evade normative structures of power, but the aesthetics of performance seem to have shifted toward new models of embodiment and intersubjectivity that art curators, critics, and theoreticians have either enthusiastically embraced or sharply counter argued. Among others, Nicolas Bourriaud's curatorial proposition of "everyday micro-utopias" (2002: 31) enhanced those relationalities that practices of participation in performance and other kinds of participatory, socially engaged and community art temporarily propose. In contrast, Claire Bishop (2012) famously criticized his arguments and posed an antithetical question: What is spectacle if not the staging of a false consensus?

While searching for experimental ways of doing ethnography, performance and participatory art have also been meticulously considered by anthropologists (see Schneider and Wright 2013; Sansi 2015). Namely, their ethico-political potential collocated these practices at the center of the anthropological interest and simultaneously aligned them to its methodology and concerns, as Arnd Schneider and Christopher Wright suggested (2006). However, while artistic practice has stepped into the anthropological field and appropriated some of its lexicon and features, it is hard to fully sustain the opposite: if experimentation in anthropology has already shifted from textual outcomes to fieldwork practices (Marcus 2007), a sense of mystery still exists about what collaboration, experimentation, and participation between art and anthropology entail and what an "artistic methodology" consists of (see Sansi 2016; Klein 2010).

Working at the crossroads of art and anthropology, over the last two years I have been wandering not always successfully within these entanglements. Ethnographically, this chapter draws from my field experience between 2014 and 2015, and my research in Italy within the frame of two international festivals dedicated to performance art: while reflecting on the core of my ethnography (Khatchikian 2016) and discussing participation and spectatorship in performance, I explored the state of simultaneously being ethnographer and performer in two performances that can be respectively defined as collaborative and delegated in Bishop's terms (2012). This experience foremost questioned my space as an ethnographer and confronted me with the difficulty of finding proper methods to grasp and translate experience and bodily perception into written language. An occasion to trespass binary pathways of thought occurred when I accepted an artist's proposal for a collaborative project: without having defined any strict position or specific goals, the project attempted to combine anthropological and artistic skills and methodologies to explore alternative points of encounter between ethnography and art practice. However, lack of shared practice engagement beyond theoretical discussion increasingly

dragged the collaboration into a state of creative paralysis from both sides, and the project was interrupted within a year, failing to produce any tangible result.

Through a collection of memories and ethnographic materials, this chapter provides an insight into my experience within these contested and intertwined territories from three standpoints and types of relationship. I therefore consider three main questions in relation to relevant bibliography: first, as a spectator *of* performance—what kind of spectatorship does performance art call for?; secondly, as a performer *in* performance—what kind of challenges does an experiential investigation in performance entail?; and, thirdly, as a collaborator in a project *with* an artist—what kind of issues can collaboration between an artist and an anthropologist raise?

What kind and for whom?

Atelier Giorgi is an independent art space in the center of Turin, Italy. The main room, now completely empty, looks spacious though intimate. At the established time, people start arriving. I am sitting with my camera on a tripod and begin filming: everyone sits silently and waits. On the white wall in front, text is projected: "Anybody can be a performer. Anybody can be an audience. Everybody is a performer and audience at the same time. Roles and rules might be altered anytime we want/can/must."[2]

A person coughs noisily; after a few seconds, another coughs. People do not pay attention and stare at the wall waiting for something to happen. The artist enters the room anonymously while the coughing continues. Papers are passed around; I read:

> RULES OF THE GAME
> Choose the cough you are most familiar with:
> Light cough; dry cough; chesty cough; chronic cough … etc.
> You are asked to cough once or more times
> and give this paper to the person seated near you.
> ***
> Take your time.

With my fixed camera directed at the audience, I observe their reactions attentively: after an initial sense of discovery, their faces gradually turn impatient as they realize nothing more is going to happen. Yet only a few leave the space without hesitation.

Body Reaction Project Cough (BRPC) was conceptualized in 2010 by Italian artist Maya Quattropani as a political statement against the increasing chemical pollution affecting the population in Southwestern Sicily. Born as a double screen video performance, *BRPC* was re-enacted on different occasions and embedded in her investigation of those body reactions, sounds, and gestures that Maya defines as "non-recitative: natural, true, and real everyday acts" (personal communication, Quattropani, Turin, 2014). By giving herself "as a starting point" and omitting her presence as an artist, participation is often explicitly demanded and guided in her actions to create what the artist defines as "a choral living situation" where alternative possibilities of communication are negotiated. As she claims, "I believe that audience has to participate: unaware spectators are mere onlookers. Contrarily, when audience touches by hand what you are researching, it becomes a shared experiment. In fact, spectators develop their own standpoints" (personal communication, Quattropani, Turin, 2014). In proposing performance as a form of radical pedagogy, however, this polyphonic exchange is often affected by a common *etiquette* and a tacit agreement: I came here to stay.

Whether this is due to a lack of training in "performance art behaviour," as some artists suggest,[3] or to an overwhelming sense of respect toward art more generally, it is common to feel disoriented in performance. Placed in the position of unwilling participant, the spectator might simply be unfamiliar with an experience that Jones (1998) described as profoundly phenomenological and mutually transformative and which art critic Lea Vergine poetically interpreted as an act of intelligence that involves an interest beyond aesthetics: an act of generosity (Vergine 2000:15).

Yet, despite their different grounding and addressees, the desire some contemporary artists feel to create artworks that enact proximity and exchange is still being compared to 1960s and 1970s performances, making the territory of participation and spectatorship central to art theory agenda. In her famous critique of Bourriaud, Bishop meticulously argues against his paradigm of "art as a state of encounter" (2012: 18) and the straightforward equation between participation in art and models of democracy in society. At the core of her criticism lies a question: "what kind of relations, how and for whom are they being produced in these artworks?" (Bishop 2004: 65). Drawing from Laclau's and Mouffe's (2001) notion of antagonism,[4] she argues that decentered subjectivities imply the lack of a unified subject, whereas agency corresponds to "a fully present, autonomous subject of political will and self-determination" (Bishop 2004: 66). Dissent and confrontation, rather than consensus, are therefore seen as the constitutive features of radical democracy. Moreover, physicality and live presence are key factors in

Bishop's political analysis: from an anthropological perspective, I nonetheless wonder how presence and spectatorship are understood by each artist.

As a long-time experimenter with media, language, and sound, French artist Marc Giloux engages in ordinary activities in his performances without searching for any physical engagement with his spectators. "Audience is something very institutional, something terrible to me" he argues. "I rather refer to spectators as visitors who discover and responsibly choose where to go. The act of visiting implies an interest" (personal communication, Giloux, Turin, 2014). Echoing avant-garde techniques and Kurt Schwitters's nonsensical poetry, sound, and voice as raw elements in his performances are subversive as they privilege perceptual experience over meaning and representation, thereby becoming the space of performance itself. For instance, in *Dutchlord*[5] the artist hides in a cellar while the audience stands above in an empty room: using a megaphone, he reads from Joyce's *Finnegans Wake* and incessantly utters the same sentence for twenty minutes. Words sound distorted and barely comprehensible, as if the physical distance of the speaker would undermine meaning to the point where words are formless and merge in pure rhythm and intensity. Marc's visitor is immersed into a stream of noise and left alone both in its experience and signification.

Being perceptually involved in the process of presentation, the spectator does not necessarily have access to other processes of performance (see Mock 2000) and may feel frustrated in seeking meanings that are often either inexistent (Fisher-Lichte 2008: 156–57) or profoundly concealed in each artist's biography. Yet while no guideline nor frame for interpretation is provided, the artist's absence allows for a certain indifference on both sides: the artist is interested in sharing a space that each visitor responsibly chooses to explore or abandon (personal communication, Giloux, Turin, 2014).

Physicality and spectatorship are similarly conceived by Chinese artist Zhou Bin. When discussing his *3716 Pearls* performance presented at the MAXXI Museum in Rome in 2014, he highlights how, despite appearances, the limits of his body are irrelevant in his practice. While nudity represented a means for arguing against Chinese traditional culture in his earlier works, his contemporaries mostly deal with process and time. Central to this shift has been a reconsideration in terms of energy: "his strength lies in the space where everybody sees that he is going to liberate a certain strength, but he actually does not" (personal communication, Zhou, Turin, 2014). In this space, spectators are dislocated from their ordinary experience and way of sensing: "people are used to look at the world with logical insight. However, logic relates to facts; intuition is closer to the creator's heart. Audience is thus irrelevant to me: provocative artists must work outside its experience" (personal communication, Zhou, Turin, 2014).

As confrontational as his words sound, the role of audience is central to the history of performance, even though its standpoint is seldom considered intellectually. In the chain of criticism that followed Bishop's article "The Social Turn: Collaboration and Its Discontents" (Bishop 2006), Grant Kester was among the first to highlight how Bishop's approach mistrusts spectators and "places the artist in a position of ethical oversight," revealing systems of meaning the viewer inadvertently submits to (Kester 2006: 22). More drastically, Jones noted that both Bourriaud's and Bishop's interpretations of artwork "show no effect (and no affect) from the work they claim 'relationally' engages them" (Jones 2013: 68). In other words, the established tendency in contemporary art to interpret artworks within a political agenda not only tends to downplay the subjectivity of experience but it also overlooks "the importance of individual, sovereign decisions and actions taking place in private, heterotopic spaces," as Boris Groys highlighted (2010: 68).

My experience in performance as spectator similarly revealed how both Bourriaud's and Bishop's perspectives seem not to grant the spectator the appropriate degree of agency and independence in the perception of a work of art. In fact, in interpreting these artworks—if such a procedure is necessary (see Sontag 1966)—the reinforcement of ideas and concepts taken from "the existing real" (Bourriaud 2002) runs the risk of producing illusionary visions, while a cynical deconstruction of their poetics likewise results in unaffected considerations. Considering Giloux and Zhou's works, both present an intrinsically antagonistic attitude toward the spectator: presupposed as a subject of independent thought à la Rancière (2009), the viewer is not literally required to participate, nor to get physically involved with the artist. Rather, s/he is given a space for imagination to be (or become) a reflective visitor (cf. Bishop 2004: 77). After all, who said spectators have anything invested?

A critical presence

While a spectatorial consciousness was developing, my naïve infatuation for art guided me toward a hermeneutical deadlock. In order to experience what I had unsatisfyingly tried to grasp verbally, the first boundary, I decided to cross, was between spectator and performer. With hindsight, I admit that I was driven by a deeper contradictory thirst: being constrained in a self-imposed scientific rigorousness, I was envious of the creativity and freedom that performance seemed to proclaim in all its sensuality. A first occasion to taste that feeling soon arrived.

In 2014, I participated in a three-day workshop and final performance curated by Italian artist Francesca Arri for *The Others*, an international art fair based

in Turin, Italy. Besides the performance event,[6] the experience of its training process interested me most: over three days, I engaged in a series of physical exercises aimed to train rhythmic and movement coordination among a small group of performers. Tasks were never individual and constantly guided by the artist. Relationality and proximity were sought through exploration of space: initial exercises familiarized participants with one another by means of gaze and voice; relationships were further developed through physical contact and coordinated improvisation in couples, smaller groups, and finally, within the whole group.

Exercise 1	gaze and visual contact	body <—> body
Exercise 2	trust and familiarization	body <—> body
Exercise 3	physical contact and coordination	body <—> body/bodies
Exercise 4	individual/group improvisation	body <—> body/bodies
Exercise 5	intervention	body <—> bodies
Exercise 6	collective improvisation and coordination	body(s)

(Fieldnote, November 6, 2014)

Communication was ambiguous: as I perceived, lack of coordination was primarily due to the resistance by some to be ruled by others. For instance, I had to tacitly shift roles from active to passive when changing partners in exercises 3 and 4, in which physical complementation was the key to the construction of a successful image. Exercise 5 perhaps made those dynamics more evident: starting with two and gradually adding people, the exercise consisted of taking control of an isolated part of a partner's body. This seemingly harmless exercise had a greater potential (Abramović's *Rhythm 0* can be a radical example). A perceivable tension between oppressive tendencies and counterbalancing energies was always present: each participant was required to occupy a position and assume responsibility for its relational implications. Starting from an individual dimension, those exercises drove us toward the construction of a unique, coherent moving image, but still defined by empowered rather than informed individualities.

As an artist, Francesca Arri is familiar with this kind of training: her performances are often articulated in intensive workshops, through which she shares part of the creative process and facilitates forms of cohesion. Their outcomes are imagined, yet uncertain: "I always start my performances with an idea or image that needs to be shaped collectively[7] before being presented. I can never predict what will happen," she explains (personal communication, Arri, Turin, 2014).

The idea of the artist as a guide is certainly not new: among others, Allan Kaprow proposed "that audiences should be eliminated entirely" in his

happenings (2006: 103). The underlying principle for such a reformulation was a conscious and collective consensus between the artist and all participants involved as a fundamental "mark of mutual respect" (ibid.). This was accomplished by preparing the scenario beforehand and discussing scores together: participants did not require professional talent but "knowledge of the scheme" (ibid.). Arri's performances are similarly neither strictly prepared beforehand, nor evanescently open-ended: the relational dimension takes place in a phase prior to presentation and involves a group of people who, while nonprofessional, are trained and temporarily familiar with each other.

A second experience as performer allowed me a deeper understanding. In December 2014, I participated in the durational delegated performance and installation *Disappearing/Desapareciendo* presented by Mexican artist Melissa García Aguirre at the second edition of the *Venice International Performance Art Week*. This time, the weeklong temporal dimension and physical absence of the artist implied some critical considerations.

Dedicated to Mexican victims of drug cartels since 2006, *Desapareciendo* consists of husking, counting, washing, drying, and grinding 30,000 corn grains. As the artist explained, this was her first experience with a durational performance and her initial plans differed; however, increasing rates of violence in Mexico and recent escalations[8] forced her to showcase her participation at an international event. In communicating the complexity of her homeland as intimately linked to her artwork, the artist sought our engagement and entrusted the group with some responsibilities. My field notes after the first day might outline an effective image:

> We talk at length about the performance and our insecurities. Melissa proposes our initial roles: my first assignment would be shelling. . . . We walk downstairs to the room, each of us directed towards our assigned table. We wait. Melissa stands to my right with the first cob in her hands. Suddenly she approaches, straightens her arms and offers me the cob: we look at each other for an indeterminate time. The first cob is now in my hands. I look at the cob; I touch it and try to wait. . . . I now have full power over the entire performance. What happens if I wait longer without doing anything? I take a deep breath and slowly start husking the cob: I grip the husks and strip them from top to base. I then start pulling the kernels: there's some resistance. I feel clumsy in that silence: people stare at me. Finally, the first grain takes off. With the sound of the kernels falling into the glass bowl, I feel more comfortable. I remind myself that those cobs are bodies and I try to visualize that idea while touching them. I ask myself: am I embodying the oppressive state or should I take care of this corn? (fieldnote, December 13, 2014)

The performance process included intimate moments of dialogue: we gathered daily to exchange our thoughts and reshape the action together; each of us had the freedom to develop an individual affection to the performance and the artist often asked for our opinions. Then something changed: by the sixth day, each performer had experienced every activity and over 30,000 corn grains were counted. Theoretically, the performance had reached its goal, but two festival days remained. The artist's decision to continue performing instinctively encountered my disapproval, as it seemed that external dynamics were overtaking the performing process. The artist did not conceal her motive: the festival closing event was dedicated to Mexico and included worldwide famous artists like Regina José Galindo, Guillermo Gómez-Peña, and art collective *La Pocha Nostra*. National and international media would cover the event, hence she felt it was important to attend. Nevertheless, a sense of detachment prevailed on the last day: the artist remained in the room, recorded a video[9] then interrupted the performance almost two hours early. None of us discussed her decision but, on leaving the room that day, I was unsure whether I felt relief or disappointment.

My simultaneous role as performer and ethnographer in both experiences raised some critical questions that kept echoing in my mind. While Bishop's understanding of delegation as a basic form of outsourced authenticity and wage exploitation (Bishop 2012: 223) frustrated my claims for freedom and creativity, it also failed in grasping my experience as performer. A range of alternatives threw a brighter light on my state. Among others, Vergine explains the inclusion of nonprofessionals in performance in corporeal terms: whereas artists in the 1960s and 1970s were obsessed by the obligation to exhibit themselves as an existential quest, a growing interest for the social and cultural dynamics of performance started since the late 1980s, when the body as a language returned through *altered* declinations—my body and the others (Vergine 2000: 289, italics by the author). From the straightforward and provocative performance of identity, Marvin Carlson further suggests that performance repertoire shifted toward exploration of the process of representation itself. Performance artists started to tackle questions like "for whom, by whom, and to what end the representation is taking place" (Carlson 2004: 198).

While recognizing the passage of agency in delegated performance as bilateral, Bishop is sharp in judging the kind and quality of relationship being transferred. As she writes, if

> the artist delegates power to the performer (entrusting them with agency while also affirming hierarchy), delegation is not just a one-way, downward gesture. In turn, the performers also delegate something to the artist: a guarantee of authenticity, through their proximity to everyday social reality,

conventionally denied to the artist who deals merely in representations. (Bishop 2012: 287)

My experience in *Desapareciendo* partially challenges this position: none of the performers was from Mexico nor directly touched by its political situation; our participation was fully voluntary and the performance offered an encounter that has, in some cases, lasted over time. If a sentiment was implicitly required, it was empathy.

My disappointment with the artist's individual and undiscussed decision to suddenly conclude the performance validates the fact that I felt entitled to a certain agency within the performative space that I erroneously transferred outside its frame. In the first experience, these dynamics were less visible but still present, as clear conceptual and spatial boundaries between artist and performers were traced. From this viewpoint, the artist's physical presence or absence in the action is completely irrelevant: the artist preserves her authority independently outside the temporal and spatial frame of the action whereas performers do not—nor they are promised to. Does this sound unequal? Instinctively, I would say it does. Yet, my understanding changed substantially with the right degree of detachment: while being a performer in performance art basically means to execute an action, being an artist implies an act of creativity beyond that action.

Nevertheless, if the relationship between artists and performers can be transparent and complicit, the implications that performers must tacitly accept by exposing themselves in performance are nonetheless delicate. These implications should not be taken for granted but often are. For instance, the artist's monopoly over performance's audiovisual documentation presents a critical point of discussion since performers, compared with artists, are not necessarily asked for their permission over its production and use. While movement and short duration might attenuate these aspects, my experience in *Desapareciendo* was different: even though only authorized personnel curated the festival documentation, their presence was discomfiting and I struggled to accept my lack of control over this process. My unfamiliarity as performer only partly explains the feeling; more ambiguously, my agency was questioned to the extent that I could not react. Cameras reminded me that I had to be responsible for someone else.

Ethical concerns also emerged at a later stage of analysis: not only had I asked myself to what extent my space as a researcher was limited when conceding a portion of agency to an artist for a prolonged time, but I also critically reconsidered my relationship with the artists I engaged with during my research. If my experience as performer stemmed from a desire to move across borders, it ultimately suffered from specular limitations: while the spaces of fieldwork provided me with a facilitating zone for *collaborative*

exchanges and dialogical relationships with the artists, the outcome of my research was nonetheless constrained to a defined ethnographic space and research process of which I was the sole author. In fact, collaboration beyond fieldwork should move a step further toward a deeper conceptual exchange between agents (cf. Sansi 2015: 5). But how does this work in practice?

An uneasy relationship

After a short and timid clapping, Hong Kong-based curator Andrew Lam Hon-kin takes the microphone: "Honestly, I am not sure if and how your methodology can go along with performance art." After a few seconds, I reply: "Could you better explain what you mean?" Secretly, I know what he means . . . and he is probably right. (fieldnote, May 4, 2016)

On a wave of enthusiasm and curiosity following my own research, in 2015 I decided to accept an artist's invitation to engage in a collaborative project. Her interest in anthropology seemed to spark from a research practice that she instinctively felt akin to, as well as a desire for dialogue outside the theoretical art discourse and her willingness to focus on archiving and processes, an ability she related to the role of ethnographers.

Her appealing proposal included travel to southwestern China, where I joined the artist in two international live art festivals. Ideally, the journey presented an opportunity for common research and work: by confronting our practices, the initial idea was to experiment on the space and meaning of collaboration between artistic and ethnographic processes. We therefore planned to collect various materials for different aims and audiences (including a talk, an exhibition, a publication, a catalog, a performance) and identified three channels for exchange that suited both our practices: dialogue, reflection, and experience. All activities had to be documented throughout the process.

While recognizing our different roles and fields of competence, we seemed to agree on creating a common space for intervention and mutual trust. Initial steps were developed in Italy and consisted of a series of encounters and speculative conversations. It quickly became evident from our exchanges how the connotation of anthropology was blurred in her imagery: having discussed at length her practice and artwork, my practice as an anthropologist remained unclear. This manifested itself in a series of questions regarding ethnography, its methodologies, process, and research tools that I initially welcomed as a sort of inverted interview; however, the discussion soon reached the inner glitches of my being as an ethnographer, confronting me with an inconvenient uncertainty: What is my practice?

As time passed, getting involved in practical terms represented the most arduous task. Undefined common space for intervention started demanding clearer frames: critical issues revolved around observation (who observes what?), time frames for research, individual aims and an increasing need to identify a focus of research (a case study) to evade the anthropologist: the other binarism that seemed to unwillingly reign between us. Furthermore, the relationship began declining from festival routines and new encounters: most vividly, the necessity to justify my presence among other artists and the incapability to communicate the scopes of our project increasingly revealed how fragile trespassing fields of competence can be.

Besides the precious value of dialogue as a process and a few more pragmatic accomplishments, the collaboration started unveiling deeper fallacies and was interrupted shortly after returning to Europe. Tenuous efforts were made to resolve the *impasse* but the relationship resulted in being unfortunately compromised. Drastically, I was explicitly asked by the artist not to use any common material—meaning audiovisual recordings—nor to include "her passive voice" into my accounts. Further, she considered the possibility of publicly discussing the experience as unethical for one main reason: the unilateral perspective of an ethnography and the potential discrediting deriving from it. Finding myself in such a restricted and problematic space, I long wondered if and how to share this experience without using detailed ethnography nor presenting it as a personal controversy, and finally decided to reveal it in its failure.

Since this was my first attempt at collaboration, I blame my impractical thinking although a few considerations can be outlined. If ethnography is collaborative per se (Strohm 2012), boundaries and quality of interaction between ethnographers and their interlocutors are increasingly challenged by new partnerships and relationships (Sansi 2015: 144). Whereas the quality of exchange is defined in ethnographic fieldwork and collaborative interlocutors agree on being subjects of inquiry, a space of collaboration implies different settings, roles, and duties from both sides. However, this can only happen when kindred motivations are honestly shared. Above all, my desire for experimentation beyond text was not counterbalanced by similar needs from the artist; moreover, I often felt perceived as a laboratory scientist with meticulous methods, grids of analysis and tables of results. Yet, presenting ethnography as a creative and interpretative process merely frustrated my attempts and resulted in a series of questions that can be summarized as: Then why is it called a science?

Even though we never reached the point of transforming our materials, divergences were evident on this topic: while the artist demanded autonomy in the process of selection and re-elaboration of materials and could visualize potential outcomes, my ideas were blurred and abstract. Certain ambiguity

derived both from my sense of ethical responsibility and an overt need to being told "what to do" by the artist: all in all, despite my revolutionary aspirations to engage alternatively, I realized I have merely been an in-depth participant observer.

Notwithstanding experimental efforts to do fieldwork differently and the increasing desire to engage in interdisciplinary collaborations—often an anxious imperative, as Marcus describes (2007: 34)—the necessity to reimagine the political space of fieldwork as both a space of empirical fact-finding and imagination (ibid.: 43) is urgently needed. In fact, the theorist "is always presented with the task of catching up while the practitioner moves forward to create a concrete new 'theoretical' manifestation waiting to be articulated." This might lead to a silent frustration and nothing more than "a petulent, misunderstood, and competitive halt," Roberta Mock suggests (2002: 2–3).

Arguing against "the dominant rhetoric of interdisciplinarity," Des Fitzgerald and Felicity Callard (2014) suggest that "collaborating might be imagined not only simply as working in conjunction . . . but might also unsettle the sedateness of such conjunction." In other words, the space of collaboration, or "experimental entanglement" (ibid.), cannot only be based on dialogue and exchange but its kind, quality, tempo, structure, ethics, and outcomes have yet to be negotiated. Drawing from Rancière's *Distribution of the Sensible* (2004), Kevin Strohm similarly argues for a redefinition of the anthropological episteme not on ethical and moral terms (which presuppose the existence of given inequalities) but in terms of politics: from this perspective, collaboration requires a necessary disruption of the boundaries between anthropology and its other (Strohm 2012: 119). Strohm's point of departure is a reconsideration of the anthropological episteme as a form of policing, "an episteme that configures and distributes the ethnographic scene" (ibid.: 108). It follows that the primary issue is not to produce a trustworthy representation; rather, "to understand how the anthropological episteme led to such a representation to begin with, and to allow for its disruption and reconfiguration by the subject of politics; namely, the ethnographic subject" (ibid.). As Strohm concludes, it is only in those collaborative encounters that the aesthetic experience can activate a disruption and redistribution of roles and places of anthropology and its other, hence of what can be done within the anthropological episteme (ibid.: 117). A critical question nonetheless resonates: Why should artists be interested in collaborating with anthropologists?

In seeking answers, I found comfort in the three-day *Connecting Art and Anthropology* (CAA) workshop organized by Amanda Ravetz in 2007, which gathered artists, curators, and anthropologists to discuss possible collaboration. Through its extensive online documentation, both points of encounter and disagreement are shared: unfortunately, the project did not

evolve and the possibility of a residency mentioned in the closing remarks[10] never happened. Reflecting upon her participation in CAA, Anne Grimshaw writes in her report:

> I have found myself returning to what seems to be a simple yet fundamental difference between anthropologists and artists. It is not to do with individual creativity, aesthetic forms, disciplinary conventions. It relates to human subjects. To be an anthropologist you have to be interested . . . in how people experience, live in and imagine the world. Artists may be interested in this too but it is not the necessary foundation of the work they do.[11]

In my failed collaborative project, a residency was also contemplated as a potential space-time frame that could suit the artist's practice and fieldwork, thereby meeting my needs for "serious methodology" and establishing proper time frames for both of us. This may have shifted the attention toward a more effective practice involvement, but it never happened and, honestly, I doubt it would have succeeded within these premises. In fact, I agree with Grimshaw and interestingly found easier connection and conceptual exchange with other kinds of creative processes than only those specific to the visual arts: among others, I had insightful dialogues with graphic designers on potential visualization of text through other forms; with scenographers on the use and transformation of ethnographic space; with theater directors on the possibility of communicating theoretical discourses through a different, experiential language; as well as with art curators on the challenges that practical collaboration with artists entail. In my experience, this relates largely to their client/audience-oriented attitude and their ways of working, if not always in accordance with, at least in conjunction to a wider range of professions.

Conclusions: Parallel convergences

Whereas the artist's presence and the reading of its documentation long occupied a key space in the art theoretical agenda on performance mostly in terms of authenticity and representation (see Féral 1982; Jones 1997; Auslander 2006), the inclusion of performance into the ethnographic scene generates alternative considerations. My experiences reveal that, by changing positions and moving across fields and borders of authority, the ethnographer experiences different types and quality of relationships that lead to a series of intertwined reflections.

First, while the presence of an audience certainly constitutes a pivotal element of performance, artists are not always interested in having

sympathetic relationships with their spectators. As provocative artists, they are neither concerned with spectators' needs, nor eager to be literally understood. Co-presence and intersubjectivity in performance seem therefore to have little to do with value: if meaning and sense should derive from an interaction between artist and beholder in Bourriaud's *Relational Aesthetics* (2002), the artist in performance is less interested in creating or providing any meaning at all. Stemming from an understanding of individual experience as a critical practice, performance has more to do with sharing experiences than exchanging values, and *shared* experience does not mean *same* experience. Consequently, whether we victimize spectators as recipients of an artistic tyranny (Bishop 2012) or we emphasize their interaction as the ingredient for a democratic and socially engaged art, we likewise fail in considering their multiple perspectives as well as the different understanding of spectatorship that each artist presents.

Similarly, the terms of participation, collaboration, and delegation in performance are highly subjective and the artist's presence alone cannot be taken as discriminatory. I feel that unaffected accounts of performance and art more generally reinforce on art and audiences complicated readings that seem to engulf artworks within a glossy, nebulous, intellectual, and theoretical dimension. Given also anthropology as an inherently interpretative discipline, firsthand experience and in-depth, prolonged empirical research holds the potential to engage effectively, and affectively, with art practices. Yet, crossing borders between disciplinary and intellectual contexts is not always an easy exercise: beyond apparent methodological and thematic affinities, the aesthetics of fieldwork and those of artistic processes differ fundamentally (Schneider 2015).

As the domain of performance merges with ethnography, new challenges are therefore being tackled: points of encounter and resistance between these two political dimensions are numerous and the spaces of collaboration do not always dwell harmoniously. In my experience, not only was I afraid to face an unknown audience but also, moving across fields of competence implied a certain ambiguity that I made efforts to accept. I often wondered which I would be, an inquisitive researcher or a pseudo-artist?

Further, collaborations between anthropologists and artists affect independency from both sides, as a portion of agency is ceded to the other for the sake of dialogue and exchange. However, as Arnd Schneider highlighted, dialogue does not imply level positions between partners, nor sympathetic relationships:

Future art-anthropology collaborations will have to deal with certain parameters coming from different disciplinary backgrounds, and certain

eruptive fault lines . . . around which productive, but contested and sometimes conflictive dialogues will develop. (Schneider 2015: 25)

Besides looking at what practitioners do (see Geertz 1973), the transformation of the anthropological inquiry, its subject matter, the processes through which its knowledge is produced and its formal outcomes are thus central (Strohm 2012). This ambitious process might result in a series of failed attempts and debated, fragmented results: for collaborations to lead somewhere else, all parties should be willing to move within the unknown. Overprotection of individual spaces, as I perceived in my attempt at collaboration, does not open such a possibility.

Overall, like action artists, contemporary ethnographers have the right to recognize themselves as constituent to their research, both in their conceptual stance and pragmatic engagements. While artists often suffer from being constantly required to interpret and conceptualize their practice, I find the tendency to limit the work of anthropologists to ethnography and the collection and analysis of materials as purely anachronistic: whereas the process of sense-making through writing has been largely achieved, perhaps the time to produce sense through practice has also arrived.

Acknowledgments

I wish to thank Thomas Fillitz for supporting my work and sharing his suggestions throughout the writing process. My thanks also to Anita Kreffl for her patient proofreading, Diego Federico and Goda Palekaitė for their comments on earlier versions of this chapter, and all the artists involved in my research.

4.2

Contemporary Art in the Global South: Occupation // Participation // Knowledge

Alex Flynn

Notions pertaining to the theoretical platform that has come to be known as the "Global South" are increasingly present in the discourse and practice of contemporary art. But how to define such a broad theoretical project? Definitions that point to the contested spatiality of the term provide a useful starting point. The Comaroffs argue that "whatever [the Global South] may connote at any given moment, it always points to an 'ex-centric' location, an elsewhere to mainstream Euro-America, an outside to its hegemonic centers, real or imagined" (2012). Matthew Sparke, however, takes a subtly different approach, one that echoes the concerns of a very particular type of extra-institutional contemporary art: "the Global South is everywhere, but it is also somewhere, and that somewhere [is] located at the intersection of entangled political geographies of dispossession and repossession" (2007: 117).

Given the diversity of definitions, and bearing in mind this notion of spatiality for the purposes of this chapter, I choose to focus attention more particularly on the theoretical apparatus of the Global South platform. What I would like to call attention to is how this platform resonates throughout, but is also informed by, the discourse and practice of contemporary art practitioners at once in the everywhere, but also the somewhere. The Latin American scholars of the *modernidad/colonialidad* network (hereafter referred to as the M/C network), including Aníbal Quijano (2000, 2007), Walter Mignolo (2007,

2009, 2011), Arturo Escobar (2007, 2008), and Enrique Dussel (1998, 2008), have put forward a series of theoretical and practical tools that underpin the Global South platform including "epistemic disobedience" (Mignolo 2011: 122–23); "epistemic de-linking" (Mignolo 2007: 450); and "epistemic reconstruction" (Quijano 2007: 176). Mignolo argues that in order to realize alternative worlds, worlds that exist beyond the imaginary of the imperial, one must start with a process of epistemic de-linking, which in itself is the result of acts of epistemic disobedience. Rejecting the thinking of an imperial/colonial knowledge, one that is premised upon the mercantilization of life, requires alternative models of knowledge generation, and a key aspect of the Global South platform is that it seeks to decolonize not just knowledge, but also importantly, the apparel of knowledge-making. This second moment therefore seeks to create conditions whereby a re-signification of meaning is possible, distinct from "the web of imperial/modern knowledge and from the colonial matrix of power" (Mignolo 2009: 23).

In this chapter I focus on how contemporary art practitioners engage with notions of epistemic disobedience and the production of knowledge, both responding to and generating theoretical insights for a corpus of theoretical discourse. This study, situated at a particular interstice of aesthetic production and knowledge generation, complements similar work carried out by Teresa Caldeira (2014) on how youth groups and their artistic interventions re-signify spaces of the city, María Elena Lucero's decolonial reading of two of Hélio Oiticica's most emblematic works (2009), Thomas Fillitz's (2016) demonstration of how South-South circulation of artworks occurs at the Biennale of Dakar, and Mignolo's own growing involvement with artists and curators, such as Pedro Lasch and Alanna Lockward.

Building on such scholarship, I argue that contemporary art theory and practice is assuming an ever more important role in the configuration and reconfiguration of the Global South platform. The emphasis that this platform places upon knowledge generation means that artists working from within this paradigm encounter and respond to an entirely different notion of "participation" than that articulated by Claire Bishop (2004, 2006, 2012) or Nicolas Bourriaud (2002). I further argue that what characterizes and shapes these processes is their location: marginal to the apparel of mainstream academia, and positioned at the porous frontier of institutional and noninstitutional contemporary art spaces, these practices occur instead from within a skein of networks and hierarchies deriving from multiple modes of life. And it is this crossing of axes—the horizontal and the vertical, the mercantile and the post material, the ephemeral and the utopian—that renders such re-signification, participation, and production of knowledge entirely unique.

Traditionally, scholars have pointed to large-scale organized social movements such as the Zapatistas (Juris and Khasnabish 2013) or the Landless Workers'

Movement (Graeber 2002), or even in extremely generic terms "Global South grassroots movements" (Starr 2005: 155) as torchbearers of the kind of societal change that epistemic disobedience points toward. This is not in any way incorrect: social movements have been and continue to be absolutely central to the imagining of new worlds. What I seek to highlight in this chapter however is contemporary art practitioners' and participants' particular role as theorizing agents, and how a particular type of contemporary art generates theory that complements and complexifies the work of decoloniality scholars, thus pointing to different ways to exist within the world.

The skein of artistic practices that I describe in this chapter puts forward a new proposition, one that invites the creation of meaning in a sense which is intrinsically multiple and based in the social. Kelly Gillespie contends that "shifting the basis of our knowledge is shifting our way of being in this world" (personal communication, 2015) and the following ethnography demonstrates how artistic practice connects to relationality, and the elaboration of meaning to as yet unknown imaginaries and societal change.

Contemporary art in São Paulo

An eight-lane highway in the middle of downtown São Paulo. Underneath the asphalt is a hidden river, just one of hundreds of underground currents that traverse the city. On Friday and Saturday nights, at this particular intersection, there is a club for rock kids. The pavement fills up and Led Zeppelin drum fills blare out. Next door, there is Bin Laden's *boteco*, a small bar where the owner models himself on Osama Bin Laden: he uses military fatigues all day, wearing a long gray beard and turban. Then there is the *churrasco do gato,* the "cat BBQ" where street vendors sell grilled meats, right next to a club called Caravaggio's, where the smoking section rubs shoulders with the Palestinian immigrants who have set up a restaurant that has been tear-gassed by the police, which itself is next to a small community of homeless people who live under a viaduct. In amid this dense confluence of humanity is a tall building, the Occupation Hotel Cambridge.

Tonight's event is a talk by Raquel Rolnik, former UNHCR special rapporteur and current architecture professor at the University of São Paulo. She is going to speak about her new book, *Guerra dos Lugares* (the War of Places, 2015) as part of the artist Ícaro Lira's residency program at the *Residência Artística Cambridge*.

The *Residência* takes place within the Occupation Hotel Cambridge, a former luxury hotel that went from hosting celebrities like Bing Crosby and Nat King Cole in the 1950s, to charging for rooms by the hour in the 1980s and

FIGURE 4.2.1 *The Occupation Hotel Cambridge. Photograph by Alex Flynn.*

1990s, before becoming a nightclub, and then finally an empty and abandoned space. On entering, there are marble steps, and then *grades*, iron bars, behind which is a huge red door. It is made entirely of metal, and there is a sliding section to see who is on the other side. It is behind this door that in 2012, the Movimento dos Sem Teto do Centro (Movement of Homeless in the Centre, MSTC) barricaded themselves from the police to occupy this building. Later, residents tell me that in occupying the building, collectivized teams of labor removed fifteen tons of rubbish, before the 170 families could properly move in: 500 people dwelling in a fifteen-story building without elevators, sanitation, electricity, or privacy.

In the lobby, an MSTC leader, Carmen, shouts at me from the mezzanine. "Let's go Alex, they're all here." Carmen got to know Eliane Caffé, a São Paulo director, and together they worked on a film about the occupation, "The Cambridge Squatter." Juliana Caffé, Eliane's niece, accompanied the process, and having discussed various ideas with Yudi Rafael, the two curators opened

FIGURE 4.2.2 *Carmen da Silva Ferreira, one of the leaders of the MSTC. Photograph by Luiza Sigulem.*

successful discussions with the MSTC leadership about the possibility of a one-year artistic residency program within the occupation.

One flight of steps up is the space called the library, and the room is absolutely full. Raquel Rolnik stands at the front holding a plastic microphone that is plugged into a speaker on wheels. Next to her is Ícaro. He looks nervous, standing with his back to a pillar, directing Juliana and Yudi to get more plastic chairs. There are large red flags stretched across the walls and the sound of the traffic from the highway below comes through the open windows. It is April 19, 2015, the very first event of the Ícaro's three-month program, and the very first event of the *Residência Artística Cambridge*.

FIGURE 4.2.3 *Ícaro Lira. Photograph by Alex Flynn.*

Ícaro speaks first. The audience is mixed, comprising urbanists, residents of the occupation, students, artists, journalists, curators, and university researchers. Ícaro speaks about a different type of artwork, and how important it is to have Raquel speak, here, in this place, at this time. He thanks some people, including Carmen, who is sitting at the front with her arms folded. And then he finishes, handing the microphone quickly to Juliana and Yudi, before going to pace at the back of the room. Yudi and Juliana are equally tentative. It feels strange perhaps to introduce a work of art, which will take the form of a talk, from someone so eminent, from within inside an occupation. Dimensions of social stratification are visible in the room: the occupation's residents arrive later, as they are coming in from work. There is an easily observable differentiation in how they dress, compared to the academics, artists, and students. In fact, Ícaro, in his short opening address, comments that it is a shame there aren't more people from the occupation present.

Raquel by contrast, after these preliminary speeches, dominates the stage and effortlessly communicates complex academic ideas to a mixed audience, arguing how adequate living conditions are a citizen's right and how political and economic systems throughout the world have failed to provide these rights for the majority of the world's citizens. Underlining the predatory tendencies of the global property market Raquel talks directly to the occupation's residents, arguing that it is only through direct action in concert with different sectors of society that the colonialization of land and living conditions can be combated.

After Raquel's talk,[1] Carmen, unexpectedly, takes the microphone. Yudi, Juliana, and I exchange glances. Carmen gives a strong speech that moves people to cheers, again dominating the stage, and demanding the attention

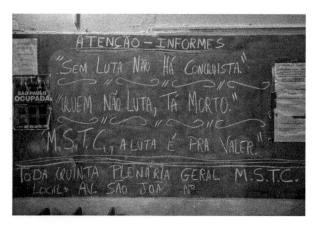

FIGURE 4.2.4 "Quem Não Luta Tá Morto." *Photograph by Luiza Sigulem.*

of everyone present. It is impossible not to be impressed by her incredible performance. After Carmen has finished speaking, there is time for questions and discussion. There are some specific questions on urbanism as well as solidarity comments that echo Carmen's speech on the necessity to fight. As the MSTC slogan goes: *Quem Não Luta Tá Morto*—who doesn't fight is dead.

Afterward, the curatorial team and friends go to a bar and people are relieved and surprised by how well the event turned out. Raquel's speech has reached many different audiences and on the way out there are moments of *confraternização*: the curatorial team chat with the occupation's residents, introducing themselves and outlining the *Residência* and what they hope will happen. Ícaro invited me to the project initially in exactly this spirit, to exchange ideas, and offer a different angle: little do we know, I shall end up working in the *Residência* for the next year. In the bar, the main subject of conversation is how the *Residência* can communicate better— through posters and videos—to try and reach different people. There is a strong concern about audience and how to involve more residents in Ícaro's program.

The curators order more drinks and I am surprised to see how reflexive they are about their own practice: it is three in the morning and they are still talking about what it means to be conducting art events in an occupation in the center of São Paulo: what it means that Carmen grabbed the microphone; how her presence as a leader created a certain dynamic; how we can better facilitate discourse from the floor without forcing the issue. A major concern is the movement's vertical structure of leadership, and whether Carmen will "order" residents to attend the project's activities. We think ahead to future events: How can the project best facilitate a free exchange of opinions?

It has been a good night but I understand from the others that this is just the beginning, a feeling reinforced by a sketch that Ícaro shows me from his notebook a couple of days later, detailing his proposed activities for the remaining two months:

A further five public talks; walks for project partners to other MSTC occupations; a film census reaching all 170 families; a group of psychotherapists to meet every two weeks offering group therapy within the occupation; a work group to investigate the library's potential as a communal learning space; fortnightly cinema club events with films tied to each public talk; workshops with an independent publisher aimed at the occupation's children; and a book, containing contributions from everyone who participates in the project, with critical reflexive texts. It is going to be a busy period.

FIGURE 4.2.5 *Planning a residency. Photograph by Alex Flynn.*

Epistemic disobedience

A sense of traversing the institutional is both explicit and implicit to the positionality and practice of the *Residência Artística Cambridge* and occupies many layers. At its simplest, the *Residência* was an artistic residency program that invited four artists to each work for a flexible three-month period during a theoretical calendar year.[2] However, the location of the *Residência* was key to the artists' practice: removed from the typical spaces of the contemporary art world, the *Residência* invited artists to work within a radical social movement, enter into unmediated daily dialogue in a residential building that houses 500 people, and conduct a research process in one of the most stigmatized locations of downtown São Paulo.

The occupation is one of nine spaces managed by the MSTC, itself part of a wider collective, the Frente de Luta por Moradia (FLM, Front for Just

Housing). This collective articulates the struggle for the right to a home within a very specific and hostile context: São Paulo is one of the most unequal cities in the world, characterized as a series of fortified enclaves (Caldeira 2000), and as such, the *Residência* responded to, and articulated, a very different understanding of contemporary art practice. Importantly, this understanding was underpinned by the inevitable encounters of various axes: aesthetics and politics; artistic and activist intervention; the ephemeral and the utopian; and the horizontal and the vertical.

The *Residência* was also entirely unfunded: curators, artists, and collaborators all worked for free. The lack of financial relationships or sponsorships is unusual for a project that is entirely nonprofit, and for the *Residência*, it meant that the project had limited access to technical support, although photocopying, printing, and basic A/V was provided by the office of the MSTC. This lack of sponsorship was not accidental. Through repeated interviews with the curators, it became clear that the *Residência* sought to explicitly position itself against more commercialized contemporary art enterprises. The curatorial team returned time and again to the fetishization of the object and the mercantilization of artistic labor, and as the residency's program progressed, the curatorial direction of the project began to orient itself toward a post-material understanding of contemporary art: many times I was informed that without tangible objects, it is harder to make a sale.

Situated thus on the borders of the contemporary art world in diverse senses, the project considered itself not only extra-institutional but also experimental. In this sense, the curatorial team argued that the project put forward a broader proposition that went beyond its marginalized location, which in any case is nothing new,[3] in seeking to enact a prefigurative politics: to embody within its everyday political practice the forms of social relations, decision-making, and de-hierarchization that could contribute to discussions of how contemporary art projects articulate themselves. This is perhaps the most significant level on which the *Residência* sought to de-link from more market-oriented art world institutions: one of the key elements of the *Residência* was the desire to create horizontality within the relationships of the project, and thereby, open a reflexive space that proposed an ongoing critique of the project, the project's activities, and the parameters in which it operated.

Walter Mignolo cites Partha Chatterjee's conviction that in order to re-orient "eurocentered modernity" toward future local modernities, it must be realized that knowledge itself is premised upon "an intricately differentiated structure of authorities which specifies who has the right to say what on which subjects" (Chatterjee in Mignolo 2009: 12). The relationships between the *Residência*'s curatorial team and the artists moved away from more traditional models, where an artist's work is generally expected to exist within a specific time frame and perhaps may even be subject to veto by an institution director, a gallery

owner, or an influential collector. Discussions between project participants were open, a-hierarchical and sometimes difficult, and this horizontality highlights the endless points of conflict between which the project moved. The project's understanding of horizontality and attendant possibilities of dissonance in this sense was much more influenced by theoretical work of alterglobalization scholars/activists such as Marianne Maeckelbergh (2009), Jeff Juris (2008), and Maple Razsa (2015) as opposed to art historians, whose use of term can be more imbricated with the possibility of all images being "aesthetically equal" (Groys 2010).

The *Residência*'s conditions of precarity, its de-hierarchized organizational structure, and its focus on noncommercial art thus all gesture toward a disobedience, a distancing from art world models that reflect what decolonial scholars term the magic "western modernity" (Coronil 1997, Chakrabarty 2000) but also, importantly, narrow definitions of aesthetics. The AestheTics/AestheSis research group argues that decolonialized artistic practitioners seek to reject compliance with "the beautiful and the sublime . . . to undo, to heal, to celebrate, to empower themselves and spread the empowerment by building networks, communities and love."[4] The call to arms separatism of this statement is clear enough: by contrast however the *Residência*'s proposition is of analytic interest precisely because its horizontalized process acknowledged the project's limitations in being situated within long-standing vertical structures of power.

The questions that such reflexivity gave rise to were multiple and interconnected. For example, to what extent could a contemporary art project realistically "go beyond," as the *Residência*'s discourse phrased it, the contemporary art world in which it was embedded? Alongside their participation, all the artists within the *Residência*'s program were contracted to powerful commercial galleries, and it became a question as to how these relationships would manifest themselves in the future. Project participants also asked each other whether the project could really be considered extra-institutional, when it operated within a centrally conceived, and organized, social movement where one leader could determine an entire family's future with a non-contestable decision. A recurring question became what would the desire to enact horizontality entail on a daily basis? What kind of knowledge, or art, or output could be produced by a horizontalized project that operated in interstitial spaces characterized by their verticality?

In thinking through processes of re-signification, it is striking how these contested spaces became key research themes of the project. For example, working within a social movement context that is centrally conceived and organized, the *Residência* encountered and responded to an entirely different notion of "participation" than that articulated by Claire Bishop or Nicolas Bourriaud.

Participation and the production of knowledge

Participation had always been a theoretical focus for the *Residência*, as exemplified by Ícaro's comment at the very first event. But what kind of participation could occur where axes of verticality and horizontality crossed, the point that in mathematics is called the "origin"?

As the months passed, it became increasingly clear that the *Residência* was operating both within and without of a social movement logic that seeks to mobilize and massify its members and structures. This social movement technology is premised upon a pyramidal structure of power, and the charisma of leaders to place a large group to a defined and often utopian purpose. This paradigm appears in scholarly analysis variously focused on "collective behaviour" (Park 1967), "mob mentality" (Arendt 1951), or "rational choice" (Olson 1965) but the activities articulated by the *Residência* were, from the very start, premised upon a very different understanding of what it means to participate. The first resident artist, Ícaro Lira, and the second artists in residence, Jaime Lauriano and Raphael Escobar, all worked with an artistic process that was entirely non-obligatory. While Ícaro organized public talks, workshops for the occupation's children, and cine-club nights for a more general public, among other activities, Jaime and Escobar's residency centered on cooking a series of three communal dinners, each attended by around forty of the occupation's residents.

The curator and theorist Nicolas Bourriaud argues in *Relational Aesthetics* (2002) that art should be evaluated with reference to the relations that the work facilitates and the models of sociality that it proposes. In this understanding, an artwork "has as its theoretical horizon the realm of human interactions and its social context" (2002: 14) creating "micro-utopias," temporary spaces in which people can enter into dialogue and create meaning in a democratic manner. Both Ícaro's and Jaime and Escobar's approaches entered into a certain dialogue with relational aesthetics: the focus on post-material art in the *Residência*'s discourse meant that an association with the paradigm was inevitable, although none of the artists ever cited it as an influence. Indeed, what distinguished these artists' work from the relational aesthetics paradigm, was the temporal dimension in which their activities took place.

In their own ways, both of these first two residencies focused on relationships, networks, and the creation of a space in which meaning could be elaborated: the micro-utopia, in Bourriaud's terminology. But working alongside residents over a period of months made possible a symbolic redrawing of the lines and practices of how not only the occupation was perceived and experienced, but also the *act* of occupation itself. The non-obligatory nature of the artists' activities stood in stark contrast to many of the collective

duties set out by the MSTC leadership. To ensure the smooth running of a residential space, and in a social movement paradigm that has been described as pragmatic (Carter 2005; Mezsaros 2000), there are obligatory cleaning duties, collectivized work parties and general assemblies, as well as a level of discipline regarding drinking, parties, and noise. Whether one agrees with such dimensions of personal discipline within a communal space or not, the artistic processes that were conducted within the *Residência*, whether they were invitations to dinner or public talks, make clear that participation was a neither a one off visit to a museum or private gallery to engage with any given artwork in the Bourriaud paradigm, nor experiencing what Claire Bishop terms a more antagonistic experience (2004), one driven by motives of activation, authorship, or community (2006: 12).

What emerged from the *Residência*'s positionality at the heart of a social movement and at conflicting logics of organization, is that participation had an *a priori* definition for the occupation's residents, a conditionality that is absent from the analysis of both Bourriaud and Bishop due to their focus on the artist, as opposed to the work's content itself, the people, who ultimately comprise its legitimacy. Liam Gillick describes it thus: "My work is like the light in the fridge. It only works when there are people to open the fridge door. Without people, it's not art—it's something else—stuff in a room" (2000: 16).

Gillick is one of the artists with whom Bourriaud worked while conceptualizing relational aesthetics, and his assumptions concerning participation and temporality are revealed in this citation. For Gillick, work only becomes art when someone opens the fridge door. In this understanding, another person might open the door, or another, but it will only be for a brief moment that light is shone upon his work, and each person's capacity, or manner of "opening the fridge door" is presumed to be the same. In other words, a person is interchangeable for Gillick, their function being merely to "shine light." By contrast, in the *Residência*, where the horizontal meets the vertical, participation was anything but an endless resource to be herded by a mounted police officer around the Tate Modern, or a mechanical opening and closing that could be performed by an automaton. It was rather a currency that underpinned the primary reason to be a member of the MSTC, in that it was exchanged for, and subjectively equaled, the right to a home. Without having actively participated, first in one of the many MSTC grassroots communities throughout São Paulo's suburbs, and then later if selected for an apartment, in an occupation itself, there can be no sustainable and long-term relationship between resident and movement. This lead to a re-signification of the term participation as the occupation's residents come to discrete and personal understandings as to what any given artistic event proposed by the residency was for, whether it was obligatory, and if not, whether it was worth attending.

At one group therapy event, the psychotherapists were puzzled that forty residents were present, whereas a more normal attendance would be less than ten. As per routine, the facilitators went around the group to make introductions, and when asking why participants wanted to take part, a resident explained that he was present because leaders had told him it was a good idea and that it was worth "points." Theoretically, this model is closer to notions of participation as outlined by Angelique Haugerud's ethnography of the Billionaire's movement in the United States where as one executive committee member states: "Surprise surprise!—people who do the most work have the most power" (2015: 153) than the alterglobalization activists detailed by Marianne Maeckelbergh, who see participation as key to the process of prefigurative politics (2009: 72). But fundamentally, focusing on the people who participate, as opposed to viewing participation as a curatorial input, reveals that in the interstices of social movement and artistic practice, participation has a symbolic position in a complex relationship structured by exchange: residents set aside energy and time to participate, in exchange for the right to a home. For a lot of residents, investing in participation was a unique gift that they traded in exchange for an affordable housing solution. But of course, in an anthropological understanding, and thinking alongside recent scholarship (Sansi 2015), such a gift, here taking the form of participation, must contain a *hau*, the spirit that lives within all gifts and that seeks to return to the original giver. But what is this return for the artist that steps casually into a complex series of preexisting relations? And how can art which seeks to not be mercantilized, move away from being reduced to a commodity, and yet offer a clearly defined return: what form will the *hau* of the artist take?

These questions and many others were subject to reflection within the project, a central aspect of the *Residência's* attempts at horizontality. Maeckelbergh's emphasis on horizontalized participation as key to the process of enacting prefigurative politics is important in this analysis. The implicit and explicit epistemic disobedience inherent to the *Residência's* project created a certain friction in its interaction with at least two spheres: the wider political ecology, as Arturo Escobar would term it, of the contemporary art world, and the pragmatic logic of the MSTC. But how did this work toward the re-signification of the act of occupation? One of the daily practices that underpinned the wider desire to horizontalize within the *Residência* was the way in which practitioners sought to conceptualize the structures in which they operated. Through their work, the artists Ícaro Lira, and Jamie Lauriano and Raphael Escobar called into question how the project worked with, mitigated, or even sought to challenge the pyramidal logic of mobilization on the one hand, and the market-driven exploitation of the potential of aesthetics on the other. These artists negotiated continually with the curatorial team, their galleries, the MSTC leadership, and the occupation's residents, to try

and understand what constituted an occupation with aesthetic connotations, and how notions such as participation could be rethought through artistic intervention.

Recent scholarship highlights efforts to decolonialize academic knowledge production and create a space open to horizontal dialogue between epistemes from different traditions. Robert Aman in a Latin American context (2016) and Sabelo Ndlovu-Gatsheni and Siphamandla Zondi (2016) in an African context both seek to re-mean academic space and therefore the type of knowledge that can be produced therein. The *Residência* addressed notions of participation through the activities of its resident artists, but it also offered a possibility to make a comment on what occupation is, and how, through interacting with 500 individuals every day for a full year, the role of contemporary art could be reconfigured. The curators, Juliana and Yudi, rejected the notion that what they were doing was activism, as did the artists. The core activity for these practitioners was based upon an aesthetic platform, albeit one that sought to disengage with Kantian ideals of beauty. The artist Hito Steyerl echoes Matthew Sparke's deterritorialized perspective on the Global South when addressing what an occupation can mean, and where it might exist:

> The territory of occupation is not a single physical place, and is certainly not to be found within any existing occupied territory. It is a space of affect, materially supported by ripped reality. It can actualize anywhere, at any time. It exists as a possible experience. (2011)

The practitioners of the *Residência* sought to move away from the reification of art and the artist, and not just open, but sustain, possibilities of dialogue with the everyday, the relational, and the seemingly invisible. In this scheme, the project invited people from both within and without of the occupation site to "occupy" and be disobedient in a myriad of different ways, recognizing the unique resonance and political significance of the Hotel Cambridge for the wider urban space.

Networks

The *Residência*'s work in the interstices of aesthetics and politics, and the vertical and the horizontal, meant that it provoked a constant current of diverse collaborators, drawn from both within and without the occupation, inside the occupation's physical space. Ícaro described his project as the installation of a network while Jaime and Escobar's strongest motivation was facilitating better connections between the residents of the occupation and diverse

actors in the wider city. As the project progressed, I began to understand that it was the specificity of these connections that underpinned attempts to re-signify core everyday political concepts.

When the *Residência* first started in the occupation, beyond the metal front door and grades, all windows at the back of the building were not just protected by metal bars form the outside, but were also boarded up on the inside of the building by large sheets of plywood. The occupation, in its early moments in 2012, was also a fortress of sorts, as the leadership feared eviction by a hostile military police.[5] Both Ícaro's, and Jaime and Escobar's projects sought to build closer connections between the occupation and the wider urban landscape in which it is both embedded and marginalized and the efforts of the project as a whole created a lot of media interest and paths of intellectual, journalistic, and critical transit in the occupation's space. One of the most notable examples of how this transit led to a re-signification was in a broadsheet feature on the *Residência* in one of Brazil's most conservative newspapers, *Estadão*.[6] In the article, the Hotel Cambridge is repeatedly referred to as an occupation as opposed to an invasion. This distinction seems small, but in the deeply politicized environment of São Paulo, it is highly symbolic, conferring legitimacy upon the Hotel Cambridge that the vast majority of occupations are denied. "To occupy" and "to invade" also connote different legal states, in which the former makes reference to a constitutional legal clause[7] and therefore the possibility of legality, whereas the latter invokes the civil notion of trespass, which places the "invader" at the immediate mercy of police action (Hammond 2004). Two weeks after the publication of the article, Carmen stated that such coverage was a victory, and that the MSTC had never been represented this way by the broadsheet press. At this point, project participants began to consider the symbolic transformation of the Hotel Cambridge's space, and how the aesthetic connotations of their work had facilitated this re-appropriation of a term.

The series of dinners organized by Jaime and Escobar equally sought to create a transit of ideas, but being closed events, the focus was much more on the relationship between artist and resident. At the dinners, and through long conversations not just at the dinner table, but in the process of inviting each resident personally by going door to door, the artists developed an understanding of the kinds of professional services that are offered by members of the occupation. Jaime and Escobar built a network of trades and skills, with the aim of creating a form of aestheticized "White Pages" document. Their aim was to highlight how the occupation was unnecessarily marginalized from the everyday flux of small commercial trades that characterize São Paulo, or any other city, and reinforce the idea that residents of the occupation were not skills deficient, or in need necessarily of charity and donations, but that they were individuals with skills and agency. The concept of a form of "White

Pages" document led Escobar to create a series of business cards for small businesses inside the occupation, and eventually create a series of backlit logos that were installed above each business' place of work.

Through an incremental process of events, public talks, newspaper and magazine headlines, and the re-appropriation of the vocabulary of occupation, the *Residência* helped to contribute toward a re-signification of what an occupation could be. In the period in which the *Residência* was active, the mayor of São Paulo gave a campaign speech in the library, the occupation applied for formal recognition as a cultural space, a Brazilian cinema actress gave a talk at a cine-club event, and a whole series of relationships between residents and project participants were forged, a process that could never have occurred if the project had taken place over a shorter time frame.

In this sense, the production of knowledge within the occupation occurred through a specifically contextualized network. The activities of *Residência* were the result of, but also constituted by, a series of conversations from radically different perspectives, many of which centered on ways of living in the city, driving a research process to create different forms of knowledge, from outside of the academy. The diverse activities of the *Residência* promoted the notion that knowledge was not something that could be restricted solely to institutional spaces, but that it would inevitably irradiate from within a community, through the activation of relations of worlds that are, and worlds yet to be.

Conclusion

The *Residência Artística Cambridge*'s particular type of open-ended contemporary art practice, embedded in the relational, and articulated within a certain temporal framework, provides a glimpse of García Canclini's notion of the locus of "imminence" (2015). One of the key motivations of the *Residência*'s project was the creation of networks that could extend from the architectonic space of the occupation, and beyond São Paulo, to contemporary art contexts around the world. The practitioners within the *Residência* did not intend their project to be a model for other projects. On the contrary, their only pretension was that in creating a horizontal space, contextualized by the vertical, and all within a certain temporality, a reflexive space could be opened in which discussion around the future of contemporary art could take place. This stance was underpinned by the problems inherent in reconciling the specificity of the local with the problems of representation of the global: there was a strong belief in the specificity of the *Residência* and the curators

resisted the idea that the project could continue beyond its designated time frame.

The *Residência*'s implicit and explicit dimensions of epistemic disobedience created a particularly situated type of knowledge that would necessarily be different in another context: what transgresses hierarchies in São Paulo will be different to similar processes in Berlin. In this sense, the dissonance that the *Residência* created is key to understanding how entirely "de-linking," could in fact potentially limit the most interesting conditions of any given process of aestheticized research. What rendered the processes of re-signification and production of knowledge so interesting in the *Residência* was precisely the understanding that this was occurring at inevitable points of conflict: one of the program's key achievements was precisely to make visible the very contradictions upon which it was based. In this sense, participation and knowledge collided under very specific circumstances: the crossing of axes of the vertical and the horizontal, the ephemeral and the utopian, and the confused positionalities of a multiplicity of actors, enabled invasion to become occupation, occupation to become appropriation, and post-material contemporary art practice here becomes ethnographic academic knowledge.

4.3

The Idle Goddess: Notes about Post-Relational Anthropology and Art

Roger Sansi

In the last few decades, we have witnessed the emergence of both "relational art" and "relational anthropology." The purpose of this chapter is to trace the connection, or better, the relation, between both. From there we will look at their aftermath—what has come after relational art and anthropology?

Relational art and its critics

At the turn of this century, Nicolas Bourriaud's book *Relational Aesthetics* (2002) presented a generation of artists who worked with social relations, rather than objects. Felix Gonzalez Torres made piles of candy in geometrical forms, like pyramids or rectangles. But the artwork was not in its material form: these piles of candy were offered to the public, until the pile was emptied and filled with candy again. The "artwork" was in the act of giving and taking candy, in the gift exchange. Bourriaud described "relational art" as "taking as its theoretical horizon the whole of human interactions and its social context, rather than the assertion of an independent and private symbolic space" (2002: 14). Art is a situation of encounter (ibid.: 18): "All works of art produce a model of sociability, which transposes reality or might be conveyed by it" (ibid.). The form of the artwork is in the relations it establishes: to produce a form is

to create the conditions for an exchange. The artist becomes a mediator, a person that fosters and provides situations of exchange, rather than a creator of objects. For Bourriaud, relational art practices establish particular social relations for particular people; the artist tries to keep a personal contact with the public that participates in the exchange, fostering what he calls a "friendship culture" (ibid.: 32), in contraposition to the impersonal, mass production of the culture industries. These practices open alternative spaces of possibility, what he calls micro-utopias. "Relational art" does not pretend to lead a general revolution, but modest, local interventions: "social utopias and revolutionary hopes have given way to everyday micro-utopias and imitative strategies" (ibid.: 31).

A project by Francis Alÿs, *When faith moves mountains* (realized 2002), could be another good example of these "friendship cultures." The idea behind the project was to move a mountain, quite literally: to move a dune to the outskirts of the city of Lima, Peru. The project counted with the participation, in different forms, of several people: a filmmaker, a curator, a professor at the University of Lima and his students. They convinced 800 students to participate in this project, which consisted of working for a whole day moving sand with a shovel from a 500-meter-long dune.

Many things could be said about what this work represented (in relation to Peru, urbanism, and underdevelopment) but what seems more interesting is that this is a totally futile project that generates, according to Fisher, "'conviviality,' or the founding moment of a community" (Fisher 2007: 119) among the group of people who participated in the action, giving their labor for free. This is an act of collective waste of labor that, because of its very obvious uselessness, ends up taking the form of a celebration. However, there is a clear separation between the action itself and its result as a work of art, which in this case took the form of a film and a set of photographs that have been shown in different international art venues. The "work of art" is this documentation, and as such, it belongs to the artist. Alÿs himself explains this separation between him and the participants:

> The second part (the film) belongs to me clearly. . . . Whether the first part, the day itself, belongs to me, to the volunteers . . . to Cuauh and Rafa . . . [the curator and the filmmaker]. To the dune itself, I would personally find it difficult to tell. (Medina et al. 2005: 143)

The art critic Grant Kester has pointed out the ambiguities of these forms of "relation": while the event or action itself is participatory, its outcome—the artwork, the document, the video that will be shown in art venues around the world—belongs to the artist. At another level, as Kester also points out, Alÿs and his collaborators seem to have decided to involve middle-class students

in the action, rather than the residents of the shantytown near the dune, to avoid being too literally "activist," too obviously related to the problems of the shantytown, or conversely, to avoid being accused of exploiting shantytown dwellers for his art project. Alÿs's project remains in this sense at a safe "poetic distance" from the actual site of the dune, its immediate realities (Kester 2011: 72). In more general terms, Kester questions relational art projects because they reduce social life and social exchange to an art form produced by artists to be displayed in art spaces.

In opposition to these processes of aesthetization or artistification of the everyday, Kester defends collaborative projects that subsume art in social practice. In his recent book *The One and the Many: Contemporary Collaborative Art in a Global Context* (2011), Kester discusses several examples of this "collaborative art." Among them is the Dialogue collective, working in central India, with an *Adivasi* ("indigenous") community. In Kester's words, the art collective "analyzed the spatial choreography of village, life, the protocols governing the movement and aggregation of bodies, and the distribution of power, labour, and access among men, women, and children" (ibid.: 79). In other words, they did fieldwork. Out of this fieldwork "the water pump quickly emerged as a central nexus of meaning in village life" (ibid.). So they developed plans for restructuring the pump sites. Their intervention was rather simple: building smooth concrete pads, more efficient pumps, and decorated enclosures. More than the symbolism of the decoration, Kester argues, what is important about the project is that it provided women (who are in charge of water in the village) with a protected space of interaction. As opposed to Alÿs's work, Dialogue would have chosen to engage directly with the tensions, problems, and divisions of the community they work with, rather than setting them aside and looking for a metaphorical image that may be effective on screen, like a line of people moving a dune (ibid.: 95).

It is quite clear that the work of Dialogue operates from a practice that anthropologists could readily identify as fieldwork, while that would be much more difficult to say of Alÿs's projects. And yet Dialogue's work can also open many questions. For example, what process was their "fieldwork" following? Was the "analysis of the spatial choreography" (ibid.: 79) of the village just an act of observation, or did it involve asking people in the village what did they wanted from them? It is clear that the art collective had a complex understanding of the internal tensions and differences within the community, but what about the tensions and differences that were created by their presence in the village? And what about the power they seem to attribute to themselves by affecting certain changes in the life of the village? That is less clear from Kester's description. In other terms, the problems of "agency" that one could identify in Alÿs's work could also be found, if at another level, in long-standing, community-oriented ethnographic projects, like Dialogue's.

Some art critics have reacted to both relational aesthetics and community art practices, claiming on the opposite for the need to return to the autonomy of art. Claire Bishop (2012) for example has argued that the aim of art is not to generate a "friendship culture," or to create communities or foster collaboration, but to question, antagonize, and promote dissent. In this sense, she champions works that has a critical or "antagonistic" approach, appealing for "more bold, affective troubling forms of participatory art" that create "artificial hells" (Bishop 2012: 6–7) rather than Bourriaud's everyday micro-utopias.

We could find some examples of this antagonistic approach in the work of Santiago Sierra. In *21 Anthropometric Modules made from Human Faeces by the People of Sulabh International, India* (2007) Sierra showed twenty-one monoliths made of human excrement, which had been collected by a charity in India, Sulabh, employing lower cast Dalits whose job is cleaning the streets and public toilets of bodily waste. The feces were dried and chemically processed to become odorless, and were showed at a London gallery as human-size monoliths, coming out of the crates in which they were shipped to London. When asked about exploitation by a *Time Out* journalist, Sierra replied: "Exploitation is everywhere, especially in a city built on imperial foundations like London. It's in the water and the coffee we drink" (Ward 2007).

Sierra does not shy away from it: he has clearly made of economic exploitation the central theme of his work. He does not pretend to express generosity, to create communities, or to renounce authorship on behalf of the public; on the contrary, he makes manifest the mechanisms of artistic authorship in participatory art as a form of exploitation. But precisely because of that, Sierra's work is also made of social relations, but of a radically different kind than "gifts"; after all, commodity exchanges are also a form of "social relation." Furthermore, Sierra's work is clearly recognizable as art: it does not try to disappear in everyday life; his works are still sculptures, in the sense of authored exhibits presented in art galleries. In fact he explicitly claims to be a minimalist with a guilt complex (Sierra 2004: 33): instead of drawing lines or making monoliths with materials, he makes them with people. And the results are artworks sold in international art galleries.

It could be argued that there is a clear difference between the projects of Dialogue with the *Adivasi* and Sierra's work with the Dalits. The first presents itself as a collaborative project that helps ameliorate the life of the villagers, while the second quite shamelessly defines itself in terms of exploitation. But a closer look at these projects would show a more complex picture. It is difficult to assess from the descriptions, but we could ask to what extent the interventions of the Dialogue collective in the villages have been consensual or have generated resistance. On the other hand, in spite of Sierra's cultivation of a bad boy image, his project with the Dalits was actually sponsored by the charity that employs them, Sulabh, which didn't accept any payment because

they understood that, this work was good publicity for them (they actually kept one of the monoliths).[1] In this sense Sierra's project was collaborative. Maybe we cannot take for granted that just because a collective is well intentioned, serious, does research, and spends much time in the field, their work will be more democratic and cooperative with the community than an international art star whose ultimate goal is to make a shocking piece for the international art market. In both cases, the issues at stake are the actual power relations, and the play of agencies that are established in the ground, rather than the good intentions. And still, all of these projects entail different forms of working with relations; in a way, they are all "relational."

Relational and post-relational anthropology

In the field of social anthropology, the "relational" turn in the last decades has been represented by authors like Marilyn Strathern (1988), Roy Wagner (1981), Philippe Descola (2005), or Eduardo Viveiros de Castro (2009). Although they have substantial differences, which I will not discuss here, they share an interest in *intrinsic* relations (Jensen 2012: 49), that is to say, relations that come first, shaping the terms or entities they are connecting. To put it in Strathern's terms, the gift as a relation takes precedence over the entities it constitutes (see Strathern 1988). Gifts are not given objects, but relations that happen; they are not there before they happen; they cannot be easily naturalized or reduced to a sociological model (like exchange). As opposed to intrinsic relations, extrinsic relations would be a result, rather than a premise, of the connection between the terms. In extrinsic relations, the terms or entities connected would remain unchanged—since the connection or relation is external to the term or entity.

These questions as we see are explicitly ontological. An intrinsic relation is a theory and practice of *being*, in which things (terms or entities) are *because* of a relation. So is an extrinsic relation, in which the relation comes second to the thing, and does not substantially add to or change to its being. In these terms, they stand for radically different ontological assumptions.

Why were and are these anthropologists interested in intrinsic relations? Precisely because they were interested in these ontological questions. In fact, the proponents of relational anthropology have also been claimed as the forefathers of the "ontological turn" (Henare et al. 2007). The notion of (social, constructed) relations as secondary to (natural, given) being, of the externality of relations, reproduces the ontological assumptions of what Latour (1991) has called "modernity," Strathern's) "Euro-American understanding," (1988), or Descola's "naturalism" (2005). These authors, on the other hand, in response

to their ethnographies, were and are proposing to describe reality in different terms, terms that may invert the sequence, from the primacy of beings or facts over relations to the other way around.

This "relational" move has been contentious in various ways. First, it could be confused with a wider and longer-lasting project of shifting the focus of social enquiry from structures to connections, interactions, and networks (Pedersen 2012: 60), where connection or relation would be described in affirmative terms as expanding social worlds and fighting the individualist and alienating tendencies of modern society. In these terms, the ontological assumption behind the "relation" is that it is external: it comes after the fact, after the individual, to construct a social world—a network that is added up upon already preexisting, given individuals. On the other hand relational anthropologists have sometimes studied "relations that separate" (Strathern 1988) processes of differentiation from ontological totalities, rather than connections that unite separated entities. The reversal of the gift is a good example of that: rather than describing the gift as a constructed relation that builds connections between already existing individuals, the gift in anthropology is often described as a process that produces hierarchy— processes of self-differentiation between a given totality. The reference to Dumont here would not be irrelevant[2] as well as to Mauss (2003) and other forefathers of anthropology. In many ways "relational anthropology" is coming back to classical questions in the discipline. We could even say that it is having recourse to classical concepts of anthropology, re-reading and, reinventing these concepts. For Martin Holbraad, one of the advanced students of relational anthropology, a concept is recursive when "it changes every time it is used to express something" (Holbraad 2012: 76), and this change is built upon the previous uses. It is also important to understand that what Holbraad and others (Henare et al. 2007) are proposing in fact is a radical criticism of the model of representation, that we change our very understanding of what a concept is: a concept may not be just a representation separated from the thing it represents, it may be an outcome of the thing itself. In this sense, the internalist use of the concept of relation widens it beyond the externalist sense of relation as establishing a connection.

Second, this approach has particular implications in understanding, precisely, the relation between ethnographic objects and the concepts used to describe them. The objective of relational anthropology is to "establish a continuity between the object of description and the description itself" (Viveiros de Castro and Goldman 2009: 31): not to represent reality but to establish a continuity. That does not mean that the concept of relation is borrowed from an ethnographic discourse; it is, in contrast, explicitly invented by the anthropologist to describe the ontological assumptions encountered in the field. But this invention, it is argued, is not discontinuous from these

assumptions (as in etic theories of emic discourses), but an extension of the world described. The concept would not be an abstract representation, but a recursive extension of its object.

This does not mean that relational anthropology literally transposes native ontologies. That has been one of the main criticisms of the so-called ontological turn—the reification of a cultural/ontological other, and the uncritical assumption that the anthropologist was only describing this other culture/ontology. This reification would be a throwback to cultural essentialism after decades of cultural critique (i.e., Carrithers 2010). But that argument falls short of understanding the relational argument. When Strathern and Wagner approach the Melanesian thought or Viveiros de Castro elicits Amerindian cosmology, they are clearly and explicitly inventing a relation—they are not simply and literally describing or representing relational ontologies. What is relational is anthropology itself.

In this sense, the objective of a relational anthropology would be a bit more complex than simply establishing a distinction between "our" Western ontology, which would be described as dualist and representational, in opposition to other ontologies, that would be relational and recursive (Escobar 2010). This argument would be flawed, first of all, because it is built on the basic premise of the very model it wants to question, namely dualism, by establishing oppositions built upon terms that preexist the relation: us and them, West and rest, dualist and relational ontologies. A truly relational argument cannot be based on the premise of the existence of two radically opposed objects before the relation that constitutes them.

In recent years, a number of voices in anthropology are proposing to move beyond relational anthropology. Some authors contend that not everything can be reduced to relations, participation, networks: there is always a moment of separation (Candea et al. 2015). For example, in his work on the relations between anthropology and archaeology, Tom Yarrow found that it is precisely the disconnection and difference between the ways in which these disciplines produce knowledge what sets up the possibility for productive engagement (Yarrow and Garrow 2010). And yet this literature does not question relational ontology deep down, but it is only extending it. Following Strathern's critique of Latour, in *Cutting the Network* (1996), Candea et al. (2015) defend that any relation produces a form of disengagement, just like any detachment is premised on a previously existing relation (Candea et al. 2015: 24). But the primacy of relations over entities is not really questioned. In fact, when Morten Axel Pedersen (2012) proposes a post-relational anthropology, he starts from the assumption that the task of anthropology has always been to invent relations; a "post-relational" anthropology would only intensify this invention of relations, to the extent that the concept of relation itself would become superfluous: "By continually reinventing the relation, anthropology

must eventually come to obviate this concept by making the intensive basis of social life so conventional that it needs no further mention" (ibid.: 64). A post-relational anthropology is still premised on the relation, coming after the relation, only bringing it to its logical end: when everything becomes relational, there is no need to mention relations in the first place.

This conclusion brings forth the central question of relational thought: eventually, it is all encompassing. Everything becomes a relation; there is no possible escape from it. Even if the relation becomes all encompassing, tautological, a relation is a relation. Could we ask if it is a useful tool for thought, even risking being accused of falling back in dualist thinking? Is it possible to think and make in nonrelational terms? Is a nonrelational anthropology, a nonrelational art, thinkable? And if so would it be desirable? To address these questions, we should consider first how are relational art and relational anthropology similar—or indeed related.

Relational management

We could say that relational art and relational anthropology are indeed based on similar premises. For Bourriaud, "art is an activity consisting in producing relationships with the world with the help of signs, forms, actions and objects" (Bourriaud 2002: 107). This may be read alongside a relational anthropology that is premised on the notion that relations take precedence over the entities they constitute. If relational aesthetics and relational anthropology are proposing analogous ontological questions, what is the connection between them?

According to Viveiros de Castro, Lévi-Strauss once defined art as the ecological reserve of the savage mind in the modern world (Viveiros de Castro 2002: 489); the modern artist would be the *bricoleur* of our times, a modern "primitive," for art makes people out of things, instead of things out of people.

This relational vision of the work of art is deeply engrained in the philosophical aesthetics of modernity, what Jacques Rancière has called the "aesthetic regime of art" (2002), based on the writings of authors such as Schiller. According to Rancière, Schiller's aesthetic education was proposing a fully fledged revolution, a revolution of sensible existence. Aesthetics, after Schiller, does not simply constitute a separate field of practice based on the autonomy of art. It is not art that is autonomous, but the mode of experience that aesthetics is proposing (ibid.: 133), a mode of experience based on play. This is precisely what is central about the notion of play; for Schiller, "Play's freedom is contrasted to the servitudes of work" (Rancière 2009: 31). Work is what we do for a living, out of necessity, but it is not necessarily what we want to do, something we identify with; play, as opposed to work, would be

a free activity where people can afford to be themselves. Schiller's proposal to put play at the center of existence is not just a proposal to educate good, responsible citizens, but also the utopian promise of a different form of life, in which what we do and who we are, work and life, are not separated: "a collective life that does not rend itself into separate spheres of activities, a community where art and life, art and politics, life and politics are not severed one from another" (Rancière 2002: 136).

The modern aesthetic utopia emerged as a critique of capitalism, clearly in line with the Marxist critique of alienation of capitalist labor, where workers sell their workforce for a wage, but do not identify the product of their work as their own creation. The exception to this rule would be artists, who would identify the product of their labor as their creation. The utopian promise of communism would be based on overcoming these separations between work and art, praxis and *poiesis*. The aesthetic utopia, and modern art after it, put this question at the center of its concerns. In Bourriaud's terms "modern art rejects to separate the finished product from existence; Praxis equals *poiesis*. The act of creation is to create oneself."[3] Hence art, or better the aesthetic regime of art, appears as a relational utopia in direct confrontation to the alienation, separation, representation, and commodification that characterize modern capitalism. Not just the ecological reserve of the savage mind, but also the promise of a future "relational society."

Perhaps it may sound disingenuous to ask if this relational utopia has been achieved. But it is not, if we start by thinking to what extent relational forms of artistic practice, which in theory are in direct opposition to capitalist production and the society of the spectacle, but in practice often end up being used by the system they question. Or even worse, they may end up being instrumentalized to justify the dismantling of actual social services, by channeling notions of empowerment, creativity, and collaboration, becoming devices of neoliberal governmentality (Miessen 2011). Claire Bishop has shown how during the New Labour governments in the UK (1997–2010), community art was embraced as a sort of "soft social engineering" (Bishop 2012: 5), promoting participation in the arts as a form of preventing social exclusion. For Bishop, social inclusion for New Labour was deeply rooted in a neoliberal agenda, seeking to "enable all members of society to be self- administering, fully functioning consumers who do not rely on the welfare state and who can cope with a deregulated, privatised world" (ibid.: 12). Notions of creativity as innate talent of the socially excluded, an energy that could be transformed from a destructive to a constructive impulse, are also quite common in these cultural policies. Invocations to the "big society" by Conservative governments in the UK or the "participative society" in the Netherlands only extend these proposals to a much more general political framework, envisioning a society of empowered citizens that participate and self-organize, instead of depending on the welfare state.

The "new spirit of capitalism," as it has been described by sociologists Boltanski and Chiapello (2006), is purely relational, built upon an ontology of the network, an open plane of immanence, in Deleuzian terms, opposed to the hierarchies of structure and representation of previous industrial models of capitalism. The immanent network privileges relations, communication, encounter, openness, and indeterminacy over structures and objects. The new capitalism would expand horizontally by extending networks, establishing relations, opening communications, and encountering innovation, rather than vertically by producing structures and objectified commodities. In fact art practice is central to the redefinition of capitalism; "the New Spirit" has incorporated the artistic utopia into the new managerial discourse, in order to build a new identity for the worker: from alienated factory wage laborer to creative professional. In this context, not only have art practices been re-appropriated by the society of the spectacle (Debord 1967), but in more general terms, the artistic critique of capitalism has been incorporated in a hegemonic discourse in which workers are invited to identify with their jobs, participate, be motivated and creative, and work in their free time, when they were not supposed to.

As it turns out, then, it is our own "Western society" that has become the paradigm of the relational. To come back to anthropology, this point further questions the argument that anthropologists study non-Western relational ontologies in opposition to our Western dualist ontology. The fact is that the emergence of a relational anthropology in the last decades is not only parallel to the rise of relational art, but also to the (recursive) reformulation of capitalism as a relational system, a "participative society." The use of the very same terms (network, creativity, participation and so forth) in anthropology, art, and management should at least have given us a hint of this relation.

We come back then to the question: If everything is relational, what does the concept of relation explain? And if there is a dominant form of relation—through the paradigm for capitalist management— do the other forms (say art or anthropology) not risk becoming reduced to the former? Can we say that in the participative society, "all relations have become toxic" (Bromberg 2013)?

Nonrelationality

In reaction to the re-appropriation into new forms of capitalism of all the critical gestures of the past, one possible answer would be to reject relations—a nonrelational gesture that puts forward the irreducibility of the object to any network, connection, or process of becoming. The philosopher Graham Harman, for example, has advocated that the primacy of relations over things

is no longer a liberating idea, since it reduces things to their pragmatic impact on humans and on each other (Harman 2014). In these terms, he has proposed a nonrelational aesthetics, an art without relations, concerned with objects deeper than their relation to humans.

In recent years these radical forms of new materialism, like Harman's "nonrelational aesthetics," are being widely read in contemporary art circles. One example would be Pierre Huyghe's recent work. In *documenta* 13 (2012), Huyghe displayed, among other things, a Modigliani sculpture whose head was covered by a beehive. There was no apparent "relation" between sculpture and beehive. Both existed independently, indifferent to each other or to the public that observed them at *documenta*. In his own terms:

> You don't display things. You don't make a mise-en-scène, you don't design things, you just drop them. And when someone enters that site, things are in themselves, they don't have a dependence on the person. They are indifferent to the public. You are in a place of indifference. Each thing, a bee, an ant, a plant, a rock, keeps growing or changing. (Huyghe in Mooney 2013)

And yet this nonrelational gesture, the return to notions like object and detachment, could induce the suspicion that these new materialisms can be read in part as a return to order, to classical aesthetics, to autonomy, after decades of heteronomy, in which relational and social art practices were not only dissolving the art object, but the autonomy of art itself, disappearing in everyday life. Is the return to the object a return to the singular work of art, to the lonely artist, and even further to the institution? We should discuss Harman's proposal at some length before reaching a conclusion.

Harman starts by proposing the term "nonrelational aesthetics" (2014). And the first surprising statement is that this is not meant as a retort to Bourriaud's *Relational Aesthetics*. For Harman, what Bourriaud means by relations are staged encounters between humans. Harman opposes relationality in a larger sense—as questioning the independence of artworks from their social, political, and even physical settings or their commercial value. Or, in general terms: relationality questions the independence of objects from other objects. Harman's philosophy, on the other hand, defends the irreducible independence of objects from other objects. Speculative realism (his philosophy) questions the primacy of relations over objects, since relations reduce things to their pragmatic impact. For Harman, this is no longer a liberating idea.

Objects can be reduced by relations in two ways: first, to their constitutive particles (downward) as it is often made in science; second to their effects, or upward, like the social sciences often do. And for Harman, "to defend this view is to commit oneself to a world in which everything is already all that

it can be" (ibid.) where all affordances are already there. For Harman, these reductions are forms of knowledge, attempts to explain objects. But philosophy and more importantly art are not forms of knowledge, and therefore do not need to reduce the object to knowledge. On the contrary, the art object can resist to knowledge and reduction.

Harman finds inspiration in the philosophy of Heidegger and the art criticism of Clement Greenberg. Both point to the existence of a background of objects that are irredeemable to the surface of our knowledge of the world. At this point Harman acknowledges that his argument may be mistaken with a high modernist conception of the autonomy of the artwork—which is arguably what Clement Greenberg stood for. And Harman concedes that to an extent when he marks a clear separation between science on the one hand, that pretends to reduce the object to knowledge, and on the other hand philosophy and art, who do not pretend to know objects, but acknowledge their ignorance.

However, Harman does not agree with the formalist criticism that the likes of Greenberg (1961) or Fried (1981) would make of "theatrical" or performative practices in art since the 1960s—in which the limit between the artwork and the spectator was blurred. For Harman, theatricality, or theater, does not attempt to explain the object, and in this sense it is not relational. In fact for Harman the theatrical is the nonrelational (Harman 2014: 4), since theater is less a site for observation than for pity, fear, and impersonation—a place where we do not observe what is portrayed but become it, through mimesis in the actor's rather than the illustrator's sense of the term.

The paradox of this argument is that what Harman identifies as non-relational, is quite similar to what Bourriaud had called, previously, relational art, and Harman describes as staged relations between humans. But then what is relationality? For Harman, it seems, relationality is the attempt to reduce an object to another, to paraphrase it, either downward or upward, to its parts or to its effects. Mimesis, impersonation, pity, fear, would not be a form of reduction in these terms. Now this is a rather difficult, not to say contradictory, argument. Perhaps we could say that theatrical mimesis is always very aware of its limits—the impossibility of reduction of one to another. For Harman, we should clarify, people are also objects among other objects. And objects are irreducible to each other. Art would express this paradox—the impossibility of establishing a true relation. This is what Harman describes in terms of the "allure" of objects, a sensation in which we distinguish between the object itself and its immediate qualities creating an opening for a different level of reality to enter, a reality in which sensual qualities are not directly presented as the necessary part of objects, nor objects as unified wholes. But at this point it is very difficult to understand what distinguishes Harman's speculative realism so radically from classical aesthetics. The aesthetic experience remains an event of encounter between

someone who perceives and an object of perception. And that, we could say, is not that far away from how Kant understood the aesthetic judgment (1951).

So after all, some contemporary claims for the recognition of objects could be read in terms of a return to more classical notions of aesthetics, from Kant to Greenberg. And yet this does not mean that these apparent returns to the object are antipolitical, in opposition to relational art and aesthetics. As Rancière has argued, the contradiction between autonomy and heteronomy, the detachment of art from life and its dissolution in everyday life, are integral to the politics of aesthetics since its very origins. The founding paradox of the aesthetic regime is that art is art insofar as it is also something other than art: as far as possible it brings a promise of emancipation, the elimination of art as a separate reality, and its transformation into a form of life (Rancière 2009: 36).

But this movement toward the total dissolution of art into everyday life has often been counteracted by the opposite movement, of protecting and reinforcing the autonomy of art, of resisting its dissolution into everyday life. This is what Rancière calls the "politics of the resistant form," which "encloses the political promise of aesthetic experience in art's very separation, in the resistance of its form to every transformation into a form of life" (ibid.: 44). For Rancière the persistent tension of the "politics of becoming-life in art" and the "politics of the resistant form," or heteronomy and autonomy, is constitutive of the politics of aesthetics. It may appear self-evident how heteronomy, or the impulse to dissolve art into everyday life, is political: the dissolution of art in everyday life is premised upon the utopian ideal that art has the power to transform society, that art has an effect. On the other hand, autonomy and detachment may appear as apolitical since they withdraw from the public debate. But on the contrary, what Rancière argues is that the autonomy of art is built precisely against the constitution of any specialized fields of practice and knowledge within a given social structure, proposing instead the construction of a community of sense against this very social structure. The apparent separation from other fields of practice is in reality a form of questioning the very social division of labor into fields in modern society, the reduction of practice to labor, and hence the alienation of work from life. In other words, the autonomy of art does not simply seek the recognition of the practice of art as another specialized profession, among other forms of work; rather, it questions these very notions of work, skill, and expertise. Aesthetics, after Schiller, does not simply constitute a separate field of practice based on the autonomy of art. It is not art that is autonomous, but the mode of experience that aesthetics is proposing (Rancière 2002: 133), a mode of experience based on play, not work. This is precisely what is central about the notion of play for Schiller, as we have seen before. The visual allegory that Schiller and Rancière use to explain this point is a famous classical bust of Juno Ludovisi. The statue, for Schiller, is a self-contained "free appearance."

To a modern ear, this expression tends to evoke the self-containment celebrated by Clement Greenberg. But Schiller's self-containment is not about work's material autonomy. What the free appearance of the Greek statue manifests is the essential characteristics of divinity, its idleness or indifference. Standing before the idle goddess, the spectator too is in a state that Schiller defines as that of idleness or free play (Rancière 2009: 27).

In this sense, the Juno Ludovisi, like works of relational art in the modern regime of aesthetics, points to a political horizon of liberation, of free play. In spite of its infinite detachment and remoteness, it is also a political work of art that establishes a relation, if a "relation that separates," to make reference to Strathern once again.

Conclusions: There is no way out of relations—but that may be OK

Reading Harman's proposal for a "nonrelational aesthetics," one could say that it may not go very far away from what aesthetics has been all along, in what Rancière has called the "aesthetic regime." But that does not mean that proposals for a nonrelational art are antipolitical. On the contrary, they complement relational art, because they also contain the promise of liberation, if in a radically different way. Saying that, ultimately, I am implying that nonrelational art is indeed relational, since it is the result of a relation— the aesthetic regime. That, of course, may be my biased reading as an anthropologist, whose task, as we have seen, is to invent relations, or in Harman's terms, reducing objects to knowledge. But to be honest I think that is what Harman—or philosophy in general—does too. Michael Scott (2014), one of the anthropologists that has taken more time and effort to critically assess the legacy of relational anthropology, has presented his own version of what would be an "object-oriented" anthropology, analogous to Harman's attempts in philosophy. Scott, working in Melanesia, like Strathern and Wagner, encountered forms of sociality that did not respond to their models of a cosmos in which everything is related, and where social agents need to cut relational continuity. Scott, on the other hand, encountered a context where the opposite was the case: relations had to be created, not cut. This was a world that presupposed then the existence of objects *before* relations.

And yet, for Scott, this does not question the fact that relations do exist, and that indeed it is only through relations that knowledge is produced. If in fact any object exists before a relation, is something we can only assume *after* we have established, or better, "invented" a relation with it.

In these terms, anthropology cannot escape relationality, and nor can art. But that does not mean that the relations that art or anthropology invent have to be necessarily poisoned by other forms of relation that are dominant in our society-like management. It is not by withdrawing from, but by multiplying relations that these toxic connections may be overcome. If anything like a post-relational anthropology or art should exist, however, it should be premised on a critical awareness of the dangers of an all too pervasive relationality.

Notes

Introduction

1 For Guggenheim see https://www.guggenheim.org/video/about-the-guggenheim-ubs-map-global-art-initiative (accessed May 15, 2016); for Tate Modern see http://www.tate.org.uk/context-comment/articles/tate-and-africa (accessed January 10, 2013).

2 English edition: (2011), *Anthropology of Images: Picture, Medium, Body*, trans. T. Dunlap (Princeton and Oxford: Princeton University Press).

3 Belting adopts Mitchell's differentiation between image and picture: images are representations we have in us, whereas pictures are the concrete, material representation of images (Mitchell 1995). Mitchell dealt in-depth with the various images—graphic, optical, perceptual, mental, or verbal ones—in his *Iconology* (1987).

4 Sansi discusses this topic regarding nonrelational art (this book).

5 See also well Campbell (2002).

6 One of Morphy's critiques actually regards the missing of a "fully developed theory of representation" (2009: 10).

7 See the collection's website: http://scva.ac.uk/about/collections/robert-and-lisa-sainsbury-collection (accessed January 26, 2017).

8 Wuming Huahui was founded in 1973, Xing Xing in 1979. See K. Archey (2014), "The Un-Officials | Art Before 85'. Boers-Li Gallery, Beijing," *Art Agenda*, April 25. Available online: http://www.art-agenda.com/reviews/%E2%80%9Cthe-un-officials-art-before-85%E2%80%9D/ (accessed April 9, 2017).

9 GAM website: http://www.globalartmuseum.de/site/home/ (accessed February 16, 2016).

10 Insofar as global/contemporary art is in this conception a matter of local perspectives, and not of outsider definitions, the inclusion or exclusion of ethnic arts is subject to local discourses, and cannot be answered universally.

11 The concept of global art nevertheless is not unanimously accepted. For some, it has been "Westernized," re-appropriated, and creates new hierarchies that again are established by the European/North American art world (for instance Bydler 2004: 24; Barriendos 2009: 98–9).

12 Insofar as auction sales are published, while prices of galleries are largely considered as private and confidential—so are those of art fairs—economic studies of sales prices of artworks rely exclusively on data provided by auctions.

13 For *Art3f* see http://www.art3f.fr/index.php/en/; for *Affordable Art Fair* see https://affordableartfair.com/about (both accessed April 10, 2017).

14 The primary market is related to galleries and studio sales—that is works of art that so far have not entered the market circuit. Auction houses are considered as secondary market, as the works of art had already a previous commodity status.

15 Art dealers differ from gallerists in many respects: their exclusive focus is selling artworks. Their basic costs are minimal: they have no exhibition spaces (at most a small warehouse), they do not organize special exhibitions or produce catalogs, and need not organize receptions or exclusive dinners. They mostly have no clear art program, and are not working on an artist's career.

16 French original: (1998), *Esthétique relationelle*, Dijon: Les presses du réel.

17 For a closer consideration of Bourriaud's concepts see Sansi in this book.

18 For exchanges between art and anthropology related to fieldwork see in particular Schneider and Wright (2006), Marcus (2010), as well as the Center for Ethnography, directed by George Marcus at University of California Irvine, which investigates and probes collaborative ethnographic research.

Chapter 1.1

1 A lecture held at the Université Laval, Québec, Canada, October 5, 2006.

2 See Bakewell (1998), Freedberg (1989), Gell (1998), Schaeffer (1996).

3 See Boas ([1927] 1955), Fienup-Riordan (1996).

4 English publication: Descola, P. (2013), *Beyond Nature and Culture*, trans. J. Lloyd, Chicago and London: The University of Chicago Press.

5 See Boas ([1927] 1955): 250–51, and Feld (1982).

6 In a similar manner one may discern first in the images (that is to say in the evolution of occidental art from cubism on) with most anticipation the signs of erosion of the naturalist ontology. It became perceptible much later in other domains.

7 See Munn (1973), and Myers (1999).

8 See Kindl (2005), Lumholtz (1900), and Negrín (1997).

9 Cheng (1991), and Jullien (2003).

Chapter 1.2

1 My analysis of this terrain is indebted to my practical engagement with these technologies as tools for communication and also for ethnographic research. I am also indebted to Bram Vroonland, Eva Theunissen, Matthias de Groof, Tito

Marci, and Giuliana Ciancio for the precious exchanges we have recently had on the topics addressed in this chapter.

2 The ways in which images can be considered immersive are indeed manifold. On the one hand, for instance, in cinema, immersion can be looked upon as a standard empathic/psychological procedure for making viewers forget about the difference between their everyday life and that of the characters in a film (Vish, Tan, and Molenaar 2010; Smith 2003; Grau 2003). Immersion can, however, also be seen at an even more abstract and metaphorical level as a way to express the "visual hypertrophy" (Taylor 1994) that supposedly characterizes today's late capitalist societies and the consequent (postmodern) supposed merging of reality and representation that has attracted the attention of scholars from all fields. In my case, however, I am more interested in the actual attempts at physically wrapping viewers in images, of helping them to forget with the help of a set of sensory procedures, the frame that contains the image. This is ideally the space of virtual reality, 3D and augmented reality, one where the act of viewing becomes a physical experience (cf. Sloterdijk 2011; Helmreich 2007) interpellating senses that it cannot represent (Grau 2003).

3 Among them we can mention, Immersive (by Trapcode), FOV (Sixtime etage), Go Immersive (Salon Films), and Immersive Media.

4 Alhazen was an Arab mathematician and philosopher who lived in Egypt at the turn of the first millenium CE.

5 Gombrich suggested that images inhabit the realm of nature as opposed to words that rely upon conventions and culture (2006).

6 The value of these images as objects of contemplation has been stressed by Sendler (1985), who suggests that they are images of the invisible.

7 Paradoxically this position is not too dissimilar to that of contemporary neurosciences (Gallese 2009).

8 "Technical media are models of the so-called human precisely because they were developed strategically to override the senses" (Kittler 2010: 36).

9 It could be interesting here to open up a parallel between the meaning of observing in the context of contemporary digital image-based practices and in the context of transcendental meditation.

Chapter 2.1

1 From the French verb *rassembler*, which means *gather* or *bring people together* the in Creole language.

2 The traditional *karabela* is the Haitian variation of the Afro-Caribbean dress, composed of flounced bodice and skirt, sometimes called *quadrille* or *bandana* dress in other islands of the Antilles. It derives from the everyday cotton dress worn by local women since the eighteenth century. It can be white, vividly single colored or cut in a printed cotton. Today, the *karabela* is mostly used for ceremonies and traditional dances.

3 The new automatic processes of screen-printing allow the reproduction of high-definition images on garments. Designers can reproduce a broad range of images on the pieces they create by using the photo emulsion screen-printing technique, starting from the print of the pattern on a transparent base from a computer, printer, or photocopier.

4 The *cholita* dress is made of three or four layers of garments. Each skirt can require up to 6 meters of textile to create enough volume and transform the female bodily attitudes and appearance.

5 The Ethical Fashion Initiative is monitored by the International Trade Center (ITC), a United Nations Agency. In June 2014, Stella Jean gave a talk about "the power of empowered women" on the occasion of the fiftieth anniversary of ITC, at the Geneva UN headquarters, then at the World Trade Organization (WTO) where the outfits created with the active participation of West African craftsmen have been exhibited, available online: http://ethicalfashioninitiative.org

6 *Bogolan* is a traditional West African textile, sometimes called mudcloth because it is usually dyed by women with natural fermented mud, before being hand-woven. The *bogolan* tradition persists in many regions of Mali, Burkina Faso, and the Niger river area. Craftsmen weave regular stripes of *bogolan* cotton on narrow looms before sewing them by hand to produce the final fabric.

7 See Stella Jean's website: http://www.stellajean.it/about-stellajean/ (accessed October 17, 2016).

8 In September 2013, Giorgio Armani launched a unique program to support emerging fashion designers by allowing them to show their work in the Armani Teatro situated in Via Bergognone in Milan. Armani selected Stella Jean's Spring 2014 collection as the first young talent's work to be shown in his theater during the Milan Fashion Week.

9 Because the Antilles islands have been subject to different European colonial powers, many traditions of cockfights still persist in the Haitian, Puerto Rican, Martiniquan, and Guadeloupian cultures where public competitions can involve huge amounts of money. The cockfights mostly take place in the dry season, from December to March. Among the fighting roosters, the *coqs-pagnol* from the east of Haiti are the most reputed.

Chapter 2.2

1 Works cannot be bought at biennials, but the preview days for art professionals and the international media are enthusiastically used to get in contact with the galleries and to close sales.

2 The AKM is destined to be demolished; close to Gezi Park; this was the beginning of the public resistance in 2013.

3 See Karaca (2011).

Chapter 2.3

1 I am leaving out of my discussion George Dickie's "institutional theory" of the art world, insofar it is a variant of Danto's.

2 For the African continent's several unique events: in 1971 an exhibition of Marc Chagall, in 1972 of Picasso, or in 1974 of Pierre Soulage.

3 Considerations about a new legal status for the Biennale have been allowed since 2012 under President Macky Sall.

4 In 1998 Achille Bonito Oliva (Italy), in 2000 James Elliott (UK), in 2002 Ery Camara (Senegal/ Mexico), and in 2004 Sarah Diamond (Canada).

5 See the program of the critical anthropology of art of Marcus and Myers (1995).

6 Yet, others see collaborative art, which emphasizes social relations, as present-day leading art form (see, among others, Papastergiadis 2008).

7 "Global Art and the Museum" (GAM) was directed by Hans Belting, Peter Weibel, and Andrea Buddensieg at ZKM/Centre for Art and Media, Karlsruhe, Germany.

8 For a discussion of the concept in an anthropological perspective, see Fillitz (2015).

Chapter 3.1

1 This chapter uses the terms "art system," "art market," and "art world" interchangeably to refer to the social behavior of people engaged in making, buying, selling, exhibiting, and writing about contemporary art.

2 St. Louis's indigenous history at Cahokia extends back several thousand years but has no cultural impact on the contemporary society.

3 Central or hegemonic art markets like those in New York, London, Paris, and Cologne operate differently, along lines of "superstar" markets as analyzed by Rosen 1981 and Adler 1985.

4 Van Gogh was the post-Impressionist artist who sold only one painting in a brief and psychologically tortured life. His work later was judged aesthetically supreme, and one of his paintings sold for the highest price ever recorded for a painting in a public sale a hundred years after his death. Peter Watson's book (1992) gives an exciting report of the sale in 1990.

5 The survey explicitly stated it included foreign artists as well as Italians.

6 Established artists in the United States routinely have contracts establishing the gallery's right to monopoly representation on a consignment basis. Artists producing investment-quality work may also have contracts stipulating advance sales to the gallery, but not emerging artists whose work has not attained commodity status.

7 This of course is my term. Most artists would not explicitly connect their work with van Gogh, but would point out that their work is as good as work shown in prestigious galleries, and that they refuse to cater to popular culture or low-class taste.

8 Interviews were conducted in Italian unless specified that they were in English, and will be referred to by interview date (translations are by the author). Material in square brackets is added to clarify the meaning of the interviewee; material in curly brackets is the author speaking during the interview. Ellipses denote omitted material. I converted currency references from lire to dollars (US$) at the prevailing rate of exchange, about 1,800–2,000 lire to one US dollar during the period of research.

9 Members of the Florence art world had the same opinion as St. Louisans had of the lifespan of a contemporary art gallery—about five years. The reasons are the same in both places: many people who own galleries tend to have a secure income from some other source, and open the gallery in order to express their passion for art. After some years the lack of support from the community makes them re-evaluate their commitment to the business of selling contemporary art—after all they don't have to make a living from it—and encourages them to follow some other expressive passion.

10 Paloscia's 1997 book on contemporary art listed eighty-one galleries active in Florence in the early 1970s (ibid.: 29, note 9), of which only fifteen appeared on my list for 1999–2000. But a 19 percent survival rate over almost thirty years is probably better than average for small business.

11 This creative type of critic is not totally unique to Italy. Clement Greenberg is perhaps the example most familiar to Americans for his role in advancing the Abstract Expressionists in post–Second World War New York.

12 Many Italians use the phrase "contemporary art" to denote avant-garde, postmodern, or otherwise nontraditional challenging work, using "modern art" to refer to nonchallenging work by living artists. In all interviews I made it clear that by "contemporary art" I referred to any work by living artists, reserving "modern art" for work made in the first half of the twentieth century.

13 We have seen that their complaint about the simple number of galleries is not supported by comparative data, as the Florentine number seems unexceptional. They must mean there are too few galleries specializing in avant-garde or challenging art relative to the number of artists, which by my analysis of local art markets is always true.

14 I sampled thirty homes stratified into ten wealthy, ten middle-, and ten working-class families, but not randomly chosen. The eighteen works included twelve original oil paintings, two watercolor or tempera paintings, two editioned prints, and almost two drawings. The figures given omit a number of smaller, less significant works.

15 In the high art world the terms "pretty" or "decorative" are usually used as an insult to denote the work catering to low culture, popular taste.

16 A term used always with scorn by respondents, even when they admitted to living from the income from family shops.

Chapter 3.2

1 Headlines obtained by means of the research input "2008+crise" (2008+crisis) on the Folha de São Paulo website: https://goo.gl/oOPEbO (accessed on November 17, 2016).

2 The media narratives presented in this chapter do not represent the entire rhetorical diversity present in the media, nor do they represent wholly hegemonic perspectives, but rather the general tone of the crisis period in question.

3 Research input with the terms "*mercado de arte+crise*" (art market+crisis) performed on Google search on November 26, 2012.

4 In short, the primary market within the art market refers to the first sale of a work of art, from the hands of the artist to its first buyer, with or without the intermediation of a gallery. As for the secondary market, it refers to the resale market for works of art, where an artwork passes from the hands of a previous buyer to a second (third, fourth, etc.) buyer. Such is in general the case of art auctions.

5 Creating, according to some specialists, an overvaluation bubble of young Brazilian artists, considered expensive when compared to more experienced artists of other nationalities.

6 Thomas Fillitz, in his article "Anthropology and discourses on global art" (2015), writes from his own ethnographic experiences in West African sites about a notion of global art that opposes the idea of a universally defined contemporary art since the 1980s, "the monopoly of the European/North American art world." According to the author, "global art asserts today's multiplicity of contemporary art as the production of locally or regionally specific normative systems. The concept centrally focuses on the equality of all contemporary art creation. Indeed, it decentres the European/North American art world. In doing so, global art aims at considering the global art worlds-network as constituted of multiple interconnected centres, and shifts the attention to regional exchanges" (ibid., 311). In turn, the notion of a global art market hereby used, while welcoming the production of contemporary art from locations other than Europe or North America and pervading different localities through major events such as international art fairs around the world, remains focused on European/North American markets.

7 According to TEFAF, HNWIs are people with over US$1 million in investments and ultra-HNWIs are individuals with over US$30 million (Andrew 2013).

8 Two examples of this investment are the opening of a temporary headquarters of the White Cube gallery in Brazil between 2012 and 2015, and another major gallery of the global art market that opened commercial representation in the country. According to the person responsible for the commercial representation, "the galleries know that Brazil has major artists, major galleries, and that there is money, but they do not know, or are unsure, that great collectors exist in Brazil" (personal communication, São Paulo, December 11, 2014). Still according to this interlocutor, part of his work was to verify if there were major collectors interested in buying international art.

9 All translations of the interlocutors' citations from Brazilian into English by the author.

10 Available online at http://abact.com.br/abact-missao (accessed on November 07, 2016). According to my personal notes, at the beginning of 2016, the numbers disclosed indicated fifty-two galleries present in eight Brazilian states—some of the associated galleries have closed their doors in the last two years.

11 Apex-Brasil is an agency associated with the Ministry of Foreign Affairs whose main objective is to "promote Brazilian products and services abroad and attract foreign investments to strategic economic sectors . . . strengthening the Brazil brand" (APEX-BRASIL website n.d.).

12 Created in 1951, the São Paulo Biennial is in its fifty-second edition and is considered by many, alongside the *Biennale di Venezia* and *documenta* in Kassel, one of the three main events of the international artistic circuit.

13 Lava Jato (Car Wash) is a federal police investigation in Brazil against corruption schemes involving Petrobrás, one of the Brazil's largest state-owned companies. Some of the people involved in these schemes allegedly received artworks as bribes. For many analysts, the operation is at the base of a judicial-media coup underway in Brazil, which has recently deposed the former president Dilma Rouseff.

Chapter 3.3

1 See: http://savvy-contemporary.com/index.php/projects/colonial-neighbours/ (accessed December 1, 2016).

2 Ibid.

3 Evidently, not all art is either visual or composed of a "physical entity" (Gell 2006: 172, see Chua and Elliott 2013), but can be sensory, relational, or conceptual. Gell's construal of the powers of art as a transcending magic furthermore risks glorifying artistic production and reifying the technological processes of art.

4 Retrieved from the official website of the Taskforce Schwabinger Kunstfund. Available online: http://www.taskforce-kunstfund.de/en/chronology.htm (accessed December 3, 2016).

5 Ibid.

6 Ibid. See: http://www.bundesregierung.de/ContentArchiv/DE/Archiv17/ Pressemitteilungen/BPA/2013/11/2013-11-11-bkm-kunstfund.html (accessed January 15, 2017).

7 See: http://www.taskforce-kunstfund.de/en/chronology.htm (accessed December 3, 2016). The proposal for the bill (in German) is also available online: http://www.bundesrat.de/SharedDocs/ drucksachen/2014/0001-0100/2-14.pdf?__blob=publicationFile&v=4 (accessed February 20, 2017).

8 See: http://www.taskforce-kunstfund.de/en/chronology.htm (accessed December 3, 2016).

9 Ibid.

10 Ibid.

11 Ibid.

12 See: http://www.kunstmuseumbern.ch/de/service/medien/archiv-medienmitteilungen/medienmitteilungen-2016/15-12-16-kmb-begruesst-gurlitt-entscheid-1656.html (Kunstmuseum Bern statement) and the official agreement between the three parties, available online: (http://www.bundesregierung.de/Content/DE/_Anlagen/BKM/2014-11-24-vereinbarung-bund-freistaat-bayern-stiftung-kunstmuseum-bern.pdf?__blob=publicationFile) (both accessed February 20, 2017).

13 Both available online on www.lostart.de (accessed February 23, 2017).

14 See: https://www.kulturgutverluste.de/Webs/EN/ProjectGurlitt/Index.html (accessed December 4, 2016).

15 See: http://www.taskforce-kunstfund.de/en/chronology.htm (accessed December 3, 2016).

16 This figure was obtained from the official Taskforce website.

17 See: http://www.taskforce-kunstfund.de/en/nc/fragen.htm (accessed December 4, 2016).

18 Ibid.

19 Ibid.

20 "Beschlagnahme," in Database "Degenerate Art." Freie Universität Berlin, Forschungsstelle "Entartete Kunst." Available online: http://www.geschkult.fu-berlin.de/e/db_entart_kunst/geschichte/beschlagnahme/ (accessed December 5, 2016).

21 Ibid.

22 Ibid.

23 See: http://savvy-contemporary.com/index.php/concept/ (accessed December 8, 2016).

24 Available online: http://savvy-contemporary.com/index.php/projects/colonial-neighbours/ (accessed December 8, 2016).

25 They borrow this notion from Conrad and Randeria (2002).

26 See: http://savvy-contemporary.com/index.php/projects/colonial-neighbours/ (accessed December 8, 2016).

Chapter 3.4

1 Earlier (van der Grijp 2006: 13), I labeled this drive the "cognitive motive." I now prefer the adjective "educational" in order to better distinguish it from the psychological motive.

2 In choosing these four categories of motivations, I do not exclude the existence of others, such as political or power seeking. Moreover, the various motivations and mutual relationships can change over time; they can *re*configure. This is why I consider the biographical method combined with extended case studies as an appropriate method within this research field (van der Grijp 2006, 2009a, 2014, 2015, 2016).

3 The tribal art collectors in Derlon's and Jeudi-Ballini's book (2008: 249) prefer others to believe that their first purchases were not expensive and that, in the degree that their taste and insight developed, they made good finds for relatively little money. All this is meant to say that they constructed their collection because of their personal merits and not because of their wealth. This does not alter the fact that they *now* pay considerable sums of money from time to time.

4 Between 2010 and 2016, I conducted fieldwork in Taiwan every year. I met Chan-wan Kao in 2010 and 2012 in Toucheng, and in 2011 and 2013 in Taipei.

5 Previously, the site of his hotel consisted of a fishing village with thirty-four old houses, which Kao had bought one by one. He was the first to build a large hotel on the coast in the region and will probably also be the last because of the government quota for the construction of new buildings at the coast.

6 Between 1895 and 1945, Taiwan was a Japanese colony.

7 In 1908, his father arrived in Tahiti, just before the Chinese revolution of Chun Yat Sen and Chiang Kai Shek. It was the second Chinese immigration wave in French Polynesia—at the time still called Établissements Français en Océanie. The first Chinese immigration wave occurred in the 1860s (Saura 2002).

8 The CFP franc (or XPF in banking terms) is the currency used in French Polynesia (as well as in New Caledonia and Wallis and Futuna). On January 30, 2017, 100 CFP = US$ 0.9.

9 At the time, a return voyage from Tahiti to Marseilles still took a total of forty days.

10 The interviews, conducted in French, are translated to English by me. I am grateful to Bruno Saura for bringing me in touch with Chichong.

11 The Taiwanese government considered this kind of trade as smuggling because there were no import taxes paid, while the People's Republic of China (on the mainland) saw it as internal trade. The People's Republic of China considered Taiwan indeed as its own province, but from a Taiwanese perspective these were two different countries.

12 In 2012, 7.5 million tourists visited Taiwan and, in the same year, more than twice this number, sixteen million, visited that Chinese town. In the latter town, which is according to Chinese criteria only a small town, twenty million visitors were expected in 2013 (personal communication Kao, Taipei, 2013).

13 Maurice Utrillo (1883–1955) was a French townscape painter belonging to the School of Paris. In 1950, Utrillo represented France at the *Biennale di Venezia*.

14 Ambroise Vollard (1886–1939) was the Parisian dealer of several now famous Impressionist and post-Impressionist painters such as Gauguin, Matisse, Picasso, and others (see, for example, Vollard 1994).

15 On Gauguin see Pineri (2003) and van der Grijp (2009b: 115–37).

16 In 1976, French Polynesia issued an airmail stamp of 50 CFP (US$0.45) with a reproduction of this painting.

Chapter 4.1

1 Marina Abramović on *Rhythm 0* (1974), Marina Abramović Institute, 2014, c. 01:00 minutes. Available online: https://vimeo.com/71952791 (accessed February 8, 2017).

2 Text copyright Maya Quattropani 2014.

3 As Italian artist Manuela Macco suggests, "People generally don't know how to behave during performances. They don't know they can leave; they rather stay and feel bothered, in discomfort" (personal communication, Macco, Turin, 2014).

4 See Laclau and Mouffe ([1985] 2001).

5 Video copyright Marc Giloux 2014. Available online: https://www.youtube. com/watch?v=a23PcZSvHpY (accessed October 16, 2016).

6 Video copyright Contemporary Art Torino Piemonte 2014. Available online: https://www.youtube.com/watch?v=LaCRJC95cW4 (accessed December 3, 2015).

7 Francesca Arri refers to this kind of training as "devised work"; see Oddey (1994); Fryer (2013).

8 The facts García Aguirre refers to are today notoriously known as the *Iguala* mass kidnapping, when forty-three students from the Ayotzinapa Rural Teachers' College disappeared on September 26, 2014 in the Mexican state of Guerrero. To date, their bodies have not been found and their families continue considering them "missing," as they fear a rush in the closing of the case to cover a state involvement. When I encountered the artist, less than three months had passed and no certain information was available.

9 Video copyright Melissa García Aguirre 2015. Available online: https://www. youtube.com/watch?v=uBmdgsj9WM8 (accessed December 7, 2015).

10 See discussion online: http://www.miriad.mmu.ac.uk/caa/trans. php?day=3&group=0&session=1630 (accessed January 31, 2017).

11 See Grimshaw's final report. Available online: http://www.miriad.mmu.ac.uk/ caa/reports.php?show=ag (accessed November 29, 2016).

Chapter 4.2

1. The entire talk is available online at: https://www.youtube.com/watch?v=4Rq_naj24Hl (accessed February 2, 2017).

2. The four residents, in chronological order, were Ícaro Lira, Jaime Lauriano and Raphael Escobar, Julián Fuks, and Virginia de Medeiros. This chapter focuses on the first two residencies.

3. In the early 1990s a group of African American artists in Houston, Texas, including Rick Lowe, mobilized Joseph Beuys's concept of "social sculpture" in founding Project Row Houses. This permanent installation, opened in 1994 in a marginalized area, comprising a set of eight renovated shotgun houses dedicated to artists' projects.

4. See https://transnationaldecolonialinstitute.wordpress.com/about-2/ (accessed February 2, 2017).

5. One of the most striking examples of military police action against occupations in Brazil occurred in Brasilia in June 2016. Two military police helicopters fired on the Hotel Torre Palace building, before a tactical team was dropped onto the roof. See: https://www.youtube.com/watch?v=jOliJ_P3Qus (accessed February 2, 2017).

6. Full article is available online at: http://cultura.estadao.com.br/noticias/artes,artistas-criam-no-antigo-hotel-cambridge-de-sao-paulo,10000048707 (accessed February 2, 2017).

7. Article 7 of the Brazilian Constitution guarantees the right to a home, stating that a minimum salary must cover all basic needs, including dignified living conditions. Regarding occupations, constitutional lawyers have also discussed how the right to a home involves, beyond the right to occupy a space, the right to transform that space into a home, in virtue of the fact that to dwell constitutes a basic facet of the human character (Sarlet 2008).

Chapter 4.3

1. Available online: http://www.santiago-sierra.com/200709_1024.php (last accessed February 10, 2014).

2. I believe that hierarchy is not, essentially, a chain of superimposed commands, nor even a chain of beings of decreasing dignity, nor yet a taxonomic tree, but a relation that can succinctly be called "the encompassing of the contrary" (Dumont 1980: 239).

3. "L'art moderne . . . refuse de considérer comme séparés le produit fini et l'existence à mener. Praxis égale *poiesis*. Créer, c'est se créer" (Bourriaud 1999: 13).

References

Introduction

Abbing, H. ([2002] 2006), *Why Are Artists Poor? The Exceptional Economy of the Arts*, Amsterdam: Amsterdam University Press.

Artprice (2016), "Jahresbericht: Der Markt für zeitgenössische Kunst 2016," *Artprice*. Available online https://de.artprice.com/artprice-reports/der-markt-fur-zeitgenossische-kunst-2016 (accessed January 26, 2017).

Augé, M. (1994), *Pour une anthropologie des mondes contemporains*, Paris: Critiques-Aubier.

Barriendos, J. (2009), "Geopolitics of Global Art: The Reinvention of Latin America as a Geoaesthetic Region," in H. Belting and A. Buddensieg (eds.), *The Global Art World. Audiences, Markets, and Museums*, 98–115, Ostfildern: Hatje Cantz Verlag.

Belting, H. (2001), *Bild-Anthropologie. Entwürfe einer Bildwissenschaft*, Munich: Wilhelm Fink Verlag.

Belting, H. (2009), "Contemporary Art as Global Art: A Critical Estimate," in H. Belting and A. Buddensieg (eds.), *The Global Art World. Audiences, Markets, and Museums*, 39–73, Ostfildern: Hatje Cantz Verlag.

Belting, H. (2013), "From World Art to Global Art: View on a New Panorama," in H. Belting, A. Buddensieg, and P. Weibel (eds.), *The Global Contemporary and the Rise of New Art Worlds*, 178–85, Cambridge, MA and Karlsruhe: The MIT Press and ZKM/Center for Art and Media.

Bharucha, R. (2007), "The Limits of the Beyond," *Third Text*, 21(4): 397–416.

Bishop, C. (2012), *Artificial Hells: Participatory Art and the Politics of Spectatorship*, London and New York: Verso.

Bourriaud, N. (2002), *Relational Aesthetics*, trans. S. Pleasance and F. Woods with the participation of M. Copeland, Dijon: Les presses du réel.

Buck, L. and J. Greer (2006), *The Contemporary Art Collectors' Handbook*, London: Cultureshock.

Bydler, C. (2004), *The Global Art World Inc. On the Globalization of Contemporary Art*, Stockholm: Acta Universitatis Upsaliensis, Figura Nova Series 32.

Campbell, S. (2002), *The Art of Kula,* Oxford and New York: Berg.

Coote, J. and A. Shelton, eds. (1992), *Anthropology, Art, and Aesthetics*, Oxford: Clarendon Press.

Descola, P. (2005), *Par-delà nature et culture*, Paris: Gallimard.

Downey, A, (2007), "Towards a Politics of (Relational) Aesthetics," *Third Text*, 21 (3): 267–75.

Downey, A. (2009), "An Ethics of Engagement: Collaborative Art Practices and the Return of the Ethnographer," *Third Text*, 23(5): 593–603.

Enwezor, O. (2006). "The Production of Social Space as Artwork: Protocols of Community in the Work of Le Groupe Amos and Huit Facettes," in B. Stimson and G. Sholette (eds.), *Collectivism after Modernism: The Art of Social Imagination*, 223–52, Minneapolis: University of Minneapolis Press. Available online: http://www.lot.at/sfu_sabine_bitter/enwezor.pdf (accessed November 12, 2016).

Fillitz, T. (2014), "The Booming Global Market of Contemporary Art," *Focaal*, 69: 84–96.

Foster, H. (1996), "The Artist as Ethnographer," in H. Foster (ed.), *The Return of the Real. The Avant-Garde at the End of the Century*, 171–203, An OCTOBER Book, Cambridge, MA and London: The MIT Press.

Gell, A. (1992), "The Technology of Enchantment and the Enchantment of Technology," in J. Coote and A. Shelton (eds.), *Anthropology, Art, and Aesthetics*, 40–66, Oxford: Clarendon Press.

Gell, A. (1998), *Art and Agency. An Anthropological Theory*, Oxford: Clarendon Press.

Grasseni, C. (2007), "Introduction. Skilled Visions: Between Apprenticeship and Standards," in C. Grasseni (ed.), *Skilled Visions: Between Apprenticeship and Standards*, 1–19, New York and London: Berghahn Books.

Grasseni, C. (2011), "Skilled Visions: Towards an Ecology of Visual Inscriptions," in M. Banks and J. Ruby (eds.), *Made to Be Seen. Perspectives on the History of Visual Anthropology*, 19–44, Chicago and London: The University of Chicago Press.

Grimshaw, A. and A. Ravetz (2015), "The Ethnographic Turn—and After: A Critical Approach towards the Realignment of Art and Anthropology," *Social Anthropology/Anthropologie Sociale*, 23(4): 418–34.

Groys, B. (2008), "The Topology of Contemporary Art," in T. Smith, O. Enwezor, and N. Condee (eds.), *Antinomies in Art and Culture. Modernity, Postmodernity, Contemporaneity*, 71–80, Durham and London: Duke University Press.

Harman, G. (2014), "Art without Relations," *ArtReview*, September. Available online https://artreview.com/features/september_2014_graham_harman_relations/. (accessed December 28, 2016)

Harris, C. (2013), "In and Out of Place: Tibetan Artists' Travels in the Contemporary Art World," in F. Nakamura, M. Perkins and O. Krischer (eds.), *Asia Trough Art and Anthropology. Cultural Translation Across Borders*, 33–46, London et al.: Bloomsbury.

Heinich, N. (2014), *Le paradigme de l'art contemporain: Structures d'une révolution artistique*, Paris: Gallimard.

Hopferer, B., F. Koch, J. Lee-Kalisch, J. Noth, eds. (2012), *Negotiating Difference: Chinese Contemporary Art in the Global Context*, 49–62, Weimar: Verlag und Datenbank für Geisteswissenschaften.

Jopling, C., ed. (1971), *Art and Aesthetics in Primitive Societies,* New York: Dutton.

Kester, G. (2011), *The One and the Many: Contemporary Collaborative Art in a Global Context*, Durham and London: Duke University Press.

Marcus, G. E. (2010), "Contemporary Fieldwork Aesthetics in Art and Anthropology: Experiments in Collaboration and Intervention," *Visual Anthropology*, 23(4): 263–77.

Marcus, G. E. and F. R. Myers (1995), "The Traffic in Art and Culture: An Introduction," in G. E. Marcus and F. R. Myers (eds.), *The Traffic in Art and Culture. Refiguring*

Art and Anthropology, 1–51, Berkeley, Los Angeles and London: University of California Press.

Martin, S. (2007), "Critique of Relational Aesthetics," *Third Text*, 21(4): 369–86.

Mitchell, W. J. T. (1987), *Iconology. Image, Text, Ideology*, Chicago and London: The University of Chicago Press.

Mitchell, W. J. T. (1995), *Picture Theory: Essays on Verbal and Visual Representation*, Chicago and London: The University of Chicago Press.

Moeran, B. and J. S. Pedersen (2011), "Introduction," in B. Moeran and J. S. Pedersen (eds), *Negotiating Values in the Creative Industries. Fairs, Festivals and Competitive Events*, 1–35, Cambridge: Cambridge University Press.

Moore, H. L. (2012), "What's in an Event?," in The Event as a Privileged Medium in the Contemporary Art World, *Maska* XXVII (147–48): 85–9. Available online: https://issuu.com/zavodmaska/docs/maska_2011_147-148_web (accessed January 27, 2017).

Morphy, H. (2009), "Art as a Mode of Action: Some Problems with Gell's Art and Agency," *Journal of Material Culture*, 14 (1): 5–27.

Morphy, H. and M. Perkins (2006), "Introduction: The Anthropology of Art: A Reflection on Its History and Contemporary Practice," in H. Morphy and M. Perkins (eds.), *The Anthropology of Art: A Reader*, 1–32, Malden, MA and London: Blackwell.

Moulin, R. ([1992] 1997), *L'artiste, l'institution et le marché*, Paris: Flammarion-Champs arts.

Moulin, R. ([2003] 2009), *Le marché de l'art: Mondialisation et nouvelles technologies*, Paris: Flammarion-Champs arts.

Myers, F. R. (2002), *Painting Culture. The Making of an Aboriginal Culture*, Durham and London: Duke University Press.

Nakamura, F., M. Perkins and O. Krischer, eds. (2013), *Asia Trough Art and Anthropology. Cultural Translation Across Borders*, London et al.: Bloomsbury.

Noth, J. (2012), "Landscapes of Exclusion: The No Name Group and the Multiple Modernities in Chinese Art around 1979," in B. Hopferer, F. Koch, J. Lee-Kalisch, and J. Noth (eds.), *Negotiating Difference: Chinese Contemporary Art in the Global Context*, 49–62, Weimar: Verlag und Datenbank für Geisteswissenschaften.

Onians, J. (2003), "A Natural Anthropology of Art," *International Journal of Anthropology*, 18 (4): 259–64.

Onians, J. (2006), "Introduction," in J. Onians (ed.), *Compression vs Expression. Containing and Explaining the World's Art*, vii–xi, Sterling and Francine Clark Institute, Williamstown, MA, New Haven and London: Yale University Press.

Papastergiadis, N. (2008), "Spatial Aesthetics: Rethinking Contemporary Art," in T. Smith, O. Enwezor, and N. Condee (eds.), *Antinomies in Art and Culture. Modernity, Postmodernity, Contemporaneity*, 363–81, Durham and London: Duke University Press.

Papastergiadis, N. (2011), "Collaboration in Art and Society: A Global Pursuit of Democratic Dialogue," in J. Harris (ed.), *Globalization and Contemporary Art*, 275–87, Malden, MA and London: Wiley-Blackwell.

Peterson, K. (1997), "The Distribution and Dynamics of Uncertainty in Art Galleries: A Case Study of New Dealership in the Parisian Art Market, 1985-1990," *Poetics*, 25: 241–63.

Plattner, S. (1996), *High Art Down Home. An Economic Ethnography of a Local Art Market*, Chicago and London: The University of Chicago Press.

Power, D. and J. Jansson (2008), "Cyclical Clusters in Global Circuits: Overlapping Spaces in Furniture Trade Fairs," *Economic Geography*, 84(4): 423–49.

Price, S. (1989), *Primitive Art in Civilized Places*, Chicago and London: The University of Chicago Press.

Rancière, J. (2001), *Le partage du sensible*, Paris: La Fabrique-éditions.

Rancière, J. (2004), *Malaise dans l'esthétique*, Paris: Éditions Galilée.

Roberts, J. and S. Wright (2004), "Art and Collaboration," *Third Text*, 18(6): 531–2.

Sansi, R. (2015), *Art, Anthropology and the Gift*, London et al.: Bloomsbury.

Schneider, A. (2015), "Towards a New Hermeneutics of Art and Anthropology Collaborations," *Ethnoscripts*, 17(1): 23–30.

Schneider, A. and C. Wright, eds. (2006), *Contemporary Art and Anthropology*, Oxford and New York: Berg.

Schneider, A. and C. Wright, eds. (2010), *Between Art and Anthropology. Contemporary Ethnographic Practice*, Oxford and New York: Berg.

Schneider, A. and C. Wright, eds. (2013), *Anthropology and Art Practice*, London et al.: Bloomsbury.

Smith, T. (2011), *Contemporary Art-World Currents*, London: Lawrence King Publishing.

Smith, T. (2013), "Contemporary Art: World Currents in Transition Beyond Globalization," in H. Belting, A. Buddensieg, and P. Weibel (eds.), *The Global Contemporary and the Rise of New Art Worlds*, 186–92, Cambridge, MA and Karlsruhe: The MIT Press and ZKM/Center for Art and Media.

Steiner, C. (1994), *African Art in Transit*, Cambridge: Cambridge University Press.

Thompson, D. (2008), *The $ 12 Million Stuffed Shark. The Curious Economics of Contemporary Art*, London and New York: Palgrave MacMillan.

Thornton, S. (2008), *Seven Days in the Art World*, London: Granta Publications.

Van Damme, W. (2006), "Anthropologies of Art: Three Approaches," in Venbrux, E., P. S. Rosi, R. L. Welsch (eds.), *Exploring World Art*, 69–81, Long Grove, IL: Waveland Press.

Van Damme, W. (2008), "Introducing World Art Studies," in K. Zijlmans and W. van Damme (eds.), *World Art Studies: Exploring Concepts and Approaches*, 23–61, Amsterdam: Valiz.

Velthuis, O. (2007), *Talking Prices: Symbolic Meaning of Prices on the Market for Contemporary Art*, Princeton and Oxford: Princeton University Press.

Venbrux, E. and P. S. Rosi (2003), "Conceptualizing World Art Studies: An Introduction," *International Journal of Anthropology*, 18(4): 191–200.

Vogel, S. B. (2013), "Globalkunst—Eine neue Weltordnung," in S. B. Vogel (ed.), Globalkunst—Eine neue Weltordnung, *Kunstforum*, 220: 12–59.

Volkenandt, C. (2004), "Kunst weltweit? Versuch einer Einleitung," in C. Volkenandt (ed.), *Kunstgeschichte und Weltgegenwartskunst. Konzepte—Methoden—Perspektiven*, 11–30, Berlin: Dietrich Reimer Verlag.

Wagner, E. and T. Westreich Wagner (2013), *Collecting Art for Love, Money and More*, New York: Phaidon.

Wang, A. (2014), "Art apolitique, expérience privée et subjectivité alternative dans la Révolution culturelle," *Perspectives Chinoises*, 4: 29–39.

Weibel, P. (2013), "Globalization and Contemporary Art," in H. Belting, A. Buddensieg, and P. Weibel (eds.), *The Global Contemporary and the Rise of*

New Art Worlds, 20–27, Cambridge, MA and Karlsruhe: The MIT Press and ZKM/Center for Art and Media.

Weiss, R. and et al. (2011), *Making Art Global (Part 1). The Third Havana Biennial 1989*, Exhibition Histories Series, London: Afterall Books, Saint Martins College of Art and Design, University of Arts London.

Westermann, M., ed. (2007), *Anthropologies of Art*, Sterling and Francine Clark Institute, Williamstown, MA, New Haven and London: Yale University Press.

Wright, S. (2004), "The Delicate Essence of Artistic Collaboration," *Third Text*, 18 (6): 533–45.

Chapter 1.1

Bakewell, L. (1998), "Image Acts." *American Anthropologist*, 100 (1): 22–32.

Belting, H. (2004), *Pour une anthropologie des images*, trans. J. Torrent, Paris: Gallimard.

Boas, F. ([1927] 1955), *Primitive Art*, New York: Dover Publications.

Cheng, F. (1991), *Vide et plein. Le langage pictural chinois*, Paris: Éditions du Seuil.

Descola, P. (2005), *Par-delà nature et culture*, Paris: Gallimard.

Feld, S. (1982), *Sound and Sentiment. Birds, Weeping, Poetics, and Song in Kaluli Expression*, Philadelphia: University of Pennsylvania Press.

Fienup-Riordan, A. (1996), *The Living Tradition of Yup'ik Masks: Agayuliyararput, Our Way of Making Prayer*, Seattle and London: University of Washington Press.

Freedberg, D. (1989), *The Power of Images. Studies in the History and Theory of Response*, Chicago and London: The University of Chicago Press.

Gell, A. (1998), *Art and Agency. An Anthropological Theory*, Oxford: Clarendon Press.

Ingold, T. (1998), "Totemism, Animism, and the Depiction of Animals," in M. Seppälä, J.-P. Vanhala, and L. Weintraub (eds.), *Animal. Anima. Animus*, 181–207, Pori: FRAME: The Finnish Fund for Art Exchange and Pori Art Museum.

Jullien, F. (2003), *La grande image n'a pas de forme*, Paris: Seuil.

Kindl, O. (2005), "L'art du nierika chez les Huichol du Mexique. Un 'instrument pour voir'," in M. Coquet, B. Derlon et M. Jeudy-Ballini (eds.), *Les cultures à l'œuvre. Rencontres en art*, 225–48, Paris: Adam Biro and Éditions de la MSH.

Lumholtz, C. S. (1900), "Symbolism of the Huichol Indians," *Memoirs of the American Museum of Natural History*, 3(1): 1–228.

Morphy, H. (1991), *Ancestral Connections: Art and an Aboriginal System of Knowledge*, Chicago and London: The University of Chicago Press.

Munn, N. D. (1973), *Walbiri Iconography: Graphic Representation and Cultural Symbolism in a Central Australian Society*, Chicago and London: The University of Chicago Press.

Myers, F. R. (1999), "Aesthetic and Practice: A Local Art History of Pintupi Painting," in H. Morphy and M. Smith Boles (eds.), *Art from the Land. Dialogues with the Kluge-Ruhe Collection of Australian Aboriginal Art*, 219–59, Charlottesville: University of Virginia Press.

Negrín J. (1977), *El arte contemporáneo de los Huicholes*, Guadalajara: Universidad de Guadalajara.

Saladin d'Anglure, B. (1990), "Nanook, Super-Male. The Polar Bear in the Imaginary Space and Social Time of the Inuit of the Canadian Arctic," in R. Willis (ed.), *Signifying Animals: Human Meanings in the Natural World*, 178–95, London: Unwin Hyman.

Schaeffer, J.-M. (1996), *Les célibataires de l'art. Pour une esthétique sans mythes*, Paris: Gallimard.

Taylor, A. C. (2003), "Les masques de la mémoire. Essai sur la fonction des peintures corporelles jivaro," *L'Homme*, 165: 223–48.

Taylor, L. (1996), *Seeing the Inside: Bark Painting in Western Arnhem Land*, Oxford: Clarendon Press.

Chapter 1.2

Argan, G. C. (2008), *Storia dell'Arte Italiana: Dall'Anticihita' al Medioevo*, Milano: RCS Libri.

Babb, L. A. (1981), "Glancing: Visual Interaction in Hinduism," *Journal of Anthropological Research*, 37 (4): 387–401.

Bazin, A. (1967), "*What is Cinema*," vol. 1, Berkeley, Los Angeles and London: University of California Press

Boltanski, L. and E. Chiapello (2006), *The New Spirit of Capitalism*, trans. G. Elliott, London and New York: Verso.

Clanton, C. (2016), "Uncanny Others: Hauntology, Ethnography, Media," PhD diss., Goldsmiths' College, University of London.

Crary, J. 1990, *Techniques of the Observer: On Vision and Modernity in the Nineteenth Century*, Cambridge, MA and London: The MIT Press.

Didi-Huberman, G. (2003), *Images in Spite of All: Four Photographs from Auschwitz*, trans. S. B. Lillis, Chicago and London: The University of Chicago Press.

Dundes, A. (1980), *Interpreting Folklore*, Bloomington and Indianapolis: Indiana University Press.

Eck, D. (1998), *Darsan: Seeing the Divine Image in India*, New York: Columbia University Press.

Edwards, E. (2003), "Talking Visual Histories: Introduction," in L. Peers and A. Brown (eds.), *Museums and Sources Communities*, 83–99, London and New York: Routledge.

Edwards, E. (2006), "Photographs and the Sound of History," *Visual Anthropology Review*, 21 (1–2): 27–46.

Elsaesser, T. (2013), "The "Return" of 3-D: On Some of the Logics and Genealogies of the Image in the Twenty-First Century," *Critical Inquiry*, 39(2): 217–46.

Elsaesser, T. and M. Hagener (2015), *Film Theory: An Introduction Through the Senses*, 2nd edn., London and New York: Routledge.

Favero, P. (2013), "Getting our Hands Dirty (again): Interactive Documentaries and the Meaning of Images in the Digital Age," *Journal of Material Culture*, 18 (3): 257–77.

Favero, P. (2017), "'The Transparent Photograph': Reflections on the Ontology of Photographs in a Changing Digital Landscape," Special Issue *Anthropology & Photography*, 71–16. Available online: http://www.therai.org.uk/images/stories/ photography/AnthandPhotoVol7.pdf (accessed July 17, 2017).

Florensky, P. (2002), *Beyond Vision: Essays on the Perception of Art*, edited by N. Misler, translated by W. Salmond, London: Reaktion Books.

Flusser, V. ([1983] 2005), *Towards a Philosophy of Photography*, London: Reaktion Books.

Foucault, M. (1977), *Discipline and Punish: The Birth of the Prison*, translated by A. Sheridan, New York: Vintage Books.

Gallese, V. (2009), "Mirror Neurons, Embodied Simulation, and the Neural Basis of Social Identification," *Psychoanalytic Dialogues*, 19: 519–36.

Gehl, R. (2009), "YouTube as Archive. Who will Curate this Digital *Wunderkammer*?," *International Journal of Cultural Studies*, 12: 43–60.

Gell, A. (1992), "The Technology of Enchantment and the Enchantment of Technology," in J. Coote and A. Shelton (eds.), *Anthropology, Art, and Aesthetics*, 40–66, Oxford: Clarendon.

Gilardi, A. (2002), *Storia della fotografia pornographica*, Milano: Mondadori.

Gombrich, E. H. (2006), *The Story of Art*, London: Phaidon Press.

Grau, O. (2003), *Virtual Art: From Illusion to Immersion*, Cambridge, MA and London: The MIT Press.

Greenblatt, S. (1990), "Resonance and Wonder," *Bulletin of the American Academy of Arts and Science*, 4(4): 11–34.

Hauser, A. ([1951] 1999), *The Social History of Art: From Prehistoric Times to the Middle Ages*, vol. 1, London and New York: Routledge.

Hay, J. and N. Couldry (2011), "Rethinking Convergence/Culture: An Introduction," *Cultural Studies*, 25(4–5): 473–86.

Helmreich, S. (2007). "An Anthropologist Underwater: Immersive Soundscapes, Submarine Cyborgs, and Transductive Ethnography," *American Ethnologist*, 34 (4): 621–41.

Jay, M. (1988), "Scopic Regimes of Modernity," in H. Foster (ed.), *Vision and Visuality*, 3–23, San Francisco: Bay Press.

Jenkins, H. (2006), *Convergence Culture: Where Old and New Media Collide*, New York: New York University Press.

Kittler, F. (2010), *Optical Media. Berlin Lectures 1999*, trans. A. Enns, Cambridge: Polity Press.

Marks, L. (2002), *Touch: Sensuous Theory and Multisensory Media*, Minneapolis and London: University of Minnesota Press.

McQuire, S. (1998), *Visions of Modernity: Representation, Memory, Time and Space in the Age of the Camera*, London et al.: Sage.

Merleau-Ponty, M. (1964), "Eye and Mind," in J. M. Edie (ed.), *The Primacy of Perception: And Other Essays on Phenomenological Psychology, the Philosophy of Art, History and Politics (Studies in Phenomenology and Existential Philosophy)*, trans. W. Cobb, 159–90, Evanston and Chicago: Northwestern University Press.

Metz, C. ([1977] 1982), *The Imaginary Signifier: Psychoanalysis and the Cinema*, translated by C. Britton, A. Williams, B. Brewsler, and A. Guzzetti, Bloomington and Indianapolis: Indiana University Press.

Mirzoeff, N. (1999), *An Introduction to Visual Culture*, London and New York: Routledge.

Mitchell, W. J. T. (1984), "What is an Image?," *New Literary History*, 15(3): 503–37.

Mitchell, W. J. T. (1994), *The Reconfigured Eye: Visual Truth in the Post-photographic Era*, Cambridge, MA and London: The MIT Press.

Pinney, C. (2001), "Piercing the Skin of the Idol," in C. Pinney and N. Thomas (eds.), *Beyond Aesthetics. Art and the Technologies of Enchantment*, 157–79, London and New York: Berg.

Pinney, C., and N. Peterson (2003), *Photography's Other Histories (Objects/ Histories)*, London and New York: Routledge.

Ritchin, F. (1990), *The Coming Revolution in Photography: How Computer Technology Is Changing Our View of the World*, New York: Aperture.

Ryan, M.-L., (2015), *Virtual Reality 2. Revisiting Immersion and Interactivity in Literature and Electronic Media*, Baltimore: John Hopkins University Press.

Sendler, E. (1985), *L'Icona: Immagine dell'Invisibile*, Milano: Edizioni San Paolo.

Sheikh, G. (1997), "The Making of a Visual Language: Thoughts on Mughal Painting," *Journal of Arts and Ideas*, 30–31: 7–32.

Sloterdijk, P. (2011), *Bubbles Spheres Volume I: Microspherology. Semiotext(e) / Foreign Agents)*, translated by W. Hoban, Cambridge, MA and London: The MIT Press.

Smith, G. M. (2003), *Film Structure and the Emotion System*, Cambridge: Cambridge University Press.

Taussig, M. (1993), *Mimesis and Alterity: A Particular History of the Senses*, Hove: Psychology Press.

Taylor, L. (1994), *Visualizing Theory*, London and New York: Routledge.

Thrift, N. (1997), "The Rise of Soft Capitalism," *Cultural Values*, 1(1): 29–57.

Visch, V. T., S. Tan and D. Molenaar (2010), "The Emotional and Cognitive Effect of Immersion in Film Viewing," *Cognition and Emotion*, 24 (8): 1439–45.

Wright, C. (1998), "The Third Subject: Perspectives on Visual Anthropology," *Anthropology Today*, 14 (4): 16–22.

Chapter 2.1

Appadurai, A., ed. (1988), *The Social Life of Things: Commodities in Cultural Perspective*, Cambridge: Cambridge University Press.

Beck, U. (2006), *The Cosmopolitan Vision*, trans. C. Cronin, Cambridge: Polity Press.

Connerton, P. (2006), "Cultural Memory," in C. Tilley, W. Keane, S. Kuechler, M. Rowlands, and P. Spyer (eds.), *Handbook of Material Culture*, 314–24, London et al.: Sage.

Descola, P. (2005), *Par-delà nature et culture*, Paris: Gallimard.

Featherstone, M. (2005), "Localism, Globalism, and Cultural Identity," in R. Wilson and W. Dissanayake (eds.), *Global Local: Cultural Production and the Transnational Imaginary*, 46–77, Durham and London: Duke University Press.

Gell, A. (1992), "The Technology of Enchantment and The Enchantment of Technology," in J. Coote and A. Shelton (eds.), *Anthropology, Art and Aesthetics*, 40–66, Oxford: Clarendon Press.

Gilroy, P. (1993), *The Black Atlantic. Double Consciousness and Modernity*, Cambridge, MA: Harvard University Press.

Hume, M. (2013), "Fashion's New Stella", *Business of Fashion*, September 17. Available online: https://www.businessoffashion.com/articles/intelligence/ fashions-new-stella (accessed October 20, 2016).

Keane, W. (2005), "Signs are not the Garb of Meaning: On the Social Analysis of Material Things," in D. Miller (ed.), *Materiality*, 182–205, Durham and London: Duke University Press.

Kondo, D. (1997), *About Face: Performing Race in Fashion and Theater*, London and New York: Routledge.

Miller, D. (2010), *Stuff*, Cambridge: Polity Press.

Rutherford, J., ed. (1990), *Identity. Community, Culture, Difference*, London: Lawrence and Wishart.

Warnier, J.-P. (2006), "Inside and Outside: Surfaces and Containers," in C. Tilley, W. Keane, S. Kuechler, M. Rowlands, and P. Spyer (eds.), *Handbook of Material Culture*, 186–95, London et al.: Sage.

Chapter 2.2

Aima, R. (2016), "As Car Bomb Rocks Turkey, Contemporary Istanbul Surprises With Brisk Sales," ArtnetNews, November 4. Available online: https://news.artnet.com/market/as-attack-rocks-turkey-contemporary-istanbul-surprises-with-strong-sales-733658 (accessed November 20, 2016).

Baker, G. (2010), "The Globalization of the False: A Response to Okwui Enwezor (2004)," in E. Filipovic, M. van Hal, and S. Ovstebo (eds.), *The Biennial Reader*, 446–53, Bergen and Ostfildern: Bergen Kunsthall and Hatje Cantz.

Biennial Foundation (2017), *Directory of Biennials*. Available online: http://www.biennialfoundation.org/home/biennial-map/ (accessed February 27, 2017).

Boucher B. (2016), "Istanbul's Art International Fair Cancels 2016 edition," ArtnetNews, April 25. Available online: https://news.artnet.com/market/istanbul-art-international-fair-cancels-2016-481028 (accessed November 17, 2017).

Bydler, C. (2004), *The Global Art World Inc. On the Globalization of Contemporary Art*, Stockholm: Acta Universitatis Upsaliensis, Figura Nova Series 32.

Cameron, D. (2011), "8th International Istanbul Biennial," in J. Hoffmann and A. Pedrosa (eds.), *Istanbul'u Hatırlamak—Remembering Istanbul*, 150–63, Istanbul: IKSV, Yapi Kredi, Vehbi Koç Foundation.

Cultural Exchange (n. y.), Available online: http://www.culturalexchange-tr.nl/mapping-turkey/visual-arts/festivals-and-events/biennials (accessed February 27, 2017).

Dervişoglu, G. (2009), "Corporate Support on Art: A vicious or virtuous cycle?," in What, How and For Whom/WHW (eds.), *Metinler—The Texts*, 39–51, Istanbul: IKSV, Yapi Kredi, Vehbi Koç Foundation.

Esche, C. and V. Kortun (2007), "The World is Yours," in Istanbul Modern, *Simdi Zaman Gecmiş Zaman/Time Present Time Past. Highlights from 20 years of the International Istanbul Biennial*, 318–22, Istanbul: IKSV.

Fillitz, T. (2009), "Contemporary Art of Africa: Coevalness in the Global World," in H. Belting and A. Buddensieg (eds.), *The Global Art World. Audiences, Markets, and Museums*, 116–34, Ostfildern: Hatje Cantz.

Gielen, P. (2009), "The Biennial: A Post-Institution for Immaterial Labour," *Open! Cahier on Art and the Public Domain*, 16: 8–17.

Hanru, H. (2011), "10th International Istanbul Biennial," in J. Hoffmann and A. Pedrosa (eds.), *Istanbul'u Hatırlamak—Remembering Istanbul*, 186–99, Istanbul: IKSV, Yapi Kredi, Vehbi Koç Foundation.

Hasegawa, Y. (2011), "7th International Istanbul Biennial," in J. Hoffmann and A. Pedrosa (eds.), *Istanbul'u Hatırlamak—Remembering Istanbul*, 128–43, Istanbul: IKSV, Yapi Kredi, Vehbi Koç Foundation.

Hoffmann, J. and A. Pedrosa (2011), "Introduction," in J. Hoffmann and A. Pedrosa (eds.), *Isımsız—Untitled: El kitabi—The Companion*, 22–9, Istanbul: IKSV, Yapi Kredi, Vehbi Koç Foundation.

IKSV Istanbul Foundation for Culture and Arts (2013a), "The Financing of International Contemporary Art Biennials," in U. M. Bauer and H. Hanru (eds.), *Shifting Gravity. World Biennial Forum No 1*, 153–71, Ostfildern: Hatje Cantz.

IKSV Istanbul Foundation for Culture and Arts (2013b), Press Release, 13th Istanbul Biennial, January 8, 2013. Available online: http://bienal.iksv.org/en/archive/newsarchive/p/1/622 (accessed February 15, 2017).

IKSV Istanbul Foundation for Culture and Arts (2016), Press Release, 15th Istanbul Biennial. Available online: http://bienal.iksv.org/en/archive/newsarchive/p/1/1438 (accessed February 15, 2017).

Karaca, B. (2011), "When Duty Calls . . .: Questions of Sensitivity and Responsibility in Light of the Tophane Events," *Red Thread*, Selection 2009–11, Issues 1–3: 37–41. Available online: http://www.red-thread.org/en/article.asp?a=49 (accessed November 20, 2016).

Kinsella, E. (2016), "How Political Instability in Turkey Negatively Impacted the Art Market," ArtnetNews, July 26. Available online: https://news.artnet.com/market/turkish-art-market-explained-573734 (accessed November 14, 2016).

Kortun, V. (2011), "3rd International Istanbul Biennial," in J. Hoffmann and A. Pedrosa (eds.), *Istanbul'u Hatırlamak—Remembering Istanbul*, 54–67, Istanbul: IKSV, Yapi Kredi, Vehbi Koç Foundation.

Madra, B. (2011), "1st International Istanbul Contemporary Art Exhibitions and 2nd International Istanbul Biennial," in J. Hoffmann and A. Pedrosa (eds.), *Istanbul'u Hatırlamak—Remembering Istanbul*, 24–41, Istanbul: IKSV, Yapi Kredi, Vehbi Koç Foundation.

Martinez, R. (2011), "5th International Istanbul Biennial," in J. Hoffmann and A. Pedrosa (eds.), *Istanbul'u Hatırlamak—Remembering Istanbul*, 94–104, Istanbul: IKSV, Yapi Kredi, Vehbi Koç Foundation.

Martini, V. (2010), "The Era of the Histories of Biennials Has Begun," in E. Filipovic, M. van Hal, and S. Ovstebo (eds.), *The Biennial Reader* (Suppl.), 9–13, Bergen and Ostfildern: Bergen Kunsthall and Hatje Cantz.

Mörtenböck, P. and H. Mooshammer (2008), "Plan and Conflict. Networked Istanbul," *Third Text*, 22(1): 57–69.

Örer, B. (2011), "Foreword," in J. Hoffmann and A. Pedrosa (eds.), *Isımsız—Untitled: El kitabi—The Companion*, 10–17, Istanbul: IKSV, Yapi Kredi, Vehbi Koç Foundation.

Rogoff, I. (2009), "Geo-Cultures: Circuits of Arts and Globalizations," *Open! Cahier on Art and the Public Domain*, 16: 106–15.

What, How and for Whom/WHW (2011), "11th International Istanbul Biennial," in J. Hoffmann and A. Pedrosa (eds.), Istanbul'u Hatırlamak—Remembering Istanbul, 206–15, Istanbul: IKSV, Yapi Kredi, Vehbi Koç Foundation.

Chapter 2.3

Becker, H. S. (1982), *Art Worlds*, Berkeley, Los Angeles, London: University of California Press.

Belting, H. (2013a), "From World Art to Global Art: View on a New Panorama," in H. Belting, A. Buddensieg and P. Weibel (eds.), *The Global Contemporary and the Rise of New Art Worlds*, 178–85, Cambridge, MA and Karlsruhe: The MIT Press and ZKM/Center for Art and Media.

Belting, H. (2013b), "The Plurality of Art Words and the New Museum," in H. Belting, A. Buddensieg and P. Weibel (eds.), *The Global Contemporary and the Rise of New Art Worlds*, 246–54, Cambridge, MA and Karlsruhe: The MIT Press and ZKM/Center for Art and Media.

Bydler, C. (2004), *The Global Art World Inc. On the Globalization of Contemporary Art*. Stockholm: Acta Universitatis Upsaliensis, Figura Nova Series 32.

Danto, A. C. (1964), "The Art World," *Journal of Philosophy*, 61: 571–84.

Danto, A. C. (1997), *After the End of Art*, Princeton and Oxford: Princeton University Press.

Enwezor, O. (2002), *Großausstellungen und die Antinomien einer transnationalen globalen Form*, Berliner Thyssen-Vorlesung zur Ikonologie der Gegenwart 1. Munich: Fink.

Enwezor, O. (2009), "No title", in October Questionnaire on "The Contemporary", *October*, 130: 33–40.

Fillitz, T. (2013), "Global Art and Anthropology: The Situated Gaze and Local Art Worlds in Africa," in H. Belting, A. Buddensieg and P. Weibel (eds.), *The Global Contemporary and the Rise of New Art Worlds*, 221–27, Cambridge, MA and Karlsruhe: The MIT Press and ZKM/Center for Art and Media.

Fillitz, T. (2015), "Anthropology and Discourses on Global Art," *Social Anthropology/ Anthropologie Sociale*, 23(3): 299–313.

Groys, B. (2008a), "The Topology of Contemporary Art," in T. Smith, O. Enwezor and N. Condee (eds.), *Antinomies in Art and Culture. Modernity, Postmodernity, Contemporaneity*, 71–80, Durham and London: Duke University Press.

Groys, B. (2008b), *Art Power*, Cambridge, MA and London: The MIT Press.

Harney, E. (2004), *In Senghor's Shadow. Art, Politics, and the Avant-Garde in Senegal, 1960 – 1995*, Durham and London: Duke University Press.

Konaté, Y. (2009), *La Biennale de Dakar. Pour une esthétique de la création africaine contemporaine – tête à tête avec Adorno*, La Bibliothèque d'Africultures, Paris: L'Harmattan.

Marcus, G. E., and F. R. Myers (1995), "The Traffic in Art and Culture: An Introduction," in G. E. Marcus, and F. R. Myers (eds.), *The Traffic in Art and Culture. Refiguring Art and Anthropology*, 1–51, Berkeley, Los Angeles, London: University of California Press.

Nakamura, F., M. Perkins, and O. Krischer, eds. (2013), *Asia through Art and Anthropology. Cultural Translation across Borders*, London et al.: Bloomsbury.

Nzewi, U.-S. C. (2013), "The Dak'Art Biennial in the Making of Contemporary African Art, 1992-Present," PhD diss., Emory University, Atlanta.

Papastergiadis, N. (2008), "Spatial Aesthetics: Rethinking the Contemporary," in T. Smith, O. Enwezor and N. Condee (eds.), *Antinomies in Art and Culture. Modernity, Postmodernity, Contemporaneity*, 363–81, Durham and London: Duke University Press.

Phillips, R. B. (2005), "The Value of Disciplinary Difference: Reflections on Art History and Anthropology at the Beginning of the Twenty-First Century," in M. Westermann (ed.), *Anthropologies of Art*, 242–59, Clark Studies in the Visual Arts, Sterling and the Francine Clark Art Institute, Williamstown, MA, New Haven and London: Yale University Press.

Smith, T. (2011), *Contemporary Art-World Currents*, London: Lawrence King Publishing.

Stallabrass, J. (2004), *Art Incorporated. The Story of Contemporary Art*, Oxford: Oxford University Press.

Sylla, A. (2011), Histoire des arts plastiques sénégalais. *Ethiopiques* 87. Available online: http://ethiopiques.refer.sn/spip.php?article1796 (accessed December 03, 2016).

Tang, J. (2011), "Biennalization and its Discontent," in B. Moeran and J. S. Pedersen (eds.), *Negotiating Values in the Creative Industries. Fairs, Festivals and Competitive Events*, 73–93, Cambridge: Cambridge University Press.

Thomas, N., and D. Losche, eds. (1999), *Double Vision. Art Histories and Colonial Histories in the Pacific*, Cambridge: Cambridge University Press.

Vogel, S. B. (2013), "Globalkunst—Eine neue Weltordnung," in S. B. Vogel (ed.), "Globalkunst—Eine neue Weltordnung", *Kunstforum*, 220: 12–59.

Chapter 3.1

Adler, M. (1985), "Stardom and Talent," *American Economic Review*, 75: 208–12.

Becker, H. S. (1982), *Art Worlds*, Berkeley, Los Angeles, London: University of California Press.

Crispolti, E. (1996), *Rapporto sul Sistema dell'Arte Moderna e Contemporanea in Toscana*, Fiesole: Fondazione Primo Conti per la Regione Toscana.

Halle, D. (1993), *Inside Culture, Art and Class in the American Home*, Chicago and London: The University of Chicago Press.

Italian Statistical Abstract 1998. (1999), *ISTAT* (National Statistical Institute).

Paloscia, T. (1997), *Accadde in Toscana 2-L'Arte Visiva dal 1941 ai primi anni settanta*, Florence: Polistampa.

Plattner, S. (1996), *High Art Down Home: An Economic Ethnography of a Local Art Market*, Chicago and London: The University of Chicago Press.

Plattner, S. (1998), "A Most Ingenious Paradox, The Market for Contemporary Fine Art," *American Anthropologist*, 100(2): 482–93.

Plattner, S. and A. Cacòpardo (2003), "L'arte contemporanea in un ambiente rinascimentale: Firenze e la sua realtà artistica," *La ricerca folklorica*, 47: 143–55.

Profile of Italy. (1997), *ISTAT* (National Statistical Institute), Essays 2.

Rheims, M. (1980), *The Glorious Obsession*, trans. P. Evans, New York: St. Martins Press.

Rosen, S. (1981), "The Economics of Superstars," *American Economic Review*, 71(5): 845–58.

Watson, P. (1992), *From Manet to Manhattan: The Rise of the Modern Art Market*, New York: Random House.

Chapter 3.2

Agência Brasileira de Promoção de Exportações e Investimentos (Apex-Brasil). Available online: http://www.apexbrasil.com.br (accessed November 21, 2016).

Andrew, C. (2013), *TEFAF Art Market Report 2013: The global art market, with a focus on China and Brazil*, Helvoirt: The European Fine Art Foundation (TEFAF).

Associação Brasileira de Arte Contemporânea (ABACT). Available online: abact.com.br (accessed November 15, 2016).

Barros, G. (2007), "Condenado, ex-banqueiro nega os crimes e ataca BC," *Folha de São Paulo*, April 8. Available online: http://www1.folha.uol.com.br/fsp/dinheiro/fi0804200708.htm (accessed October 14, 2015).

Fernandes, M. Q. (2013), "Políticas públicas e mercado das artes visuais: o programa Brasil Arte Contemporânea," *IV Seminário Internacional— Políticas Culturais*, November 16–18. Available online: http://culturadigital.br/politicaculturalcasaderuibarbosa/files/2013/11/Mariana-Queiroz-Fernandes.pdf (accessed January 20, 2016).

Fetter, B. W. (2014), "A emergência de novas latitudes no mundo das artes: o projeto Latitude e a inserção da arte brasileira no mercado global," *Visualidades*, 12 (2): 143–57. Available online: https://www.revistas.ufg.br/VISUAL/article/download/34482/18182 (accessed December 15, 2015).

Fetter, B. W. (2016), "Narrativas conflitantes e convergentes: as feiras nos ecossistemas contemporâneos da arte," PhD diss., Universidade Federal do Rio Grande do Sul, Porto Alegre.

Fialho, A. L. (2013), "As pesquisas e suas lacunas," *Select*, October-November: 44–5.

Fialho, A. L. (2014), *Sectorial Study - the contemporary art market in Brazil*, 3rd ed., July. Available online: http://media.latitudebrasil.org/uploads/arquivos/arquivo/relatorio_ing-4.pdf (accessed November 21, 2016).

Fillitz, T. (2015), "Anthropology and Discourses on Global Art," *Social Anthropology/ Anthropologie Sociale*, 23 (3): 299–313.

Folha de São Paulo [site], Available online: http://www.folha.uol.com.br (accessed November 5, 2016).

Fraga, F. (2012), "Investimentos na parede," *Gazeta do Povo*, July 23. Available online: http://www.gazetadopovo.com.br/economia/investimento-na-parede-2f5mdqv4bsjxofiutktzv4itq (accessed November 7, 2016).

Furlaneto, A. (2013), "O lucrativo negócio da arte brasileira," *O Globo*, January 6. Available online: http://oglobo.globo.com/cultura/o-lucrativo-negocio-da-arte-brasileira-7205925 (accessed November 7, 2016).

Gil, G., and J. Ferreira (2007), "Mais cultura para mais Brasileiros," *Folha de São Paulo*, November 11. Available online: http://www1.folha.uol.com.br/fsp/opiniao/fz1111200709.htm (accessed October 11, 2015).

Latour, B. (1994), *Jamais fomos modernos - Ensaio de antropologia simétrica*, trans. C. I. Costa, Rio de Janeiro: Editora 34.

Latour, B., and S. Woolgar ([1979] 1986), *Laboratory Life: the Construction of Scientific Facts*, Princeton and Oxford: Princeton University Press.

Latitude – platform for Brazilian art galleries abroad, Available online: http://www.latitudebrasil.org/ (accessed November 15, 2016).

Martí, S. (2013), "Estudo atesta pico de euforia no mercado brasileiro de arte," *Folha de São Paulo*, July 24. Available online: http://www1.folha.uol.com.br/ilustrada/2013/07/1315439-estudo-atesta-pico-de-euforia-no-mercado-brasileiro-de-arte.shtml (accessed November 21, 2016).

Miguel, T. (2011), "Crise sem depressão no mercado de arte," *Sapo*, March 14. Available online: http://sol.sapo.pt/artigo/14611/crise-sem-depressao-nos-mercados-de-arte (accessed November 5, 2016).

Phillips, D. (2012), "Brazil's Booming Art Market," *The Financialist*, November 14. Available online: https://www.thefinancialist.com/brazils-booming-art-market/ (accessed November 15, 2016).

Portal Brasil (2012), "Contemporary Art Brazil," *Portal Brasil*, February 7. Available online: http://www.cultura.gov.br/artigos/-/asset_publisher/WDHlazzLKg57/content/soft-power-577081/10883 (accessed October 11, 2015).

Presse, F. (2012), "Mercado de arte no Brasil cresce com demanda, colecionadores e muito dinheiro," *G1*, May 29. Available online: http://g1.globo.com/pop-arte/noticia/2012/05/mercado-de-arte-no-brasil-cresce-com-demanda-colecionadores-e-muito-dinheiro.html (accessed November 10, 2016).

Riles, A. (2001), *The Network Inside Out*, Michigan: University of Michigan Press.

Sá Earp, F., and G. Kornis (2010), *Estudo da Cadeia Produtiva das Artes Visuais – Relatório Final Consolidado*, Rio de Janeiro: Instituto de Economia, Universidade Federal do Rio de Janeiro.

Chapter 3.3

Appadurai, A. (1986), "Introduction: commodities and the politics of value," in A. Appadurai (ed.), *The Social Life of Things. Commodities in Cultural Perspective*, 3–63, Cambridge: Cambridge University Press.

Bergmann, A. (2015), *Der Verfall des Eigentums. Ersitzung und Verjährung der Vindikation am Beispiel von Raubkunst und Entarteter Kunst (Der Fall Gurlitt)*, Tübingen: Mohr Siebeck.

Berggreen-Merkel, I. (2016), 'Vorwort', in *Bericht über die Arbeit der Taskforce Schwabinger Kunstfund 2013-2015*, 7, Berlin: Taskforce Schwabinger Kunstfund.

Bloch, W. (2017), "Ex-Kolonialmächte wie Deutschland schulden Kamerunern viel," *Welt*, February 24, 2017. Available online: https://www.welt.de/kultur/kunst-und-architektur/article162356755/Ex-Kolonialmaechte-wie-Deutschland-schulden-Kamerunern-viel.html?utm_source=dlvr.it&utm_medium=twitter (accessed February 25, 2017).

Boldt, C. (2014), "Eine Frage der Haltung. Was bedeutet der 'Fall Gurlitt' für die Provenienzforschung, die Erforschung der Herkunft von Kunstwerken und Kulturgütern?," *Wendepunkte*, 2. Available online: http://www.fu-berlin.de/presse/publikationen/fundiert/2014_02/10_gurlitt/index.html#content (accessed December 4, 2016).

Buckley, L. M. (2016), "Ethnography at its Edges: Bringing in Contemporary Art," *American Ethnologist*, 43(4): 745–51.

Campfens, E., ed. (2014), *Fair and Just Solutions: Alternatives to Litigation in Nazi-Looted Art Disputes*, The Hague: Eleven International Publishing.

Chappell, D., and S. Hufnagel (2012), "The Gurlitt Case: German and International Responses to Ownership Rights in Looting Cases," in J. D. Kila and M. Balcells (eds.), *Cultural Property Crime: An Overview and Analysis of Contemporary Perspectives and Trends*, 221–36, Leiden and Boston: Brill.

Chua, L., and M. Elliott, eds. (2013), *Distributed Objects: Meaning and Mattering After Alfred Gell*, Oxford and New York: Berghahn Books.

Conrad, S, and S. Randeria, eds. (2002), *Jenseits des Eurozentrismus. Postkoloniale Perspektiven in den Geschichts- und Kulturwissenschaften*, Francfort/Main: Campus.

De la Fuente, E. (2010), "The Artwork Made Me Do It: Introduction to the New Sociology of Art," *Thesis Eleven*, 103(1): 3–9.

Dennis, D. B. (2012), *Inhumanities: Nazi Interpretations of Western Culture*, Cambridge: Cambridge University Press.

Dominguez Rubio, F. (2014), "Preserving the unpreservable: docile and unruly objects at MoMA," *Theory and Society*, 43(6): 617–45.

Emde, A., and R. Krolczyk, eds. (2012), *Ästhetik ohne Widerstand. Texte zu reaktionären Tendenzen in der Kunst*, Mainz: Ventil.

Evans, R. J. (2003), *The Coming of the Third Reich*, New York: Penguin Press.

Förster, L. (2016), "Plea for a more systematic, comparative, international and long-term approach to restitution, provenance research and the historiography of collections," *Museumskunde*, 81(1/16): 49–54.

Foucault, M. (1966), *Les mots et les choses*, Paris: Gallimard.

Gell, A. (1998), *Art and Agency: An Anthropological Theory*, Oxford: Clarendon Press.

Gell, A. ([1992] 2006), "The Technology of Enchantment and the Enchantment of Technology," in E. Hirsch (ed.), *The Art of Anthropology: Essays and Diagrams*, London School of Economics Monographs on Social Anthropology, 67, 159–86, Oxford and New York: Berg.

Geuss, R. (2005), *Outside Ethics*, Princeton and Oxford: Princeton University Press.

Gosden, C., and Y. Marshall (1999), "The Cultural Biography of Objects", *World Archaeology*, 31(2): 169–78.

Hoffmann, M., and N. Kuhn (2016), *Hitlers Kunsthändler. Hildebrand Gurlitt 1895–1956. Eine Biografie*, Munich: C. H. Beck.

Ingold, T. (2013), *Making: Anthropology, Archaeology, Art and Architecture*, London and New York: Routledge.

Jessewitsch, R. (2013), "Wir werden die Kunstgeschichte umschreiben müssen," *Frankfurter Allgemeine Zeitung*, December 3, 2013. Available online: http://www.faz.net/-gsa-7k0xd (accessed December 1, 2016).

Macdonald, S. (2009), *Difficult Heritage. Negotiating the Nazi Past in Nuremberg and Beyond*, London and New York: Routledge.

Ndikung, B. S. B. and R. Römhild (2013), "The Post-Other as Avant-Garde," in D. Baker and M. Hlavajova (eds), *We Roma: A Critical Reader in Contemporary Art*, 206–25, Amsterdam: Valiz.

Petropoulos, J. (2000), *The Faustian Bargain: The Art World in Nazi Germany*, Oxford: Oxford University Press.

Pinney, C., and N. Thomas, eds. (2001), *Beyond Aesthetics: Art and the Technologies of Enchantment*, Oxford and New York: Berg.

Rabinow, P. (2003), *Anthropos Today. Reflections on Modern Equipment*, Princeton and Oxford: Princeton University Press.

Rogoff, I. (2013), "The Expanding Field," in J.-P. Martinon (ed.), *The Curatorial: A Philosophy of Curating*, 41–8, London et al.: Bloomsbury.

Ronald, S. (2015), *Hitler's Art Thief: Hildebrand Gurlitt, the Nazis, and the Looting of Europe's Treasures*, New York: St. Martin's Press.

Rossmann, A. (2013), "Seine moralischen Geschäfte," *Frankfurter Allgemeine Zeitung*, December 9, 2013. Available online: http://www.faz.net/-gsa-7k87u (accessed December 2, 2016).

Sansi, R. (2015), *Art, Anthropology and the Gift*, London et al.: Bloomsbury.

Schulz, B. (2014), "Die Devisenbringer des Dr. Goebbels," *Weltkunst*, 84: 34–43.

Ssorin-Chaikov, N. (2013), "Ethnographic Conceptualism: An Introduction," *Laboratorium* 5 (2): 5–18.

Thomas, N. (2016), *The Return of Curiosity: What Museums Are Good For in the 21st Century*, London: Reaktion Books.

Weiner, J., ed. (1994), *Aesthetics is a Cross-Cultural Category: A Debate Held in the Muriel Stott Centre, John Rylands University Library of Manchester, on 30th October 1993*, Group for Debates in Anthropological Theory, Department of Social Anthropology, Manchester: University of Manchester.

Chapter 3.4

Anderson, B. (1983), *Imagined Communities: Reflections on the Origin and Spread of Nationalism*, London and New York: Verso.

Aristides, N. (1988), "Calm and Uncollected," *American Scholar*, 57 (3): 327–36.

Baudrillard, J. (1968), *Le système des objets*, Paris: Gallimard.

Baudrillard, J. (1994), "The System of Collecting," in J. Elsner and R. Cardinal (eds.), *The Cultures of Collecting*, 7–24, Cambridge, MA: Harvard University Press.

Belk, R. W. (1995), *Collecting in a Consumer Society*, London and New York: Routledge.

Bourdieu, P. (1979), *La distinction: Critique sociale du jugement*, Paris: Minuit.

Calloway, S. (2004), *Obsessions: Collectors and Their Passions*, London: Mitchell Beazley.

Chen, Shu-ching (2012), "The Magnate and His Music," *Forbes Asia*, August: 78–80.

Comte, A. (1830–42), *Cours de Philosophie Positive*, 6 volumes, Paris: Bachelier.

Derlon, B., and M. Jeudy-Ballini (2008), *La passion de l'art primitif: Enquête sur les collectionneurs*, Paris: Gallimard.

Flannery, R. (2012), "Taiwan's 40 Richest: Wealth List," *Forbes Asia*, June: 80–87.

Glasser, W. (1976), *Positive Addiction*, New York: Harper and Row.

Godelier, M. (1999), *The Enigma of the Gift*, trans. N. Scott, Chicago and London: The University of Chicago Press.

Godelier, M. (2009), *In and Out of the West: Reconstructing Anthropology*, trans. N. Scott, Charlottesville: The University of Virginia Press.

Godelier, M. (2015), *L'imaginé, l'imaginaire et le symbolique*, Paris: CNRS Éditions.

Graw, I. (2009), *High Price: Art Between the Market and Celebrity*, Berlin: Sternberg.

Heinich, N. (2014), *Le paradigme de l'art contemporain: Structures d'une révolution artistique*, Paris: Gallimard.

Higonnet, A. (2009), *A Museum of One's Own: Private Collecting, Public Gift*, Pittsburgh: Persicope.

Mauss, M. (1923–24), "Essai sur le don: Forme et raison de l'échange dans les sociétés archaïques," *L'Année Sociologique*, 1(second series): 30–186.

Muensterberger, W. (1994), *Collecting, an Unruly Passion: Psychological Perspectives*, Princeton and Oxford: Princeton University Press.

Pearce, S. M. (1995), *On Collecting: An Investigation into Collecting in the European Tradition*, London and New York: Routledge.

Pineri, R., ed. (2003), *Paul Gauguin: Héritage et confrontations: actes du colloque des 6, 7 et 8 mars 2003 à l'Université de la Polynésie Française*, Pape'ete: Éditions le Motu.

Plattner, S. (1996), *High Art Down Home: An Economic Ethnography of a Local Art Market*, Chicago and London: The University of Chicago Press.

Plattner, S. (1998), "A Most Ingenious Paradox: The Market for Contemporary Fine Art," *American Anthropologist*, 100: 482–93.

Pomian, K. (1987), *Collectionneurs, amateurs et curieux: Paris, Venise: XVIe – XVIIIe siècle*, Paris: Gallimard.

Purcell, R. W., and S. J. Gould (1992), *Finders, Keepers: Eight Collectors*, New York: Norton.

Rheims, M. (1975), *The Glorious Obsession*, New York: St Martins.

Saura, B. (2002), *Tinito, la communauté chinoise de Tahiti: Installation, structuration, intégration*, Pape'ete: Au Vent des Iles.

Saura, B. (2003), "La non-fascination de l'autre: Paul Gauguin et les Chinois en Océanie Française," in C. Pineri (ed.), *Paul Gauguin: Héritage et confrontations: actes du colloque des 6, 7 et 8 mars 2003 à l'Université de la Polynésie Française*, 108–11, Pape'ete: Éditions le Motu.

Stewart, S. (1993), *On Longing: Narratives of the Miniature, the Gigantic, the Souvenir, the Collection*, Durham and London: Duke University Press.

Thomas, K. D. (2004), "The 10 Most Expensive Living Artists. Tracking the highest prices paid for contemporary artworks," ARTnews, May 1. Available online: http://www.artnews.com/2004/05/01/the-10-most-expensive-living-artists/ (accessed September 15, 2016).

Tuchman, M. (1994), *Magnificent Obsessions: Twenty Remarkable Collectors in Pursuit of their Dreams*, San Francisco: Chronicle.

van der Grijp, P. (2006), *Passion and Profit: Towards an Anthropology of Collecting*, Berlin: LIT Verlag.

van der Grijp, P. (2009a), "Private Collecting, Motives and Metaphors," in F. Muyard, Liang-kai Chou and S. Dreyer (eds.), *Objects, Heritage and Cultural Identity*, 83–102, Nantou: Taiwan Historica.

van der Grijp, P. (2009b), *Art and Exoticism: An Anthropology of the Yearning for Authenticity*, Berlin: LIT Verlag.

van der Grijp, P. (2010), "Vers une anthropologie de l'art du lion en Chine," in M. Cros and J. Bondaz (eds.), *Sur la piste du lion: Safaris ethnographiques entre images locales et imaginaire global*, 153–67, Paris: L'Harmattan.

van der Grijp, P. (2012), "The Paradox of the Philatelic Business: Turning a Private Collection into a Professional Trade," *Material Culture Review*, 76: 41–59.

van der Grijp, P. (2014), "The Sacred Gift: Donations from Private Collectors to Museums," *Museum Anthropology Review*, 8(1): 22–44.

van der Grijp, Paul (2015), "The Gift of Tsochen Man: Private Donations to National Museums in Taiwan," *Museum and Society*, 13(3): 280–95.

van der Grijp, P. (2016), "Private Collectors in Taiwan: Their Motivations for Collecting and Relations with Museums," *Taiwan Journal of Anthropology*, 14(2): 1–32.

Veblen, T. ([1899] 1934), *The Theory of the Leisure Class*, New York: Random House.

Velthuis, O. (2005), *Talking Prices: Symbolic Meanings of Prices on the Market for Contemporary Art*, Princeton and Oxford: Princeton University Press.

Vollard, A. (1994), *Ambroise Vollard: En écoutant Cézanne, Degas, Renoir*, Paris: Grasset.

Wagner, E., and T. Westreich Wagner (2013), *Collecting Art for Love, Money and More*, New York: Phaidon.

Chapter 4.1

Auslander, P. (2006), "The Performativity of Performance Documentation," *PAJ: A Journal of Performance and Art*, 28(3): 1–10.

Bishop, C. (2004), "Antagonism and Relational Aesthetics," *October*, 110: 51–80.

Bishop, C. (2006), "The Social Turn: Collaboration and Its Discontents," *Artforum*, 44(6): 178–83.

Bishop, C. (2012), *Artificial Hells: Participatory Art and the Politics of Spectatorship*, London and New York: Verso.

Bourriaud, N. (2002), *Relational Aesthetics*, trans. S. Pleasance, and F. Woods with the participation of M. Copeland, Dijon: Les presses du réel.

Carlson, M. (2004), *Performance: A Critical Introduction*, London and New York: Routledge.

Féral, J. (1982), "Performance and Theatricality: The Subject Demystified," *Modern Drama*, 25(1): 170–81.

Fisher-Lichte, E. (2008), *The Transformative Power of Performance: A New Aesthetics*, trans. S. Jain, London and New York: Routledge.

Fitzgerald, D., and F. Callard (2014) "Entangled in the collaborative turn: observations from the field," *Somatosphere*, November 3. Available online: http://somatosphere.net/2014/11/entangled.html (accessed February 25, 2017).

Fryer, N. (2013), "Towards a Pedagogy of Devised Theatre Praxis," PhD diss. University of Warwick.

Geertz, C. (1973), "Thick Description: Toward an Interpretative Theory of Culture," in C. Geertz, *The Interpretation of Cultures*, 3–30, New York: Basic Books.

Groys, B. (2010), *Going Public*, Berlin: Sternberg Press.

Kaprow, A. ([1966] 2006), "Notes on the Elimination of the Audience," in C. Bishop (ed.), *Participation*, 102–4, London and Cambridge, MA: Whitechapel and The MIT Press.

Kester, G. (2006), "Another Turn," *Artforum*, 44(9): 22.

Khatchikian, A. (2016), "Moving Bodies: An Anthropological Approach to Performance Art," MA diss. University of Vienna.

Klein, J. (2010), "What is Artistic Research?," *Research Catalogue*, March 30. Available online: https://www.researchcatalogue.net/view/15292/15293/0/0 (accessed October 17, 2016).

Jones, A. (1997), "'Presence' in Absentia: Experiencing Performance as Documentation," *Art Journal*, 56(4): 11–8.

Jones, A. (1998), *Body Art/Performing the Subject*, Minneapolis and London: University of Minnesota Press.

Jones, A. (2013), "Unpredictable Temporalities: The Body in Performance in (Art) History," in G. Borgreen and R. Gade (eds.), *Performing Archives/Archives of Performance*, 53–72, Copenhagen: Museum Tusculanum Press.

Laclau, E., and C. Mouffe ([1985] 2001), *Hegemony and Socialist Strategy: Towards a Radical Democratic Politics*, London and New York: Verso.

Marcus, G. E. (2007), "Notes on the Contemporary Imperative to Collaborate, the Traditional Aesthetics of Fieldwork That Will Not Be Denied, and the Need for Pedagogical Experiment in the Transformation of Anthropology's Signature Method," *ARC Exchange*, 1: 33–44.

Mock, R., ed. (2000), *Performing Processes: Creating Live Performance*, Bristol, UK and Portland, Oregon: Intellect.

Oddey, A. (1994), *Devising Theatre: A Practical and Theoretical Handbook*, London and New York: Routledge.

Rancière, J. (2004), *The Politics of Aesthetics: The Distribution of the Sensible*, ed. and trans. G. Rockhill, London and New York: Continuum.

Rancière, J. (2009), *The Emancipated Spectator*, trans. G. Elliott, London and New York: Verso.

Sansi, R. (2015), *Art, Anthropology and the Gift*, London et al.: Bloomsbury.

Sansi, R. (2016), "Experimentaciones participantes en arte y antropología. Participatory Experimentation in Art and Anthropology," *Revista de Dialectología y Tradiciones Populares*, 71(1): 67–73.

Schneider, A. (2015), "Towards a New Hermeneutics of Art and Anthropology Collaborations," *Ethnoscripts*, 17(1): 23–30.

Schneider, A., and C. Wright, eds. (2006), *Contemporary Art and Anthropology*, Oxford and New York: Berg.

Schneider, A., and C. Wright, eds. (2013), *Anthropology and Art Practice*, London et al.: Bloomsbury.

Sontag, S. (1966), *Against Interpretation, and Other Essays*, New York: Farrar, Straus and Giroux.

Strohm, K. (2012), "When Anthropology Meets Contemporary Art: Notes for a Politics of Collaboration," *Collaborative Anthropologies*, 5: 98–124.

Vergine, L. ([1974] 2000), *Body Art and Performance: The Body as Language*, Milano: Skira.

Chapter 4.2

Aman, R. (2016), "Delinking from Western Epistemology: En Route from University to Pluriversity via Interculturality," in R. Grosfoguel, R. Hernández, and E. Velásquez (eds.), *Decolonizing the Westernized University: Interventions in Philosophy of Education from Within and Without*, 95–114, Lanham: Rowman and Littlefield.

Arendt, H. (1951), *The Origins of Totalitarianism*, New York: Harcourt, Brace & World.

Bishop, C. (2004), "Antagonism and Relational Aesthetics," *October*, 110: 51–79.

Bishop, C. (2012), *Artificial Hells: Participatory Art and the Politics of Spectatorship*, London and New York: Verso.

Bishop, C., ed. (2006), *Participation*, London and Cambridge, MA: Whitechapel and The MIT Press.

Bourriaud, N. (2002). *Relational Aesthetics*, trans. S. Pleasance, and F. Woods with the participation of M. Copeland, Dijon: Les presses du réel.

Caldeira, T. (2000), *City of Walls: Crime, Segregation, and Citizenship in São Paulo* , Berkeley, Los Angeles, London: University of California Press.

Caldeira, T. (2014), "Gender is still the Battleground: Youth, Cultural Production, and the Remaking of Public Space in São Paulo," in S. Parnell and S. Oldfield (eds.), *The Routledge Handbook on Cities of the Global South*, 413–28, London and New York: Routledge.

Carter M. (2005), "The landless rural workers' movement (MST) and democracy in Brazil," Working Paper Number CBS-60-05.

Chakrabarty, D. (2000), *Provincializing Europe: Postcolonial Thought and Historical Difference*, Princeton and Oxford: Princeton University Press.

Comaroff, J, and J. Comaroff (2012), "Theory from the South: A Rejoinder. Theorizing the Contemporary," *Cultural Anthropology* website, February 25. Available online: https://culanth.org/fieldsights/273-theory-from-the-south-a-rejoinder (accessed February 2, 2017).

Coronil, F. (1997), *The Magical State: Nature, Money, and Modernity in Venezuela*, Chicago and London: The University of Chicago Press.

Dussel E. (1998), "Beyond Eurocentrism: The World-system and the Limits of Modernity," in F. Jameson and M. Miyoshi (eds.), *The Cultures of Globalization*, 3–31, Durham and London: Duke University Press.

Dussel E. (2008), "Philosophy of Liberation, the Postmodern Debate, and Latin American Studies," in M. Morana, E. Dussel, and C. Jauregui (eds.), *Coloniality at Large: Latin America and the Postcolonial Debate*, 335–49, Durham and London: Duke University Press.

Escobar A. (2007), "Worlds and Knowledges Otherwise: The Latin American Modernity/Coloniality Research Program," *Cultural Studies*, 21: 179–210.

Escobar A. (2008), *Territories of Difference: Place, Movements, Life, Redes*, Durham and London: Duke University Press.

Fillitz, T. (2016). "The Biennial of Dakar and South-South Circulations," *Artl@s Bulletin*, 5(2): 57–69.

García Canclini, N. (2015), *Art Beyond Itself: Anthropology for a Society without a Story Line*, Durham and London: Duke University Press.

Gillick, L. (2000), *Renovation Filter: Recent Past and Near Future*, Bristol: Arnolfini Gallery Publications.

Graeber, D. (2002), "The New Anarchists," *New Left Review*, 13: 61–73.

Groys, B. (2010), *Art Power*, Cambridge, MA and London: The MIT Press.

Hammond J. (2004), "The MST and the Media: Competing Images of the Brazilian Landless Farmworkers' Movement," *Latin American Politics and Society*, 46(4): 61–90.

Juris, J. (2008), *Networking Futures: The Movements against Corporate Globalization (Experimental Futures)*, Durham and London: Duke University Press.

Juris, J., and A. Khasnasbish, eds. (2013), *Insurgent Encounters: Transnational Activism, Ethnography, and the Political*, Durham and London: Duke University Press.

Lucero, M. E. (2009), "Diluyendo los límites. Deslizamientos en la práctica artística de Hélio Oiticica (Brasil)," in *AAVV. I Jornadas Internacionales de Arte. Educación en la Universidad*, 1–4, PICEF. Universidad Nacional de Misiones (UNAM), Oberá.

Maeckelbergh, M. (2009), *The Will of the Many: How the Alterglobalisation Movement is Changing the Face of Democracy*, London: Pluto Press.

Meszaros G. (2000), "No ordinary revolution: Brazil's landless workers' movement," *Race & Class*, 42(2): 1–18.

Mignolo, W. (2007), "Delinking: The Rhetoric of Modernity, the Logic of Coloniality and the Grammar of Decoloniality," *Cultural Studies*, 21(2–3): 449–514.

Mignolo, W. (2009), "Epistemic Disobedience, Independent Thought and De-Colonial Freedom," *Theory, Culture & Society*, 26(7–8): 1–23.

Mignolo, W. (2011), *The Darker Side of Western Modernity: Global Futures, Decolonial Options*, Durham and London: Duke University Press.

Ndlovu-Gatsheni, S., and S. Zondi, eds. (2016), *Decolonizing the University, Knowledge Systems and Disciplines in Africa*, Durham: Carolina Academic Press.

Olson Jr. M. (1965), *The Logic of Collective Action: Public Goods and the Theory of Groups*, Harvard Econ. Stud., Vol. 124, Cambridge, MA: Harvard University Press.

Park, R. (1967), "On Social Control and Collective Behavior," in *Selected Papers*, ed. R. Turner, Chicago and London: The University of Chicago Press.

Quijano, A. (2000), "Coloniality of Power, Eurocentrism, and Latin America," *Nepantla: Views from South*, 1(3): 533–80.

Quijano, A. (2007), "Coloniality and Modernity/Rationality," *Cultural Studies*, 21(2–3): 168–78.

Razsa, M. (2015), *Bastards of Utopia: Living Radical Politics after Socialism*, Bloomington and Indianapolis: Indiana University Press.

Rolnik, R. (2015), *Guerra dos lugares: A Colonização de Terra e Moradia na Era de Finanças*, São Paulo: Boitempo.

Sansi, R. (2015), *Art, Anthropology and the Gift*, London et al.: Bloomsbury.

Sarlet, I. (2008), "Supremo Tribunal Federal, o direito à moradia e a discussão em torno da penhora do imóvel do fiador," in Z. Fachin (ed.), *20 anos de Constituição cidadã*, 41–66, São Paulo: Método.

Sparke, M. (2007), "Everywhere but always somewhere: Critical Geographies of the Global South," *The Global South I*, (1): 117–26.

Starr, A. (2005), *Global Revolt: A Guide to the Movements Against Globalization*, London: Zed Books.

Steyerl, H. (2011), *Art as Occupation: Claims for an Autonomy of Life. E-flux 30, Turner*, Chicago and London: The University of Chicago Press.

Chapter 4.3

Bishop, C. (2012), *Artificial Hells: Participatory Art and the Politics of Spectatorship*, London and New York: Verso.

Boltanski, L., and E. Chiapello (2006), *The New Spirit of Capitalism*, trans. G. Elliott, London and New York: Verso.

Bourriaud, N. (1999), *Formes de Vie. L'art moderne et l'invention de soi*, Paris: Éditions Denoël.

Bourriaud, N. (2002), *Relational Aesthetics*, trans. S. Pleasance and F. Woods with the participation of M. Copeland, Dijon: Les presses du réel.

Bromberg, S. (2013), "The Anti-Political Aesthetics of Objects and Worlds Beyond", *Mute magazine*. Available online: http://www.metamute.org/editorial/articles/anti-political-aesthetics-objects-and-worlds-beyond (accessed December 8, 2016).

Candea, M., J. Cook, C. Trundle, and T. Yarrow (2015), "Introduction: Reconsidering Detachment", in T. Yarrow, M. Candea, C. Trundle, and J. Cook (eds.), *Detachments: Essays on the Limits of Relational Thinking*, 1–35, Manchester: Manchester University Press.

Carrithers, M. (2010), "Ontology is just another Word for Culture: For the Motion (2)", *Critique of Anthropology*, 30(2): 152–200.

Debord, G. (1967), *La Société du spectacle*, Paris: Chastel.

Descola, P. (2005), *Par-delà nature et culture*, Paris: Gallimard.

Dumont, L. (1980), *Homo Hierarchicus: The Caste System and its Implications*, Chicago and London: The University of Chicago Press.

Escobar, A. (2010), "Latin America at the cross-roads. Alternative modernizations, post-liberalism, or post-development?", *Cultural Studies*, 24(1): 1–64.

Fisher, J. (2007), "In the Spirit of Conviviality," in *Francis Alÿs*, 109–120, London: Phaidon.

Fried, M. (1981), *Absorption and Theatricality: Painter and Beholder in the Age of Diderot*, Berkeley, Los Angeles, London: California University Press.

Greenberg, C. (1961), *Art and Culture*, New York: Beacon Press.

Harman, G. (2014), "Art without Relations," *ArtReview*, September. Available online: https://artreview.com/features/september_2014_graham_harman_relations/ (accessed February 27, 2017).

Henare, A., M. Hoolbraad, and S. Wastell, eds. (2007), *Thinking Through Things: Theorising Artifacts Ethnographically*, London and New York: Routledge.

Holbraad, M. (2012), *Truth in Motion. The Recursive Anthropology of Cuban Divination*, Chicago and London: The University of Chicago Press.

Jensen, C. B. (2012), "The Task of Anthropology is to Invent Relations," *Critique of Anthropology*, 32(1): 47–53.

Kant, I. ([1790] 1951), *Critique of Judgment*, trans. J. H. Bernard, New York: Hafner.

Kester, G. (2011), *The One and the Many: Contemporary Collaborative Art in a Global Context*, Durham and London: Duke University Press.

Latour, B. (1991), *Nous n'avons jamais été modernes*, Paris: La Découverte.

Mauss, M. ([1925] 2003), *Essay sur le don. Forme et raison de l'échange dans les sociétés archaïques*. Available online: http://www.uqac.uquebec.ca/zone30/Classiques_des_sciences_sociales/index.html (accessed February 27, 2017).

Medina, C., S. Buck-Morss, F. Alÿs, and C. Diserenes (2005), *Francis Alÿs: When Faith Moves Mountains*, Madrid: Turner Publications.

Miessen, M. (2011), *The Nightmare of Participation. (Crossbench Praxis as a Mode of Criticality)*, Berlin: Sternberg Press.

Mooney, C. (2013), "Pierre Huyghe," *Art Review,* October. Available online: https://artreview.com/features/october_2013_feature_pierre_huyghe/ (accessed February 27, 2017).

Pedersen, M. A. (2012), "The Task of Anthropology is to Invent Relations," *Critique of Anthropology*, 32(1): 59–65.

Rancière, J. (2002), "The Aesthetic Revolution and its Outcomes," *New Left Review*, 14: 133–51.

Rancière, J. (2009), *Aesthetics and its Discontents*, trans. S. Corcoran, Cambridge: Polity Press.

Schneider, E., and S. Sierra (2004), *Santiago Sierra. 300 Tons and Previous Works*, Kunsthaus Bregenz, Cologne et al.: Walther König.

Scott, M. W. (2014), "To be a Wonder: Anthropology, Cosmology, and Alterity," in A. Abramson and M. Holbraad (eds.), *Framing Cosmologies: The Anthropology of Worlds*, 31–54, Manchester: Manchester University Press.

Strathern, M. (1988), *The Gender of the Gift*, Berkeley, Los Angeles, London: University of California Press.

Strathern, M. (1996), "Cutting the Network," *The Journal of the Royal Anthropological Institute*, 2(3): 517–35.

Viveiros de Castro, E. B. (2002), *A Inconstancia da Alma Selvagem*, São Paulo: Cosac and Naify.

Viveiros de Castro E. B., and M. Goldman (2009), "Slow Motions: Comments on a Few Texts by Marilyn Strathern," *Cambridge Anthropology*, 28(3): 23–43.

Wagner R. (1981), *The Invention of Culture*, Chicago and London: The University of Chicago Press.

Ward, O. (2007), "Santiago Sierra: Interview," *Time Out*, December 3, London. Available online: http://www.timeout.com/london/art/santiago-sierra-interview (accessed February 27, 2017)

Yarrow, T., and D. Garrow (2010), "Introduction: Archaeological Anthropology," in D. Garrow and T. Yarrow (eds.), *Archaeology and Anthropology: Understanding Similarity, Exploring Difference*, 1–12, Oxford: Oxbow.

Index